EXPERIMENTAL GEOGRAPHY

EXPERIMENTAL GEOGRAPHY

Nato Thompson
with essays by Jeffrey Kastner and Trevor Paglen
and contributions from Matthew Coolidge, Iain Kerr, Lize Mogel, and Damon Rich

Francis Alÿs
AREA Chicago
The Center for Land Use Interpretation
The Center for Urban Pedagogy (CUP)
e-Xplo
Ilana Halperin

kanarinka (Catherine D'Ignazio)
Julia Meltzer and David Thorne
Lize Mogel
Multiplicity
Trevor Paglen
Raqs Media Collective

Ellen Rothenberg
Spurse
Deborah Stratman
Alex Villar
Daniel Tucker
Yin Xiuzhen

iCI Independent Curators International, New York

MELVILLEHOUSE
BROOKLYN, NEW YORK

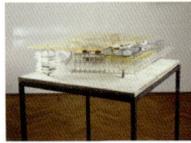

TOWARDS THE DEVELOPMENT OF AN AIR TERMINAL SITE

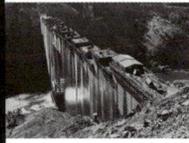

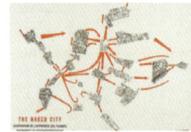

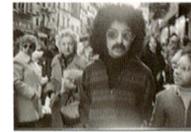

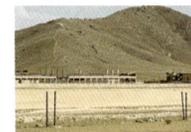

LOOP FEEDBACK LOOP

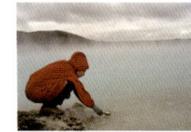

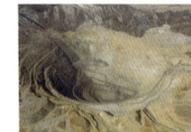

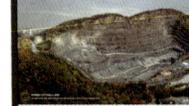

UPRIVER

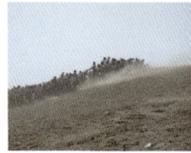

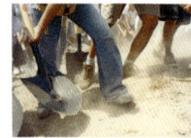

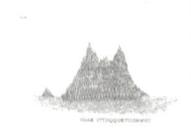

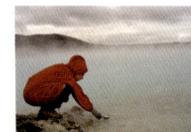

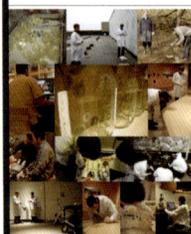

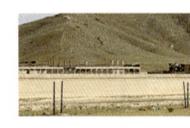

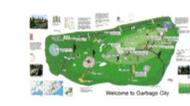

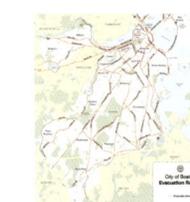

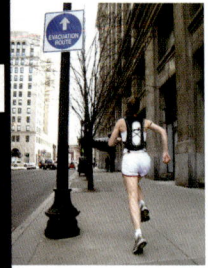

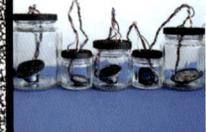

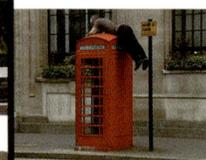

Welcome to Garbage City

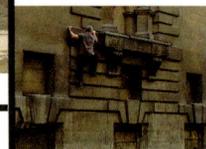

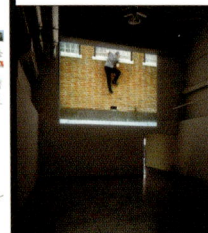

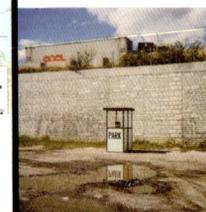

Los Angeles Urban Rangers

Los Angeles Urban Rangers

A THREAT TO PEACE:

STATEMENT OF INTENT BOUNDARIES
BRITISH COLUMBIA'S COASTAL FIRST NATIONS

FREE TRADE AREA OF THE AMERICAS

L.A. County Fair

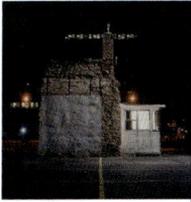

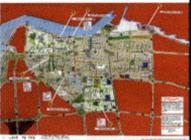

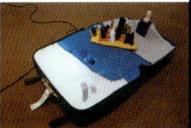

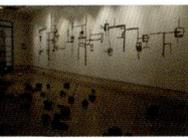

Notes for
a People's Atlas
of Chicago

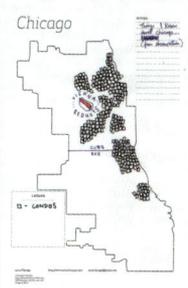

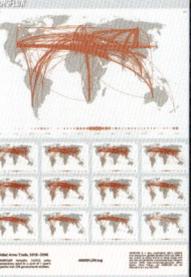

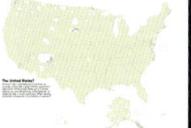

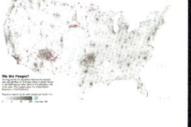

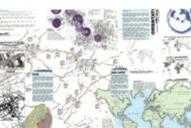

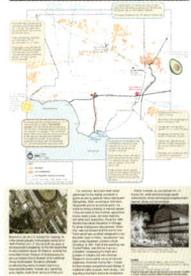

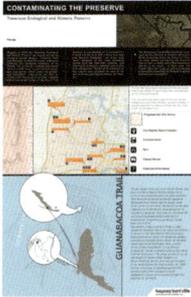

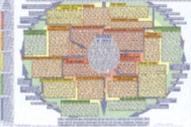

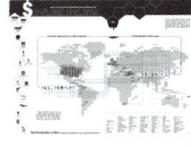

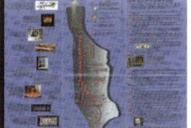

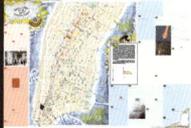

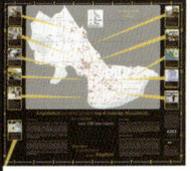

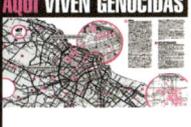

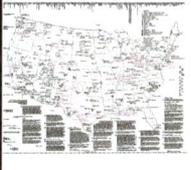

Chicago

177
178

CONTAMINATING THE PRESERVE

AQUI VIVEN GENOCIDAS

GUANABACOA TRAIL

Malibu Public Beaches

Published to accompany the traveling exhibition *Experimental Geography*, organized and circulated by iCI (Independent Curators International), New York

Exhibition curated by Nato Thompson

EXHIBITION FUNDERS
The exhibition, tour, and catalogue are made possible, in part, by the Horace W. Goldsmith Foundation, the iCI Advocates, the iCI Partners, Gerrit L. and Sydie Lansing, and Barbara and John Robinson.

EXHIBITION ITINERARY*
Richard E. Peeler Art Center
DePauw University
Greencastle, Indiana
September 19–December 12, 2008

Rochester Art Center
Rochester, Minnesota
February 7–April 18, 2009

The Albuquerque Museum
Albuquerque, New Mexico
June 28–September 20, 2009

Colby College Museum of Art
Waterville, Maine
February 21–May 30, 2010

*at time of publication

"In Two Directions: Geography as Art, Art as Geography" © Nato Thompson, 2008
"Experimental Geography: From Cultural Production to the Production of Space" © Trevor Paglen, 2008
"Rich in Reference: Thoughts on Land Art's Infrastructural Legacy" © Jeffrey Kastner, 2008
"Notes on Pedagogy and Aesthetic Form" © Damon Rich, 2008
Artist statement by Francis Alÿs is excerpted from and © Francis Alÿs and Cuauhtémoc Medina, *When Faith Moves Mountains*, Madrid: Turner, 2005.

iCI (Independent Curators International)
799 Broadway, Suite 205
New York, NY 10003
Tel: 212-254-8200
Fax: 212-477-4781
www.ici-exhibitions.org

Melville House Publishing
145 Plymouth Street
Brooklyn, NY 11201
www.mhpbooks.com

Library of Congress: 2008932805
ISBN: 9780091636586

Designer: Kelly Blair
Publication Coordinator: Sarah Thomas
Printer: Westcan Printing Group
Copy Editor: Stuart Calderwood

First Printing: 9/2008

Printed in Canada.

CONTENTS

EXHIBITION LENDERS

AREA Chicago
Bellwether Gallery, New York
Bose Pacia Gallery, New York
The Center for Land Use Interpretation
The Center for Urban Pedagogy (CUP)
Chambers Fine Arts, New York
doggerfisher, Edinburgh
e-Xplo
Ilana Halperin
kanarinka (Catherine D'Ignazio)
Julia Meltzer and David Thorne
Lize Mogel
Multiplicity
Trevor Paglen
Raqs Media Collective
Ellen Rothenberg
Spurse
Deborah Stratman
Daniel Tucker
Alex Villar
David Zwirner Gallery, New York

FOREWORD AND ACKNOWLEDGMENTS

Since its founding more than thirty years ago, iCI has been dedicated to giving museum audiences across the country and abroad the opportunity to see and experience significant recent developments in contemporary art internationally through its traveling exhibitions and publications. We are now proud to present *Experimental Geography*, which brings together works in a range of mediums created since 2000 by nineteen artists or artist collaboratives from across the United States, as well as from Latin America, Europe, and Asia.

The territory that these artists are investigating was first defined as "experimental geography" by geographer and artist Trevor Paglen in 2002. A blend of art and geography, the area is characterized primarily by its interdisciplinary nature, an openness to exploration by artists who reference multiple physical and conceptual sources, from the fields, for example, of science, history, economics, politics, culture, and even art, in thinking about the human use of land. These investigations take the form of maps and charts, both actual and virtual; bus tours; and physical intervention in the urban landscape or in nature. As the curator has described, the works range across a grid with one axis the poetic to the didactic, and the other the natural or geologic to the constructed. Taken together, they comprise a complex and thought-provoking experience, and they provide multiple routes for interacting with and expanding awareness of the changing geography in which we live.

This traveling exhibition and catalogue have been made possible through the encouragement, dedication, and generosity of many people. First and foremost, on behalf of iCI's Board of Trustees and staff, I extend warmest thanks to the exhibition's curator, Nato Thompson, who has contributed his breadth of knowledge, critical and curatorial skills, and energy to this project. Nato's essay here offers insights into

the artists and works included in the project, developed through his extensive involvement with interdisciplinary artistic practice and his deep understanding of this expanding field. We are honored to include essays by Trevor Paglen and the distinguished art critic Jeffrey Kastner. The knowledge and insights they share provide valuable perspectives from which to approach the works in this exhibition. We are also grateful for the vital texts discussing key aspects of experimental geography by artist Matthew Coolidge, founder and director of the Center for Land Use Interpretation; Iain Kerr, Spurse member and Associate Professor of Interdisciplinary Studio and Theory, Maine College of Art; artist Lize Mogel; and artist Damon Rich of the Center for Urban Pedagogy (CUP). Statements written by the artists in the exhibition also enrich this publication, and I am most grateful for those invaluable contributions.

iCI owes a debt of gratitude to all of the artists and collaborators in the exhibition, to the lenders who generously allowed their works to travel throughout the two-year tour.

All of us at iCI convey our appreciation to the supporters of this exhibition, tour, and catalogue, including the Horace W. Goldsmith Foundation, the iCI Advocates, the iCI Partners, Gerrit and Sydie Lansing, and Barbara and John Robinson. Their generous contributions helped to make this project a reality.

I also want to express special thanks from the curator to Matthew Coolidge, Lize Mogel, Trevor Paglen, and Daniel Tucker, whom Nato views as key stakeholders in the field. It is from conversations with them that the exhibition came into being.

It has been a pleasure to collaborate with Kelly Burdick and the whole team at Melville House, with whom we worked to produce this publication. We are tremendously grateful for their broad expertise and for their enthusiasm about the project and its importance.

iCI's dedicated, knowledgeable and hardworking staff deserves recognition for their efforts on *Experimental Geography*, in particular Susan Hapgood, director of exhibitions; Sarah Thomas, curatorial assistant; and Rachel May, registrar. My appreciation also goes to Frances Wu, curatorial associate, former curatorial assistant Maia Gianakos, and former curatorial interns Anna Drozda and Teresa Iannotta, as well as to Hedy Roma, former director of development; Hilary Fry, grants and membership coordinator; Kristin Nelson, development assistant; Mary Derr, communications and office administrator; Sue Scott, former communications and operations manager; Chelsea Haines, administrative assistant; and Dolf Jablonski, bookkeeper.

I also wish to add iCI's thanks to all the institutions that will be presenting this exhibition as it travels; it is their involvement that brings the project to life and to its audiences.

Finally, I extend my deep appreciation to iCI's Board of Trustees for their continuing support, enthusiasm, and commitment to all of iCI's activities. They join me in expressing our gratitude to everyone who has contributed to making this project possible.

Judith Olch Richards
Executive Director, iCI

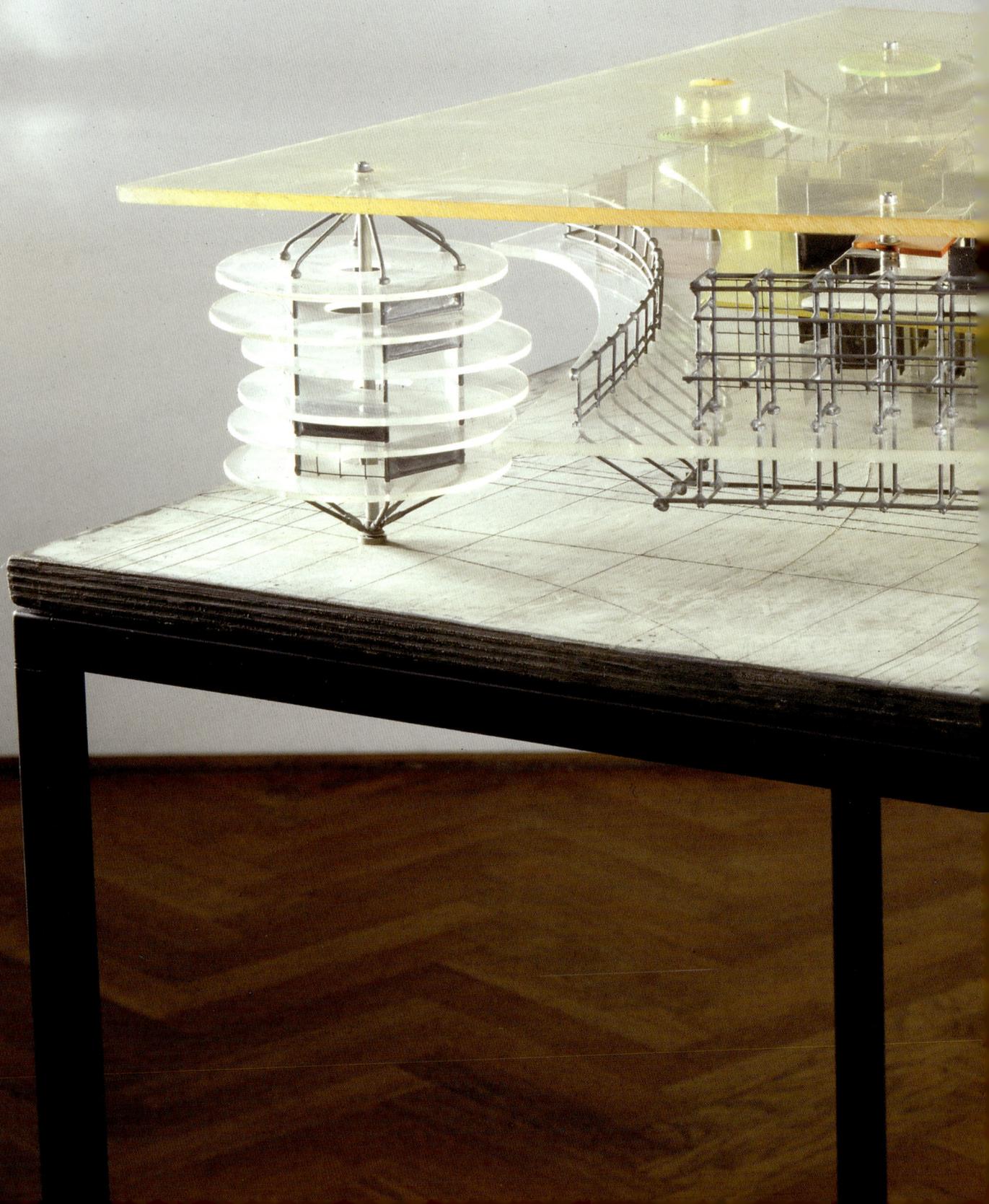

IN TWO DIRECTIONS:
GEOGRAPHY AS ART, ART AS GEOGRAPHY

NATO THOMPSON

Experimental geography, like it sounds, is more experiment than answer. The term, coined by Trevor Paglen, might bring to mind landscapes, laboratories, obscure cartographies, or a didactic analysis of a remote region of the world. And, ultimately, experimental geography is all these things. Paglen, a writer and artist based at the University of California at Berkeley, produces projects that move between a variety of discourses including those of the art world, the military, journalism, and geography, and the work in *Experimental Geography* has similar variety. While this collection is inspired by Paglen's overarching analysis, the work on display does not illustrate a complete theory—his or anyone else's. Instead, *Experimental Geography* should be considered as a new lens to interpret a growing body of culturally inspired work that deals with human interaction with the land. That is to say, the work here gains more intellectual heft when interpreted with an understanding of both contemporary geography and contemporary art. Interpreted in relation

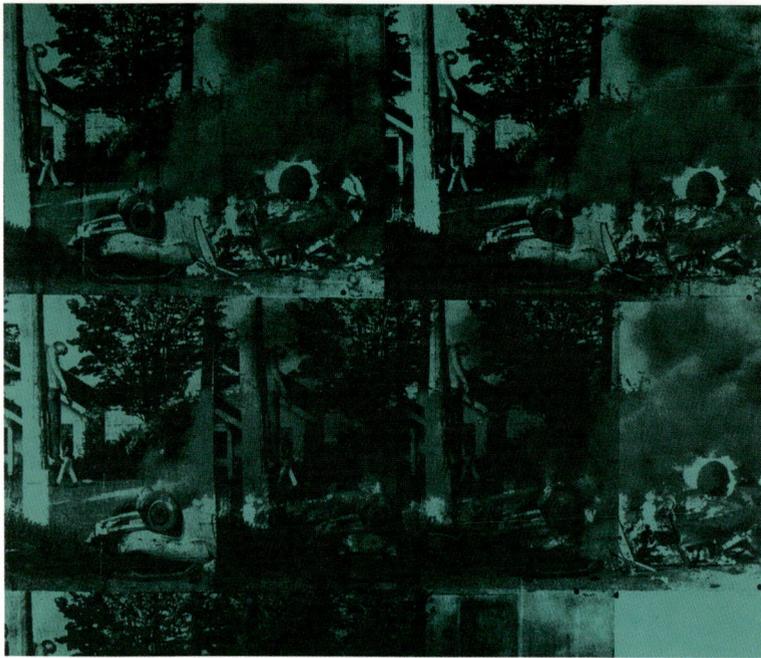

to either field alone, the work may become clouded or, possibly, be given short shrift.

As opposed to works that demonstrate a single technique or subject (a collection of landscapes, for example), this collection represents a constellation whose entirety allows us to appreciate and consider the dynamic possibilities in experimental geography. Think of the works here as operating across an expansive grid with the poetic-didactic as one axis and the geologic-urban as another.

While these dichotomies aren't necessarily set in stone—the didactic can be poetic, and the geologic can be urban, and vice versa—these binaries provide an opportunity to appreciate the range of works presented here.

•••••

When Andy Warhol reflected obliquely, "If you want to know all about Andy Warhol, just look at the surface of my paintings and films and me, and there I am. There's nothing behind it," many interpreted his Pop Art sensibility as in line with the non-representational strategies being hailed during the rise of abstract expressionism.[1] The surface was the work. But Warhol's acute observation was more nuanced. His deadpan quip implied the death of the subject in the face of a growing industry of visual culture. The television and film industries, not art, had become the largest cultural forces in the world—the mother of us all. Warhol's interest in death was not simply a morbid fascination but a realization that the individual was a product of a growing cultural machine. "Before I was shot," he once remarked, "I always thought that I was more half-there than all-there—I always suspected that I was watching TV instead of living life. Right when I was being shot and ever since, I knew that I was watching television."

I begin with Andy Warhol because he is an accepted representative of the art canon. He is a complicated yet seminal figure, and his life and work define much of contemporary artistic practice. And while

Previous pages: Constant Nieuwenhuys, *Yellow Sector* (from the *New Babylon* project), 1958. Collection of the Gemeentemuseum Den Haag

Above: Andy Warhol, *Green Car Crash (Green Burning Car I),* 1963 (detail). Synthetic polymer, silkscreen ink and acrylic on linen, 90 x 80 in. (228.6 x 203.2 cm)

his work did produce a genre like Pop Art inside the discourse of art, it also tore a hole in the fabric of that discourse as well. The field of experimental geography (and many other interdisciplinary practices) derives from similar moments of theoretic rupture. They are born when the extant frame is not wide enough and we must begin to understand the mechanisms of power, finance, and geopolitical structures that produce the culture around us. Because of Warhol's consistent belief in the power of spectacle, his work lent far more cultural power and credence to the post-Fordist mechanisms of capital that were shaping culture across the globe. Television, not art, made culture. And thus, if we are to understand Warhol's work, we must understand television and not art.

Of course, this radical shift in the focus of the interpretative lens has been slow to catch on. Art historians continue to interpret artworks via the canonical history of representation techniques of the West. And let's face it, it is a lot to ask of an art appreciator that he or she understand entire geopolitical conditions before a Warhol work becomes intelligible. However, slowly, a far more informed cross-disciplinary practice emerges that attempts to combine insights from a vast array of disciplines to make cultural actions and projects legible, and meaningful.

·····

I would like to posit that The Center for Land Use Interpretation can be seen as the Andy Warhol in the field of geography. Based in Culver City, California, since 1993, CLUI is dedicated to "the increase and diffusion of information about how the nation's lands are apportioned, utilized and perceived."[2] Clearly the polar opposite in terms of a relationship to glamour (Warhol was obsessed with celebrities; CLUI is obsessed with landfills, airstrips, and freeway on-ramps), they both retain a dry form of pointing as methodology. Acting as a facilitator, each artist simply points to the phenomena that condition our lives. While Warhol dryly points at Marilyn Monroe, CLUI points at a water-treatment plant. (For a selection of CLUI's work, see pages 42–47.) Warhol wasn't explaining what these images mean so much as placing a mirror in front of the viewer and implying, "This is who we are." We are these images. It is not that we simply watch television, but that we take the phenomena around us into our ourselves. We become what we experience. The same can be said of CLUI, which points toward the geologic and urban conditions around us and indicates that these forces produce our sense of self. Tour busses, placards, and informational kiosks takes us physically to the spaces that comprise the land we live in. It might seem fairly dry to say, "This is a court house." But the overall implication is that we are the courthouse. We are the water-treatment plant. We are the land we live on.

The core idea at the heart of experimental geography is that we make the world and, in turn, the world makes us. This insight brings into relief an intimate relationship between what we consider culture and the spaces around us. In Julia Meltzer and David Thorne's video *take into the air my quiet breath*, 2007, a Syrian architect discusses the

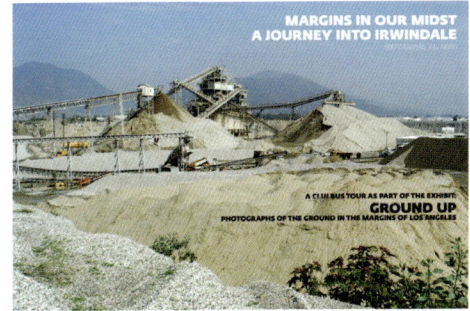

Above: The Center for Land Use Interpretation, *Untitled (image and text panels depicting the programs and projects of CLUI)*, 2007. Inkjet print. 16 x 24 in. (40.6 x 61 cm)

unfinished construction project to build a massive building complex over a fourteenth-century Mamluk mosque in Martyr's Square in Damascus. (See pages 60–61.) As the story of bureaucratic infighting and conflicting administrations emerges, we find that this urban space not only reflects the complicated and cultural forces at work in Syria, but also continues these tensions as an abandoned unfinished social space. In their work, *Erosion by Whispers*, 2007, Raqs Media Collective (see pages 56–59) contrast ephemeral cultural forces such as rumors and whispers with the supposed static nature of architectural space. The juxtaposition lies at the heart of much of the work featured in *Experimental Geography*.

SPECTACLES IN SPACE

"At the opposite pole from these imbecilities, the primarily urban character of the *dérive*, in its element in the great industrially transformed cities—those centers of possibilities and meanings—could be expressed in Marx's phrase: 'Men can see nothing around them that is not their own image; everything speaks to them of themselves. Their very landscape is alive.'"
 – Guy Debord[3]

In tracing historic antecedents for experimental geographic practice, an interesting location to begin is postwar France, with the works of Guy Debord and the eventual father of Marxist geography, Henri Lefebvre. Even before their intense discussions from 1958 to 1962, after Lefebvre had been expelled from the Communist Party, Lefebvre's writings exerted a profound influence on Debord and the avant-garde group CoBRA, particularly in his seminal book *Critique of Everyday Life* (1947).[4] In 1957, Guy Debord founded the Situationist International, a Marxist-inspired organization of artists and philosophers that came out of avant-garde associations including the International Movement for an Imaginist Bauhaus (an offshoot of CoBRA) and the Lettrist International.

 Debord's early writings on what he called "unitary urbanism" and "psychogeography" clearly lay out a framework that is impressively consistent with the one employed in experimental geography: "Geography, for example, deals with the determinant action of general natural forces, such as soil composition or climatic conditions, on the economic structures of a society, and thus on the corresponding conception that such a society can have of the world. *Psychogeography* could set for itself the study of the precise laws and specific effects of the geographical environment, consciously organized or not, on the emotions and behaviors of individuals."[5] Taking this Situationist credo at face value, the artist kanarinka, in her *It Takes 154,000 Breaths to Evacuate Boston*, 2007, runs the Boston evacuation route as a spatial interpretation of the post-9/11 urban condition. (See pages 86–89.) Installed as a series of jars with speakers inside, this psychogeographic project allows visitors to listen to her breaths, a reflection of behavior and psychologic condition, as she runs across this suggested evacuation plan.

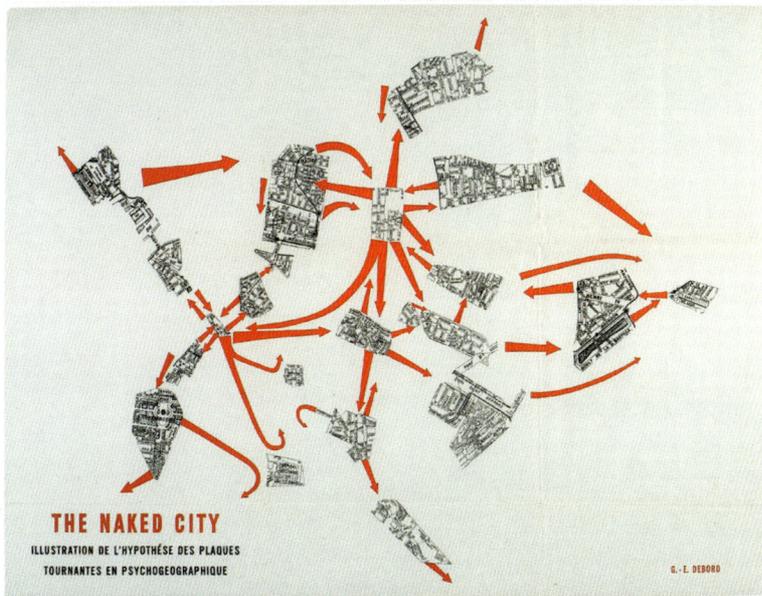

Debord's position (that our behaviors are a result of the ways we not only see the world but actually move through it) came out of a deep reaction to the largest French art movement of the early twentieth century, Surrealism. The Situationists, as well as precursors such as CoBRA with Asger Jorn, harshly critiqued the focus on the individual imagination that constituted the theories espoused by the Surrealist André Breton. "The error that is at the root of Surrealism is the idea of the infinite richness of the unconscious imagination."[6] For Debord, the individual was only a product of larger forces of capital, and the Surrealists' dependence on the individual unconscious was deeply misguided if not flagrantly status quo. The Situationists cleverly inverted the Surrealists' Freudian-inspired mandate and made the subconscious mind a product, not a producer, of urbanism. If one wants to change the mind, one must change the geographic conditions that shape it.

In demonstrating the potential for psychogeography, Debord turned to cartography. His collage of 1957 titled *The Naked City* is formed from cut-out sections of a map of Paris. In juxtaposing and combining different sections of the city, Debord took the exquisite corpse of the Surrealists and applied it directly to urbanism. And more maps began to emerge. The Dutch Situationist Constant Nieuwenhuys produced numerous maps for his utopian city, New Babylon, a city based on the organizing principle of play. Cartography as a medium through which not only to reflect existing conditions of power, but also to produce new urban relationships, became an aesthetic and geographic endeavor. Today, this legacy has hit full stride. In his *We Are Here Map Archive*, 1997–2008, *AREA Chicago* editor Daniel Tucker displays a tiny portion of the multitude of artistic cartographic materials that have emerged in the last decade, including the works of Ashley Hunt, the Beehive Design Collective, and the important urban mapping collective Repohistory. (See pages 118–159.)

While often deployed as a vehicle for empiricism, maps inherently contain political assumptions (think of the earth sitting at the center of the universe before the Copernican revolution, or the United States at the center of a map before Buckminster Fuller's Dymaxion map) and

Above left: Guy Debord, *The Naked City*, 1957. Screenprint.

Above right: Constant Nieuwenhuys, *Yellow Sector* (from the *New Babylon* project), 1958. Collection of the Gemeentemuseum Den Haag

some artists simply highlight these problematics. Artist Lize Mogel, who co-edited the book *An Atlas of Radical Cartography*, contributes a map of World's Fairs titled *Mappa Mundi*, 2008. (See pages 106–109.) The World's Fairs, which coincided with the rise of modernism and the city, embodied both the industrial and economic shifts transpiring across the globe but also the utopian dreams they inspired. Mogel's map shifts the arrangement of the world to reflect a lost history of dreams, power, and aspirations. Ellen Rothenberg interrogates a bias in the very form of cartography in her *De-Stabilized Geography: Map 3*, 2007–08. (See pages 110–113). A cartographic wall piece comprised of camouflage seams and orange pushpins, her abstract work implies a synergy between militarism and mapping. To what degree do the abstraction of space, the display of roads, fuel supplies, and bunkers, imply an abstraction of bodies and lives?

This question and many others force us to reconsider not only the obvious politics of mapping, but also which maps we choose to use. Whose life becomes abstract? Whose world gains precedence? How is value assigned and distributed? In *AREA Chicago*'s *Notes for a People's Atlas* (2007–ongoing), the power to answer these questions is given to community members living in the vicinity where a map is distributed: Asked, quite simply, to draw their own maps, individuals can privilege personal spaces, family lives, forces or conditions of oppression, in the spirit of Constant Nieuwenhuys, for play. (Samples from the project are reproduced on pages 114–117.)

In the Jorge Luis Borges story "The Exactitude of Science," a group of dedicated cartographers produce a map of a city in such fine exquisite detail that it replicates the city itself on a one-to-one scale. The map becomes that which it interprets. We find that maps also reflect not only the physical reality, but also the social realities that space produces. If biases exist in popular maps, these same biases are reflected in the manner in which we move and experience our world. The Situationists were eager to point out that the forces operating in cultural production (which they referred to as "spectacle") had a spatial corollary. If capitalism had made visual culture an excuse for the production of consumers, so too did the structure of the social space. Like Andy Warhol, the Situationists collapsed the difference between an emerging system of cultural production and that of artistic production. Unlike Warhol, the Situationists aggressively articulated this phenomenon as the next logical step of capitalism and were dedicated to subverting and overthrowing its mechanisms of control. While Warhol was poetically resigned to the flow of Brillo boxes and Campbell's soup cans, the Situationists were hard at work developing techniques to counter the effects of spectacle. They called forms of resistance to the visual aspects of advertising *détournement* and its spatial equivalent the *dérive* (the drift): "In a *dérive* one or more persons during a certain period drop their usual motives for movement and action, their relations, their work and leisure activities, and let themselves be drawn by the attractions of the terrain, and the encounters they find there."[7] In essence, the Situationists advocated walking.

The art of the pedestrian has a longstanding relationship to the city. Looking at mid-nineteenth century Paris (the Second Empire), we find the emergence of the *flâneur* dovetailing with radical restructuring of Paris by Baron Georges-Eugène Haussmann in 1852. Haussmann was charged by Napoleon III to modernize Paris by broadening the avenues, which would facilitate troop movements as well as railway traffic, initiate better sanitation, and streamline the entire city. Haussmann produced a city whose composition clearly reflected an infusion of capitalism and military control into its shop windows and boulevards. In his never-completed *Arcades Project,* the magical Marxist Walter Benjamin evinced a fascination with the manner in which the new Paris shaped and produced responses to the city, particularly in the embodiment of the nineteenth century *flâneur.* As Rebecca Solnit writes, "the *flâneur* arose, Benjamin argues, at a period early in the nineteenth century when the city had become so large and complex that it was for the first time strange to its inhabitants."[8] The *flâneur* was a stroller who walked the streets of Paris peeking in shop windows and observing crowds. His attitude was of a refined distance that observed the evolving condition of modernity. During this period, the great poet of modernism Charles Baudelaire heralded the *flâneur* as the apotheosis of the artist in an emerging urban condition. Walking was the rage in the cities. Emile Zola would traipse the streets of Paris with a notebook gaining insights into the modern subject. Gustave Courbet would paint himself as the sojourner replete with walking stick. A sign of refinement and cultural reflection went hand in hand with a propensity for the stroll.

In his book *The Practice of Everyday Life,* Michel de Certeau considered the politics of walking, "The act of walking is to the urban system what the speech act is to language or to the statements uttered."[9] De Certeau's interest was in the forms of resistance and meaning that are produced in a mild sojourn through the city. Applying Foucauldian discipline to the antics of the pedestrian, de Certeau's strategy clarified the primacy of space and the walk as its interlocutor: "The walking of passers-by offers a series of turns (*tours*) and detours that can be compared to 'turns of phrase' or 'stylistic figures.' There is a rhetoric of walking. The art of 'turning' phrases finds an equivalent in the art of composing a path (*tourner un parcours*). Like ordinary language, this art implies and combines styles and uses."[10] The city could be considered a language: a place where a short-cut across a yard or jay-walking were moments of personal flair. Loitering could be an aside, skateboarding a sonnet.

Ultimately, the discussion so far has laid out a simple framework whereby acts in space can be interpreted via the various forces that produce that space—whether it is walking, bus riding, interventions, or mapping, that is, an analysis of how culture is produced in space and, in turn, how those spaces produce culture. When Vito Acconci famously followed people in his *Following Piece,* 1969, the work gained more clarity with an understanding of the *flâneur;* the distanced viewer observing the crowd. His nonutilitarian, deeply personal journey also finds resonance in the Situationist *dérive,* as well as the city-as-language

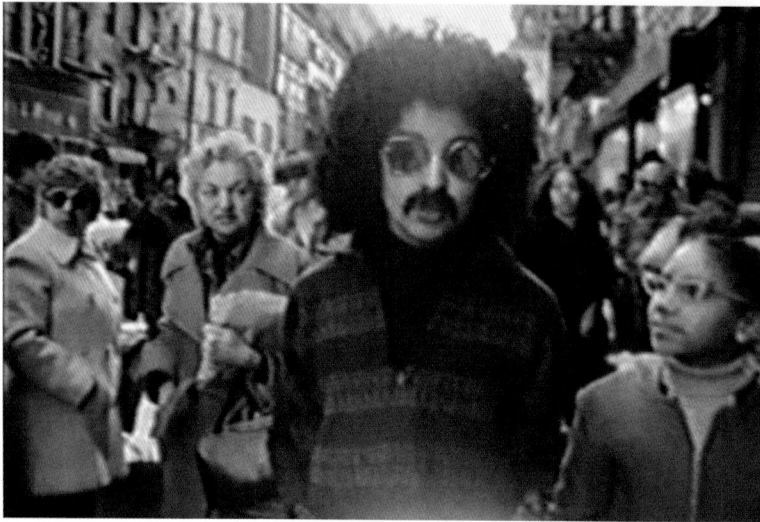

concepts of de Certeau. And finally, his walking in the city is all the more comprehensible as we understand the forces that produce the sidewalks he saunters on. To tear the meaning of the work away from the conditions and forces that shape its environment is to limit its relevance. There are many walking-based artistic projects, including those of Marina Abramović, Adrian Piper, Francis Alÿs, and Janet Cardiff.

The Center for Land Use Interpretation will often use the "tour" as a form to introduce their guests on a bus to the uses of the land around them. (See pages 42–47). Take for example a trip to the industrial city of Irwindale at the base of the San Gabriel Mountains. As CLUI tour guide Matt Coolidge stated at the onset, "We will be going to some of the most banal and dramatic landscapes in Los Angeles, and by the time we are done, we probably won't be able to tell the difference." The tour bus visited the Durbin Pit (a massive site for mining the residue of the mountain range), Hanson Spancreet complex (a company that designed concrete support beams for freeways), and the Santa Fe Dam, among other sites. In personally visiting the gears of the city-machine, one realizes that the banal activities of our daily lives (plugging in a light, commuting to work, washing dishes) actually require a vast network of structures that exist in the same cities we live in. The collective e-Xplo, consisting of Rene Gabri, Heimo Lattner, and Erin McGonigle, produces GPS-guided bus tours with synched sound. (See pages 98–101.) As an auditory environment, the tour is meant to disrupt assumptions about place in order to insert a poetic read on site. Like Debord's *Naked City*, this montage of sound and speed allows one to restructure the given map of a city.

Understanding the forces that act on any given space requires a handle on numerous fields of knowledge. The Situationists, Lefebvre, and de Certeau provide a useful template for understanding how space produces culture, but these sources are just entry points to a vast reading of spatial phenomena. Any act has economic, racial, and sexual aspects, and thus resists easy containment in a frame. In her book *Evictions* Rosalyn Deutsche criticizes urban geographers such as David Harvey and Edward Soja for discounting the roles that gender and race play in the construction of power in space. When Adrian Piper dresses like an African-American male walking in the city in *The Mythic Being*, 1973,

Above: Adrian Piper, *The Mythic Being* (film still), 1972-75

it would clearly be deeply limiting to interpret the work in a purely economic frame that excludes race and gender.

·····

Traveling through this environment, of course, can take many forms. Piper's intervention demonstrates a technique of performance that occurs throughout this exhibition. In tactically deploying their work into the parking lots, sidewalks, alleys, and bus benches of the metropolis, these artists either disrupt given power relations or reveal the power structures that remain hidden. Chaplinesque slapstick artist Alex Villar contrasts the basic functions of the body's movement to the structure of urban space itself. In his video *Upward Mobility,* 2002, Villar attempts to literally climb the building surfaces around him. Grasping onto corners and lifting himself on cornices, he flails in his attempt to move vertically as opposed to the designed horizontal nature of the city. (See pages 90–93.) In essence, Villar's videos make a viewer aware of just how coercive the city is as his efforts to resist appear almost comical in their futility.

In Deborah Stratman's *Park,* 2000, the artist produced a mobile facsimile of a parking-attendant booth. (See pages 94–97.) She then transported the quasi-security booth throughout the city of Chicago, letting it rest near abandoned lots. The introduction of this booth transformed the psychological nature of an abandoned space by implying an architecture of control. Drivers trying to park near the structure immediately wondered how to interact with this vacated station. In moving this structure throughout the city, Stratman makes evident the manner in which we, as participants in an urbanism produced via control, accept and expect this type of social interaction.

Through the work of Villar and Stratman, we gain an immediate understanding of concepts that might at times feel theoretically abstract or altogether mystifying. How does the city make us who we are? Simply put, a sidewalk is meant for non-loitering movement. A parking structure implies power that we immediately obey. But these works contain more than these simple ideas. They demonstrate play, and their implications far exceed such reductiveness. But nonetheless, these elegant and facile interventions allow us to appreciate one of geography's most critical contributions: culture and politics happen in space. We can point at them. In the wake of the art world's romance with post-modern theory, the fact that some artists and thinkers now find solace in an approach grounded in real sites with real histories might appear more reasonable. A postmodern critical malaise might find comfort in the arms of contemporary geography.

THE GLOBAL AND THE GENTRY

In Trevor Paglen's essay, he expands the reach of experimental geography to include the structures of the forces that produce culture itself. That is to say, culture does not happen in a vacuum, and neither do the ideas, careers, dreams, and exhibitions promulgated in the art world. The art world has buildings. It has offices. It exists in space. In taking this necessary leap, we must go from interpreting simply how the city works to how

the physical spaces of our world produce the various cultural discourses that comprise it (the art world, music, television, radio, film, computers, social networking, education, and on and on). If to understand Warhol we need to understand television, then today, in order to understand cultural phenomena, we must understand neoliberalism.

Because mid–nineteenth century Paris has been a touchstone for thinking about the rise of the city, we can use some if its basic characteristics as a template for uneven development in cities across the globe. As populations move toward the cities of the world (due to complex phenomena including post-Fordist manufacturing and the consolidation of agri-business), culture becomes increasingly streamlined by capitalism. As the bohemian lifestyle emerged in concert with the growing function of cities during the nineteenth century, in the twenty-first century this relationship to culturally produced space became an oft-touted new economy of "the creative class," to use a term coined by Richard Florida. In her book *Evictions*, Rosalyn Deutsche compellingly points out the manner in which cities have been restructured not by artworks, but by artists' lives: "When galleries and artists, assuming the role of the proverbial "shock troops" of gentrification, moved into inexpensive storefronts and apartments, they aided the mechanisms by driving up rents and displacing residents."[11] The term "gentrification," which fills the conversations of most city residents, brings to light the close proximity that cultural production has to spatial production. In his essay on experimental geography, Paglen asks practitioners to reconsider their relationship to economic status as cultural producers. That is, to use the argument Walter Benjamin articulates in "The Artist as Producer," to ask all participants in cultural production to be aware of the production part of their work. These conditions are not only produced by the role of culture within a city; but they produce the culture of that city in turn.

Gentrification and many of its various city-restructuring forces are certainly results of shifting global markets. As the role of the city increases, the city itself is being reshaped according to neoliberal principles. Chinese artist Yin Xiuzhen reflects this porous intra-city connection with a series of suitcases with sewn-together cities inside made from the discarded clothes of the city's residents. (See pages 102–103.) This series, aptly titled "Portable Cities," reflects the manufacturing base that makes these cities possible while also highlighting an increasing sense of global mobility.

Globalism clearly dominated the discourse of the 1990s. After the fall of the Berlin Wall and the ushering in of a neoliberal agenda devoid of a Marxist counter-argument, the jet-setting fever of global capitalism took hold. By the end of the 1990s, global biennials were sprouting up around the world, and the arts community saw an expanding function for the arts, not just in terms of global reach, but in effecting the production of urban space in general. Biennials were used for a variety of reasons, but many had to do with the positioning of the city in the global imagination. Museums such as the Guggenheim Bilbao took Milton Friedman's economics and applied them concretely to the production of a tourist-generated, post-manufacturing city.

As the initial gestalt of global capitalism wore off, certain tendencies in urban restructuring emerged. While the face of gentrification in the arts focused on the complicated role artists played in displacing themselves, the more obvious function was the rezoning of a city along racial lines. Gentrification has more than a capital component; on a global level, its effects are distributed unevenly. As the immigrants in the suburbs of Paris erupted in riots and the largely African-American city of New Orleans began to tear down the public housing after the traumatic damage of the Hurricane Katrina floods, the racialization of city planning became much more evident.

In their provocative look at the territory that defines Israel and Palestine titled *The Road Map,* 2003, the collective Multiplicity used a simple empirical formula: they compared the time it took for a person holding an Israeli passport and a resident of Palestine to go the same distance. (See pages 70–73.) The time for the Israeli citizen was one hour and that of the Palestinian citizen, five and a half hours. The inequity is unsurprising, given the vast array of checkpoints and obstacles to which a Palestinian resident is subjected. But what also becomes clear is the spatialization of a politics along religious and ethnic lines. This has implications in many aspects of everyday life. While this contested border region with its checkpoints and delays becomes a condition of daily existence, it simultaneously produces a political and cultural condition.

·····

But let us not forget the lochs, the mesas, the bluffs, the meadows, and the canyons. As much as I have focused on the increased role of the urban, these same conditions operate in what we typically understand as the natural world. Jeffrey Kastner's essay points out the collision that the Land Art works of Heizer, Smithson, and de Maria are facing as industrial forces rapidly encroach on them. The natural world does not appear to be as separated from the unnatural world as one might assume. While the illusory qualities of the term "natural" would have been difficult to discuss only ten years ago, today global warming has accelerated the specious dichotomy of natural/unnatural. As carbon emissions reduce the salmon run in southern Alaska, the globe wakes up to a startling and useful fact: It is all one system.

Artist Ilana Halperin had a sudden realization of this fact when she learned that tectonic plates move at the same pace your fingernails grow. To operate on a time scale equivalent to massive geologic phenomena produces a sense of connectedness that she describes as "geologic intimacy." She takes the process one step further in infusing the geologic with the domestic. In *Boiling Milk (Solfataras)*, 2000, Halperin attempts to boil milk in a natural hot spring. (See pages 52–55.) The gesture, while poetic, also provides an ambiguous key into the potential of a collapsed distance between the natural and unnatural.

Francis Alÿs deploys the power of metaphor similarly in *When Faith Moves Mountains*, 2002. (The work is also represented here on page 48 by a selection from *The Making of Lima*, which is about the making of *When Faith Moves Mountains*.) On April 11, 2002, five hundred

volunteers gathered at the base of a large sand dune outside Lima, Peru. Equipped with shovels, the collective mass attempted to move the dune forward by four inches. Like Halperin's, this work operates on the level of allegory and metaphor (Alÿs says as much in the title). Clearly, moving the sand dune forward four inches was an impossibility, but the rumor of its movement, and the power of the metaphor in attempting the impossible, are actually what were created. In a collection such as *Experimental Geography,* where the urge toward the didactic is healthy and at times productive and eye-opening, gestures such as those of Halperin and Alÿs make way for a more ambiguous relationship to landscape.

CULTURE MAKES DUST

To shift gears at the end of this essay, I would like to also question the concept of an interdisciplinary practice. While I have so far explicated in shorthand some of the historic and theoretic elements that produce a lens for interpreting the work included in *Experimental Geography,* I have not discussed the vicissitudes of the interaction between artistic and academic disciplines. If one were to ask those who are clearly working in the complicated terrain between fields of aesthetic and empirical investigation, the term "interdisciplinary" would produce an incredulous response. The term strikes many practitioners as grossly antiquated. But clarifying this relationship is important, as it is clearly a stumbling block for many who are involved. As this practice grows, and a field combining ambiguity, empiricism, techniques of representation, and education makes its way into popular practice (in art and in other fields) the question of what makes something "art" or "geography" will inevitably arise.

In answering this question, let's turn to two projects highlighted here by collectives whose very organizing principles imply a radical departure from traditional dichotomies of art and academia. Let's look at a project by the diffuse art collective Spurse. In *Micromobilia: Machines for the Intensive Research of Interior Bio-Geographies,* 2005–08, Spurse attempts to study all phenomena at the bacterial level. As they write, "This mobile laboratory allows visitors to understand the material reality by which supposedly separate phenomena (particularly the cultural and material) in fact, coexist and that there are simple strategies to investigate this." Spurse's project is a laboratory replete with cotton swabs, Petri dishes, dry agar medium, chalkboards, microscopes and refrigerators. (See pages 64–69). The goal is a participatory form of investigation intended to break down accepted semiotic categories of the cultural and the material. Reflecting the organizing principle of this exhibition, Spurse dramatically refuses to distinguish between phenomena that most of us consider absolutely discrete. How can a person be the same as a rock? How can the effects of a rumor be measured in the same manner as those of a river? By not privileging phenomena that we identify with humanity, we root out some of the biases underpinning the distinctions made between that art and geography. In an altogether different but equally radical

shift, the collective the Center for Urban Pedagogy (CUP) uses the mantle of pedagogy to deploy a myriad of information-delivery mechanisms. As pedagogy is the art of teaching, surely art and most academic disciplines should find common ground here. How do we communicate with one another in order to understand the world around us? In pursuit of an answer to this question, we find techniques throughout this collection reflected ranging from the didactic to the poetic, from the urban to the geologic, that allow a unified field to emerge.

Ultimately, all phenomena resolve themselves in space. Cultural and material production are not simply abstract ideas, but are forces that shape who and what we are, and they do so in places we can walk to, intervene in, and tour. The work collected here emerges from this understanding and, ideally, provides a glimpse into a form of cultural production that we are just beginning to understand. Exactly fifty years ago, Henri Lefebvre and Guy Debord began a discussion that went in two directions (one toward geography, one toward art), and it seems fitting that their seminal works dovetail here. For if who we are is a result of the cultural and material production existing today, then this subject requires the attention and fealty of every discipline across the board.

Notes

1. Gretchen Berg, "Andy: my true story," *Los Angeles Free Press* (March 17, 1967), p. 3.

2. See www.clui.org.

3. Ken Knabb, "In Theory of the Dérive," *International Situationniste #2* (December 1958), p. 51.

4. See www.notbored.org/space.html

5. Ken Knabb, ed., *Situationist International Anthology,* Berkeley: Bureau of Public Secrets, 1981, p. 5.

6. Ibid, p. 19.

7. Ken Knabb, "In Theory of the Dérive," from *International Situationniste #2,* p. 50.

8. Rebecca Solnit, *Wanderlust: A History of Walking,* New York: Viking, 2000, p. 199.

9. Michel de Certeau, *The Practice of Everyday Life,* ed., Berkeley: University of California Press, 2002, p. 97.

10. Ibid, p. 100.

11. Rosalyn Deutsche, *Evictions: Art and Spatial Politics,* Cambridge: MIT Press, 1996, p. 151.

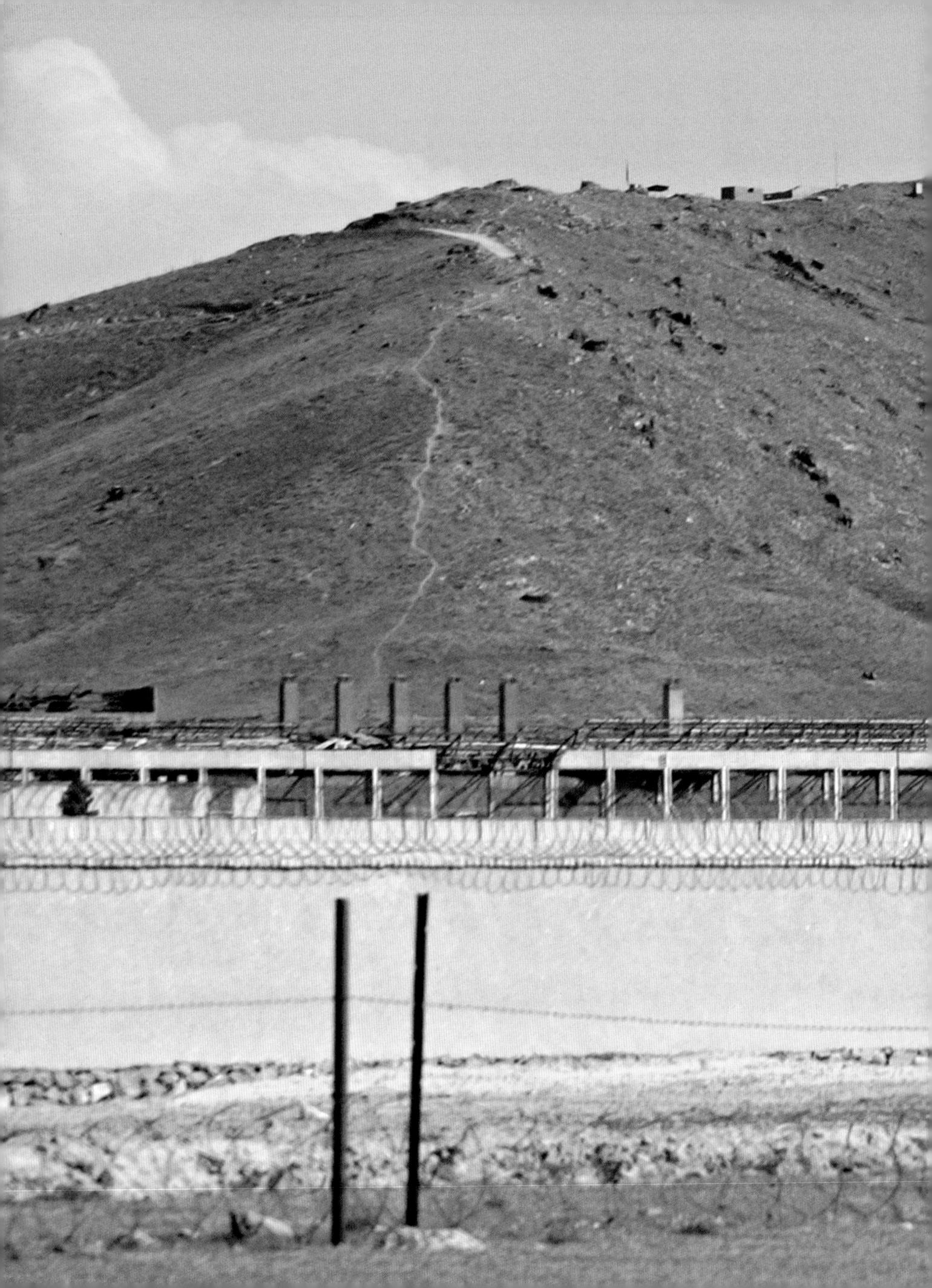

EXPERIMENTAL GEOGRAPHY: FROM CULTURAL PRODUCTION TO THE PRODUCTION OF SPACE

TREVOR PAGLEN

When most people think about geography, they think about maps.[1] Lots of maps. Maps with state capitals and national territories, maps showing mountains and rivers, forests and lakes, or maps showing population distributions and migration patterns. And indeed, that isn't a wholly inaccurate idea of what the field is all about. It is true that modern geography and mapmaking were once inseparable.

Renaissance geographers like Henricius Martellus and Pedro Reinel, having rediscovered Greek texts on geography (most importantly Ptolemy's *Geography*), put the ancient knowledge to work in the service of the Spanish and Portuguese empires. Martellus' maps from the late fifteenth century updated the old Greek cartographic projections to include Marco Polo's explorations of the East as well as Portuguese forays along the African coast. Reinel's portolan maps are some of the oldest modern nautical charts. Cartography, it turned out, was an indispensable tool for imperial expansion: if new territories were

to be controlled, they had to be mapped. Within a few decades, royal cartographers filled in blank spots on old maps. In 1500, Juan de la Cosa, who accompanied Columbus on three voyages as captain of the *Santa Maria*, produced the *Mappa Mundi*, the first known map to depict the New World. Geography was such an important instrument of Portuguese and Spanish colonialism that early modern maps were some of these empires' greatest secrets. Anyone caught leaking a map to a foreign power could be punished by death. [2]

In our own time, another cartographic renaissance is taking place. In popular culture, free software applications like Google Earth and MapQuest have become almost indispensable parts of our everyday lives: we use online mapping applications to get directions to unfamiliar addresses and to virtually "explore" the globe with the aid of publicly available satellite imagery. Consumer-available global positioning systems (GPS) have made latitude and longitude coordinates a part of the cultural vernacular. In the arts, legions of cultural producers have been exercising the power to map. Gallery and museum exhibitions are dedicated to every variety of creative cartography; "locative media" has emerged as a form of techno-site-specificity; in the antiquities market, old maps have come to command historically unprecedented prices at auction. Academia, too, has been seized by the new powers of mapmaking: geographical information systems (GIS) have become a new lingua franca for collecting, collating, and representing data in fields as diverse as archaeology, biology, climatology, demography, epidemiology, and all the way to zoology. In many people's minds, a newfound interest in geography has seized popular culture, the arts, and the academy. But does the proliferation of mapping technologies and practices really point to a new geographic cultural *a priori*? Not necessarily. Although geography and cartography have common intellectual and practical ancestors, and are often located within the same departments at universities, they can suggest very different ways of seeing and understanding the world.

Contemporary geography has little more than a cursory relationship to all varieties of cartography. In fact, most critical geographers have a healthy skepticism for the "God's-Eye" vantage points implicit in much cartographic practice. As useful as maps can be, they can only provide very rough guides to what constitutes a particular space.

Geography is a curiously and powerfully transdisciplinary discipline. In any given geography department, one is likely to find people studying everything from the pre-Holocene atmospheric chemistry of northern Greenland to the effects of sovereign wealth funds on Hong Kong real estate markets, and from methyl chloride emissions in coastal salt marshes to the racial politics of nineteenth-century California labor movements. In the postwar United States, university officials routinely equated the discipline's lack of systematic methodological and discursive norms with a lack of seriousness and rigor, a perception that led to numerous departments being closed for lack of institutional support.[3] The end of geography at Harvard was typical of what happened to the field: university officials shut down its geography department in 1948, as CUNY geographer Neil Smith tells it, after being flummoxed by their "inability to extract a clear definition

Previous pages: Trevor Paglen, *The Salt Pit (Shomali Plains northeast of Kabul, Afghanistan)*, 2006 (detail). Chromogenic print, 24 x 36 inches (61 x 91.4 cm)

of the subject, to grasp the substance of geography, or to determine its boundaries with other disciplines." The academic brass "saw the field as hopelessly amorphous."[4] But this "hopeless amorphousness" is, in fact, the discipline's greatest strength.

No matter how diverse and transdisciplinary the field of geography may seem, and indeed is, a couple of axioms nevertheless unify the vast majority of contemporary geographers' work. These axioms hold as true for the "hard science" in university laboratories as for human geographers studying the unpredictable workings of culture and society. Geography's major theoretical underpinnings come from two related ideas: materialism and the production of space.

In the philosophical tradition, materialism is the simple idea that the world is made out of "stuff," and that moreover, the world is only made out of "stuff." All phenomena, then, from atmospheric dynamics to Jackson Pollock paintings, arise out of the interactions of material in the world. In the western tradition, philosophical materialism goes back to ancient Greek philosophers like Democritus, Anaxagoras, and Epicurus, whose conceptions of reality differed sharply from Plato's metaphysics. Later philosophers like Thomas Hobbes, David Hume, Ludwig Feuerbach, and Karl Marx would develop materialist philosophies in contradistinction to Cartesian dualism and German idealism. Methodologically, materialism suggests an empirical (although not necessarily positivistic) approach to understanding the world. In the contemporary intellectual climate, a materialist approach takes relationality for granted, but an analytic approach that insists on "stuff" can be a powerful way of circumventing or tempering the quasi-solipsistic tendencies found in some strains of vulgar poststructuralism.

Geography's second overarching axiom has to do with what we generally call "the production of space." Although the idea of the "production of space" is usually attributed to the geographer-philosopher Henri Lefebvre, whose 1974 book *La Production de l'Espace* introduced the term to large numbers of people, the ideas animating Lefebvre's work have a much longer history.[5] Like materialism, the production of space is a relatively easy, even obvious, idea, but it has profound implications. In a nutshell, the production of space says that humans create the world around them and that humans are, in turn, created by the world around them. In other words, the human condition is characterized by a feedback loop between human activity and our material surroundings. In this view, space is not a container for human activities to take place within, but is actively "produced" through human activity. The spaces humans produce, in turn, set powerful constraints upon subsequent activity.

To illustrate this idea, we can take the university where I'm presently writing this text. At first blush, the university might seem like little more than a collection of buildings: libraries, laboratories, and classrooms with distinct locations in space. That's what the university looks like on a map or on Google Earth. But this is an exceptionally partial view of the institution. The university is not an inert thing: it doesn't "happen" until students arrive to attend classes, professors lock themselves away to do research, administrative staff pays the bills and registers the students, state legislators appropriate money for campus operations,

and maintenance crews keep the institution's physical infrastructure from falling apart. The university, then, cannot be separated from the people who go about "producing" the institution day after day. But the university also sculpts human activity: the university's physical and bureaucratic structure creates conditions under which students attend lectures, read books, write papers, participate in discussions, and get grades. Human activity produces the university, but human activities are, in turn, shaped by the university. In these feedback loops, we see production of space at work.

Fine. But what does all of this have to do with art? What does this have to do with "cultural production?"

Contemporary geography's theoretical and methodological axioms don't have to stay within any disciplinary boundaries whatsoever (a source of much confusion at Harvard back in the mid-1940s). One can apply them to just about anything. Just as physical geographers implicitly use the idea of the production of space when they inquire into the relationship between human carbon emissions and receding Antarctic ice shelves, or when human geographers investigate the relationships between tourism on Tanzanian nature preserves, geography's axioms can guide all sorts of practice and inquiry, including art and culture. A geographic approach to art, however, would look quite different than most conventional art history and criticism. The difference in approach would arise from the ways in which various disciplines rely on different underlying conceptions of the world. A geographer looking into art would begin with very different premises than those of an art critic.

To speak very generally, the conceptual framework organizing much art history and criticism is one of "reading culture," where questions and problems of representation (and their consequences) are of primary concern. In the traditional model, the critic's task is to describe, elaborate upon, explain, interpret, evaluate, and critique pre-given cultural works. In a certain sense, the art critic's role is to act as a discerning consumer of culture. There's nothing at all wrong with this, but this model of art criticism must (again, in a broad sense) tacitly assume an ontology of "art" in order to have an intelligible starting point for a reading, critique, or discussion. A good geographer, however, might use her discipline's analytic axioms to approach the problem of "art" in a decidedly different way.

Instead of asking "What is art?" or "Is this art successful?" a good geographer might ask questions along the lines of "How is this space called 'art' produced?" In other words, what are the specific historical, economic, cultural, and discursive conjunctions that come together to form something called "art" and, moreover, to produce a space that we colloquially know as an "art world?" The geographic question is not "What is art?" but "How is art?" From a critical geographic perspective, the notion of a free-standing work of art would be seen as the fetishistic effect of a production process. Instead of approaching art from the vantage point of a consumer, a critical geographer might reframe the question of art in terms of spatial practice.[6]

We can take this line of thinking even further. Instead of using geo-

graphic axioms to come up with an alternative "interpretive" approach to art (as I suggested in the previous paragraph), we can use them in a normative sense. Whether we're geographers, artists, writers, curators, critics, or anyone else, we can use geographic axioms self-reflexively to inform our own production.

If we accept Marx's argument that a fundamental characteristic of human existence is "the production of material life itself" (that humans produce their own existence in dialectical relation to the rest of the world),[7] and, following Lefebvre (and Marx) that production is a fundamentally spatial practice,[8] then cultural production (like all production) is a spatial practice. When I write an essay such as this, get it published in a book, and put it on a shelf in a bookstore or museum, I'm participating in the production of space. The same is true for producing art: when I produce images and put them in a gallery or museum or sell them to collectors, I'm helping to produce a space some call the "art world." The same holds true for "geography": when I study geography, write about geography, teach geography, go to geography conferences, and take part in a geography department, I'm helping to produce a space called "geography." None of these examples is a metaphor: the "space" of culture isn't just Raymond Williams' "structure of feeling" but, as my friends Ruth Wilson Gilmore and Clayton Rosati underline, an "infrastructure of feeling."[9]

My point is that if one takes the production of space seriously, the concept applies not only to "objects" of study or criticism, but to the ways one's own actions participate in the production of space. Geography, then, is not just a method of inquiry, but necessarily entails the production of a space of inquiry. Geographers might study the production of space, but through that study, they're also producing space. Put simply, geographers don't just study geography, they create geographies. The same is true for any other field and any other form of practice. Taking this head-on, incorporating it into one's practice, is what I mean by "experimental geography."

Experimental geography means practices that take on the production of space in a self-reflexive way, practices that recognize that cultural production and the production of space cannot be separated from each another, and that cultural and intellectual production is a spatial practice. Moreover, experimental geography means not only seeing the production of space as an ontological condition, but actively experimenting with the production of space as an integral part of one's own practice. If human activities are inextricably spatial, then new forms of freedom and democracy can only emerge in dialectical relation to the production of new spaces. I deliberately use one of modernism's keywords, "experimental," for two reasons. First is to acknowledge and affirm the modernist notion that things can be better, that humans are capable of improving their own conditions, to keep cynicism and defeatism at arm's length. Moreover, experimentation means production without guarantees, and producing new forms of space certainly comes without guarantees. Space is not deterministic, and the production of new spaces isn't easy.

In thinking about what experimental geography entails, especially

in relation to cultural production, it's helpful to hearken back to Walter Benjamin, who prefigured these ideas in a 1934 essay entitled "The Author as Producer."

While he worked in exile from the Nazis in Paris during much of the 1930s, Benjamin's thoughts repeatedly turned to the question of cultural production. For Benjamin, cultural production's status as an intrinsically political endeavor was self-evident. The intellectual task he set for himself was to theorize how cultural production might be part of an overall anti-Fascist project. In his musings on the transformative possibilities of culture, Benjamin identified a key political moment in cultural works happening in the production process.

In Benjamin's "Author as Producer" essay, he prefigured contemporary geographic thought when he refused to assume that a cultural work exists as a thing-unto-itself: "The dialectical approach," he wrote, "has absolutely no use for such rigid, isolated things as work, novel, book. It has to insert them into the living social context."[11] Right there, Benjamin rejected the assumption that cultural works have any kind of ontological stability and instead suggested a relational way of thinking about them. Benjamin went on to make a distinction between works that have an "attitude" toward politics and works that inhabit a "position" within them. "Rather than ask 'What is the *attitude* of a work to the relations of production of its time?'" he wrote, "I should like to ask, 'What is its *position* in them?'"[12] Benjamin, in other words, was identifying the relations of production that give rise to cultural work as a crucial political moment. For Benjamin, producing truly radical or liberatory cultural works meant producing liberatory spaces from which cultural works could emerge. Echoing Marx, he suggested that the task of transformative cultural production was to reconfigure the relations and apparatus of cultural production, to reinvent the "infrastructure" of feeling in ways designed to maximize human freedom. The actual "content" of the work was secondary.

Experimental geography expands Benjamin's call for cultural workers to move beyond "critique" as an end in itself and to take up a "position" within the politics of lived experience. Following Benjamin, experimental geography takes for granted the fact that there can be no "outside" of politics, because there can be no "outside" to the production of space (and the production of space is ipso facto political). Moreover, experimental geography is a call to take seriously, but ultimately move beyond cultural theories that equate new enunciations and new subjectivities as sufficient political ends in themselves. When decoupled from the production of new spaces, they are far too easily assimilated into the endless cycles of destruction and reconstitution characterizing cultural neoliberalism, a repetition Benjamin dubbed "Hell."

The task of experimental geography, then, is to seize the opportunities that present themselves in the spatial practices of culture. To move beyond critical reflection, critique alone, and political "attitudes," into the realm of practice. To experiment with creating new spaces, new ways of being.

What's at stake? Quite literally, everything.

Notes

1. Many of the ideas in this essay have been developed over almost two decades of conversations with my longtime friend and interlocutor Nato Thompson.

2. See for example Miles Harvey, *The Islands of Lost Maps,* New York: Random House, 2000.

3. For an institutional history of geography in the U.S., see William Koelsch, "Academic Geography, American Style: An Institutional Perspective," in Gary S. Dunbar, ed. *Geography: Discipline, Profession and Subject Since 1870,* Dordrecht: Kluwer, 2001, pp. 245-280.

4. Neil Smith, "'Academic War over the Field of Geography': The Elimination of Geography at Harvard, 1947-1951," *Annals of the Association of American Geographers*, vol. 77, no. 2 (June 1987), pp. 155-172.

5. Lefebve's analysis, like much critical geography, relies on a spatial reading of Marx.

6. Rosalyn Deutche's book *Evictions* is the best example of what a critical art-historical project along these lines might look like. I would like to see more art historians take this project up. See Rosalyn Deutsche, *Evictions: Art and Spatial Politics*, Cambridge: MIT Press, 1996.

7. Karl Marx and Friedrich Engels, *The German Ideology*, C.J. Arthur, ed. New York: International Publishers, 1947, p. 48.

8. Henri Lefebvre, *The Production of Space*, Donald Nicholson-Smith, trans., Oxford: Blackwell, 1991.

9. See Ruth Wilson Gilmore, "Tossed Overboard: Katrina, Abandonment and the Infrastructure of Feeling," Conference Paper, *Anxiety, Urgency, Outrage, Hope: A Conference on Political Feeling*, University of Chicago, October, 2007; Clayton Rosati, "The Terror of Communication: Critical Infrastructure, Property, and the Culture of Security," *American Studies Association National Meeting*, Washington, DC, November 2005.

10. Walter Benjamin, *Reflections*, Peter Memetz, ed., Edmund Jephcott, trans., New York: Schocken, 1978, p. 222.

11. Ibid.

12. Ibid.

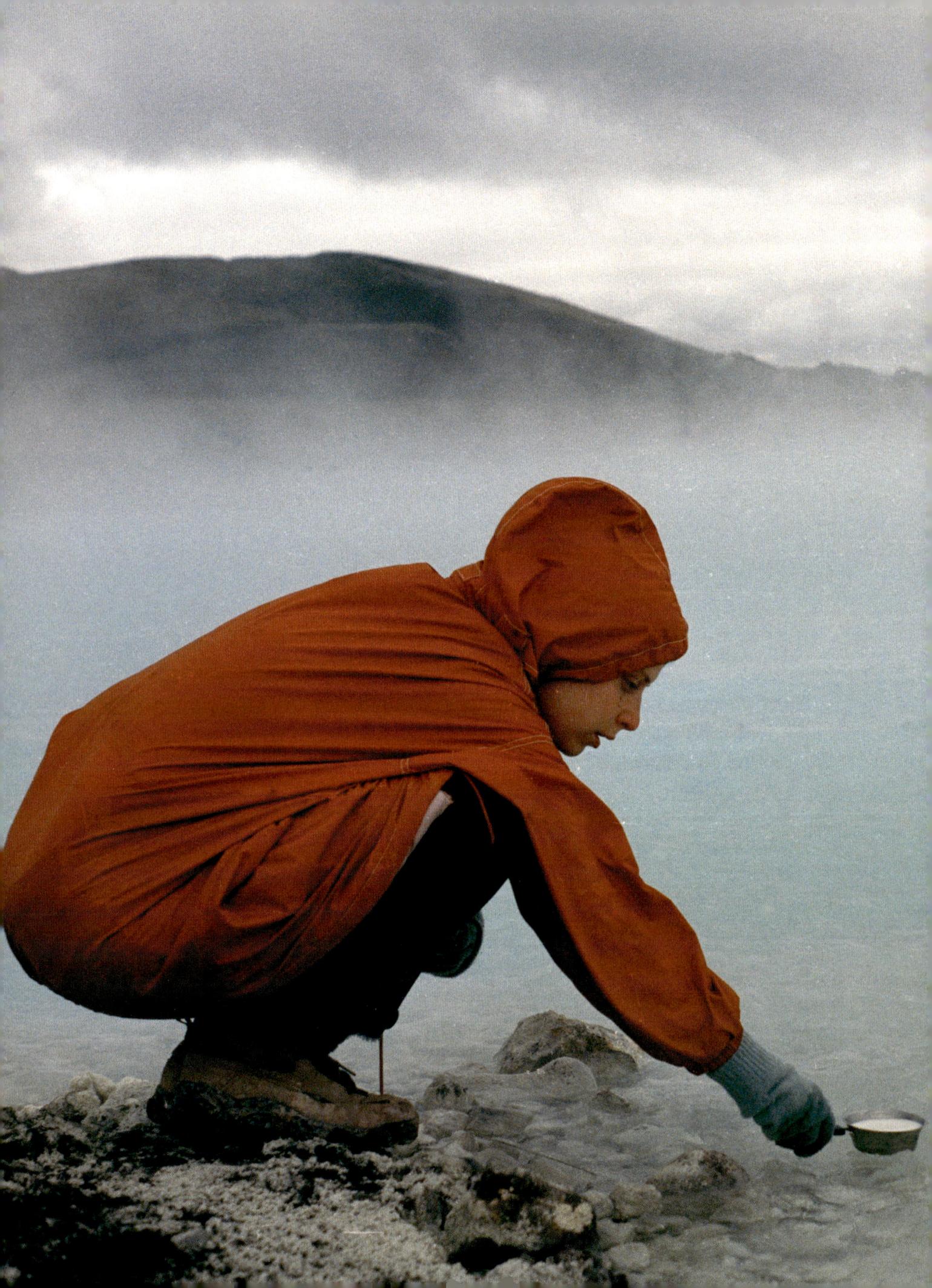

RICH IN REFERENCE: THOUGHTS ON LAND ART'S INFRASTRUCTURAL LEGACY

JEFFREY KASTNER

"Tippetts-Abbett-McCarthy-Stratton have developed other sites that have limits similar to the air terminal project. They include port and harbor facilities like the Navy pier in Chicago, a port in Anchorage and San Nicholas Harbor in Aruba. Such sites rest on wide expanses of water, and are generated by ship voyages and cargo movements. Bulk storage systems are contained by mazes of transfer pipelines that include hydrant refueling pump houses and gas dispensers. The process behind the making of a storage facility may be viewed in stages, thus constituting a whole 'series' of works of art from the ground up. Land surveying and preliminary building, if isolated into discrete stages, may be viewed as an array of artworks that vanish as they develop ... By investigating the physical forms of such projects one may gain unexpected esthetic information. I am not concerned here with the original 'functions' of such massive projects, but rather with what they suggest or evoke."

—Robert Smithson,
"Towards the Development of an Air Terminal Site," 1967[1]

A couple of years ago, I took a trip to Utah to visit Robert Smithson's *Spiral Jetty,* 1970. It's a pilgrimage familiar enough to aficionados of contemporary art, but at the suggestion of a colleague with local knowledge, I supplemented it with a few less conventionally "artistic" destinations within driving distance of Salt Lake City: the Bingham Canyon Copper Mine, a century-old open-pit operation just twenty miles southwest of the capital that's one of the largest manmade holes in the world; the Thiokol Promontory Complex, a gigantic rocket factory not far from the highway turnoff for Rozel Point and the Jetty; and just across Interstate 80 from the Bonneville Salt Flats, the abandoned Wendover Airbase complex, where the crew of the *Enola Gay,* the B-29 that dropped the atomic bomb on Hiroshima, was trained for its mission.

Such intensively industrial locations may seem temperamentally incompatible with the kind of sublime aesthetic experiences of isolated grandeur with which works like *Spiral Jetty* are usually associated. But as it was, my itinerary ended up following in Land art's conceptual footsteps much more fully than the simple back-to-nature walkabout I first imagined. As Smithson made clear over and over again in his writing and public comments—like the quote on the previous page, taken from a text that describes an early formative experience working with an engineering firm on a prospective master plan for the Dallas–Fort Worth airport—he was always more at ease around the raw stuff of the world than with the "multifarious nothings" cranked out by those who he accused of being unable to kick the "art habit."[2] Whether pointing toward ultimate functional potential (as in the photos of dams under construction he included as "Site-Selection" images with his air-terminal essay) or on the downslope of their utility, as in the decaying center of his childhood home described a few months later in his "A Tour of the Monuments of Passaic, New Jersey," the things that most fascinated Smithson were invariably "sprawling and imbedded in the landscape."[3]

I know that two decades ago, when I first became aware of the Land artists, I would have considered the relationship between Earthworks and industrialized forms of human intervention in the land like a copper pit or a rocket factory (if I would have considered them at all) as fundamentally oppositional. The conventional story of that moment, after all, is one of flight from civilization to wilderness, from the played-out, manufactured spaces of the built environment to the potential-rich, blank-slate spaces of the American West. Today, though, as the heroic monuments created by that first generation—like *Spiral Jetty,* Michael Heizer's *Double Negative,* 1969, and his ongoing *City complex,* begun in 1972, or Walter DeMaria's *The Lightning Field,* which was first described in 1969 and executed in 1977—settle into their third and fourth decades, their formal character as large-scale Postminimalist sculptural artifacts, not to mention the considerable phenomenological experiences they create for those who visit them, is increasingly mitigated by very basic physical (one might say infrastructural) influences. Erosion, for example, has been an issue for several years now along the walls of *Double Negative*'s trench, leading the Los Angeles County Museum of Art (which administers the site) to consider curtailing visitor access. The other works in this seminal group have also faced difficult issues as

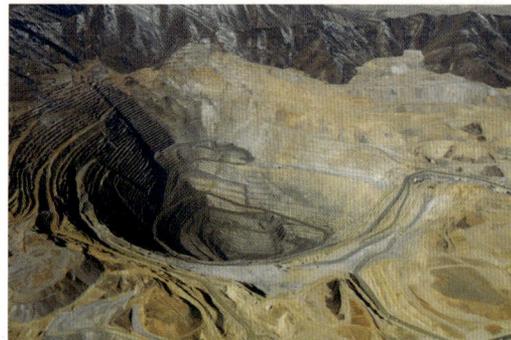

TOWARDS THE DEVELOPMENT OF AN AIR TERMINAL SITE

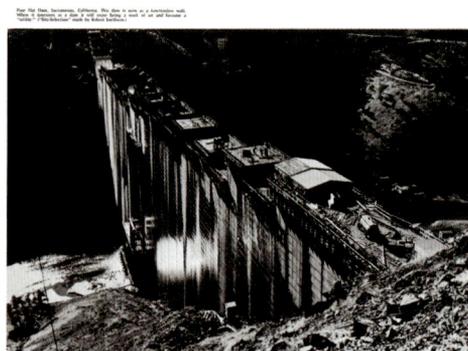

Previous pages: Ilana Halperin. *Boiling Milk (Solfataras),* 2000 (detail). Chromogenic print, 19 5/8 x 30 in. (49.8 x 76.2 cm)

Above top: Bingham Mine, Utah. CLUI Archive Photo

Above bottom: First page of "Towards the Development of an Air Terminal Site," by Robert Smithson, in *Artforum,* June 1967

civilization encroaches upon their splendid isolation—Heizer has been fighting plans for a railway through the valley where *City* lies for the better part of a decade, while the Dia Art Foundation has been busy negotiating conservation easements on the border of *The Lightning Field* to protect its viewshed from possible development and vociferously arguing against oil-drilling plans set for the Great Salt Lake in the vicinity of the *Jetty*.

Taken together, these scenarios reemphasize that these works are not isolated aesthetic rejoinders to the built environment, but are instead integrated and in dialogue with it. The fact that no one drags heavy equipment out to the boondocks anymore to move earth in the service of colossal permanent artworks in the landscape doesn't necessarily mean that the Land art impulse has died out. Instead, as this collection makes clear, it has branched into a variety of approaches whose organizing principle might be said to be a desire to unpack more completely the nature of this dialogue—to explore the character of both the operational and metaphorical relationships between natural and manufactured systems that the early Earthworks negotiated; to interrogate the complex of infrastructural conditions that contribute not only to poeticized, artistic activities on the land, but also to instrumentalized, industrial ones.

• • • • •

Maybe only God can make a tree, but only that shovel, Big Muskie, can make a hole like this.

—Quote attributed to an "anonymous strip miner," used as the epigraph to Robert Morris's "Notes on Art as/and Land Reclamation"[4]

As it happens, the final stop on my Utah trip was in some sense the inspiration for its shape as a whole. Although most of Wendover Airbase is closed to the public, it is also the site of the most developed of the satellite complexes of the American Land Museum. The museum is one of several ongoing projects by the Los Angeles–based Center for Land Use Interpretation, an organization that for some fifteen years has engaged in a form of land-based artistic practice—including exhibitions, publications, research and database development, and residency programs—that they, with characteristic plainspokenness, describe as an attempt to understand "the nature and extent of human interaction with the earth's surface."[5]

What's so compelling about CLUI's treatments is the way they remind viewers that those big empty spaces where Land art was first executed were only empty in relationship to the cramped spaces of the metropolitan culture centers. In fact, the Western United States (like many other understudied sites) has always been a place of activity—the Utah page alone of the organization's online Land Use Database (designed "to educate and inform the public about the function and form of the national landscape, a terrestrial system that has been altered to accommodate the complex demands of our society") has information on more than fifty "unusual and exemplary sites,"[6] including hazardous

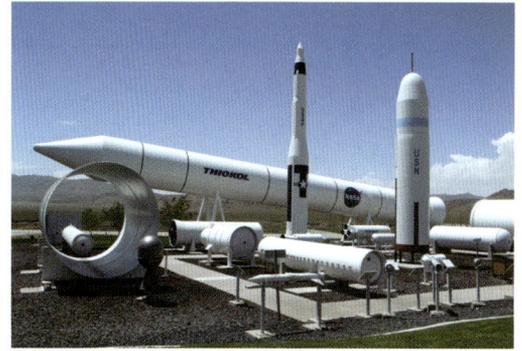

Above: Thiokol Rocket Plant Static Display, Promontory, Utah. CLUI Archive Photo

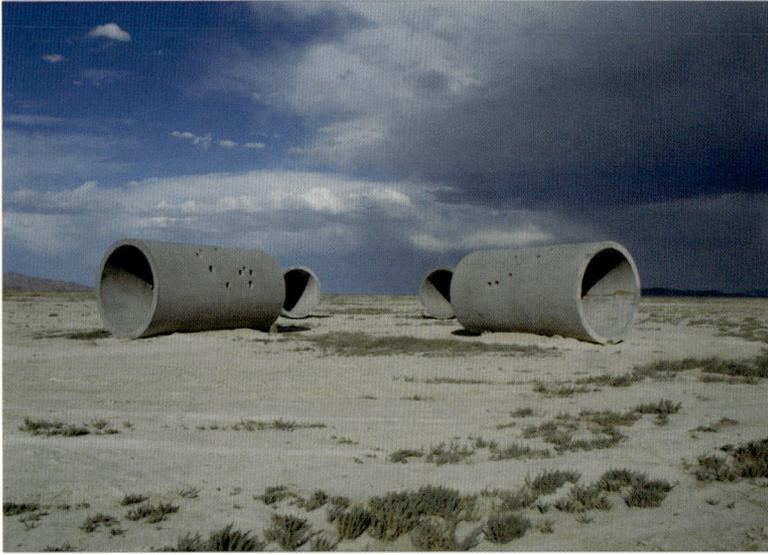

waste incinerators, small town history museums, and beryllium plants, as well as *Spiral Jetty* and Nancy Holt's *Sun Tunnels*, which lies about two hours drive north of Wendover. This leveling of information, which mirrors in some sense the program of dismantling disciplinary boundaries that the postwar generation did so much to promote, is a vital service to both artists and non-artists, and to explorers whose interests bridge both kinds of activity, because it helps to reinsert the real into the "real space" that the Land artists sought to engage.[7] (In some sense, CLUI's Land Use Database might be considered a more fully elaborated contemporary analogue to Heizer's famous incantatory list of things in the vicinity of Las Vegas and *Double Negative*: "Desert Inn, crows, pine, Stardust, ocotillo, barite, Indian reservations, buckhorn, neon wedding chapels, F-111's, prairie dogs, roulette, Flamingo, vultures, Boulder Dam…"[8]) Like Morris's observations in "Notes on Art" about the rich if ambivalent relationship between the tools and sites of industrial activity and their potential for artistic exploitation, the kinds of projects CLUI produces don't offer poetic distractions from the world of functional land use, but instead see it as an arena in which all the productive tensions between utility and meaning are enacted on a human scale.

·····

Not all of the artists in *Experimental Geography* can trace their lineage from first-generation American Land art as clearly as CLUI. But the show's thesis is expansive enough to embrace any number of approaches, including modes involving mapping and performance that owe more perhaps to European Land Art progenitors such as Richard Long or Hamish Fulton than to their American counterparts, as well as work that references surveillance and processes of labor. Significantly, the show also includes a large number of collectives (and they usually are groups; such expansive research-based projects seem best suited to multidisciplinary team efforts) whose programs, like CLUI's, tend to be more explicitly research-oriented, including New York's Center for Urban Pedagogy (CUP), whose educational approach examines the functional systems of cities; e-Xplo, a three-person collaborative that

Above left: Nancy Holt, *Sun Tunnels,* Lucin, Utah.
CLUI Archive Photo

deploys a variety of media in their projects, which often involve tours of cities; the frequently politically charged social inquiry of the team of Julia Meltzer and David Thorne; Raqs Media Collective, the New Delhi-based group whose work examines urban infrastructure; and Spurse, a wide-ranging transnational collective involving more than fifty artists that collects archival information to build a picture of metropolitan material culture. Taken together, *Experimental Geography*'s formal and conceptual diversity reflects the heterogeneous character of both artmaking and geography—literally "a description of the surface of the earth"—as they are practiced today.

"Making art in the landscape," wrote Dave Hickey of the burgeoning Land art phenomenon in the early 1970s, "allows the elevation of many splendid activities from the bondage of utility into the realms of imitation—activities like sipping iced tea from a big glass while sitting on a tractor seat, loading a rock crusher, mapping out the land beneath your feet or clearing your sinuses with the fragrance of asphalt. As George Puttenham was wont to say, the artist is 'both a maker and a counterfeiter.' These are all things worth doing in and of themselves, however rich in reference."[9] The oscillation that Hickey identifies, between utility and imitation—between the function of an activity and its potential meanings—continues to animate work made in (or these days more likely about) the landscape. Yet as time has passed, the relationship between the two has become more complicated and nuanced. The first generation of Land art practitioners may have deployed their heavy machinery in the service of aesthetics, but despite all their outsized poetry, the artistic marks they made did not overwrite entirely the traces of the functional systems that brought them into being. It is through these traces of infrastructural process, more perhaps than in the particular products they produced, that the face of today's artistic landscape is being altered.

Notes

1. Robert Smithson, "Towards the Development of an Air Terminal Site," in Jack Flam, ed., *Robert Smithson: The Complete Writings*, p. 58, Berkeley and Los Angeles: University of California Press, 1996. First published in *Artforum* (June 1967).

2. See "Some Void Thoughts on Museums," ibid, p. 42. First published in *Arts Magazine* (February 1967).

3. See "Conversation in Salt Lake City," interview with Gianni Pettena, ibid., p. 298. First published in *Domus* (November 1972).

4. Robert Morris, "Notes on Art as/and Land Reclamation," in Morris, *Continuous Project Altered Daily*, Cambridge: MIT Press, 1993, p. 211.

5. From the organization's mission statement at www.clui.org

6. See ludb.clui.org

7. "The Art of Michael Heizer," *Artforum* (December 1969), p. 34.

8. Excerpt from text in *Michael Heizer/Actual Size*, Exh. cat., Detroit: Detroit Institute of Arts, 1971, reprinted in Germano Celant, *Michael Heizer*, Milan: Fondazione Prada, 1997, p. 27.

9. Dave Hickey, "Earthscapes, Landworks and Oz," *Art in America* 59 (September/October 1971), p. 42.

LANDSCAPE IS A METAPHOR

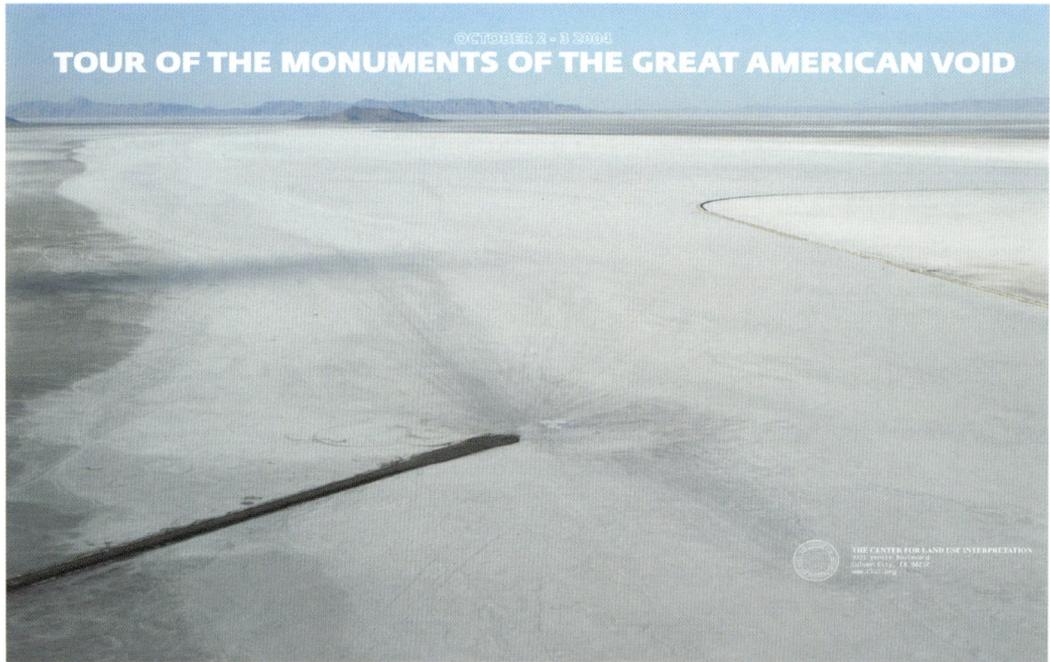

© OCTOBER 2 - 3 2008

TOUR OF THE MONUMENTS OF THE GREAT AMERICAN VOID

THE CENTER FOR LAND USE INTERPRETATION

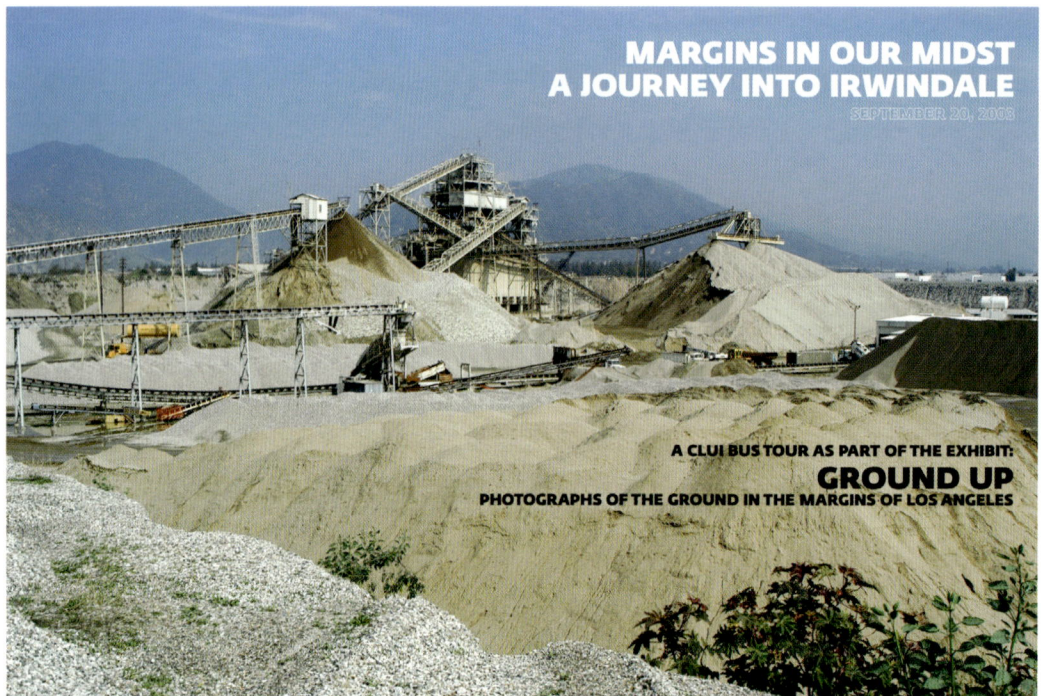

**MARGINS IN OUR MIDST
A JOURNEY INTO IRWINDALE**
SEPTEMBER 20, 2008

A CLUI BUS TOUR AS PART OF THE EXHIBIT:
GROUND UP
PHOTOGRAPHS OF THE GROUND IN THE MARGINS OF LOS ANGELES

Above: The Center for Land Use Interpretation
*(image and text panels depicting the programs and
projects of CLUI*, 2007. Inkjet prints. 16 x 24 in.
(40.6 x 61 cm) each

THE BUS TOUR AS INVERTED VITRINE:
ENGAGING WITH THE MATERIAL CULTURE OF THE MUSEUM OF THE AMERICAN LAND

MATTHEW COOLIDGE

The tour bus is a mobile theater—a captive audience, in a room of chairs, facing forward, with anticipation. The world lies ahead. *Anything* could be ahead. At the front is the narrator, off to the side of the big picture window of where we are going. The narrator's job is to be the matrix that holds the parts together, providing continuity, thematic structure, and consistency to the experience. The narrator must set people at ease so that their defenses are down and they are ready to absorb, and to prepare fertile ground that allows for the growth of new ideas. But the narrator is not the subject, only a medium, a shaman. The point is the thing pointed out, not the pointer. And people shouldn't be *too* comfortable, as the purpose of the journey is not recreation, but inspiration. To keep things exciting, we have to all be in the same experimental boat of possibility, and people should be on the edge, ready to jump. It is research.

A valuable resource on the bus is the video monitors, where supporting material for the tour, such as film clips, documentaries, slideshows, and live tracking maps, can be presented. Using the monitors, a video camera can zoom in to make distant objects in the land visible. Time and space can be folded, shrinking long distances between things with engaging and relevant video material, or making figurative allusions to places and spaces you are passing through. The possibilities for phenomenological *fris-son* between multimedia and physical place are untapped, exciting, and nearly endless. But it is important to default to the primacy of place, since there you are. It's outside the frame of the windows. Get off the bus.

The most important part of the bus tour is the destinations. Anyone in the museum profession can tell you about the importance of the visitor's proximity to the physical artifacts of the museum. This connection with "material culture" is the whole point of the museum. But in the museum of the American Land, the material artifacts are places and spaces, and they cannot be housed in a vitrine. The answer is the bus tour; creating a museum atmosphere inside the bus bubble, and taking it out to the land. The bus *is* the vitrine (and the tourists *are* part of the subject, too).

Unlike most museums though, where the artifacts are insulated from direct contact by glass cases, or the established safe-distance for people from pictures on the wall is monitored by watchful guards, the museum of land allows for full contact and immersion with the subject. In the American Land Museum, not only can you touch the artifacts, you can be in them and on them. You can be surrounded by them, enter their spaces, ingest their dander and odor. This receptive exchange is the final and deepest link in connecting people to experience. Once you have been there, you have done that. It stays.

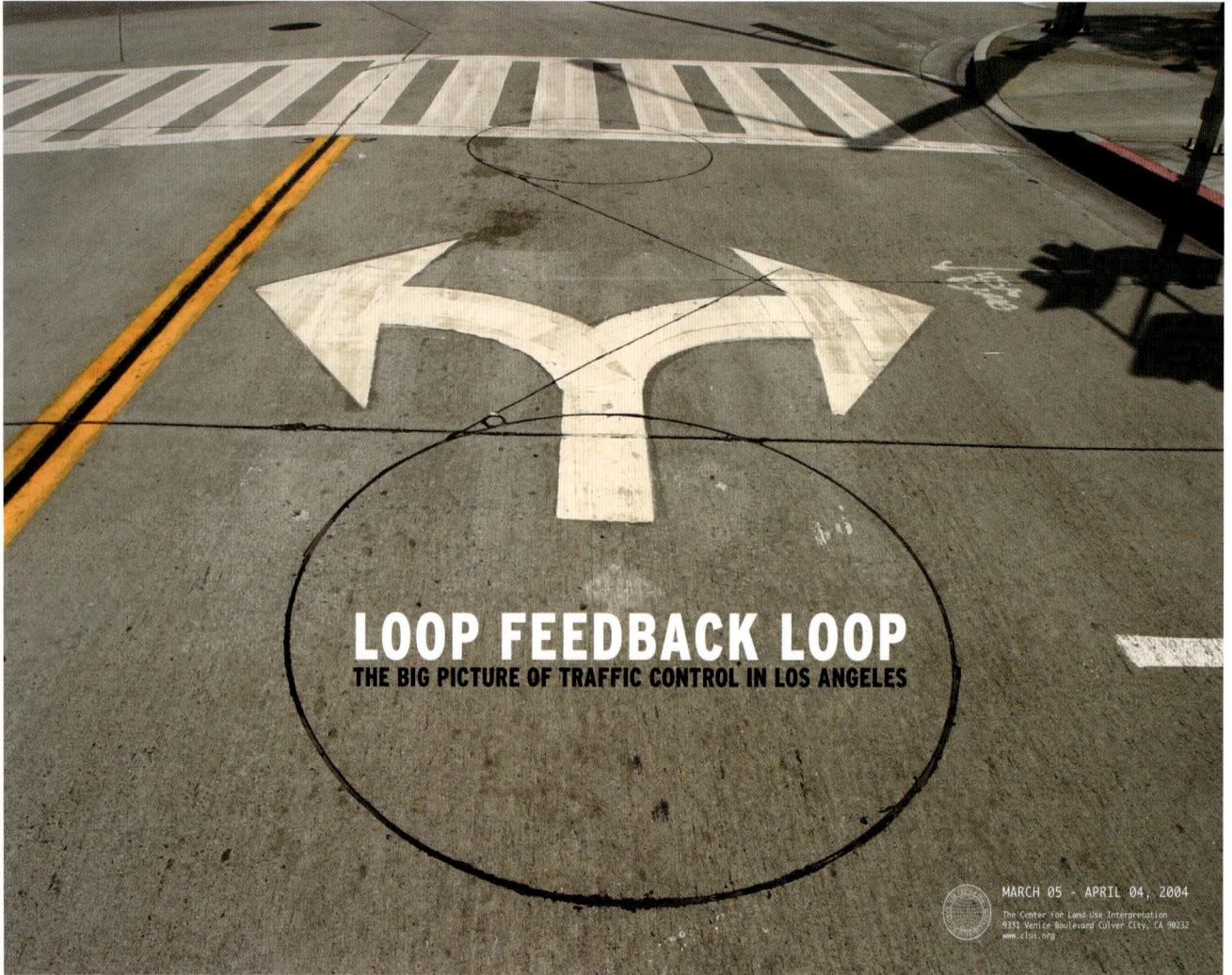

LOOP FEEDBACK LOOP
THE BIG PICTURE OF TRAFFIC CONTROL IN LOS ANGELES

MARCH 05 - APRIL 04, 2004
The Center for Land Use Interpretation
9331 Venice Boulevard Culver City, CA 90232
www.clui.org

MATTHEW COOLIDGE FOR CLUI

The Center for Land Use Interpretation is a research organization that examines the nature and extent of human interaction with the earth's surface. The Center embraces a multidisciplinary approach to fulfilling the stated mission, which is to "increase and diffuse knowledge about how the nation's lands are apportioned, utilized, and perceived." To these ends, the Center employs conventional research and information processing methodology as well as nontraditional interpretive tools. The Center collects, catalogues, interprets, and disseminates information about the contemporary landscape through its archives and public programs, which include exhibitions, publications, and tours.

The Center also exists to stimulate discussion, thought, and general interest in the contemporary landscape. Neither an environmental group nor an industry affiliated organization, the Center can work to integrate the many approaches to land use—the many perspectives of the landscape—into a single view that emphasizes the shared, common ground.

The Center operates with the belief that the physical landscape embodies an inscription of the society that operates within it, and that in reading and understanding this inscription comes a deeper awareness of the relationship between humans and their environment. Learning and teaching the vocabulary of this "language of land use" is one of the functions of the Center. Another is to discover ways of seeing the utilization of terrestrial and geographic resources that have yet to be considered.

Left: The Center for Land Use Interpretation *(image and text panels depicting the programs and projects of CLUI)*, 2007. Inkjet print. 16 x 24 in. (40.6 x 61 cm)

46 | 47

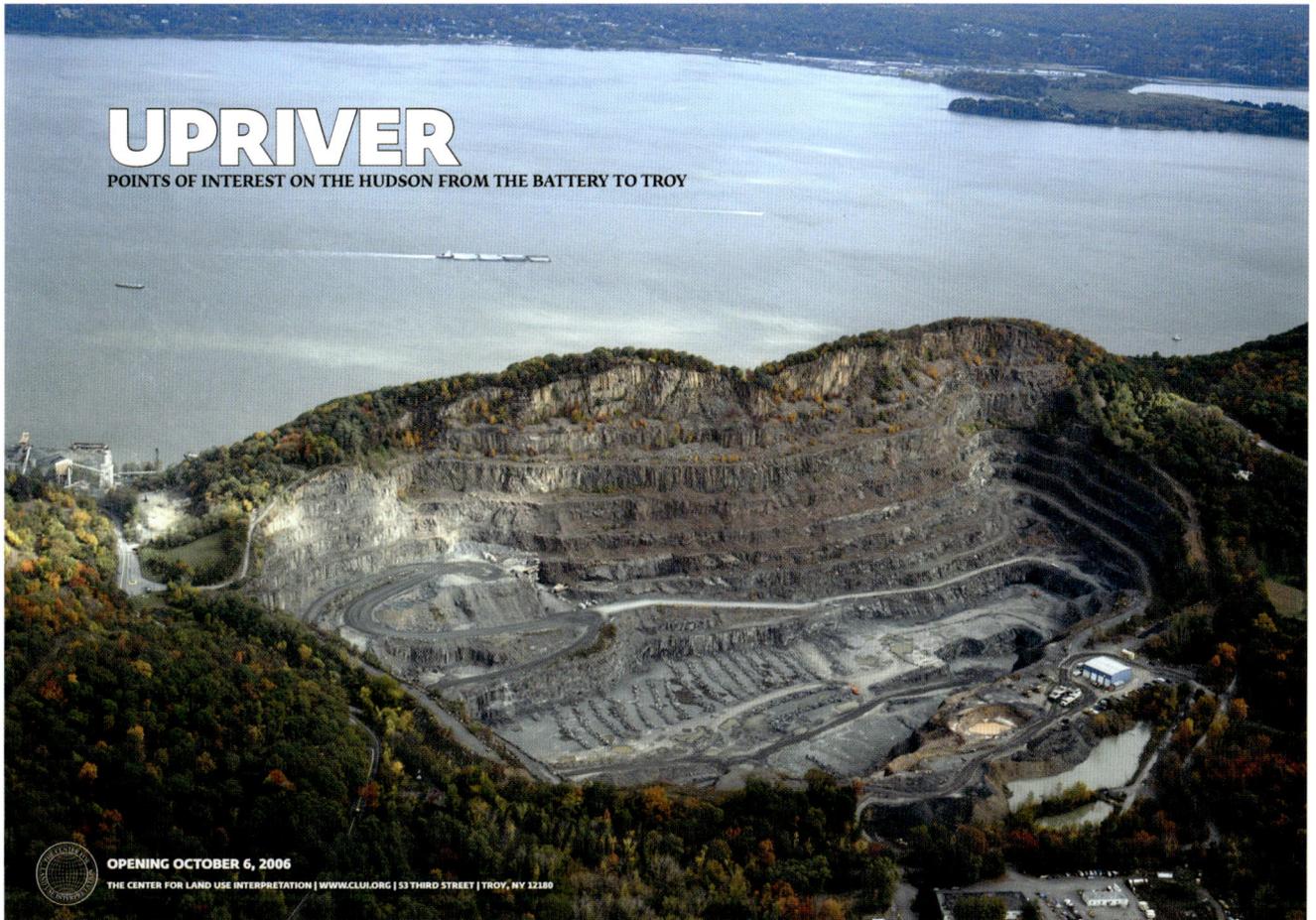

UPRIVER
POINTS OF INTEREST ON THE HUDSON FROM THE BATTERY TO TROY

OPENING OCTOBER 6, 2006
THE CENTER FOR LAND USE INTERPRETATION | WWW.CLUI.ORG | 53 THIRD STREET | TROY, NY 12180

Above and Left: The Center for Land Use Interpretation
(image and text panels depicting the programs and
projects of CLUI), 2007. Inkjet prints 16 x 24 in.
(40.6 x 61 cm) each

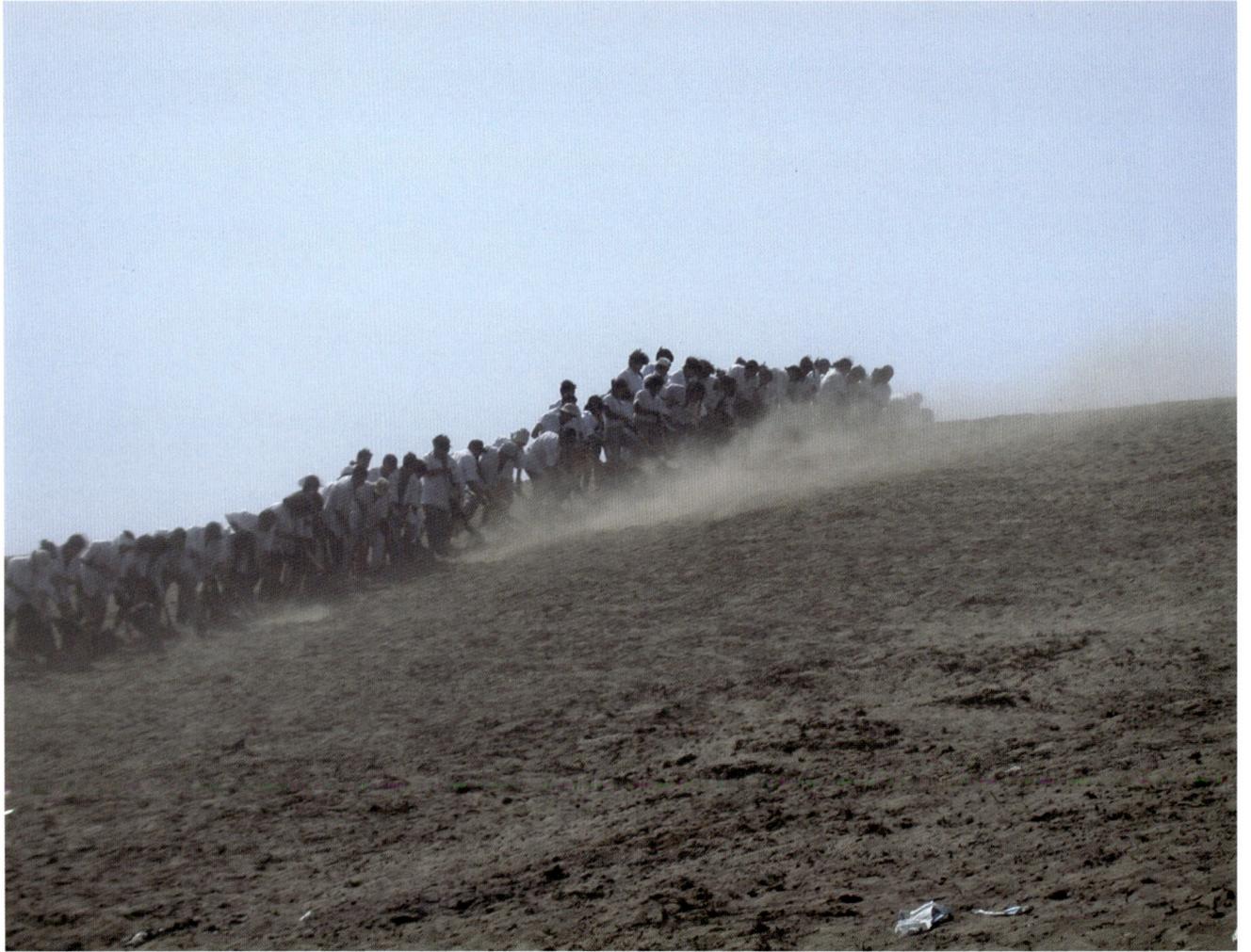

The following text is excerpted from *When Faith Moves Mountains* by Francis Alÿs and Cuauhtémoc Medina, which documents the creation of *When Faith Moves Mountains*, a project about geological displacement, but which also may be applied to *The Making of Lima*. On April 11, 2002, five hundred volunteers were equipped with shovels and asked to form a single line at the foot of a five-hundred-meter-wide dune in Ventanilla, on the outskirts of Lima, Peru. This human comb pushed a certain quantity of sand a certain distance, thereby moving the dune a few inches from its original position. The physical displacement was infinitesimal, but its metaphorical implications were not.

If I remember right, the first way the project was stated, during my first visit to Lima, was above all verbal—"Faith moves mountains"—and came before any image of the project. And this statement was so simple that its physical, visual translation had to be just as direct. From that point on, there wasn't much more to it: the obvious demonstration of the saying "to move a mountain" is to "draw a line" (which was later illustrated as a comb, used to "comb" the landscape). Remove a thin layer of sand from one side of the hill and put it back on the other and you'll cause a minimal but real geological displacement. In a more pragmatic manner, it was also the most explicit way of communicating the metaphor's physical application to the other people involved.... Yes, it's true, nothing changed, but for a few hours the possibility of change was introduced, besides the absurdity or futility of the act.

Left: Francis Alÿs (in collaboration with Cuauhtémoc Medina and Rafael Ortega), *The Making of Lima*, 2002 (video still). Single-channel video projection with color and sound, 15:37 mins.

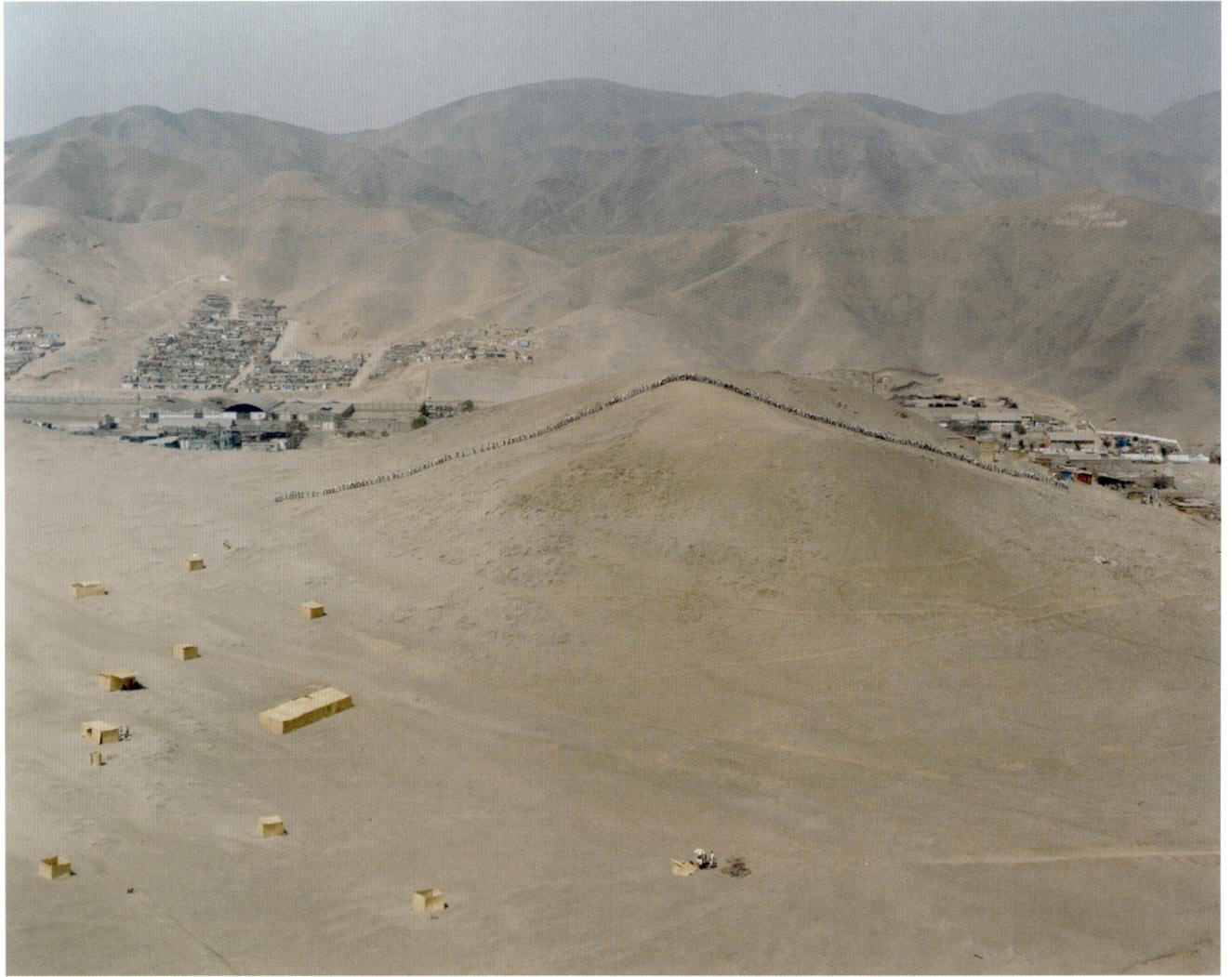

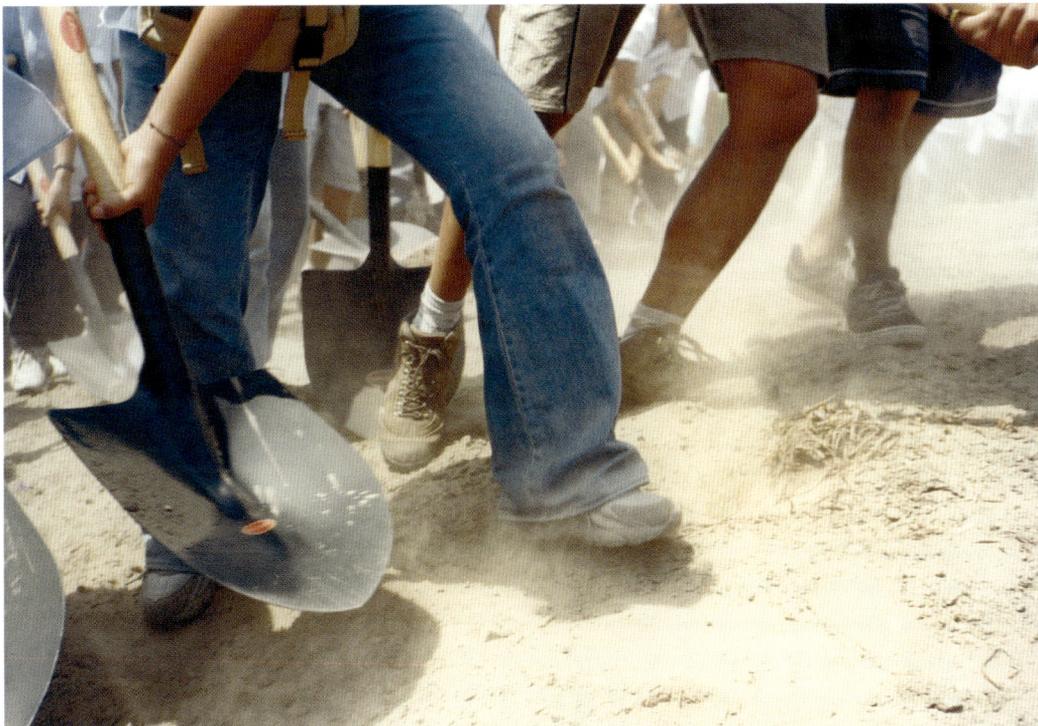

Above and Left: Francis Alÿs (in collaboration with
Cuauhtémoc Medina and Rafael Ortega), *When Faith
Moves Mountains*, 2002 (video stills). Three-channel
video installation with color and sound, 34 mins.

PLATE 2

NEAR ITTOQQORTOORMIIT

Above: Ilana Halperin, *Near ITTOQQORTOORMIIT* (from
the project *Towards Heilprin Land*), 2007. Etching on
handmade Fabriano paper, 18 x 23 in. (45.7 x 58.4 cm)

ILANA HALPERIN

GEOLOGIC INTIMACY/PHYSICAL GEOLOGY

Please explain this impulse to me—attempting physical contact with geological time.

Recently, I have been spending time in the "oddities" drawer of the geology department at the Manchester Museum. In it, I came upon a very fine collection from Mount Vesuvius of lava medallions—magma pressed between forged steel plates to form an imprint. Imagine a waffle iron that makes use of lava instead of pancake batter. In the same drawer, a small stone relief sculpture which appeared to be carved out of pure white alabaster was in fact revealed to be a limestone cast made through the same process that forms stalactites in a cave—the residue of a high-velocity calcifying process.

I have been thinking about physical geological time—the fast-moving lava flow vs. slow time inside a cave. The impulse to understand geothermal water through boiling milk in a 100-degrees-Celsius sulfur spring in the crater of an active volcano.

I spoke with a paleontologist who told me that a fossil is the presentation of the moment of death, that trace fossils record an action—eating or walking, but not the organism itself.

Jim said to me, a volcano buries itself. It perpetually erases its own history.

In *Towards Heilprin Land*, a volcanologist explained the nature of love to me. He said, you love what you get to know, what you pay attention to and therefore become more aware of. This is not a passive form of love.

This is how I feel about the volcano.

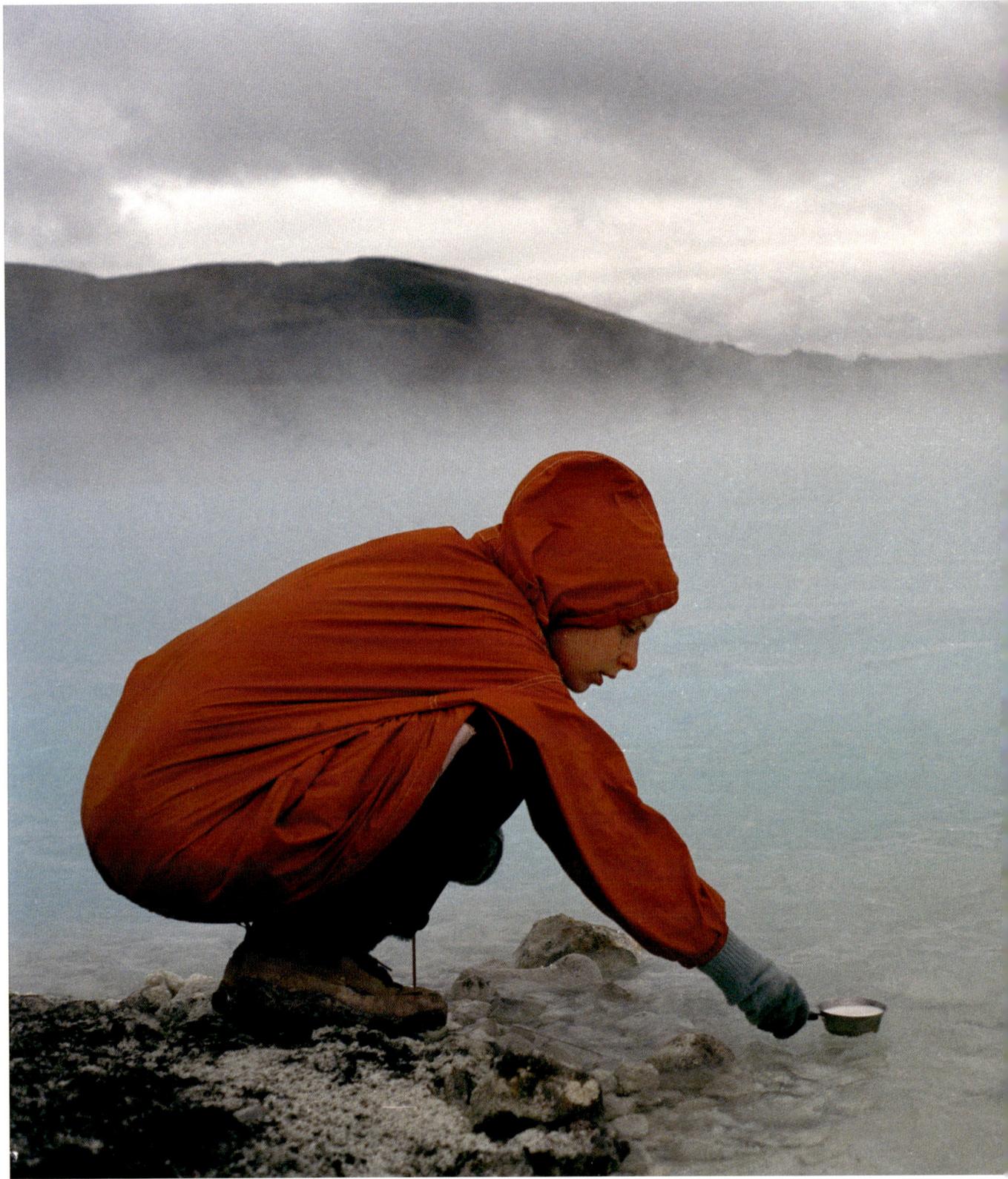

Above: Ilana Halperin, *Boiling Milk (Solfataras)*, 2000.
Chromogenic print, 19 5/8 x 30 in. (49.8 x 76.2 cm)

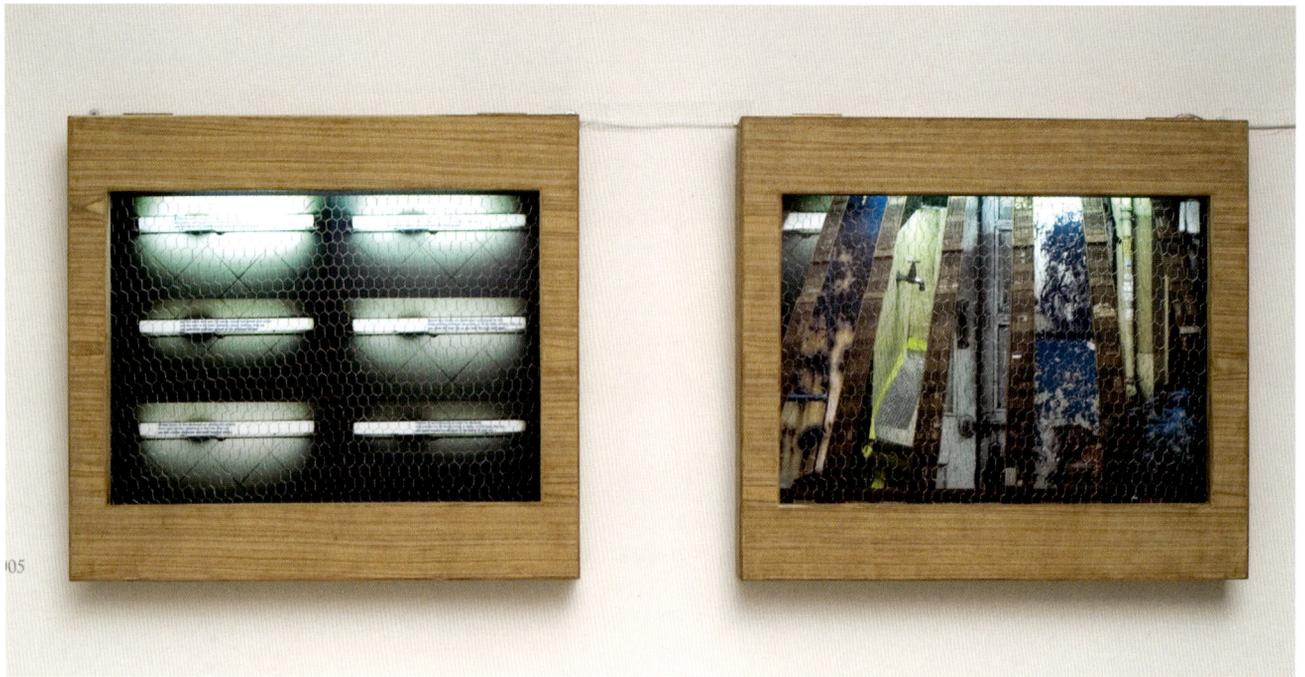

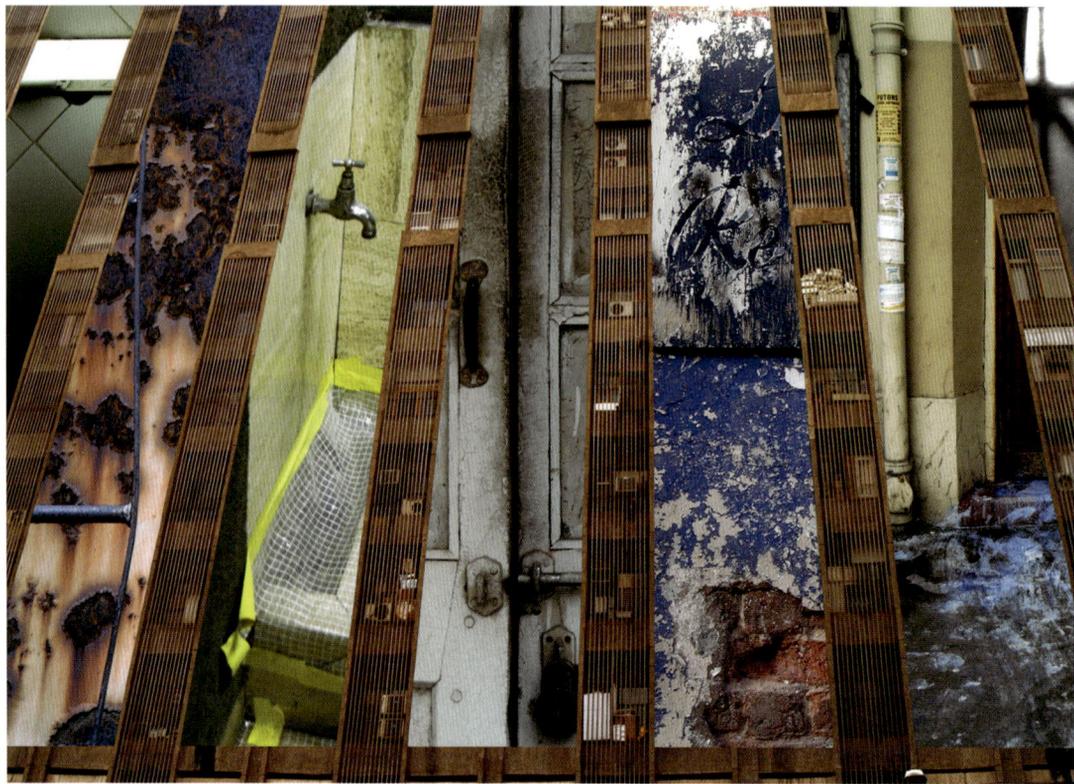

The substance of cities is bricks, stone, mortar, cement, glass, steel, and asphalt. The strength of these materials, their consistency and their chemistry, is what makes citizens feel that their lives have a durable material basis. The road you walk on to the corner store will not suddenly open up like a chasm, the building you live in will not collapse in a pile of rubble for no reason. The bridge you cross will not break if it is not bombed. The sky does not fall on the heads of law-abiding citizens. Not ordinarily.

From time to time, whispers and rumours run through these blocks of certainty like bursts of runaway voltage from a faulty transformer. Lights flicker, flare, and die, the blades of ceiling fans and the ordinary courses of daily life circle to a suspended stillness. The city is an epileptic and rumours are its seizures. Things can come undone because of a whispered rumour. Cities may be built in steel and concrete, but they are eroded by whispers. *Erosion by Whispers* reflects on the way in which rumours render cities ephemeral. Their intangible presence can be read across the density of urban infrastructure—housing, electricity, water and other utilities—to suggest that fragility is as much part of the experience of cities as the claim to endurance.

Raqs Media Collective: Jeebesh Bagchi, Monica Narula, and Shuddhabrata Sengupta.

Left top: Raqs Media Collective, *Erosion by Whispers*, 2007 (installation view). Wood, chromogenic prints, chicken-wire mesh, and fluorescent lights, 26 1/8 x 30 1/8 x 3 7/8 in. each (66.5 x 76.5 x 10 cm); 26 1/8 x 66 1/4 x 3 7/8 in. overall

Left bottom: Raqs Media Collective, *Erosion by Whispers*, 2007 (detail)

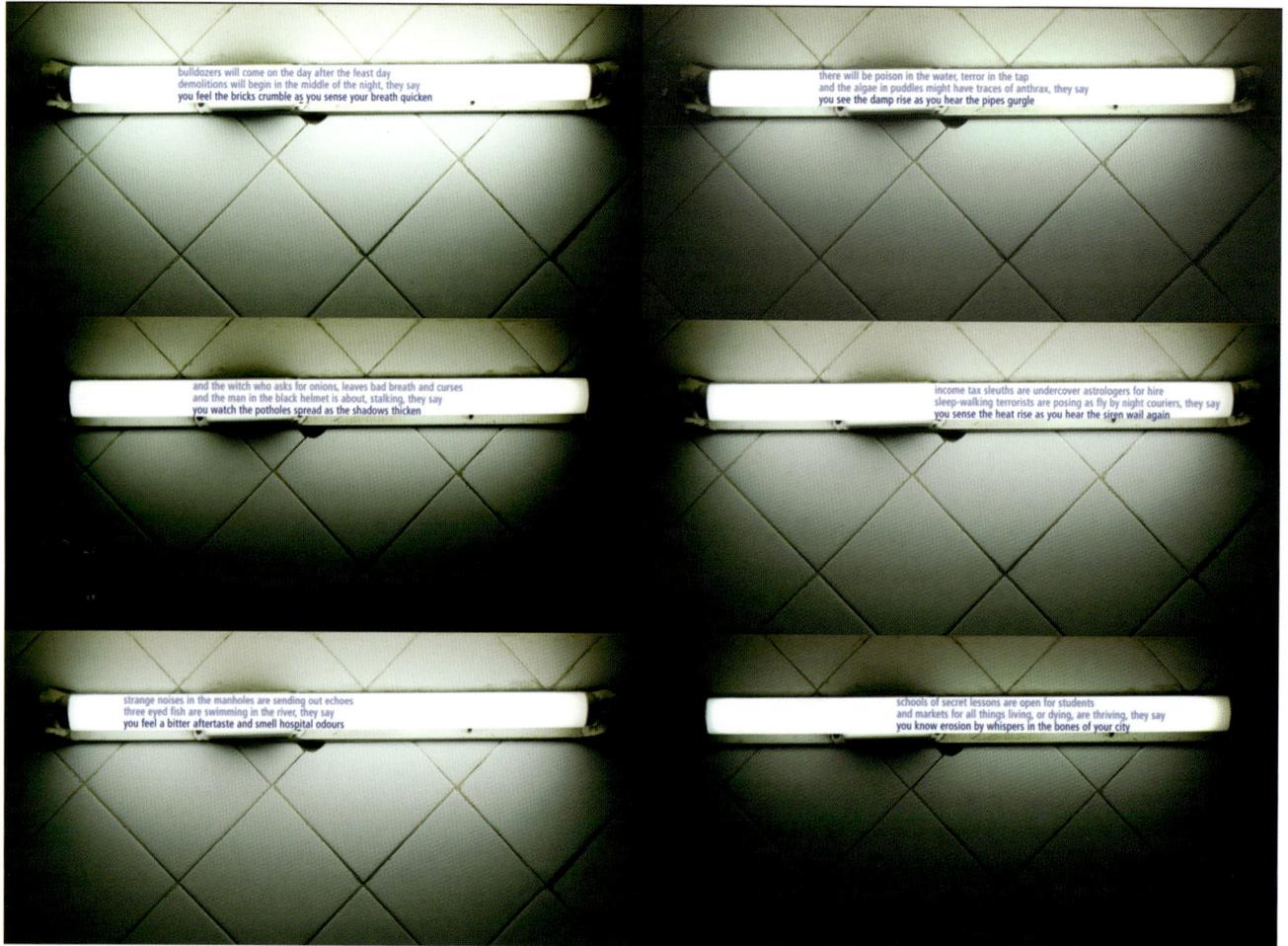

bulldozers will come on the day after the feast day
demolitions will begin in the middle of the night, they say
you feel the bricks crumble as you sense your breath quicken

there will be poison in the water, terror in the tap
and the algae in puddles might have traces of anthrax, they say
you see the damp rise as you hear the pipes gurgle

and the witch who asks for onions, leaves bad breath and curses
and the man in the black helmet is about, stalking, they say
you watch the potholes spread as the shadows thicken

income tax sleuths are undercover astrologers for hire
sleep-walking terrorists are posing as fly by night couriers, they say
you sense the heat rise as you hear the siren wail again

strange noises in the manholes are sending out echoes
three eyed fish are swimming in the river, they say
you feel a bitter aftertaste and smell hospital odours

schools of secret lessons are open for students
and markets for all things living, or dying, are thriving, they say
you know erosion by whispers in the bones of your city

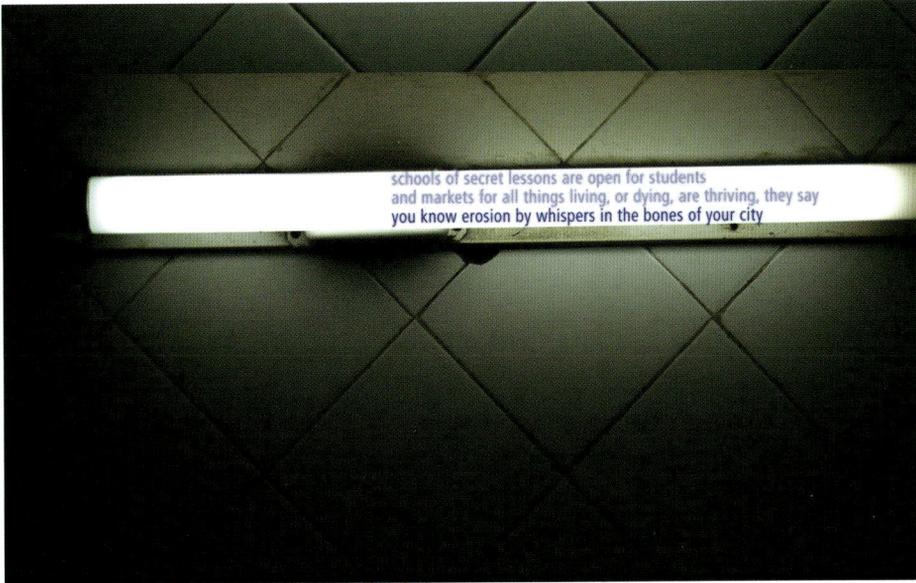

schools of secret lessons are open for students
and markets for all things living, or dying, are thriving, they say
you know erosion by whispers in the bones of your city

Left and Above: Raqs Media Collective, *Erosion by
Whispers*, 2007 (details)

In 1966, a young architect proposed a design for a five-star hotel and a new mosque in Martyrs' Square, the center of Damascus. In 1971, his plans were scrapped. In 1982, a building began to be built. Hospital? Parking Garage? Military Housing? The project—now called the Basel al-Assad Center—has been the subject of much rumor and speculation. As of 2007, the building remains unfinished. In this documentary video, *take into the air my quiet breath*, an architect recounts the chronicle of the building and considers its possible future.

Left: Julia Meltzer and David Thorne, *take into the air my quiet breath*, 2007 (video stills). Single-channel video with color and sound, 17 mins.

RESEARCH AND DEVELOPMENT

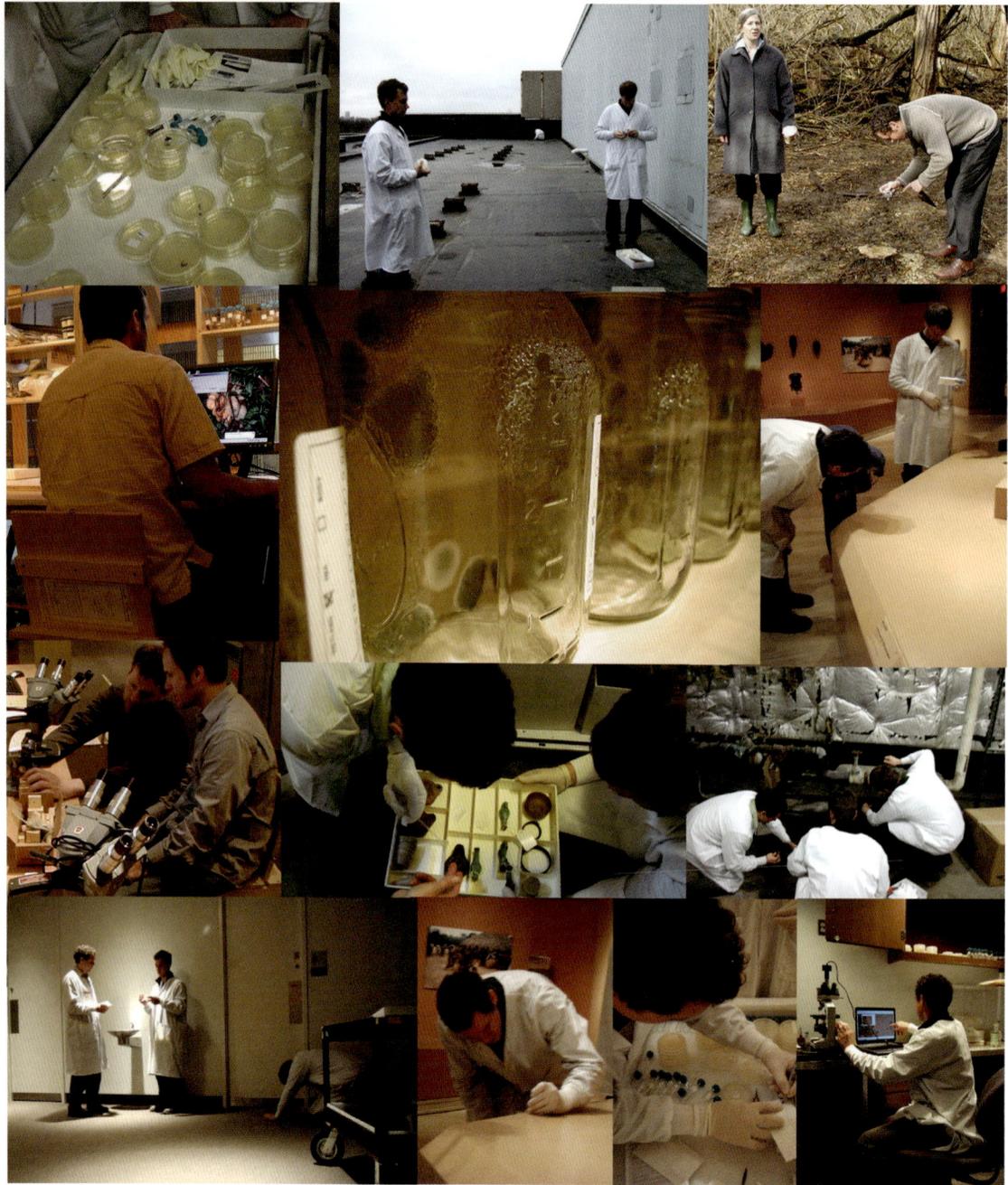

PHASE ONE: RESEARCHING THE PRODUCTION OF THE COLLECTIVE: MICROMOBILIA: MACHINES FOR THE INTENSIVE RESEARCH OF INTERIOR BIO-GEOGRAPHIES	
SPURSE	SPURSE 2005-2008
NOTES: PARTICIPATORY RESEARCH AT THE INDIANAPOLIS MUSEUM OF ART IN REGARDS TO INTERIOR BIO-GEOGRAPHIES	

PARTICIPATORY RESEARCH: GEOGRAPHY: EXPERIMENTAL

IAIN KERR

Today, all actions—from drinking a simple glass of water to reading this text—are explicitly global in their spheres of intra-activity. These activities ripple across the world crossing from micro to macro systems, from the social folded across natural systems to the spaces of the technosciences making both new cultures and new natures. How do we come to terms with this complex reality? This question is what begins participatory research practices within forms of experimental geography. We begin to answer this question by simply asking: What is happening? Already this gets messy: we who ask are not separate from what we ask about. We are within and part of what we study. Participatory research thus begins with the assumption that all forms of meaning, doing, making, thinking, and knowing are participatory entanglements with both discursive and material systems. There is a distributed geography of participation. For example, you who read this, you have within and across you vast entanglements: by cell count you are ninety percent bacteria, fungi, and protocistae, all of which is shaped by a deep history of stellar gases, the earth cooling, the development of clothing, animal human kinships, class and gender politics, air travel, transversal gene swapping and mutation of all kinds, etc. And still this acknowledgment of a geography barely begins the project of tracing our entangled becomings (participation). Simply put, it is a vast web that participates to make us and participates in our actions. This geography of participation is a fully post-human event (the world is composed of both humans and non-humans and agency is an emergent relational phenomena that happens on many differing levels of reality).

If participation is a given, then the status of subjects cannot be assumed in advance of a particular event. The production/formation of subjects or agents is because of a boundary–producing event of a particular set of relations (of which it is a part). This is the next meaning of our geography: the tracing of systems, practices, and iterative structures that all allow for the situated separation/becoming of subjects/agents through an evolving set of relations. The question is no longer how to show that nature and culture are interwoven or constructed but how they become what they are. This is what calls for experimentation. If participatory research involves the production of new systems giving rise to new forms of subjects, then to act/research is to be involved in change—experimental change. We need to recognize that acts of knowing are forms of change.

Perhaps this offers us a new way to understand these emergent geographies within the arts? If we are part of a co-emergent web of entanglements that intra-actively co-produce the real, then "representation" is simply not possible (it requires a fundamental separation between the seer and the seen). If representation and other such mirror strategies are flawed, so are their critiques that remain within representational structures (this is the limitation of practices such as institutional critique). There is a need for post-human and post-representational experimental practices that flow across geographies of becoming. An art of participatory experimental engagements that emerge from the now inseparably intrawoven geographies of being (ontology), knowing (epistemology), and doing (ethics).

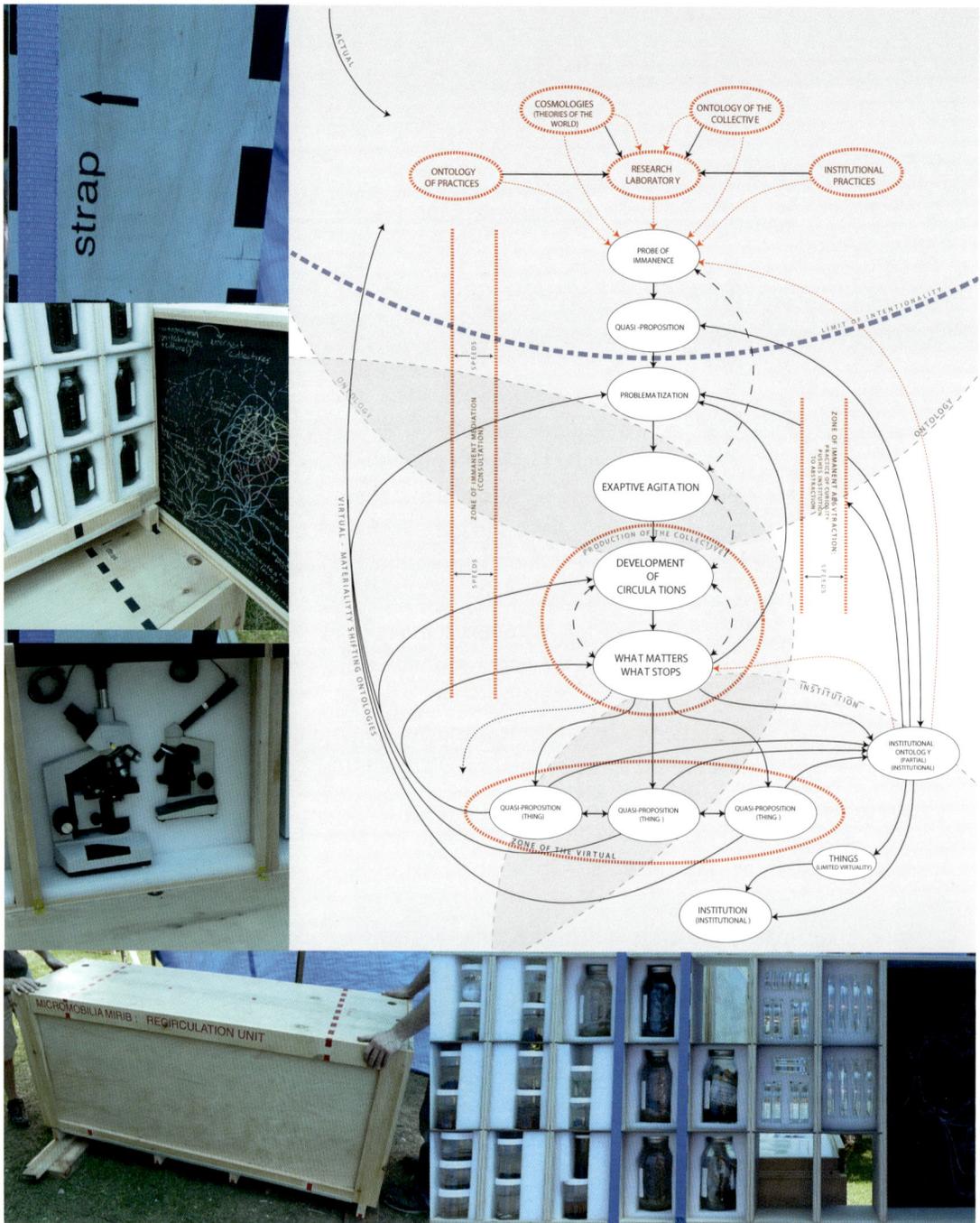

The diagram contains the following labels:

ACTUAL

COSMOLOGIES (THEORIES OF THE WORLD)

ONTOLOGY OF THE COLLECTIVE

ONTOLOGY OF PRACTICES

RESEARCH LABORATORY

INSTITUTIONAL PRACTICES

PROBE OF IMMANENCE

QUASI-PROPOSITION

LIMIT OF INTENTIONALITY

PROBLEMATIZATION

ONTOLOGY

ZONE OF IMMANENT MEDIATION (CONSULTATION)

EXAPTIVE AGITATION

ZONE OF IMMANENT ABSTRACTION (PRACTICE OF CURIOSITY PUSHES INSTITUTION TO ABSTRACTION)

SPEEDS

PRODUCTION OF THE COLLECTIVE

DEVELOPMENT OF CIRCULATIONS

SPEEDS

SPEEDS

WHAT MATTERS WHAT STOPS

VIRTUAL - MATERIALITY SHIFTING ONTOLOGIES

INSTITUTION

INSTITUTIONAL ONTOLOGY (PARTIAL) (INSTITUTIONAL)

QUASI-PROPOSITION (THING)

QUASI-PROPOSITION (THING)

QUASI-PROPOSITION (THING)

ZONE OF THE VIRTUAL

THINGS (LIMITED VIRTUALITY)

INSTITUTION (INSTITUTIONAL)

strap

MICROMOBILIA MIRIB | RECIRCULATION UNIT

MICROMOBILIA: MACHINES FOR THE INTENSIVE RESEARCH OF INTERIOR BIO-GEOGRAPHIES	
SPURSE	SPURSE 2005-2008
NOTES: DETAILS OF UNITS AND AND ANALYSIS OF SYSTEM	

Above and Following Pages: Spurse (with involvement from Chris Archer, Cole Caswell, and Jeffrey Jenkins), *Micromobilia: Machines for the Intensive Research of Interior Bio-Geographies*, 2005–08 (preparatory study)

Micromobilia is a mobile laboratory that unfolds out of three self-contained units. Designed for use within institutional settings, this laboratory continues research of the geographical: an intra-weaving of the biological, social, and physical. This laboratory supports autonomous research over time to sample, investigate, and catalyze the microbiological geography of institutional interiors. The units work from diagrammatic principles of (geo)graphy: *drawing out of the world*, an unfolding of multiple perspectives toward reconceptualizing the earth that moves inside the institutional; and *drawing in and between*, an engagement with intensive states of being where difference produces a force of emergence.

These units and their embedded tools set out to problematize the institution as a space where a series of four investigations can unfold:

> TERRAIN: The institution's interiority is part of an unfolding geographic continuum. *Micromobilia* consists of research unit(s) and practices tuned to investigate and experiment with the microbiologic strata.

> INDIVIDUALIZATION: What passes as individual things are always collectives—heterogeneous assemblages—composed of human and non-human agents and systems. *Micromobilia* articulates new individuations and initiates institutional collective becomings.

> EXAPTATION: Agitation produces modulations of new geographic zones. *Micromobilia* inserts a platform for consultation by which experimentation across a spectrum of institutions is made possible.

> ENTANGLEMENT: The research unit and the institution are always linked by what is produced between them. *Micromobilia* facilitates co-evolvement as the production of emergent, intensive geographies of difference.

PACKED UNIT: PROBLEMATIZATION UNPACKED COMPONENTS UNIT 1 PROBLEMATIZATION UNIT ASSEMBLED

PACKED UNIT: AGITATION UNPACKED COMPONENTS UNIT 2 AGITATION UNIT ASSEMBLED

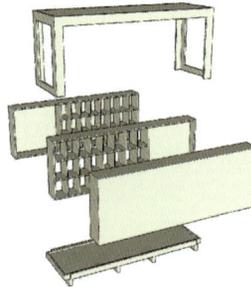

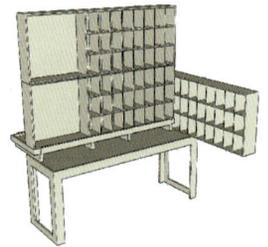

PACKED UNIT: RECIRCULATION UNPACKED COMPONENTS UNIT 3 RECIRCULATION UNIT ASSEMBLED

```
                    matter        probe of immanence
  → perplexity → practices → problematization → what matters → institution →
                                                    what stops
                  discursivities    development of
                                    circulations
              UNIT 1            UNIT 2              UNIT 3
```

DIAGRAM OF MICROMOBILIA UNITS ITERATIVE QUESTION SYSTEMS

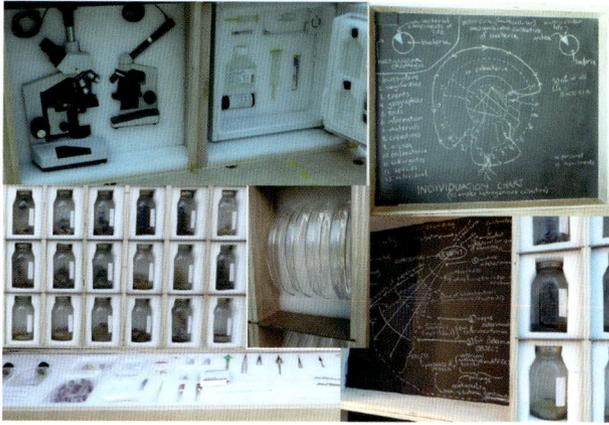

DETAILS OF MICROMOBILIA RESEARCH COMPONENTS

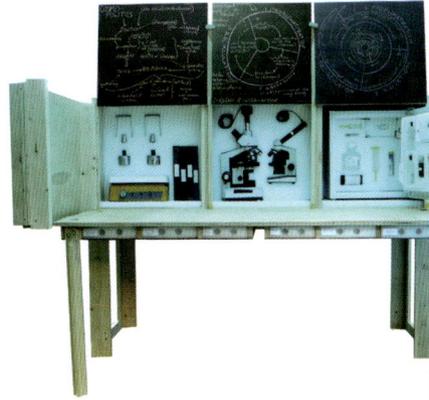

IMAGE OF PROBLEMATIZATION UNIT (FRONT VIEW -- UNIT 1))

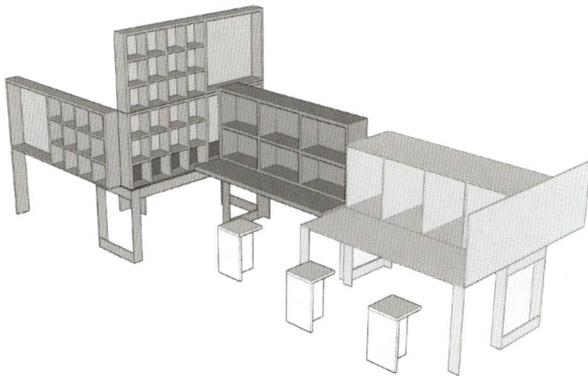

AXONOMETRIC LAYOUT OF MICROMOBILIA UNITS

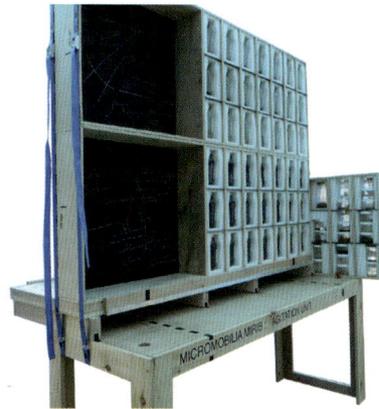

IMAGE OF AGITATION UNIT (FRONT VIEW -- UNIT 2)

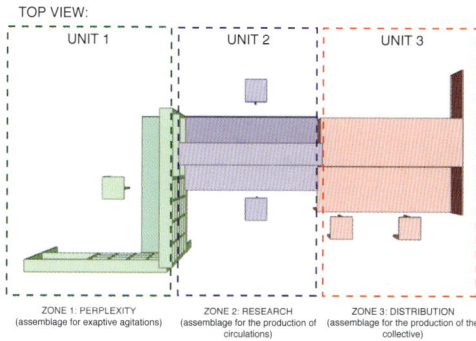

TOP VIEW:

UNIT 1 UNIT 2 UNIT 3

ZONE 1: PERPLEXITY
(assemblage for exaptive agitations)

ZONE 2: RESEARCH
(assemblage for the production of circulations)

ZONE 3: DISTRIBUTION
(assemblage for the production of the collective)

SCHEMATIC DIAGRAM OF MICROMOBILIA UNITS

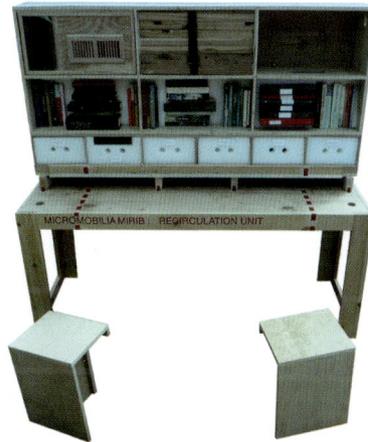

IMAGE OF RECIRCULATION UNIT (FRONT VIEW -- UNIT 3)

MICROMOBILIA: MACHINES FOR THE INTENSIVE RESEARCH OF INTERIOR BIO-GEOGRAPHIES

SPURSE (WITH INVOLVEMENTS FROM CHRIS ARCHER, COLE CASWELL & JEFFREY JENKINS)

SPURSE
2005-2008

NOTES:

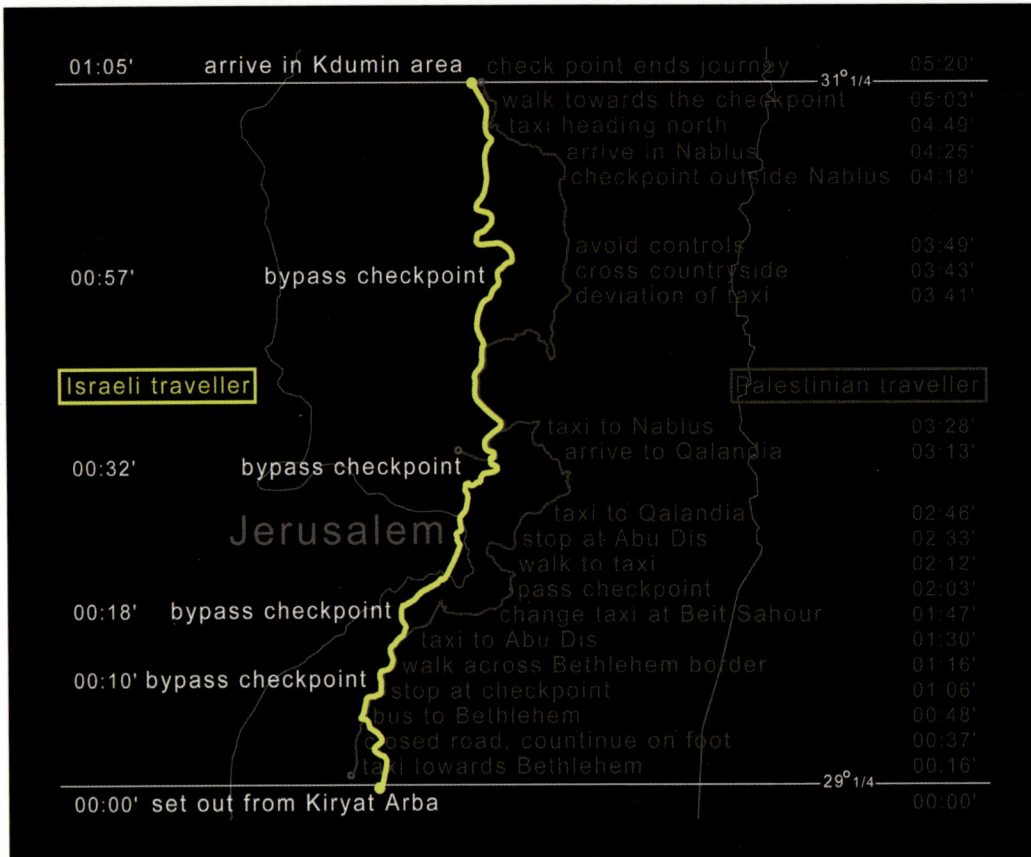

01:05' arrive in Kdumin area check point ends journey 05:20' —31°1/4—
walk towards the checkpoint 05:03'
taxi heading north 04:49'
arrive in Nablus 04:25'
checkpoint outside Nablus 04:18'

avoid controls 03:49'
cross countryside 03:43'
00:57' bypass checkpoint deviation of taxi 03:41'

Israeli traveller Palestinian traveller

taxi to Nablus 03:28'
arrive to Qalandia 03:13'

00:32' bypass checkpoint
Jerusalem
taxi to Qalandia 02:46'
stop at Abu Dis 02:33'
walk to taxi 02:12'
pass checkpoint 02:03'
00:18' bypass checkpoint change taxi at Beit Sahour 01:47'
taxi to Abu Dis 01:30'
00:10' bypass checkpoint walk across Bethlehem border 01:16'
stop at checkpoint 01:06'
bus to Bethlehem 00:48'
closed road, countinue on foot 00:37'
taxi towards Bethlehem 00:16' —29°1/4—
00:00' set out from Kiryat Arba 00:00'

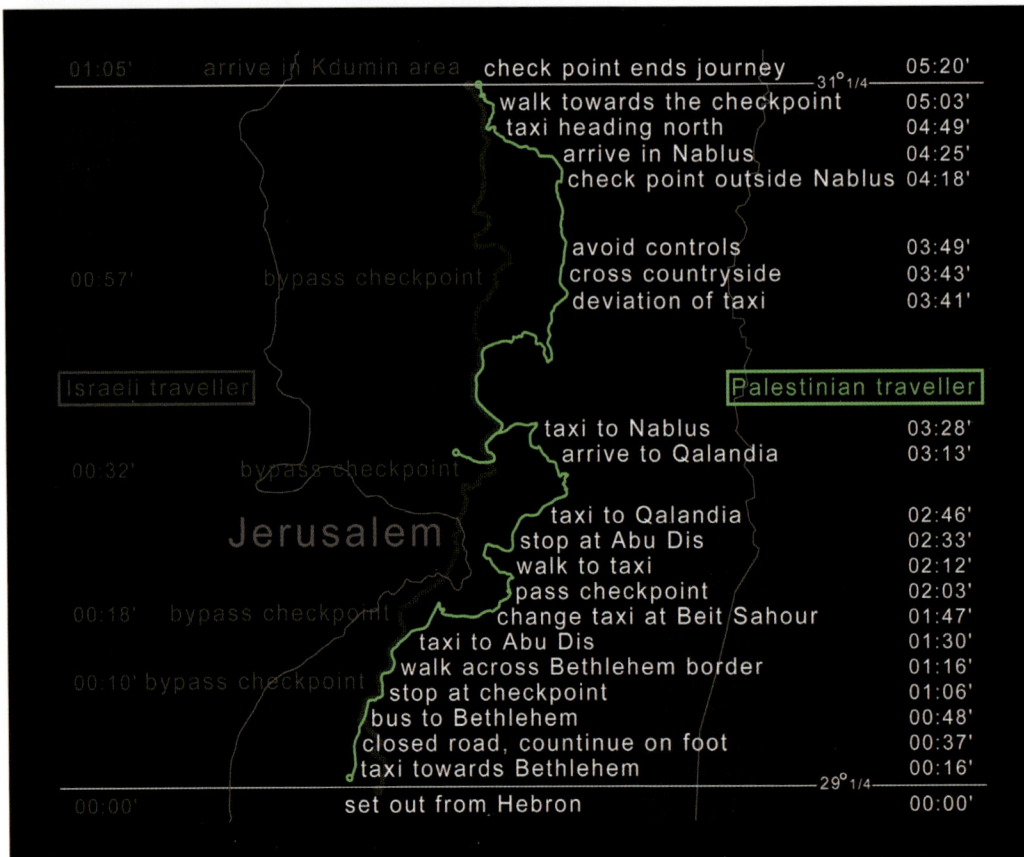

01:05' arrive in Kdumin area check point ends journey 05:20' —31°1/4—
walk towards the checkpoint 05:03'
taxi heading north 04:49'
arrive in Nablus 04:25'
check point outside Nablus 04:18'

avoid controls 03:49'
cross countryside 03:43'
00:57' bypass checkpoint deviation of taxi 03:41'

Israeli traveller Palestinian traveller

taxi to Nablus 03:28'
arrive to Qalandia 03:13'

00:32' bypass checkpoint
Jerusalem
taxi to Qalandia 02:46'
stop at Abu Dis 02:33'
walk to taxi 02:12'
pass checkpoint 02:03'
00:18' bypass checkpoint change taxi at Beit Sahour 01:47'
taxi to Abu Dis 01:30'
00:10' bypass checkpoint walk across Bethlehem border 01:16'
stop at checkpoint 01:06'
bus to Bethlehem 00:48'
closed road, countinue on foot 00:37'
taxi towards Bethlehem 00:16' —29°1/4—
00:00' set out from Hebron 00:00'

THE ROAD MAP

On January 13th, 2003, with our EU passports, we traveled along with a person with an Israeli passport from the colony of Kiriat Arba to the colony of Kudmin. The following day, we traveled along with a person with a Palestinian passport from the city of Hebron to the city of Nablus. The two routes both start and end in the same latitude; at some points they overlap.

Their traveling times, though, are profoundly different. To move between the two latitudes, the Israeli traveler took around one hour, while the Palestinian took five and a half hours. The West Bank territories are divided into three different zones: Zone A—under Palestinian Authority military and administrative control (includes most Palestinian cities); Zone B—under Israeli military control, but under Palestinian Authority administrative control (mostly includes Palestinian villages); Zone C-under Israeli military and administrative control (includes most Israeli colonies). This partition produced a leopard-skin-like territory, where the three zones alternate with one another without any apparent logic.

The different temporality of the two routes is due to the fact that the Israeli travelers, in order to move from one settlement to another—from a Zone C to another Zone C—can use the so-called bypass roads: that is, highways—often in tunnels or elevated—that link the colonies, bypassing Palestinian villages.

On the other hand, the Palestinian travelers who want to move from one city in Zone A to another in a different Zone A must pass through B or C zones, which are under Israeli military control, crossing a number of both permanent and temporary checkpoints—or trying to avoid them. Some of the checkpoints cannot be crossed by someone who has a "travel document" issued by the Palestinian Authority, unless the traveler has also been provided with a special permission issued by the Israeli government.

Multiplicity: Stefano Boeri, Maddalena Bregani, Maki Gherzi, Matteo Ghidoni, Sandy Hilal, Anniina Koivu, Alessandro Petti, Salvatore Porcaro, Francesca Recchia, and Eduardo Staszowsky.

Left: Multiplicity, *The Road Map*, 2003 (video stills). Installation of two-channel video projection and four-channel video on monitors with color and sound

Above and Left: Multiplicity, *The Road Map*, 2003
(video stills). Installation of two-channel video
projection and four-channel video on monitors
with color and sound

In all of my work, I deliberately blur lines between social science, contemporary art, investigative journalism, and even more obscure disciplines to construct unfamiliar yet meticulously researched ways to interpret the world around us.

The photographs in this exhibition depict a pair of "black sites" in Afghanistan. These are two of the secret prisons established by the Central Intelligence Agency during the early days of the "war on terror," which continue to operate. The black sites are used to house "ghost" prisoners, many of whom were kidnapped throughout the world in the CIA's "rendition" program. To find these sites, I worked with investigative journalist A.C. Thompson and researchers at Human Rights Watch correlating accounts from former CIA prisoners, flight records from agency-operated aircraft, and aerial-image archives to identify the sites, and confirmed their identity through field work in Afghanistan.

The silkscreen of "James Thomas Harbison" comes from the forged passport of a man on one of the CIA's rendition teams. The image's source is a photocopy of his passport on file at a hotel in Milan, Italy, where "Harbison" stayed while helping to orchestrate the kidnapping of Hassan Mustafa Osama Nasr (Abu Omar). Under CIA supervision, the Egyptian-born cleric was "rendered" to Egypt, where he was tortured for several years.

Left: Trevor Paglen, *"James Thomas Harbison" (CIA Officer Wanted in Connection with the Abduction of Abu Omar from Milan, Italy)*, 2007. Silkscreen on canvas, 60 x 50 in. (152.4 x 127 cm)

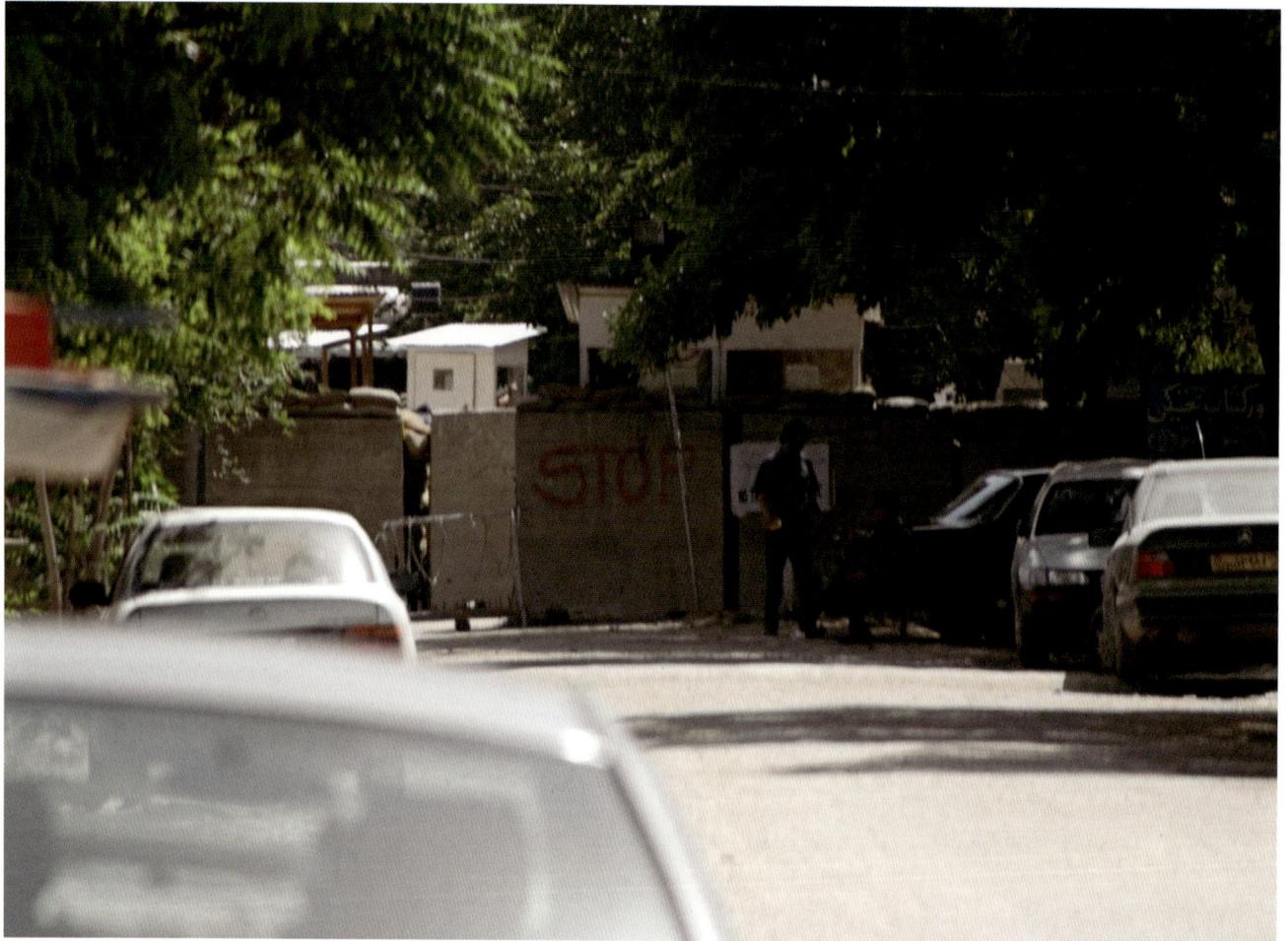

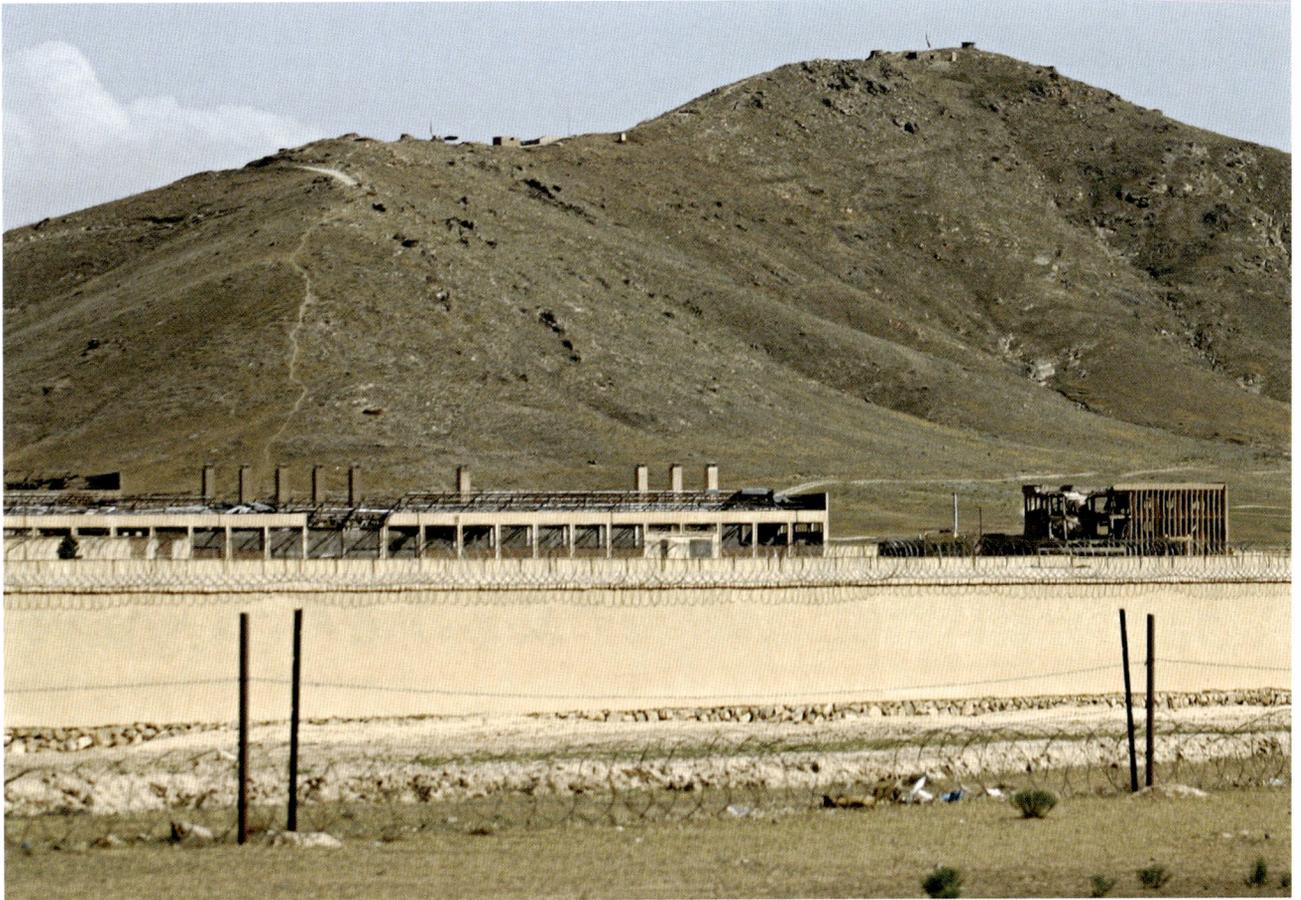

Left: Trevor Paglen, *Black Site (Kabul, Afghanistan)*,
2006. Chromogenic print, 24 x 34 in. (61 x 86.4 cm)

Above: Trevor Paglen, *The Salt Pit (Shomali Plains
northeast of Kabul, Afghanistan)*, 2006.
Chromogenic print, 24 x 36 inches (61 x 91.4 cm)

WE ARE THE CITY

NOTES ON PEDAGOGY & AESTHETIC FORM

DAMON RICH

These notes from the turn of the millennium record first steps towards using pedagogy as a frame for cultural work: not to produce or justify form-making, but to bring it to productive crisis.

I. Draft Lesson Plan

Day 1: Space detectives
Students photograph the neighborhood, and write what the images signify. Compare and contrast interpretations of stop signs, graffiti, public housing, the Trump Tower. What do these objects say? Who sends the signals?

Day 2: Life of a skyscraper
Slide lecture on land acquisition, development, financing, design, permits, and construction, including examples of community opposition, political corruption, and labor disputes. Visit the Department of Buildings.

Day 3: Design the city
Students build cardboard structures and write fictional accounts of their development, imagining the form of the city and the forces that shape it.

Day 4: Going to work
Students write fictional accounts of a day in the life of workers in their classmates' buildings.

II. Urban Pedagogy

The urban stands for an environment built by people for themselves. The suburbs are urban too, part of the expanding artificial terrain of human habitation. As urbanization spreads, urbanity loses its geographical specificity. At the same time, the dream endures of the urban as a potential object of design, shaped by collective action, coordinated and given form by architectural fantasy. This dream, even spread thinly, provides the starting point for cultural work in a pedagogical frame.

Pedagogy, the study of teaching, seeks to transmit agency, the ability to make things happen. Intimate with the material culture of everyday life, designers can publicly unpack the mechanisms by which the built environment comes to be seen as normal, in order to liberate the power of form for other ends. Studying how significance sticks to shapes, design and its public criticism amplify agency.

Society is not natural but produced in a complex context that we must study in order to change. Sometimes confused with the pedagogical, didacticism requires the active ignorance of this malleable and dynamic context,

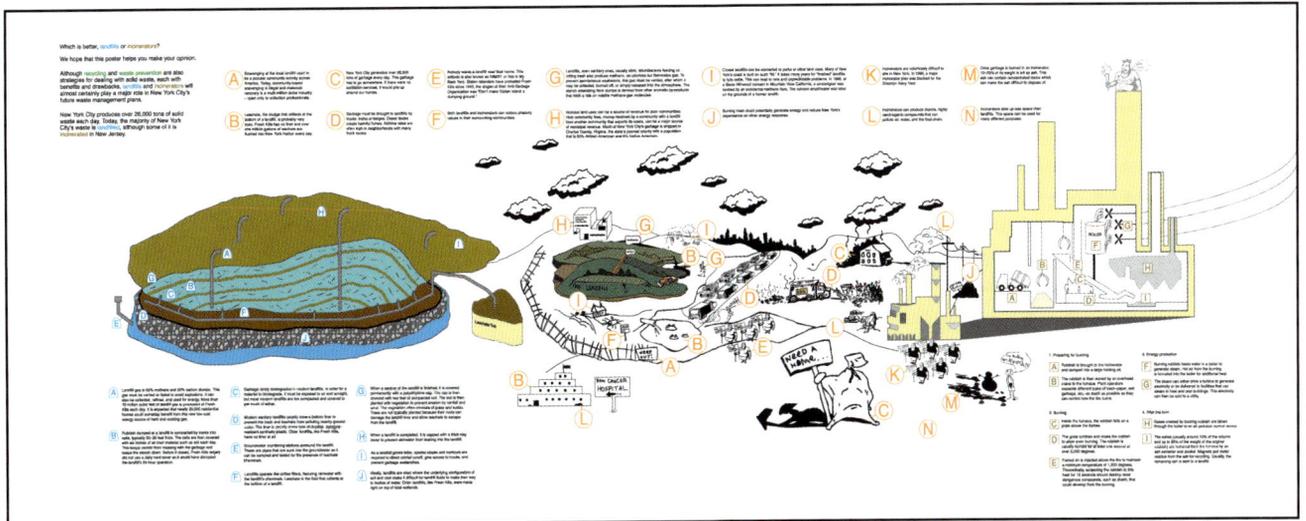

reducing the act of learning to the mastery of stable facts. Pedagogy, on the other hand, makes its way through partial utterances and contested meanings. Composers for semiotic orchestras, artists and designers working in a pedagogical frame write symphonies about the realities of social decision-making.

III. Learning from Reality Television

The development of cities, narrated by boosters or critics, pulls on grand narratives of history, identity, and destiny. Claiming, for a moment, the position of the public, students of urban pedagogy attempt to trace the events, organizations, people, documents, and places that become the story, facilitators, agents, agreements, and sites of this development. At each moment, we dumbly ask "How does something happen?"

To present the results of these investigations, we have developed a set of techniques under the banner of *montage realism*. Sifting the information collected during interviews, site visits, and library searches, we were confronted with a lack of synthesis, not only among documents from opposing stakeholders, but even in the self-presented narratives of individual documents. In fact, the overall frame of reference appeared to be in dispute. In order to preserve this provocative non-synthesis at the level of representation, we resist the abstraction of bullet points in favor of a formal practice that actively challenges assimilation, delivering an accelerated encounter with the discrepancies of reality: reality television without the story consultant. Instead of presenting information systematically linked to a cohesive structure, the structure itself is magnified to reveal the discordant information that composes it, the material specifics of abstraction: the coffee spill at the public hearing. The concretization of abstraction, pointing towards the permeability of the idealized control system, opens the door for thinking oneself as the agent.

Above: The Center for Urban Pedagogy (CUP), *Garbage Education Display System (Garbage City & Landfill vs. Incinerator),* 2002–08 (reverse view of two-sided work). Two vinyl banners, metal framing, approximately 84 x 120 x 60 in. (213.4 x 304.8 x 152.4 cm)

Welcome to Garbage City

New York City

Staten Island

Fresh Kills Landfill

GARBAGE PROBLEMS
A CUP INVESTIGATION INTO THE BUILT ENVIRONMENT

ANDREA MELLER, DAMON RICH, AND ROSTEN WOO

In 1999, New York City announced the imminent closure of its only landfill, Fresh Kills, the largest dump in the world. Shortly thereafter, the city made an international open call for designers, architects, and artists to design "solutions" to transform the Fresh Kills brownfield site into a park. As yet, there is no similar call to design a rational and equitable plan for disposing of the garbage that used to go to Fresh Kills. Today, in accordance with an "interim" plan, New York City's garbage is shipped by diesel trucks to other states. *Garbage Problems* was an interactive infrastructure education environment where users could come to learn about how and where New York City's garbage is handled, who pays how much for these practices, and who creates and implements these policies.

Garbage Problems was produced in collaboration with high school students from City-As-School. It presented the results of a semester's worth of site visits to bureaucratic offices, public hearings, waste transfer stations, and corporate office parks, archival research, and interviews with the garbage brokers and residents of Garbage City.

The Center for Urban Pedagogy (CUP)'s education model brings citizens to the far-flung scenes of decision-making processes: public hearings, community meetings, and government offices. CUP proposes to solve mundane infrastructure problems by working to expand the reach and comprehensibility of democratic outreach.

CUP is a nonprofit organization that engages artists, designers, and activists to help people understand and change where they live. The CUP website is anothercupdevelopment.org.

Left: The Center for Urban Pedagogy (CUP), *Garbage Education Display System (Garbage City & Landfill vs. Incinerator)*, 2002–08 (front view of two-sided work). Two vinyl banners, metal framing, approximately 84 x 120 x 60 in. (213.4 x 304.8 x 152.4 cm)

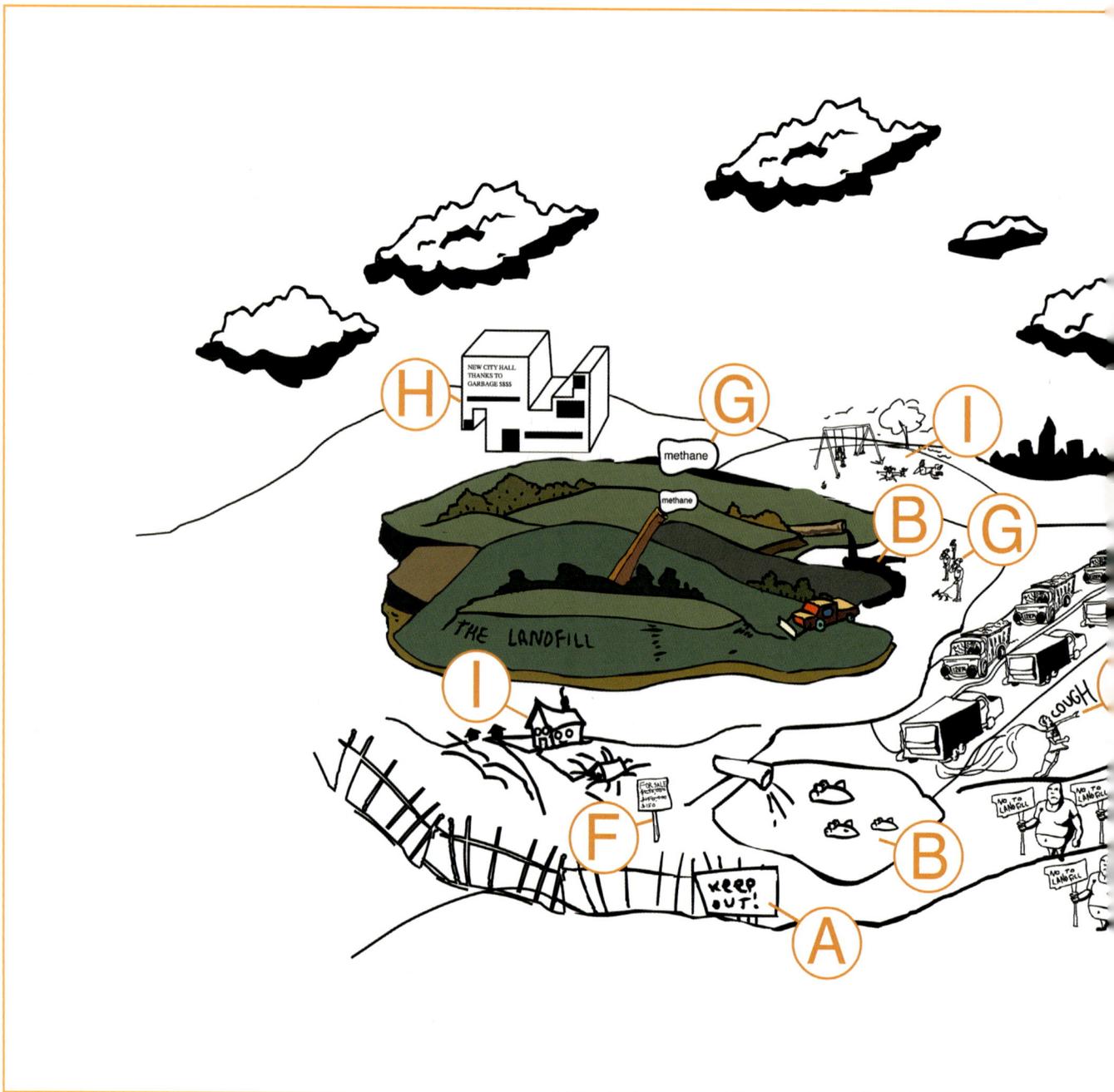

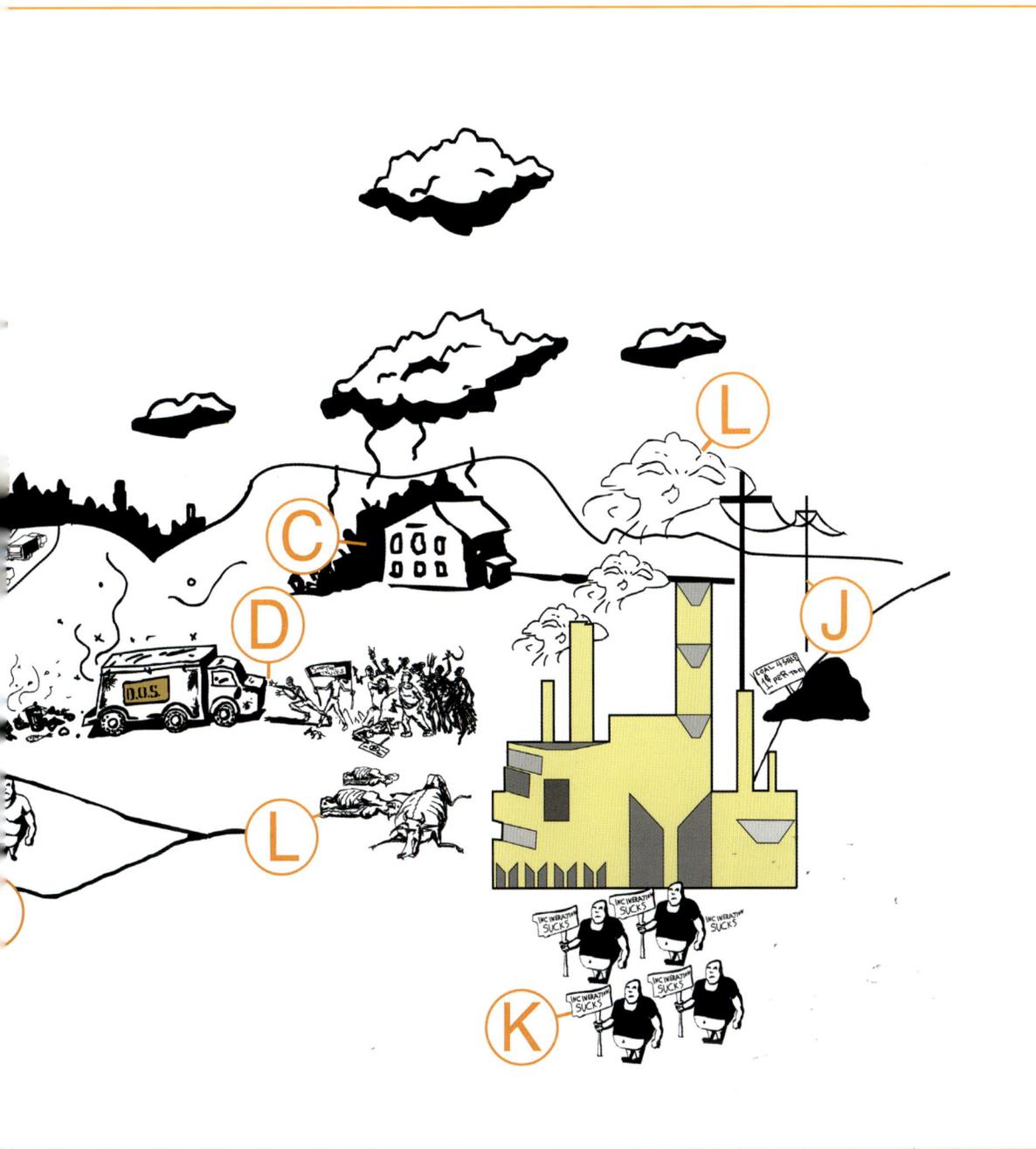

Above: The Center for Urban Pedagogy (CUP), *Garbage Education Display System (Garbage City & Landfill vs. Incinerator)*, 2002–08 (detail)

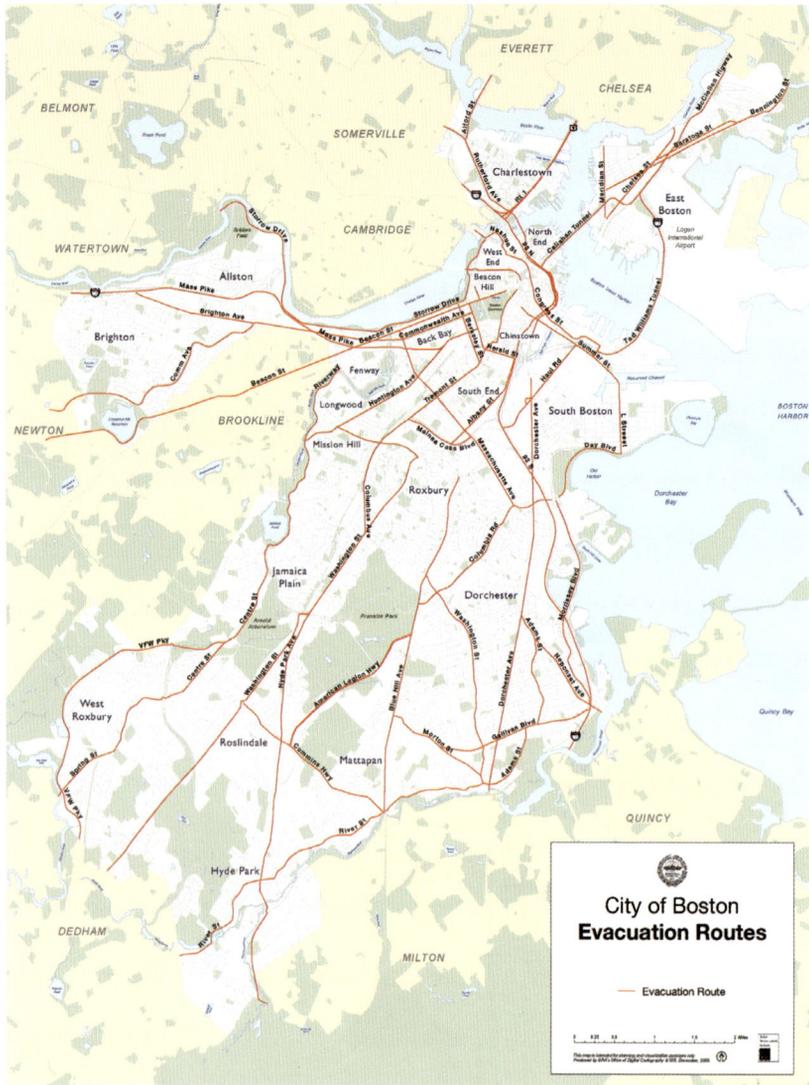

City of Boston
Evacuation Routes

— Evacuation Route

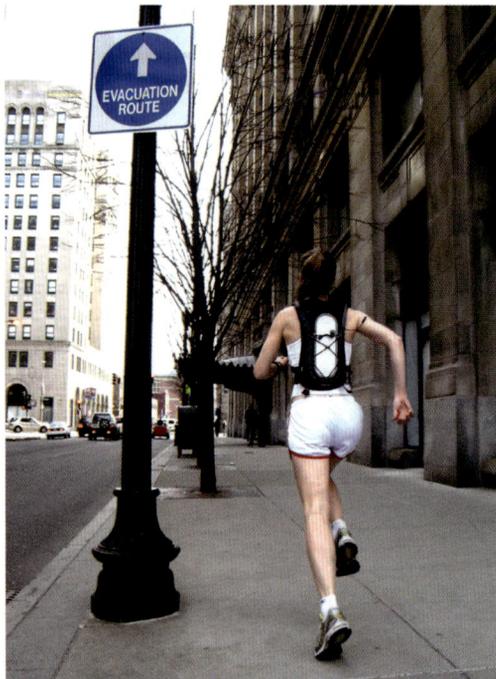

How do you measure fear in a society obsessed with security and preparedness?

The $827,500 Boston emergency evacuation system was installed in 2006 to demonstrate the city's preparedness for evacuating people in snowstorms, hurricanes, infrastructure failures, fires and/or terrorist attacks. It is part of a host of visible changes to public spaces in Boston that also includes random bag searches, fancy transportation surveillance centers, terror simulations, and public-awareness campaigns. These are visible, everyday reminders that we are vulnerable—at risk and at war.

In Spring 2007, Catherine D'Ignazio (kanarinka) ran the entire evacuation route system in Boston and measured its distance in breaths. The project is an attempt to measure our post-9/11 collective fear in the individual breaths that it takes to traverse these new geographies of insecurity.

Running the evacuation routes took 26 runs, about 100 miles, and over two months to complete. On the website, evacuateboston.com, we see the data, and results of this measurement of fear. Our fear is measured in the breaths of a single person—running, training, measuring, tracking, breathing, leaving.

For *Experimental Geography*, the archive of breaths is presented as a series of twenty-six glass jars that correspond to the number of runs completed by D'Ignazio. Organized chronologically, the jars vary in size and volume based on the number of breaths collected on each run. Each jar "breathes" through small speaker components playing the soundtrack from the run.

Left top: Map showing evacuation routes used by kanarinka (Catherine D'Ignazio) in *It Takes 154,000 Breaths to Evacuate Boston*, 2007

Left bottom: Artist running evacuation route for *It Takes 154,000 Breaths to Evacuate Boston*, 2007

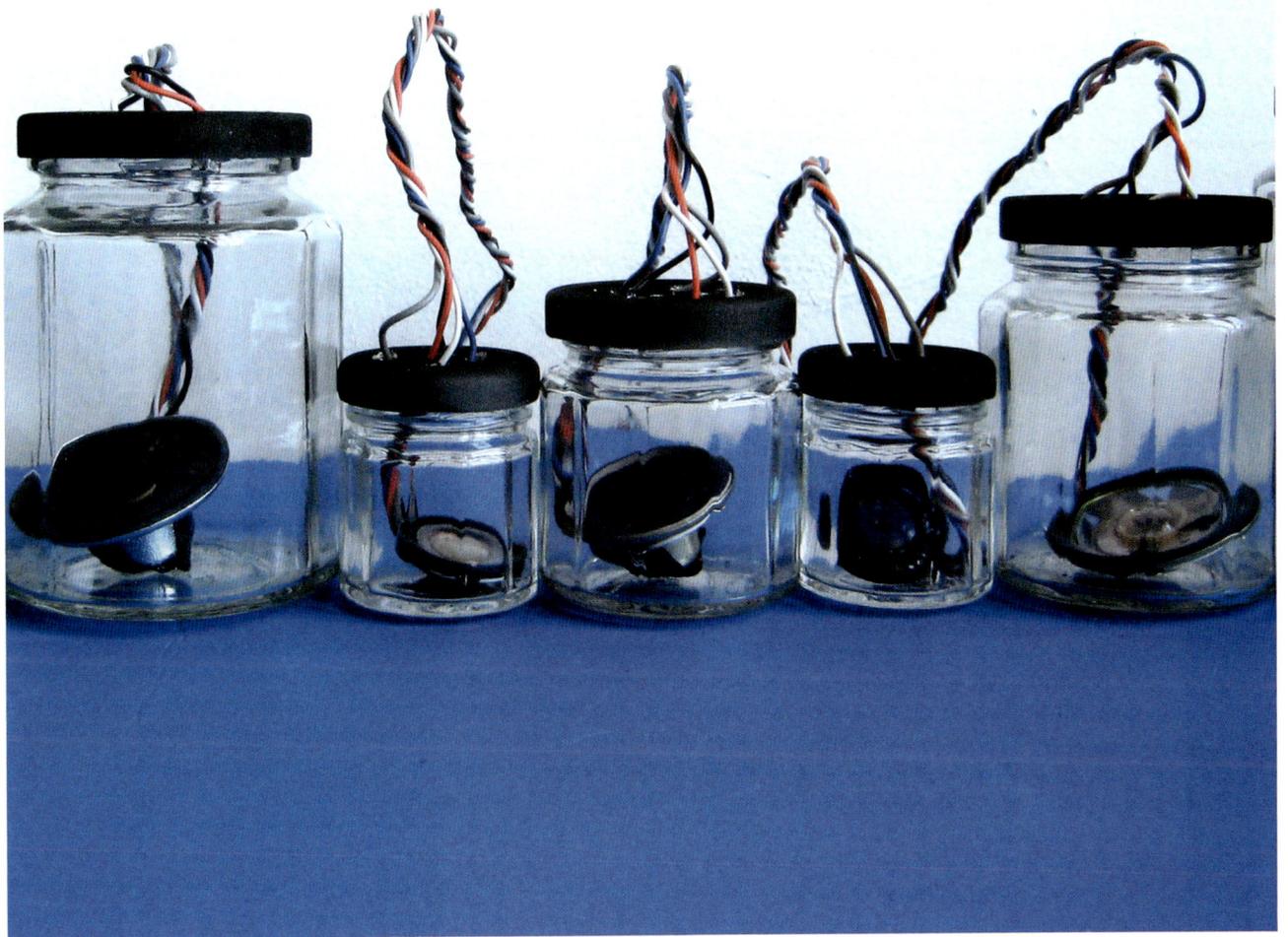

Left: Artist wearing gear used to produce *It Takes 154,000 Breaths to Evacuate Boston*, 2007

Above: kanarinka (Catherine D'Ignazio), *It Takes 154,000 Breaths to Evacuate Boston*, 2007 (detail)

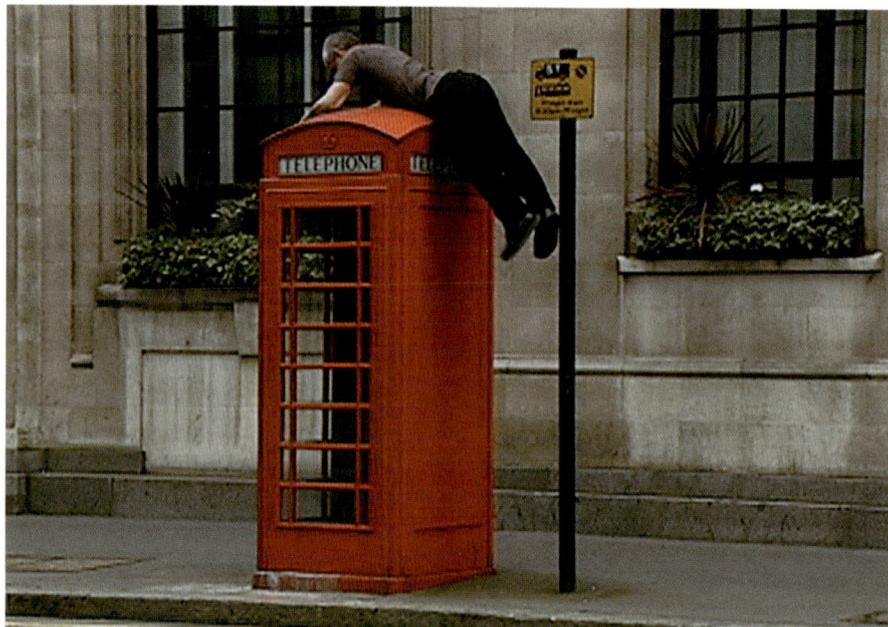

Geography imposes arbitrary lines upon territories that are essentially continuous. Everyday life then fixes these lines in place by reiterating the performances on which the permanence of this delimitation depends. The task of the self-appointed experimental geographer consists of exposing the absurd rules that organize living spaces while at the same time proposing deviating paths as a contribution toward a rearrangement. In the piece *Upward Mobility*, this is accomplished by shifting the vectors of the situation. In contrast to the invisible horizontal line drawn by everyday movements in the city, this video shows a person in search of vertical deviations from this norm. Several situations depict attempts to move upwardly in spaces like a bus stop, a telephone booth, a building marquee, and cracks on a wall that lead to a window. The character of the actions varies from that of a playful childish game to a teenage prank to a burglar break-in to a protester stunt; that is, activities that have in common the pursuit of unusual routes of action.

Left: Alex Villar, *Upward Mobility*, 2002 (video still).
Single-channel video with color, 7:43 mins.

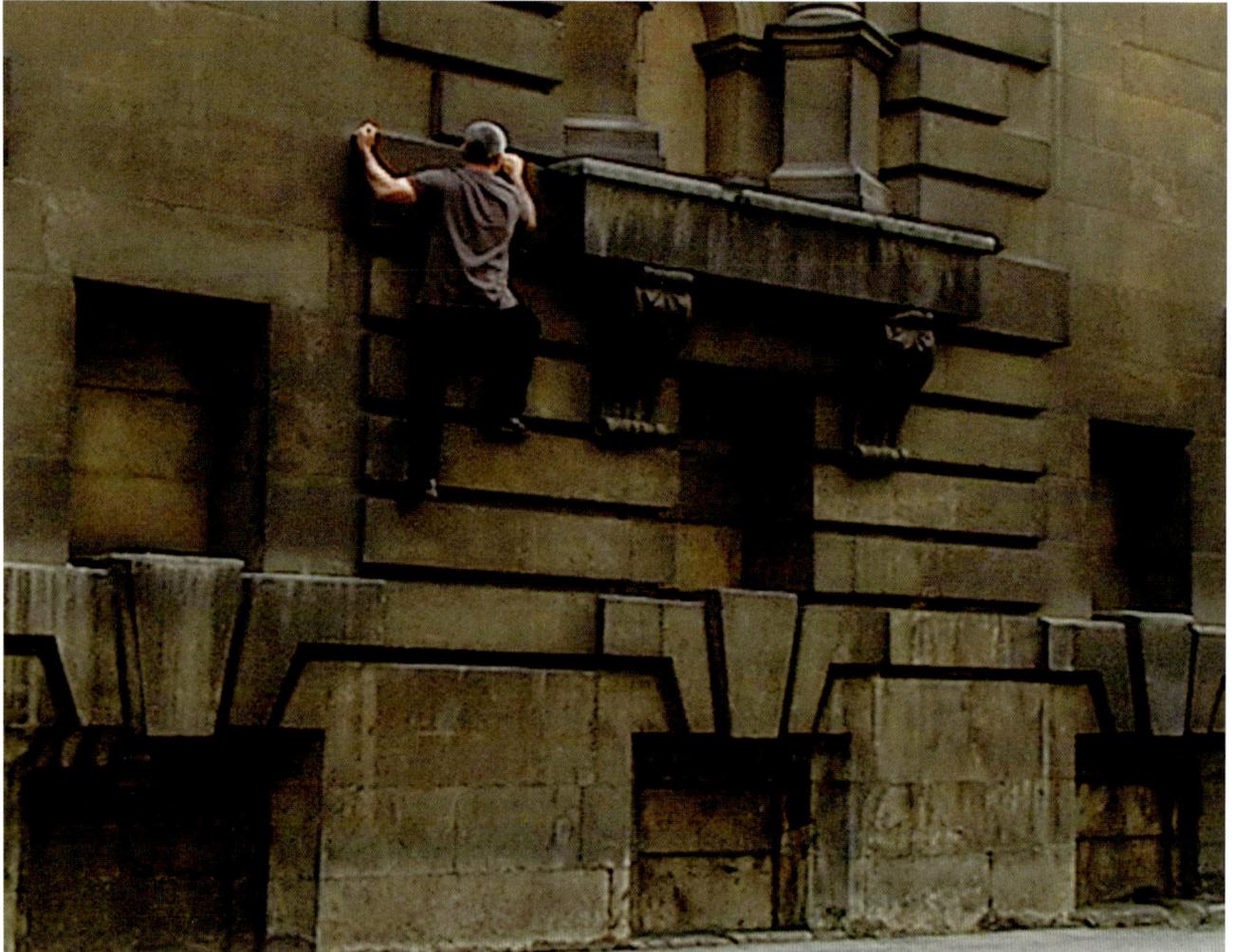

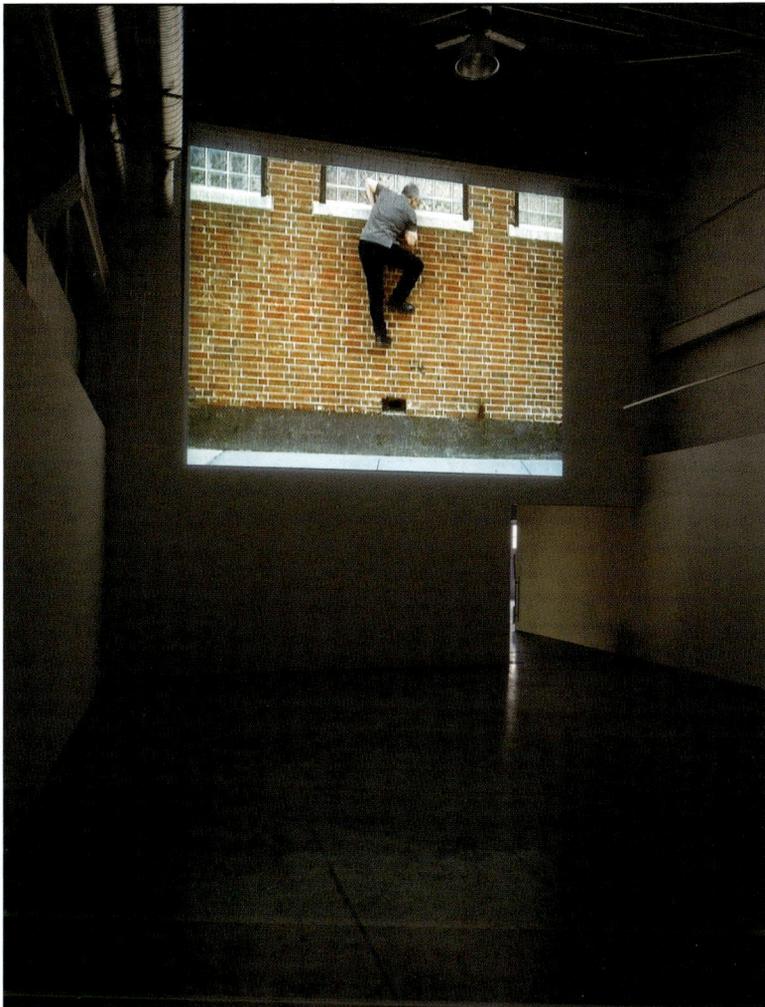

Left and Above: Alex Villar, *Upward Mobility*, 2002
(video still and installation view). Single-channel video
with color, 7:43 mins.

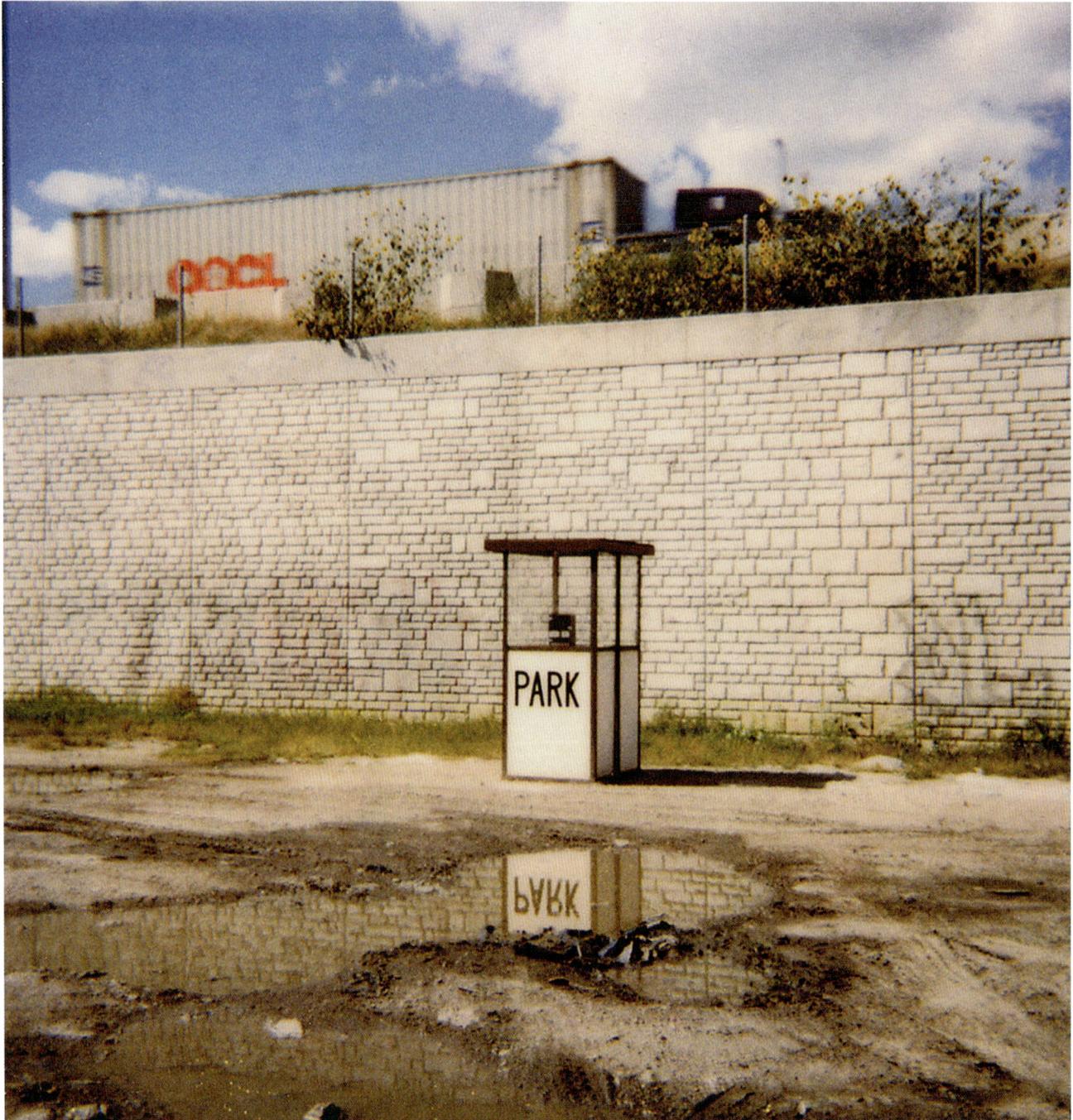

CAN ARCHITECTURE BE FRAUDULENT?

The portable parking booth created for *Park* migrated to numerous sites around Chicago over a period of several months. By "parking" at these sites, the booth implicated and usurped the land it occupied. Its presence implied that you could park. It implied that you should pay. It implied surveillance, that your car was being monitored, that it would be safe. It implied ownership.

Even the smallest buildings implicate and inform the land they occupy via the mutely pervasive policing of space. *Park* suggests that these innocuous, ubiquitous structures surreptitiously and effectively invoke social mores of authority, perhaps more effectively than larger, permanent buildings do.

Park points to landscape as retail value, where profit is driven by proximity. Downtown parking is a billion-dollars-a-year interim industry, built on what is most often a temporary use of land. Owners are speculators. They wait for the land to ripen, and in the meantime use it for parking until the property can be bought by a developer and transformed into something with a "higher and better use."

The *Park* booth is a migratory structure in the service of transportation. It seems appropriate that booths, as architecture, are not unlike cars, as architecture. Both juxtapose the enclosed sense of a private, personalized structure with the contrary fact of being surrounded by windows, leaving their tenant on permanent display. The role of "parking attendant" forces conflicting, simultaneous states of vulnerability and power. The attendant is both surveyor and surveyed.

Park began as a photographic survey of parking-attendant booths around the city of Chicago, then evolved to include a full-size migrating booth, and has sometimes also included a freely dispensed informational booklet.

Left: Deborah Stratman, image from *Park*, 2000.
Polaroid print, 3 1/2 x 4 1/4 in. (8.89 x 10.79 cm.)
each

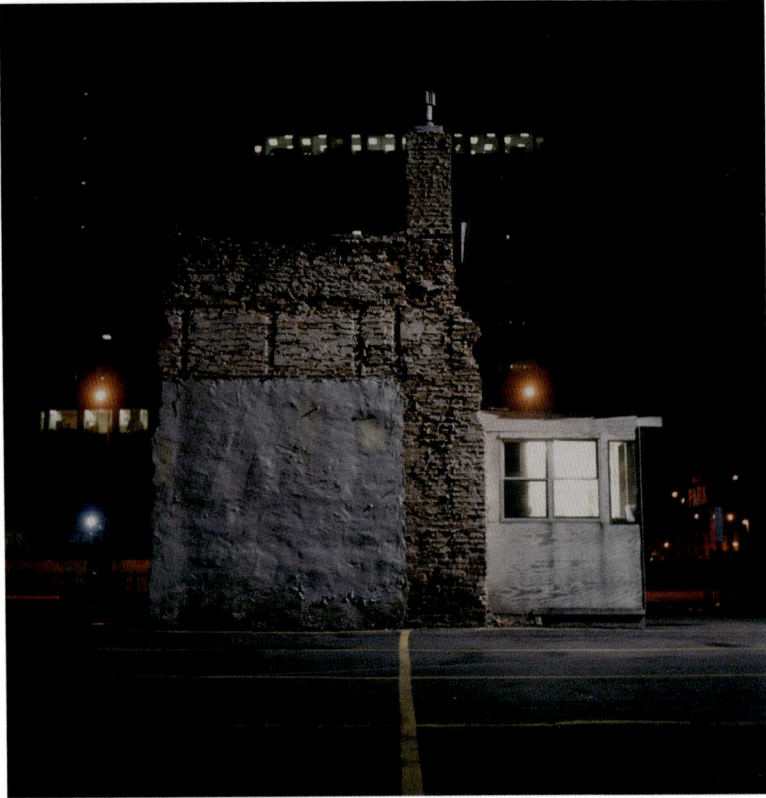

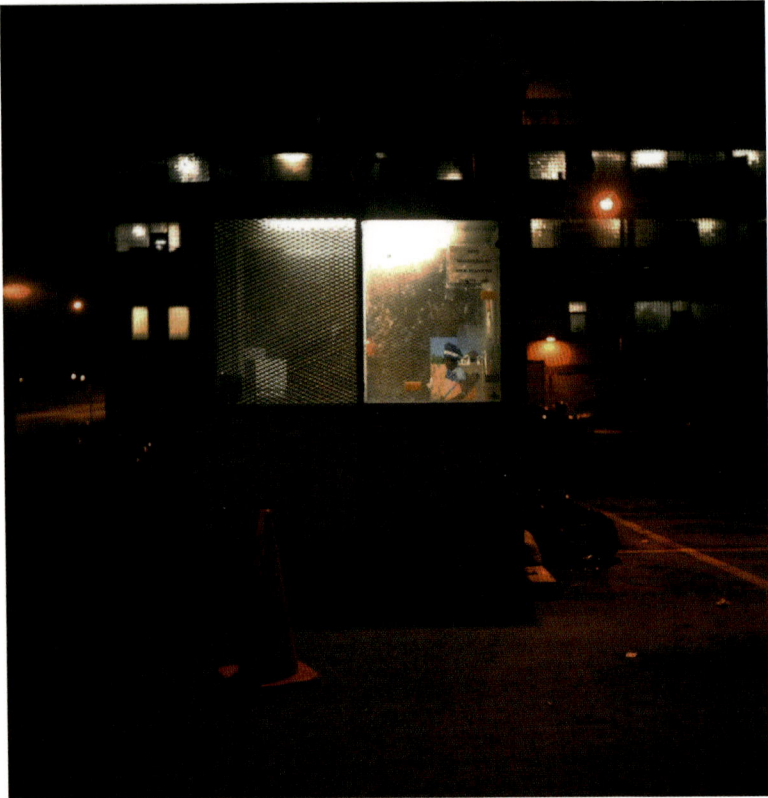

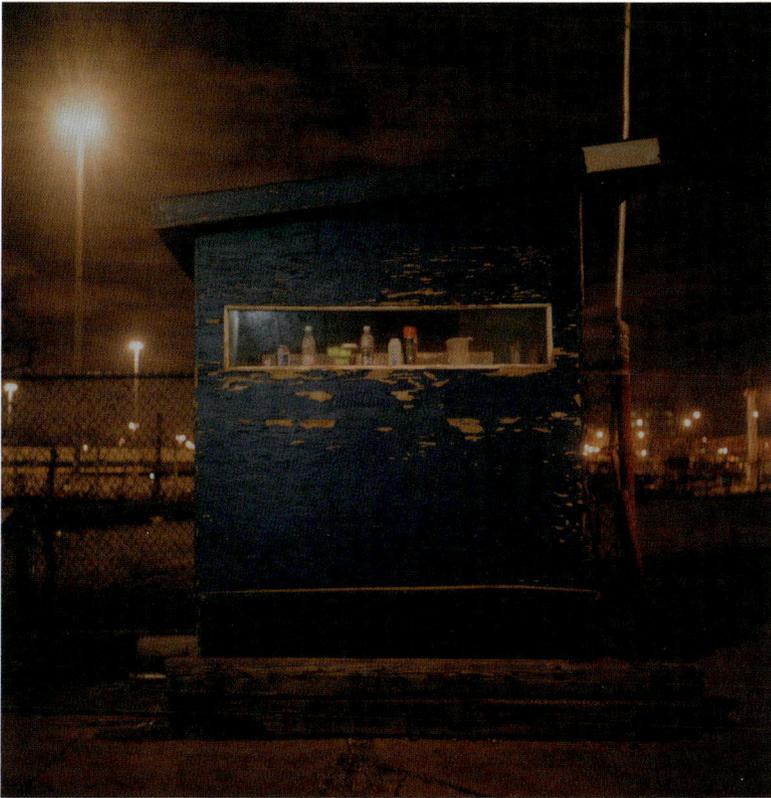
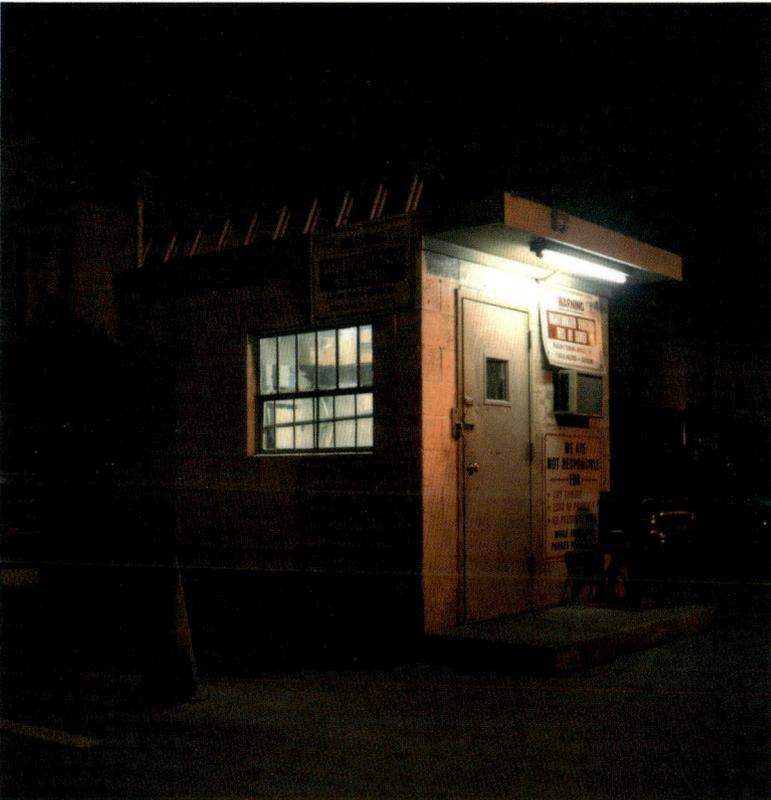

Left and Above: Deborah Stratman, images from *Park*, 2000. Chromogenic prints, 16 x 16 in. (40.6 x 40.6 cm) each

ERIN MCGONIGLE FOR E-XPLO

e-Xplo, founded in 1999 in New York by Erin McGonigle, Heimo Lattner, and Rene Gabri, develops performance-based projects in which viewers are visually "guided" through the urban, rural, local, forgotten, "hidden," and in-between spaces of the "everyday" while conceptually mapping the social and political geography of the place. Many of these public art projects are in the form of audio bus tours. Passengers board a bus and are moved through the city as they listen to a soundtrack that may contain snippets of interviews with residents, poetry, ambient noise, and other audio information that embeds a city within its fog of history and folklore, forgotten and remembered, trashed or reclaimed. The bus tours offer an alternative/opposition to the operating modes of standard sight-seeing tours, as they are not so much about sites as about the unseen.

Besides updating the Situationist *dérive* for a drive-by culture, e-Xplo also creates maps, sound, films, photographs, walks, a GPS-based audio program, and writings as reflections of their multifaceted investigation into location, context, social identity, landscape, and territories of information. In their works, which engage audiences in the process of viewing, considerations of space are at the heart of the question concerning vision and subjectivity—or, put another way, at the heart of the question concerning social politics in the sense that space can be both a reflection of a political domain and a site for which to interpret political ambitions.

e-Xplo: Rene Gabri, Heimo Lattner, and Erin McGonigle

Left: e-Xplo, *rIso Aroma, Turin*, 2001 (production still)

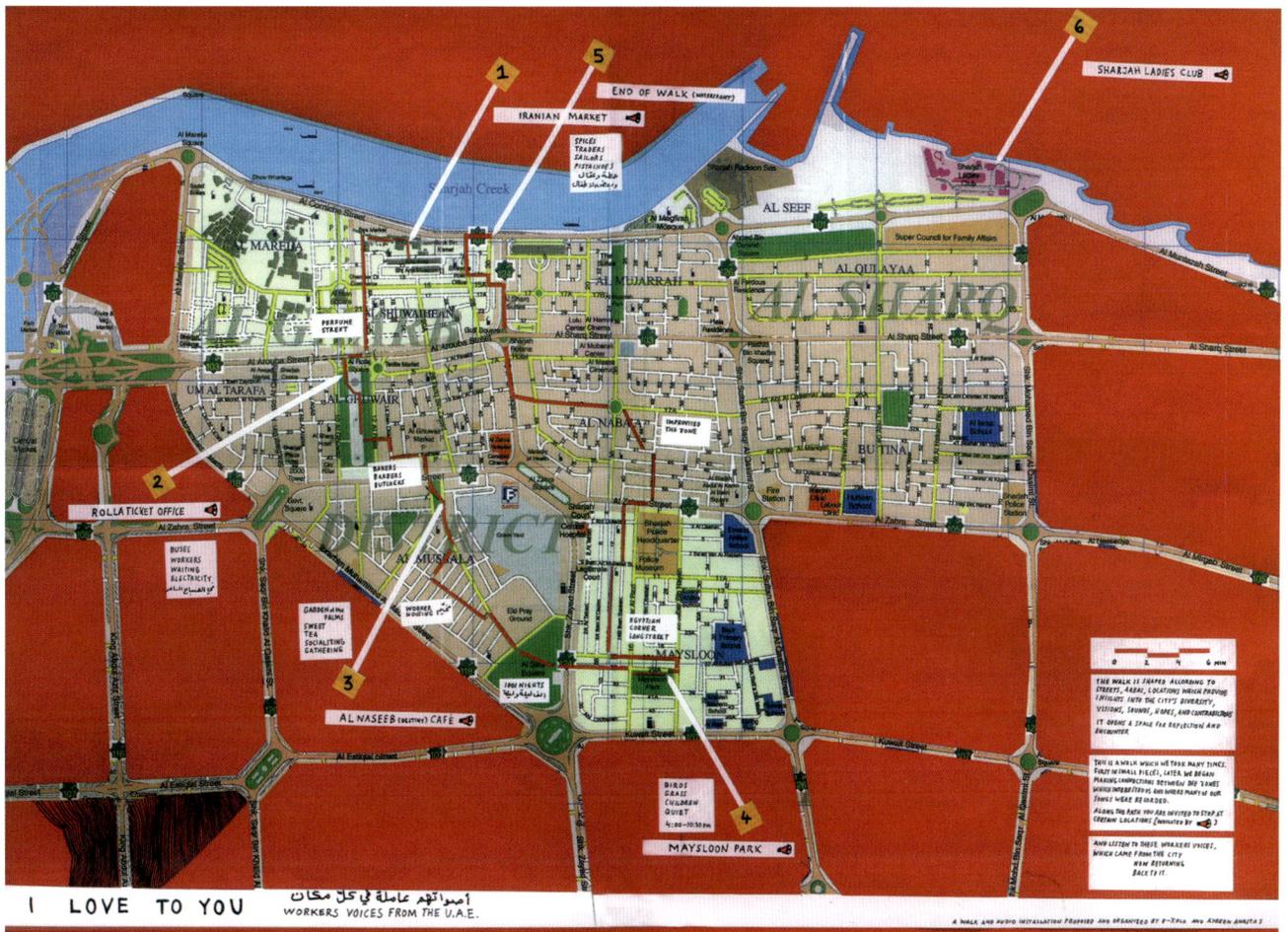

Left: e-Xplo, *Found Wanting, London*, 2003
(production still).

Above: e-Xplo, *I Love To You. Worker's Voices from the
U.A.E.*, 2007. Map

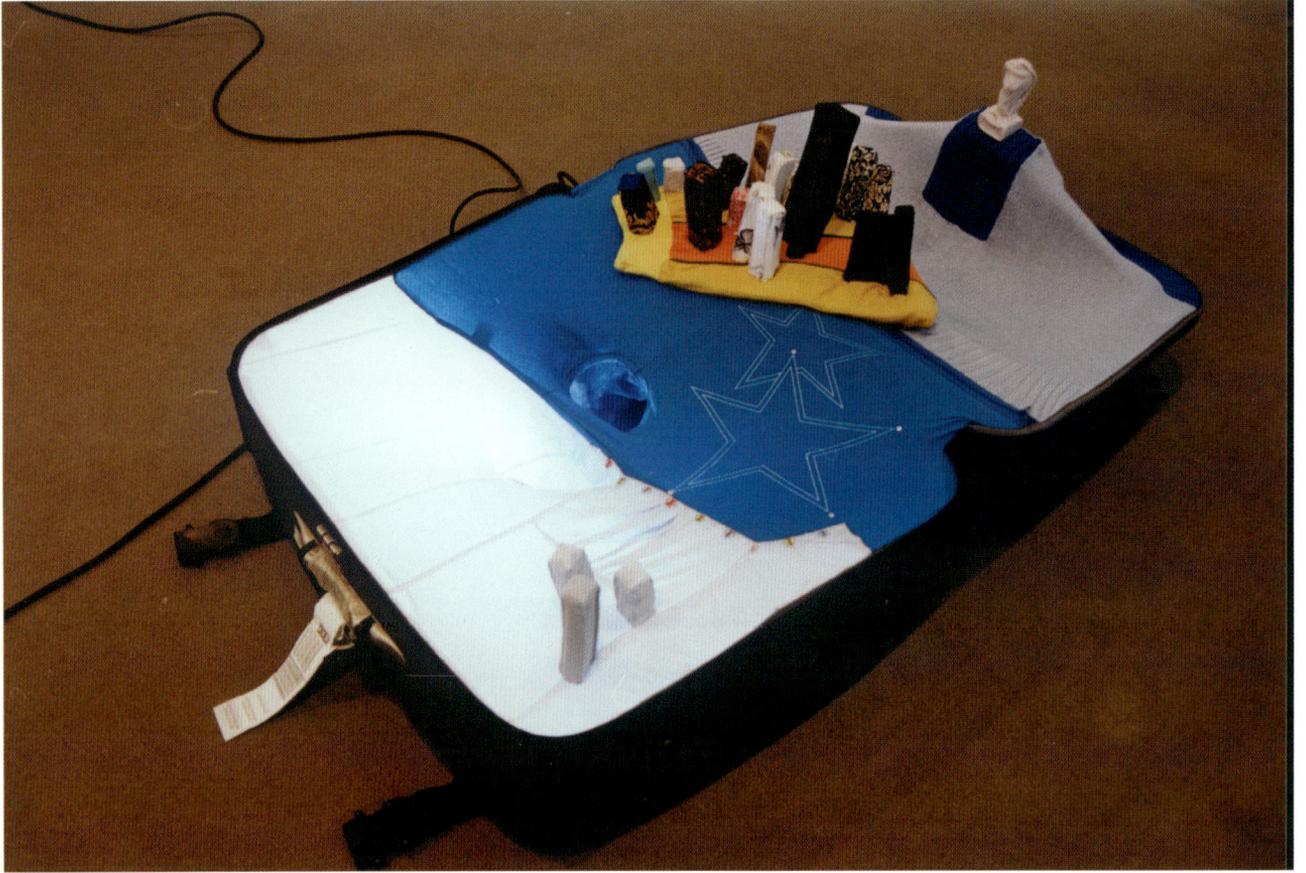

PORTABLE CITY: SINGAPORE

I went to Singapore twice in 2000. At the time I felt dizzy and vomited, but I thought it was due to the fatigue. Only when I came back to China did I know that I was pregnant.

My image of Singapore is that it is always humid, clean, and small, and it also suggests "order" and "man-made." The most typical example of the man-made is the Merlion, a fabricated animal with the body of a fish and the head of a lion. On the island of Sentosa is a thirty-seven-meters-tall sculpture of the Merlion. In my memory, Singapore is abstract—like a tiny, man-made, and orderly ship-island in the middle of the boundless sea. The only concrete thing is this man-made Merlion.

The uniqueness of Singapore is that it is a city and a country at the same time. When I used the clothes worn by Singapore locals and made them into this *Portable City: Singapore*, it also becomes a portable country.

Left: Yin Xiuzhen, *Portable Cities: Singapore*, 2003.
Audio CD recording and suitcase containing fabric,
clothing, paper map, magnifying lens, and light, 32
1/8 x 59 x 35 1/2 in. (81.6 x 149.9 x 90.2 cm) open

CARTOGRAPHY

Aging
ships from all
over the world are —
brought to coastal areas of
South and East Asia to be
dismantled, recycled, and
disposed of. This in
dustry has sprung
up here because labor and
safety regulations
are relatively unenforced. At
many of these beaches or
shipyards, workers break up
massive ships using hand tools and
their own strength, and without
protec tive gear. Ships can
contain diesel
fuel, asbestos,
and heavy
metals which
are hazardous to work
ers and the marine
environment. Materials
from the ships
also reenter
the local economy-
in Bangladesh,
most domestic steel is
recycled
from
the ship
breaking
industry.

GADANI
SHIPBREAKING
YARD

ALANG
SHIPBREAKING
YARD

MUMBAI
SHIPBREAKING
YARD

Above: Lize Mogel, *Mappa Mundi*, 2008 (detail).
Digital print, 52 x 48 in. (132.1 x 121.9 cm)

ON CARTOGRAPHY

LIZE MOGEL

This is the moment of the map. The enormous amount of recent cultural production involving maps and mapping is reaching a critical mass. This mapping impulse results from a convergence of a number of shifts in the way we think about representation and space. This trajectory has art historical roots in movements ranging from Surrealism to Land art to institutional critique to interventionist practices. The way we visualize spatial and personal relationships has also radically changed—the absolute centrality of the internet to metropolitan citizens, saturation of electronic communication, and increased mobility have taught us to understand information as embodied in map/networked form, rather than through linear narratives.

The map has always been a political agent—so projects that are politically engaged (within and beyond the confines of institutions) use the medium well. My own interest in maps and cultural mapping practices is focused on work with a critical and activist intent. These practices are often cross-disciplinary and collaborative—moving between art/design/media/architecture, geography and cartography, organizing and activism, education, journalism, and so on.

Much of this mapping work is responsive to a political moment. Therefore it is temporal, anti-monumental, and easily reproducible. These practices have an uneasy relationship to the art world, as their value lies in their usefulness and social function over anything else. At the same time, they push aesthetic and conceptual boundaries of academic or scientific cartography. kanarinka writes that "the practices that are emerging might be unrecognizable to professionals in either field"[1] and suggests a yet-to-be-named space in which they could be located.

This space is partly delineated by the terms counter-cartography, critical cartography, and radical cartography.[2] In general, these refer to maps made, used, and understood as a form of resistance. Such maps are ideal tools for activist cultural practices because of the very qualities that make them tools of power. As John Krygier and Jeremy Crampton write, "If the map is a specific set of power-knowledge claims, then not only the state but others could make competing and equally powerful claims."[3] All maps, whether institutional or counter-cartographic, embody and produce power relations. They describe relationships between people and place. They communicate through design. Counter-cartographies do not try to remake the map but instead appropriate it in order to analyze, understand, and create a balance of power.

Notes

1. kanarinka, "Art Machines, Body-Ovens, and Map-Recipes: Entries for a Psychogeographic Dictionary," *Cartographic Perspectives*, no. 53 (Winter 2006).

2. For a discussion of "critical cartography," see Jeremy W. Crampton and John Krygier, "An Introduction to Critical Cartography," *ACME: An International E-Journal for Critical Geographies*, vol. 4, no. 1, 2006. "Radical cartography" is defined in Lize Mogel and Alexis Bhagat, eds., *An Atlas of Radical Cartography,* Los Angeles: Journal of Aesthetics & Protest Press, 2007.

3. Ibid.

Mappa mundi is part of an ongoing project that explores two kinds of popular representations of the world—the iconic world map and the international spectacle of World's Fairs. As technology and commerce blur more and more geographic boundaries, the ubiquitous world map becomes inadequate to describe the intricacies of globalization. *Mappa mundi* is an attempt to remake the world map, relying on associative geographies rather than physical ones.

These experiments within the confines of the specific form of the world map reconfigure it to create new geographies that represent contemporary global situations. Familiar borders are denied, and new connections between places are brought to the surface. This map mash-up is more conducive to narratives of globalization, but more difficult, disorienting.

Mappa mundi draws relationships between the 1915 San Francisco World's Fair; the Panama Canal; the Northwest Passage in Canada; a mothballed naval fleet in the Suisun bay near San Francisco; shipbreaking sites in Pakistan, India, Bangladesh, and China; and the North Pole. These are linked by common narratives of shipping, sovereignty, commerce, and exploitation (of resources and people). The map plays with scale—cities are rendered as large as nations; an archipelago of decommissioned ships links one place to another, one part of the story to another.

Mappa mundi refers to medieval world maps that sometimes conflated real and imaginary geography, made at a time when the complete picture of the physical world was still being formed.

Left: Lize Mogel, *Mappa Mundi*, 2008. Digital print, 52 x 48 in. (132.1 x 121.9 cm)

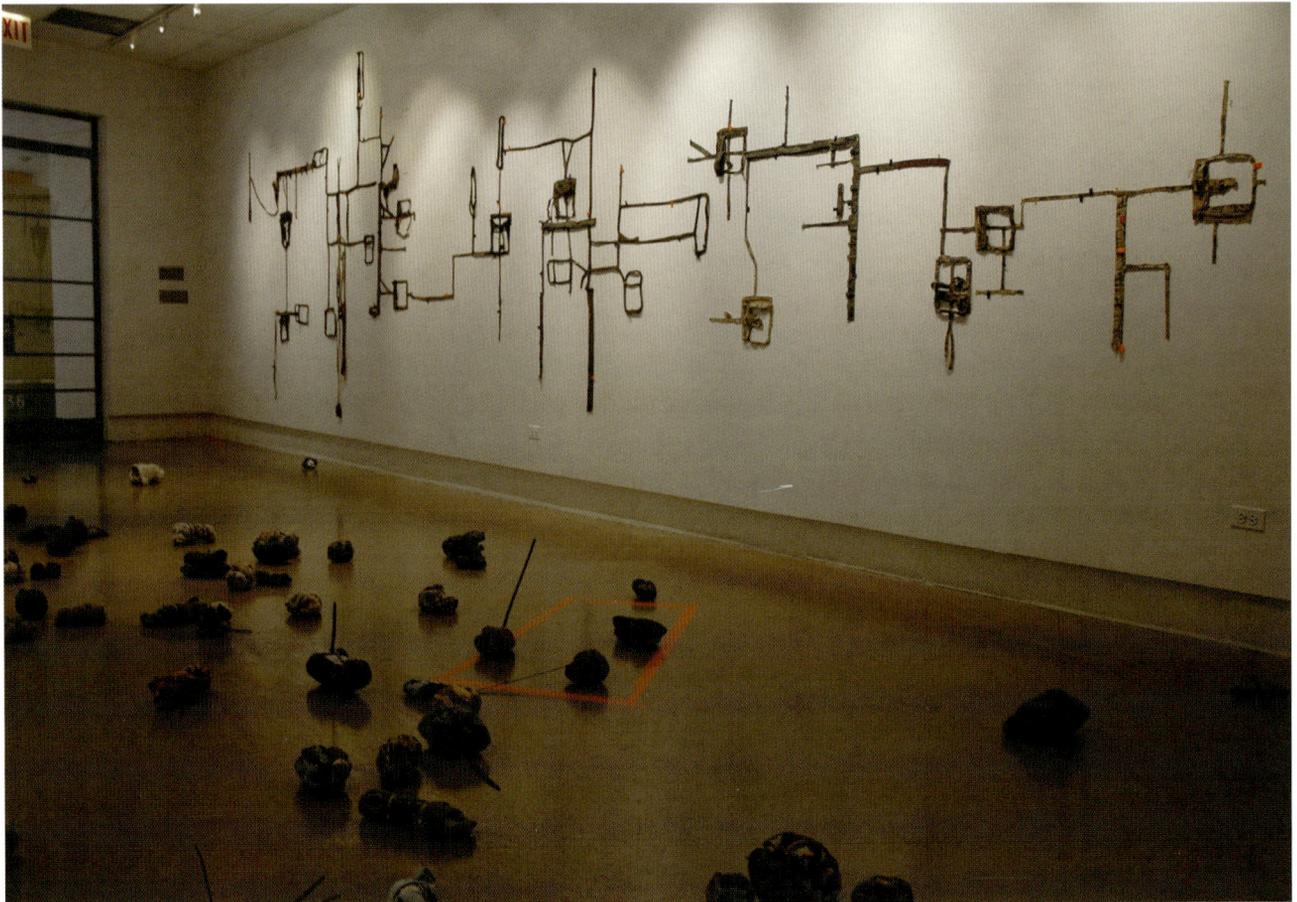

DE-STABILIZED LEXICON

stealth: From the eye of a smart bomb to fragments left on the pavement, *stealth* calibrates distance and scale, attempts to both measure and disrupt the interval between contested global geographies and our images of these landscapes.

research: In 2004 I visited the Natick Soldier Systems Center, a Department of Defense installation responsible for technology development and engineering—fielding and sustainment of military food, clothing, shelters, airdrop systems, and soldier support. After a background check, an on-site search of my car, and a final review of documents, I was granted permission to enter the base to visit the Individual Protection Directorate. A member of the Materials and Systems Integration Team, a U.S. Army group that develops and tests camouflage, met with me.

Down the hall from a poster for *Future Force Warriors*, I tried on night-vision goggles, body armor, and camouflage makeup. We viewed various climatic dioramas (arctic, desert, and woodland) used to test camouflage effectiveness, and we examined the extensive collection of military uniforms from international armies. Samples of new camouflage patterns, some digitized and others looking like '50s tablecloths, were on display. After several hours, a military team member asked if I would mind answering a question: Could I tell him about two artists, Mondrian and Seurat, and what they have to do with camouflage? Weeks later we exchanged packages, trading art books for samples of "failed" camouflage patterns.

map: An interlocking network, an aerial view, cut from used, recycled clothing available everywhere. Pink camouflage parkas with fur trim, stretchy lime-green camouflage exercise pants, miniature fleece camouflage pajamas, and pants in graduated sizes with flag patches on each pocket, junior uniforms for *Future Force Warriors* cut down to their seams.

bundles: Improvised Ecological Debris, IEDs, an ecology of production, fabricated from the recycled remains of the maps, bound in zip ties and wire, ready-to-use.

Left: Ellen Rothenberg, *De-Stabilized Geography: Map 3*, 2007–08. Camouflage fabric, metal and plastic map tacks, metal and plastic map flags, zip ties, wire, approximately 120 x 336 in. (304.8 x 853.4 cm)

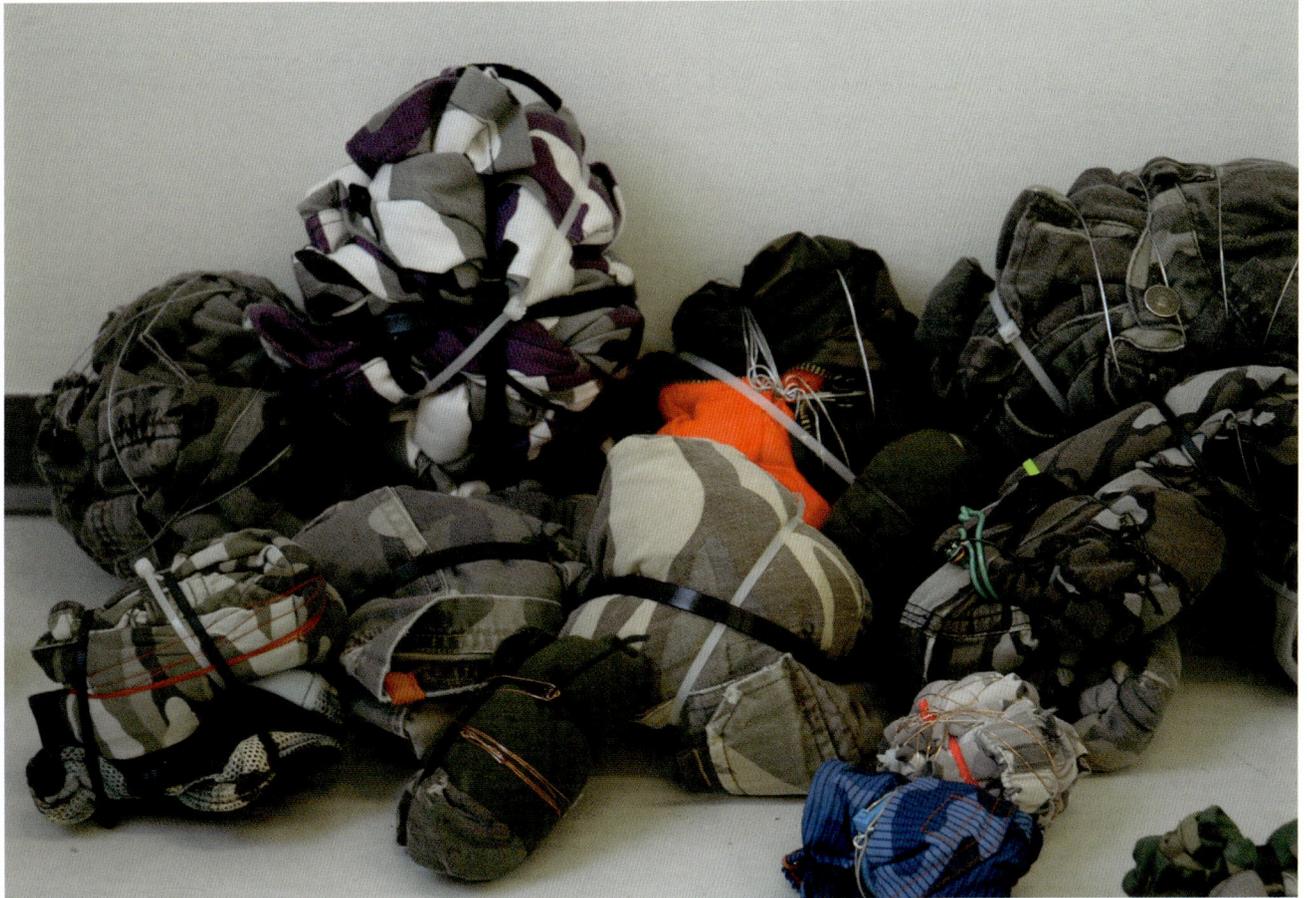

Left and above: Ellen Rothenberg, *De-Stabilized
Geography: Map 3*, 2007–08 (details). Camouflage
fabric, metal and plastic map tacks, metal and plastic
map flags, zip ties, wire, approximately 120 x 336 in.
(304.8 x 853.4 cm)

Notes for
a People's Atlas
of Chicago

A call for collaboration to fill in the many gaps and locate sites of relevance

Calling all mapmakers, historians, informal researchers and citizens with good memory! Help to complete this map.

Chicago is a place where people move through and people settle. Anyone working, living and playing here—especially those involved in political and social struggles owe a debt of solidarity to other places far-and-wide for inspiration they have provided for the people they have brought to the city in the past. We as residents of Chicago have inherited a deep tradition of activism and political struggles from this city/regions past, and there is an ethics to continuing those struggles rather than viewing ourselves as autonomous agents. What if there was a map of the city of Chicago that told the stories of locally based nodes of international solidarity and social movement work through time?

Over the next few years AREA will be working with researchers and local historians (like you?) to create maps based on Chicagoans connections to international struggles and local histories of social movements. You may want to map only information from a very specific time period, group, country-of-origin, neighborhood, or approach. Help to write the histories that inspire you. Help others not forget.

Download your own blank map at http://www.areachicago.com

1929
The Bud Billiken Day Parade
31st/Michigan to Washington Park
Founded by the Chicago Daily Defender in 1929, was part of an effort by African Americans to claim the right to use Washington park.

1929-35
Chicago John Reed Club
1475 S. Michigan Ave.
Left-wing literary/arts organization that published Left Front Magazine.

1930
Un-Eviction Movement
121 N. LaSalle St., City Hall
After two protesters are killed by police, a crowd of tens of thousands carry their bodies to Mayor Cermack's office and he temporarily suspends the use of evictions.

'30s-'40s
Chicago's Negro People's Front
Bronzeville
Community, Cultural and Communist organizing in this period was a continuation of the ideas/traditions of the 1920s Harlem Renaissance.

1936.02.14-16
The National Negro Congress (NNC)
3555 S. Giles Ave.
Over 800 delegates, 43% of them from Chicago, representing 500 organizations, filled the Eighth Regiment Armory for the inauguration.

1936-1938
Artists Union of Chicago
1475 S. Michigan Ave.
Out of the John Reed Club, forms this WPA organization.

1939
Back of the Yards Neighborhood Council
Packingtown/Back of the Yards
Saul Alinsky and Joe Meegan covered the southwest-side Packingtown area, canvassing the church community to attend the inaugural meeting.

1941
South Side Community Art Center
3831 South Michigan Avenue

1951-
College of Complexes
901 N. Clark St., now 4008 N. Lincoln Avenue
Myron "Slim" Brundage's College of Complexes (billed as "The Playground For People Who Think")
http://www.collegeofcomplexes.org

1961-
Black Stone Rangers
Woodlawn Neighborhood
In its early existence the street gang grew to be a major social service provider and began to form an alliance with the Black Panther Party.

1962
SCLC Operation Breadbasket Founded
55th St./LaSalle St.
A free breakfast program at St. Anna Church.
Organized by Rev. Willie Barrow and Rev. Jesse Jackson, later evolves into Rainbow-PUSH.

1964-1968
SDS JOIN Community Union Office
Winthrop/Argyle
Students for a Democratic Society (SDS) founds Jobs Or Income Now (JOIN) Community Union" to organize within poor white communities like Uptown.

1965
AACM Founded
63rd Street Beachhouse
The Association for the Advancement of Creative Musicians formed community around avante-garde jazz and opened a school for musicians.

1966.07
Cicero March
Ogden ave/Cicero
290 marchers—In response to Jerome Huey, a black teenager pile hunting in Cicero, had been beaten by white youth.

1966.01.22
MLK Jr. moves to Chicago
1550 S. Hamlin Ave.
Later that year Martin Luther King Jr. would initiate the Chicago Freedom Movement to end discrimination in housing, employment, and schools.

1966
Division Street Riots
California/Division
Spawned Spanish Action Comitee

1966
Goodfellows march
5333 N. Lincoln
Located at the 20th District Summerdale Police Station on Foster Avenue

1967
Citizens Alert
Uptown
Founded to address police brutality in 1967 by a group of community activists.

1967
The Wall of Respect
43rd St./Langley Avenue
The Organization of Black American Culture (OBAC) paint The Wall of Respect, a mural dedicated to African American leaders.

1968.03
Afro Arts Theater
39th/Drexel
Bobby Rush meets Fred Hampton Jr. and asks him to join the Illinois Black Panther Party

1968
Peoples Park initiated
Armitage/Halsted
Formed by IWW, Young Lords, and others fighting urban renewal in Lincoln Park.

1968
Young Lords Health Center
848 W. Armitage
Dr. R. Emeterio Betances Free People's Health Center may have lasted till 1974

1968
The Young Patriots Uptown Health Service
4408 N. Sheridan

1968-'72
Jane
1075 W. Cermak (CWLU Offices)
Heather Booth does her first abortion referral in 1965. This eventually leads to the founding of Jane, which lasts until 1973

1968-early '70s
Rising Up Angry Group/ Newspaper office
2261 N. Lincoln

1968-early '70s
The Chicago Seed
950 W. Wrightwood

1968-early '70s
Concerned Citizens Survival Front
2912 N. Lincoln Ave

1968-early '70s
Latin American Defense Org. health clinic
2935 W. North Avenue

1968-1974
Illinois Black Panther Party office
2350 W. Madison
The BPP ran a free breakfast program for kids, a free health clinic, and political education classes. In 1969 organized a Rainbow Coalition with the Young Lords and Young Patriot's.

1969.05.14-18
McCormick Seminary Occupation
2415 N. Sheffield (now DePaul University)
Young Lords Organization and Concerned Citizens of Lincoln Park occupy McCormick Seminary for four days.

1969.06
Students for a Democratic Society Final Convention
Webster/96th Street, Chicago Coliseum
Led to drastic split into Revolutionary Youth Movement (RYM I), RYM II, and Weatherman (later Weather Underground).

1971-'80s
The Stewart-Warner Company
Diversey, btw. Wolcott/Ravenswood
Factory organized by members of the Sojourner Truth Organization who successfully kicked out the corrupt union.

1971
"Campaign Against Pollution"
220 N Wacker Dr., Civic Opera House
Disrupts Standard Oil corporate meetings.
Included Black Panther Health Center, Womens Liberation Union, Young Lords.

1973
Midwest Academy
28 E Jackson Blvd
During the 1970s, one of the nation's most important training centers for organizers, the Midwest Academy, was founded in Chicago.

1974
The Coalition of Labor Union Women
Congress/Michigan
Formed in Chicago in 1974 to give union women access to leadership positions denied in the male-dominated union structure.

1977.06
"Cruz-Osorio Park"
California/Division
Humboldt park renamed to commemorate the murder of two Puerto Rican teenagers who were killed by Chicago Police officers in 1977.

1979
Women and Children First bookstore opens
5233 N. Clark

1979-1998
Randolph Street Gallery
756 N. Milwaukee
RSG was an experimental art space that defined an important period of Chicago art for nearly 20 years.

1983
Harold Washington elected Mayor
5300 S. Southshore Drive
Backed by the Multi-Racial Coalition led by Slim Coleman, Jesus "Chui" Garcia, and Rudy Lozano (murdered later that year at 4050 W. 25th Street)

1985-89
Axe Street Arena
2778 N. Milwaukee Ave
Started by 8 artists and activists this community cultural space hosted programs focusing on mail art, US intervention in Central America, Haymarket and Puerto Rican independence.

1990.04
MWCA at Cook County Hospital AIDS ward.
101 N. LaSalle St.
Members of ACT-UP participate in organizing with National Women's Caucus Action The ward previously closed to women.

1991-99
Uncomfortable Spaces
415 N. Sangamon, Tough Gallery
Cooperative of commercial galleries: MWMWM Gallery, Tough Gallery, Ten in One Gallery, and Beret International Gallery.

1996.08.21-31
Active Resistance
2012 W.Chicago Ave
The conference's Counter/Media project sowed seeds for what would become indymedia.org.

2001.06
19-day hunger strike by Little Village neighborhood
3120 S Kostner Ave
Mothers and supporters fighting for creation of Little Village-Lawndale High School (location won).

2003.06
Congress Hotel Workers Strike
184 W Washington St

2003.09.20
Lake Shore Drive Takeover against the War in Iraq

2004.10
Chicago City College Strike
1900 W VanBuren
Malcom X College and other City Colleges throughout Chicago, where 900 Teachers Walk Out across city for the first time in 27 years.

2004.06
Save Senn Coalition
5900 N. Glenwood
Residents of the Edgewater/Uptown neighborhoods mobilized around a military school opening in the local Senn High School.

2006.07.21-23
The 2006 National Hip Hop Political Convention
5500 N St. Louis Ave
Held at Northeastern Illinois University.

2006.06.23
Birth of the IWW-SWU IU660
2759 W. Logan Blvd
Industrial Workers of the World Starbucks Workers Union.

2006.08
Elvira Arellano seeks Sanctuary
2716 W. Division
Immigrant Rights Activist finds sanctuary from deportation at Adalberto United Methodist Church in Humboldt Park.

1859
John Jones, Abolitionist
4100 N Clark St., Graceland Cemetery
Grave site of John Jones,
a free black tailor who served as a link between African Americans and white abolitionists.[a]

1884.03.26
Illinois State Federation of Labor
99 W. Randolph
The first convention of the Illinois State Federation of Labor.[a]

1886.05.04
Hay Market Riot
Randolph/Desplaines
Socialists, anarchists and workers with demands of labor rights and the need for an eight-hour workday organized the rally.[a]

1872-73
Bread Riot
LaSalle/Kinzie
Protests for relief and food for the poor.

1890's
Greif's Hall
54 W Lake Street
Meeting Hall of German Socialists.

1894.05.11
Pullman Strike
Pullman Neighborhood
Workers struck the car works in May by late June railway workers had agreed to boycott trains carrying Pullman cars nationwide.[a]

1893
Womens Congress
111 S Michigan, Art Institute
This particular meeting had sessions such as "Woman as social leader," "The Solidarity of Womens issues"

1900
Chicago Federation of Labor
70 W Adams (CFL Offices)
The CFL commits $2,000 a week to the support of the Street Car Union Amalgamation of Street Railways Employees

1905.06.27
International Workers of the World initiated
Clark/Erie, Brands Hall
Eugene Debs, Mary Mother Jones, Lucy Parsons, William Trautmann, Vincent Saint John, Ralph Chaplin and Big Bill Haywood were present.[a]

'10s-'50s
Bughouse Square
901 N Clark St, Washington Square Park
Regular free speech/soapbox speaker venue

1910.09-1911.02
Chicago garment workers' strike.
18th/Halsted
Sixteen women struck the garment company Hart, Schaffner, and Marx. By weeks end, the original sixteen were joined by 2,000 women.[a]

1913
IWW Congress Hotel Strike
184 W Washington Street
IWW's Walter M. Eggeman starts to organize a working strike aimed at sabotaging the hotel industry in Chicago, specifically the Congress.

1917-1932
Dill Pickle Club
18 Tooker place
The Dill Pickle evolved from a center for labor organizing and radical agitation to a bohemian resort that attracted a variety of intellectuals.[a]

'20s-
The Washington Park Forum
Discussion group also known as the "Bug Club"

1925
Womens World Fair
Lakeshore Dr./Huron
160,000 People in attendance.

'30s
The "Red Belt"
Multiple locations
Home headquarters of several radical organizations.[a]

1928
Pullman Porters Threaten Strike
Service workers on the trains organized in 1925 as the "Brotherhood of Sleeping Car Porters (BSCP)"

[a] It was to John and Mary Jones's house that John Brown brought his band of militant abolitionists when they came through Chicago in 1859 on their way to Harpers Ferry, Virginia.

[a] It included Knights of Labor, farm grange organizations, Cigar makers, iron molders, typographers, journeymen horseshoers and farriers, truck makers, painters, tanners, curriers, shoemakers and miners. The meeting included 16 Chicagoworkers and 13 from downstate who represented, Springfield, Joliet, Danville, Bloomington, Aurora, Morris, Streator, Pekin, Ottowa, and Bartonville. This momentous occasion was eventually crushed by the war on organized labor that followed the 1886 Haymarket riots and the Federation was dead by 1900. Much of the labor organizing at this time was led by the International Working Peoples Association or Black International.

[a] Following the labor unrest of the Haymarket Square, the event known popularly as the 'Haymarket riot' erupted after an explosion interrupted the event. The explosion killed 8 police and 4 protestors, and led to a violent police response that killed other protestors and resulted in the capture of eight known anarchists and labor leaders who were considered suspects of the bombing (only 2 of which were actually in attendance at the rally).

[a] Federal troops were called in to squash the trains moving and to break the strike, prompting violence and looting in Chicago. With the arrest of the leaders in Chicago, the strike collapsed, and workers returned August 3, 1894.

[a] Further Readings: See Chicago IWW timeline/bibliography in AREA Chicago#3 and "The Labor Trail: Chicago's History of Working Class Life and Struggle" http://labortrail.org/

[a] When the United Garment Workers union (UGW) officially sanctioned the strike, 41,200 workers walked off the job. Jane Addams served as a mediator for this strike. http://ocp.hul.harvard.edu/ww/events chicago strike.html "I won't my pay" Hannah Shapiro and the Garment Workers' Strike of 1910" By Sarah Weiss Grady 71996
Chicago Metro History Fair http://www.aica.org/org/cmb e4/4 HF pay paper.html

[a] Often called "the Indoor Bughouse Square," Founded by Jack Jones, a Wobbly organizer and former husband of Elizabeth Gurley Flynn, and managed for a time by the anarchist Ben Reitman, artists, poets, and performers".

[a] Worker's Hall, 1618 West Madison Street, International Labor Defense, 2057 West Madison Street, West Side Worker's Forum, 338 South Halsted Street Social Science Institute, 1118 West Madison Street, and Communist Headquarters, 1415 West 18th Street.

[a] They later were squashed and reduced to a less politically friendly offing, telling gang by the 1970s. Leader Jeff Fort formed relationships with Reverend John Fry, Jesus Jackson and eventually secured a job training as a get from the federal government, Jeff Fort would eventually end up in prison for attempting to collaborate with Libyan leader Col. Moammar Kaddafi.

[a] Call for by West Side Organization, Student Nonviolent Coordinating Committee and Congress on Racial Equality. This event received particularly violent backlash and is said to have spawned a disenchantment with non violent civil disobedience in Chicago. (Further reading: The first half of "Two Societies, 1965-1968", Eyes on the Prize II(Alexandria, VA: PBS Video, 1990) offers a fine visual overview of the Chicago Freedom Movement.)

[a] Activists included Fred Glick, Jay Miller, Jack Kershak, Norman Lapping and the Rev. Stephen Whitehead.

[a] Wall celebrates Mohammed Ali, W.E.B. DuBois, H. Rap Brown/Jamil Abdullah Al-Amin, Stevie Wonder, James Brown, Charlie Parker, Nina Simone, Claude McNeil, Ornette Coleman, Wyatt Tee Walker, Gwendolyn Brooks, Malcolm X and many more. In 1968 OBAC changes its name to the Coalition of Black Revolutionary Artists (COBRA) and later to the African Commune of Bad Relevant Artists (Afri Cobra) in support of Pan-Africanism. The building the mural was on was demolished in 1971.
http://www.blacknessart.northwestern.edu/wallofrespect/main.htm

[a] A.t.a the Abortion Counseling Service of the Chicago Women's Liberation Union began when Heather Booth provided her first abortion referral in 1965. This eventually leads to the founding of Jane, which lasts until 1973. http://www.cwluherstory.com/CWLUAbout/itimeline.html

[a] The chairman Fred Hampton was murdered by Chicago Police December 4, 1969 evoked the corner at 2337 West Monroe.

[a] Chicago hosts the founding convention of the Coalition of Labor Union Women (CLUW)

[a] The space included an exhibition gallery, black box performance space for time based arts, and a project space. Over 1,000 artists made use of the space over the years, and benefited from a re: granting program was designed to share funds from RSG with a broader group of Chicago artists. 44 issues of P-Form, a performance magazine was published there as well.

[a] After the "mattress action" in which bed representing the missing spaces for women from the hospitals AIDS ward were dragged to a busy intersection near City Hall, the ward was then opened to women after that time.

[a] Included early initiators of groups like Food Not Bombs!, Earth First!, Sister Subvertor, Anti Racist Action, Critical Mass, Autonomous Zone, prisoner support groups, Free Mumia groups, and Counter Media.

The main sources for this research include the Chicago Encyclopedia, Chicago Tribune Archives, Wikipedia.org and numerous topic specific sources.

Initiated in 2006,
An Ongoing Project by AREA Chicago. Art/Education/Activism
[www.areachicago.org | areachicago@gmail.com]

Because maps are never finished and only tell part of a story. Because they are visual tools for sharing with others. Because they can be produced by many people and combined to tell stories about complex relationships. Because power exists in space, struggle exists in space, and we exist in space. Because we cannot know where we are going if we don't know where we are from.

Notes for a People's Atlas presents maps made by people who live in the city that they map. The maps are distributed through various local networks (sometimes published in a newspaper, sometimes sent to a mailing list, other times just left in various community spaces throughout the city) who will be encouraged to mark their interpretation of sites of relevance in the place where they live, work, and play. Sometimes the maps are researched and reveal specialized knowledge, other times they are hyper-subjective, playful, and experimental. Sometimes they are many things at once. The completed maps are then collected into a local archive that is sponsored by a host organization dedicated to maintaining the collection and distribution of the maps. An updated listing of all the People's Atlas initiatives can be found at:

peoplesatlas.areaprojects.com

Left: *AREA Chicago*, "Solidarity Map," 2006. From
Notes for a People's Atlas, 2006–ongoing. Designed by
Dave Pabellon, researched by Daniel Tucker

Chicago

Things I know
about chicago...
~~~~~~~~~~
(from observation)

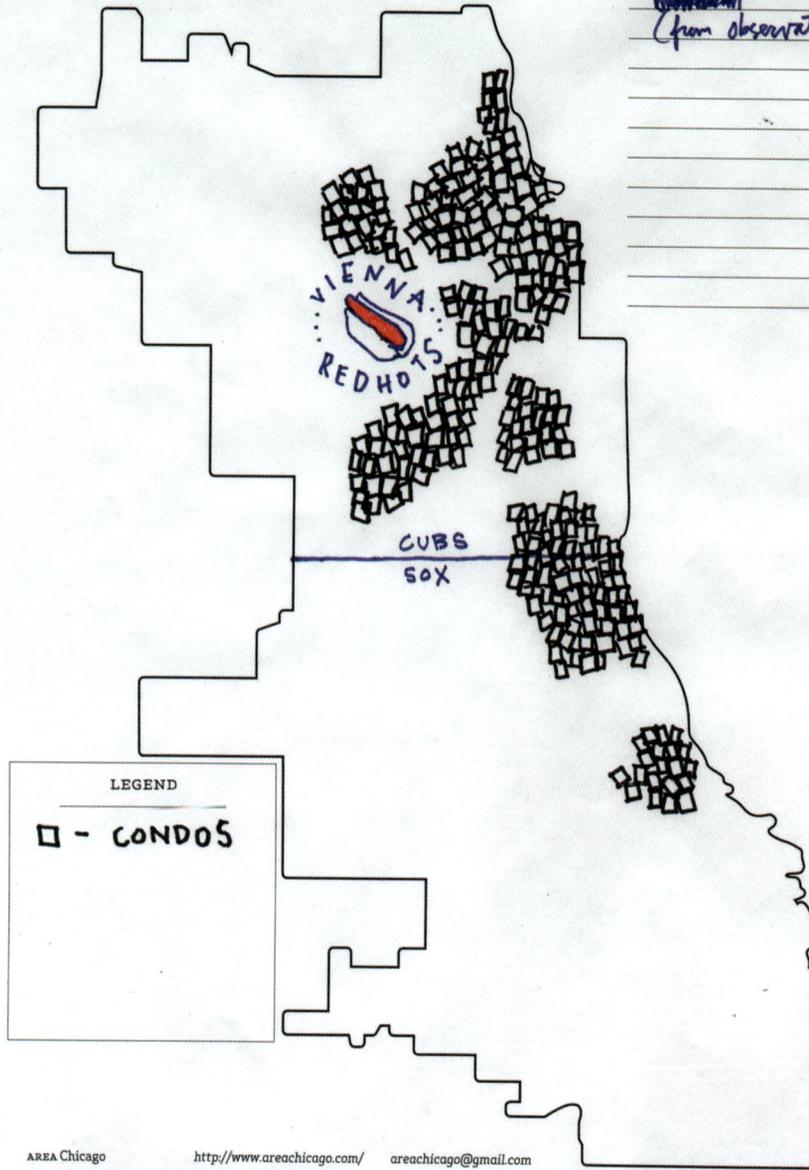

VIENNA
REDHOTS

CUBS
SOX

## LEGEND

☐ – CONDOS

AREA Chicago     http://www.areachicago.com/     areachicago@gmail.com

c/o Stockyard Institute
Depaul University School of Education,
2320 N. Kenmore, 3rd floor, room 323
Chicago, IL 60614

Left: *AREA Chicago*, "Condos," 2007. From *Notes for
a People's Atlas of Chicago*, 2006–ongoing.

Above: *AREA Chicago*, participants touring the market
in Zagreb, 2007. From *Notes for a People's Atlas*,
2006–ongoing.

A THREAT TO PEACE: "Iraq stands alone because it gathers the most serious dangers of our age in one place."
—Pres. Bush addressing the nation from Cincinnati on Oct. 7, 2002

DANIEL TUCKER
PROJECT ORGANIZER, THE WE ARE HERE MAP ARCHIVE

In recent years, a large number of artists, designers, and activists have turned to the map form to help them represent their questions, analyses, and proposals for the spatial politics of contemporary life. The maps are often fun, playful; they experiment with form and representation, and they are rigorous forms of research with pedagogical potential. *The We Are Here Map Archive* is organized to present a wide range of these new critical cartographic experiments. It will introduce diverse audiences to an international spectrum of mapmakers.

Most of the maps that comprise the archive are reproduced on pages 118–159. See mapsarchive.org

*Maps by Ayreen Anastas and Rene Gabri, Beehive Design Collective, Bureau d'études, The Center for Urban Pedagogy (with Rosten Woo, Longshore Workers Coalition, Labor Notes, Bill Rankin, thumb projects, Stephanie Whitehouse, and William Hood), Adriane Colburn, Counter-Cartographies Collective, Ecotrust Canada, Amy Franceschini, Friends of William Blake, Hackitectura and collaborators, Grupo de Arte Callejero, Ashley Hunt, Indymedia Estrecho and collaborators, The Institute for Infinitely Small Things, Los Angeles Urban Rangers, Lize Mogel and Dario Azzellini, Indypendent, New York City, Bill Rankin, Repohistory, Nikolas R. Schiller, subRosa, Temporary Travel Office, and Jeffrey Warren.*

Left: Indypendent, New York City, *A Threat to Peace,* 2003. The map documents military sites in the U.S.

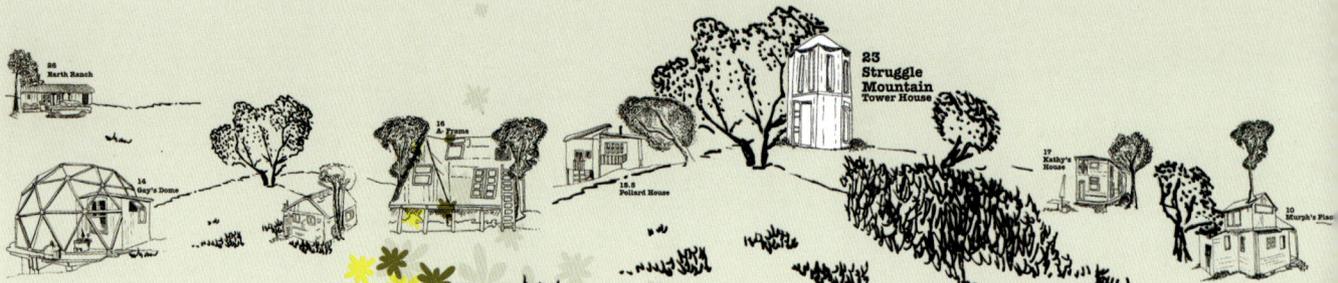

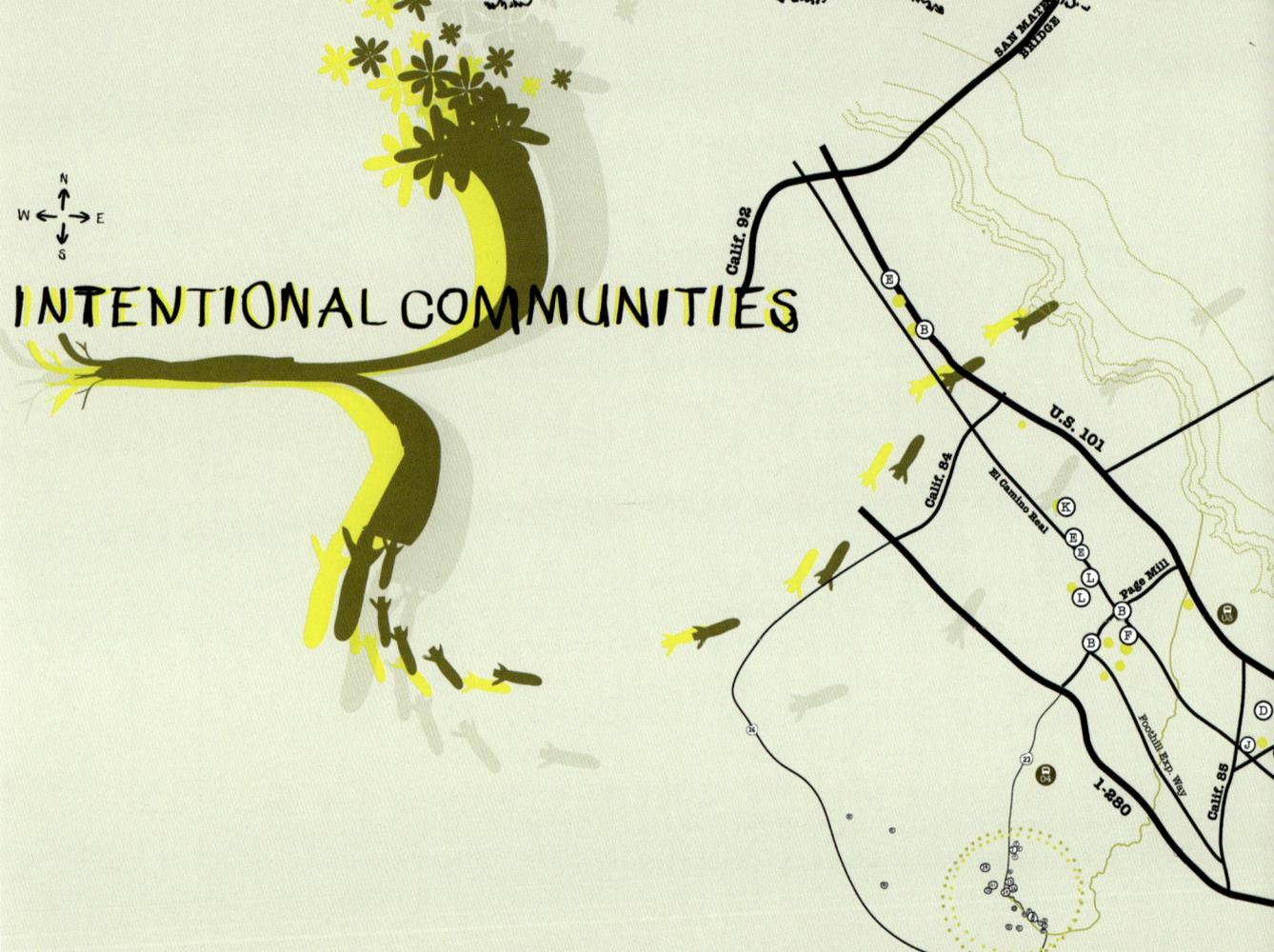

# INTENTIONAL COMMUNITIES

N
W ← → E
S

**23 Struggle Mountain** Tower House

36 North Ranch

14 Gay's Dome

16 A-Frame

15.5 Pollard House

17 Kathy's House

19 Murph's Place

SAN MATEO BRIDGE

Calif. 92

U.S. 101

Calif. 84

El Camino Real

Page Mill

Foothill Exp Way

Calif. 85

I-280

The local landscape is our campus!

San Jose   Alviso   Vista Slope   Struggle Mountain

*This map presents data from two types of intentional communities; Locations and profits of Defense Contractors and the names and locations of a group of radicals/draft resisters/ back-to-the-lande.
"The early work done in the Valley by people with visions of improving the world wasn't isolated from their politics or what was going on around them. It was part of a broader movement, of a profou
-Lee Felsenstein, Homebrew Computer Club

*Sources: Pacific Studies Center, Common Dreams, & text taken directly from company websites

# FROM YOUR OWN BACKYARD

This is an updated list of the top 12 Defense Contractors in Silicon Valley. After each company there is a city total and a total for their entire Silicon Valley presence for the 2006 fiscal year.

**Total: $4,861,847,920**

In 1971 the revenue for Defense Contractors totaled:
**Total: $740,000,000**

Calif. 237

Calif. 17

Lawrence Exp. Way

---

**Ⓐ BAE Systems**
1205 Coleman Ave, Santa Clara, CA

BAE Systems is a global company engaged in the development, delivery and support of advanced defense and aerospace systems in the air, on land and at sea.

City Total: $186,141,086

**Ⓑ Communications & Power Industries**

Communications & Power Industries (CPI) provides micro-wave, radio frequency, power and control solutions for critical defense, communications, medical, scientific and other applications.

811 Hansen Way, Palo Alto, CA
City Total: $27,746,010

607 Hansen Way, Palo Alto, CA
City Total: $3,295,902

301 Industrial Way, San Carlos, CA
City Total: $4,942,835

Silicon Valley Total: $35,984,747

**Ⓒ EDO Corporation/ITT**
Morgan Hill, CA

EDO Defense Systems business unit designs and manufactures high-performance electronic assemblies for military and space applications, and develops and produces electromechanical systems and equipment for government and commercial marine and aircraft applications. The primary product areas include electronic warfare systems, radar systems, embedded systems, RF/Microwave products, air quality monitoring, nuclear detection, and manufacturing services.

City Total: $15,422,346

**Ⓓ General Dynamics Adv. Info Services**
100 Ferguson Dr, Mountain View, CA

General Dynamics Advanced Information Systems is a leading provider of mission solutions in command, control, communications and computers, intelligence, surveillance and reconnaissance. Customers include those in the defense, intelligence, homeland security and homeland defense and international communities.

City Total: $99,305,470

**Ⓔ L-3 Communications**

BAE Systems is a global company engaged in the development, delivery and support of advanced defense and aerospace systems in the air, on land and at sea.

150 Constitution Drive Menlo Park, California
City Total for Co. Menlo Park: $3,295,902

950 Industrial Rd San Carlos, CA 94070
San Carlos $17,168,411

Silicon Valley Total: $20,464,313

**Ⓕ Lockheed Martin**

LM is a systems integrator and information technology company for the U.S. Department of Defense and U.S. federal government agencies. LM is the largest provider of IT services, systems integration, and training to the U.S. Government. LM specializes in missile defense, "hit-to-kill" technology. "Lockheed Martin systems include smart submunitions to give the warfighter maximum flexibility as well as fire support mobile artillery and guided munitions to dominate the battlefield." The company wants to go highest tech with its "combat Internet system," a rugged handheld computer, that will put a "dot-com face on the modern battlefield." The company is hiring in Silicon Valley, looking to replace "Boeie the Riveter" with "Buzie the Software Programmer."

3251 Hanover St, Palo Alto, CA
City Total: $3,401,988

1111 Lockheed Martin Way, Sunnyvale, CA
City Total: $4,119,379,819

3200 Zanker Rd, San Jose, CA
City Total: $46,279,599

Silicon Valley Total: $4,170,061,406

**Ⓖ Northrope Grumman**

Northrop Grumman Corporation is a $33 billion global defense and technology company whose 150,000 employees provide innovative systems, products, and solutions in information and services, electronics, aerospace and shipbuilding to government and commercial customers worldwide.

6577 San Ignacio Ave, San Jose, CA
City Total: $106,967,858

401 E Hendy Ave, Sunnyvale, CA
Sunnyvale $77,823,759

Silicon Valley Total: $184,791,617

---

**Ⓗ Radix Technologies**
329 Bernardo Ave, Mountain View, CA

Radix offers complete solutions including antennas, tuners, digital signal processors, Human Machine Interface (HMI) display and data storage, management and distribution.

Silicon Valley Total: $16,766,838

**Ⓘ Rockwell Collins Inc.**
2701 Orchard Pkwy San Jose, CA 95134

Rockwell Collins is a global company that develops communication and aviation electronic solutions for government customers. They supply the U.S. Department of Defense with communication, and navigation systems for airborne, ground, and shipboard applications. As well as manufacturing aircrafts and helicopters.

Silicon Valley Total: $52,886,220

**Ⓙ Savi Technology**
2701 Orchard Pkwy San Jose, CA 95134

The company is the primary technology provider for the world's largest RFID consignment monitoring network for the U.S. Department of Defense, which employs RFID, barcode, cellular and satellite communications systems to track more than 35,000 conveyances daily across a global network of 1400 locations in more than 48 countries.

351 E Evelyn Ave Mountain View, CA 94041
City Total: $3,100,880

1292 Anvilwood Ave, Sunnyvale, CA
City Total: $47,808,541

Silicon Valley Total: $50,909,221

**Ⓚ SRI International**
333 Ravenswood Ave Menlo Park, CA 94025

SRI International, formerly the Stanford Research Institute is an independent, non-profit research institute conducting client-sponsored research and development for the government. They develop software security systems, advanced sensing and situation awareness technologies, communication systems using GPS, as well as providing remote explosive testing. They have performed nearly $2 billion in contracts with the government.

Silicon Valley Total: $51,561,688

**Ⓛ Stanford University**

Standford University applies technical and political expertise to studying missile defense systems, address the threat of chemical and biological weapons, proliferation, and the potential use of weapons by terrorists. They improve upon existing weapons and secure material technology for making new weapons. In 2007, 100 students and 4000 teachers "Say NO to Rumsfeld" as "Distinguished Visiting Fellow" at the Hoover Institute.

616 Serra St. E200 Stanford, CA 94305-6055
City Total: $7,772,177

Palo Alto, CA
City Total: $418,893

Silicon Valley Total: $8,191,070

**Ⓜ Vision Systems Int'l**
841 River Oaks Pkway San Jose, CA 95134

Vision Systems International, LLC (VSI) is the worlds leading supplier of Helmet Mounted Cueing Systems for fixed-wing, tactical fighter aircraft. VSI has been selected by both Boeing and Lockheed Martin as the supplier of choice for Helmet Mounted Cueing Systems for a wide range of fixed-wing fighter aircraft including the F/A-18, F-15, F-16 and most recently, the F-35 Joint Strike Fighter.

Silicon Valley Total: $25,805,658

---

GARDENING
SUPERFUND SITES

Total Superfund Acreage: 2732
2560 acres = 4 square miles
Total Superfund Acreage: + 4 square miles

In Santa Clara County - the heart of Silicon Valley - there are 29
Superfund sites, more than any other county in the US, and 20
of them were "directly caused by the processes of producing
silicon wafers and other high-tech electronic components."

**Palo Alto**

1 Hewlett Packard
640 Page Mill Rd
EPA ID# CAD000000000

2 Hewlett Packard
1501 Page Mill Rd
EPA ID# CAD000000000

**Mountain View**

3 CTS TriStar Inc.
EPA ID# CAD000000000

4 Spectra Physics Inc
EPA ID# CAD000000000

5 Jasco Chemical Corporation
EPA ID# CAD000000000

6 Teledyne Semiconductor
EPA ID# CAD000000000

7 Intel Corp
EPA ID# CAD000000000

8 Fairchild Semiconductor Corp
EPA ID# CAD000000000

9 Raytheon Company
EPA ID# CAD000000000

10 Moffett Naval Air Station
EPA ID# CAD000000000

**Sunnyvale**

11 Advanced Micro Devices
EPA ID# CAD000000000

12 Advanced Micro Devices
EPA ID# CAD000000000

13 Westinghouse Electric Corporation
EPA ID# CAD000000000

14 TRW Microwave Inc
EPA ID# CAD000000000

**Santa Clara**

15 National Semiconductor Corp
EPA ID# CAD000000000

16 Micro Storage Intl Micro I /
EPA ID# CAD000000000

17 Applied Materials
EPA ID# CAD000000000

18 Intel Pacific II
EPA ID# CAD000000000

19 Synertek
EPA ID# CAD000000000

**Cupertino**

20 Intersil/Siemens Corp
EPA ID# CAD000000000

**San Jose**

21 Lorentz Barrel & Drum Co.
EPA ID# CAD000000000

22 Fairchild Semiconductor Corp
EPA ID# CAD000000000

Above: Amy Franceschini, *Silicon Valley Superfund
Sites,* 2006 (later version)

Right: Jeffrey Warren, *Armsflow,* 2006. Printed to
advertise an online mapping project, this map displays
changes in arms transactions from 1950–2006.

# ARMSFLOW

Exports

2006

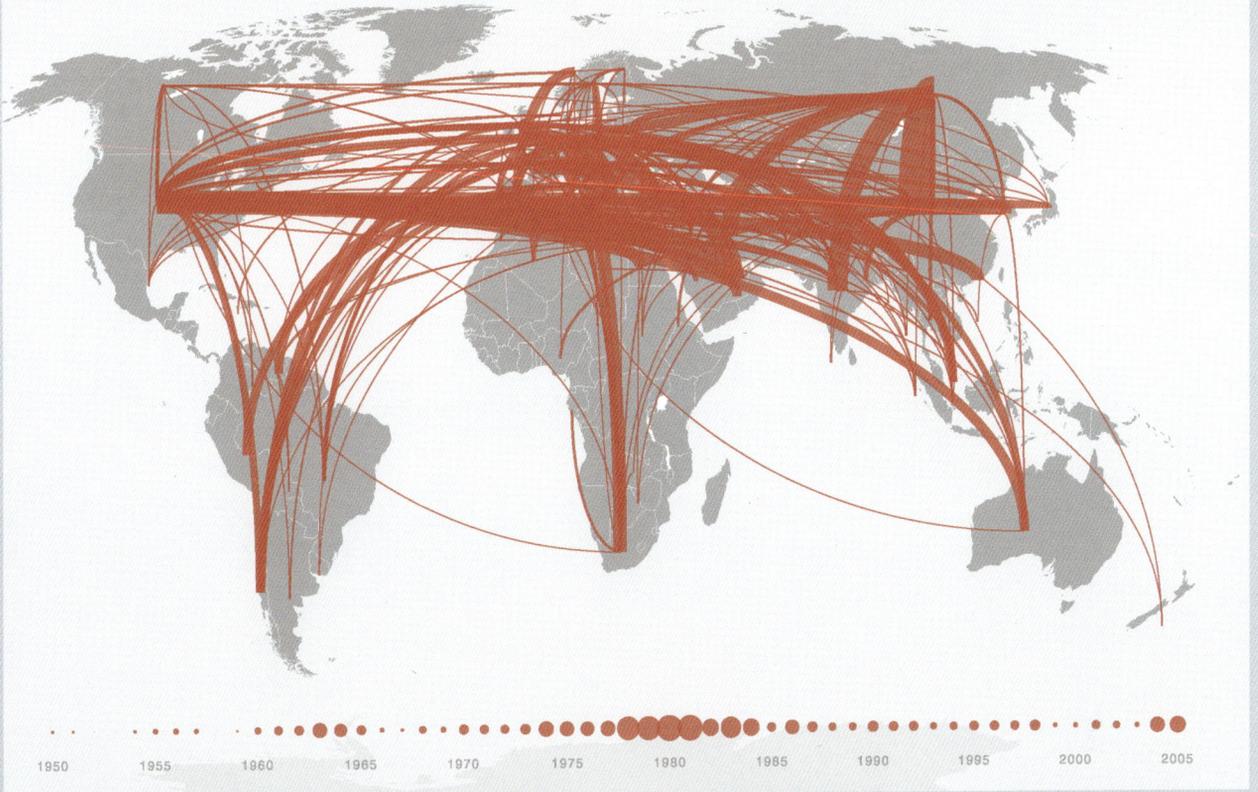

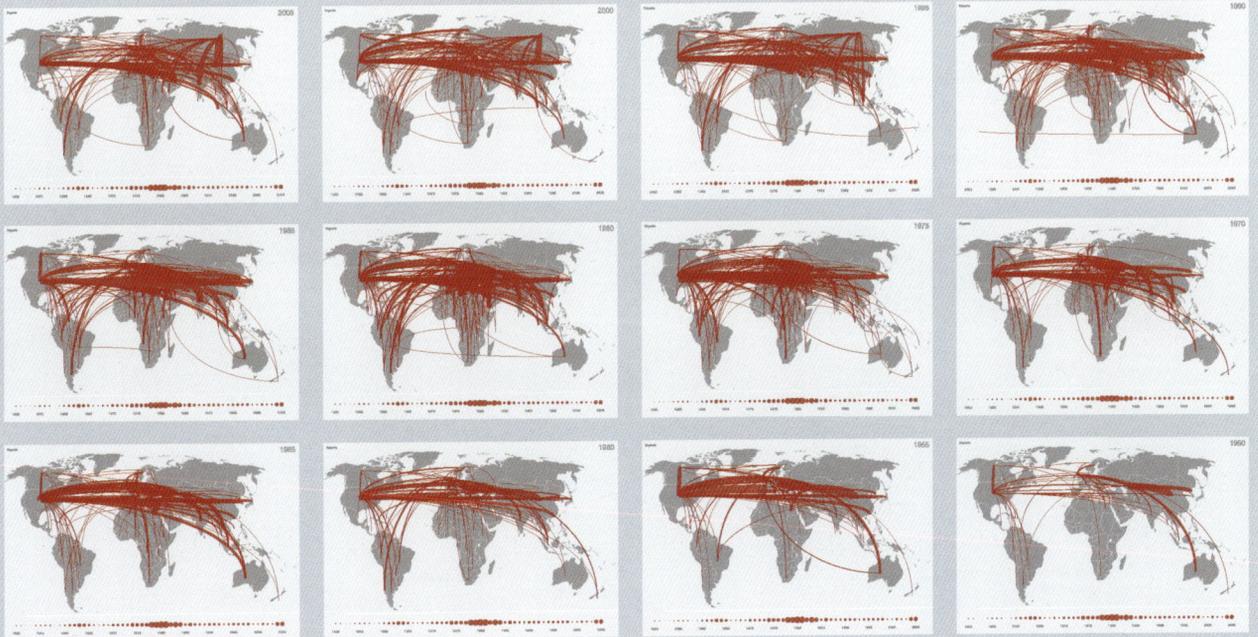

### Global Arms Trade, 1950–2006

ARMSFLOW includes 14,619 arms transactions (each is a sum of 1 year's exports) and 228 government entities.

**ARMSFLOW.org**

ARMSFLOW is a data visualization which displays arms transactions globally between 1950 and 2006. It was created by Jeffrey Warren of Vestal Design with data from the Stockholm International Peace Research Institute (SIPRI: http://armstrade.sipri.org). Jeffrey Warren, Vestal Design, and ARMSFLOW are not affiliated in any way with SIPRI.

**The Highways Are Amazing.**
Houston, 1996–2000, 2002.

friend
activity
restaurant
shop
bar

foot
bicycle
car

**I Visit My Friends Pretty Regularly.**
New York City, 1999–2004.

foot
train
car

friend
activity
restaurant
bar

**I Miss the Thrill of the Grid.**
Cambridge, 2002–2003.

foot
bicycle
train
car

friend
activity
restaurant
bar

**The Same House For Eighteen Years.**
North Chicago Suburbs, 1978–1996.

friend
activity
restaurant
mall

foot
bicycle
train
car

**Learning German.**
Berlin, 2004.

foot
bicycle
train

museum
restaurant

**No Friends In This Town.**
Philadelphia, 2000–2001.

activity
restaurant
history

foot
bicycle
train
car

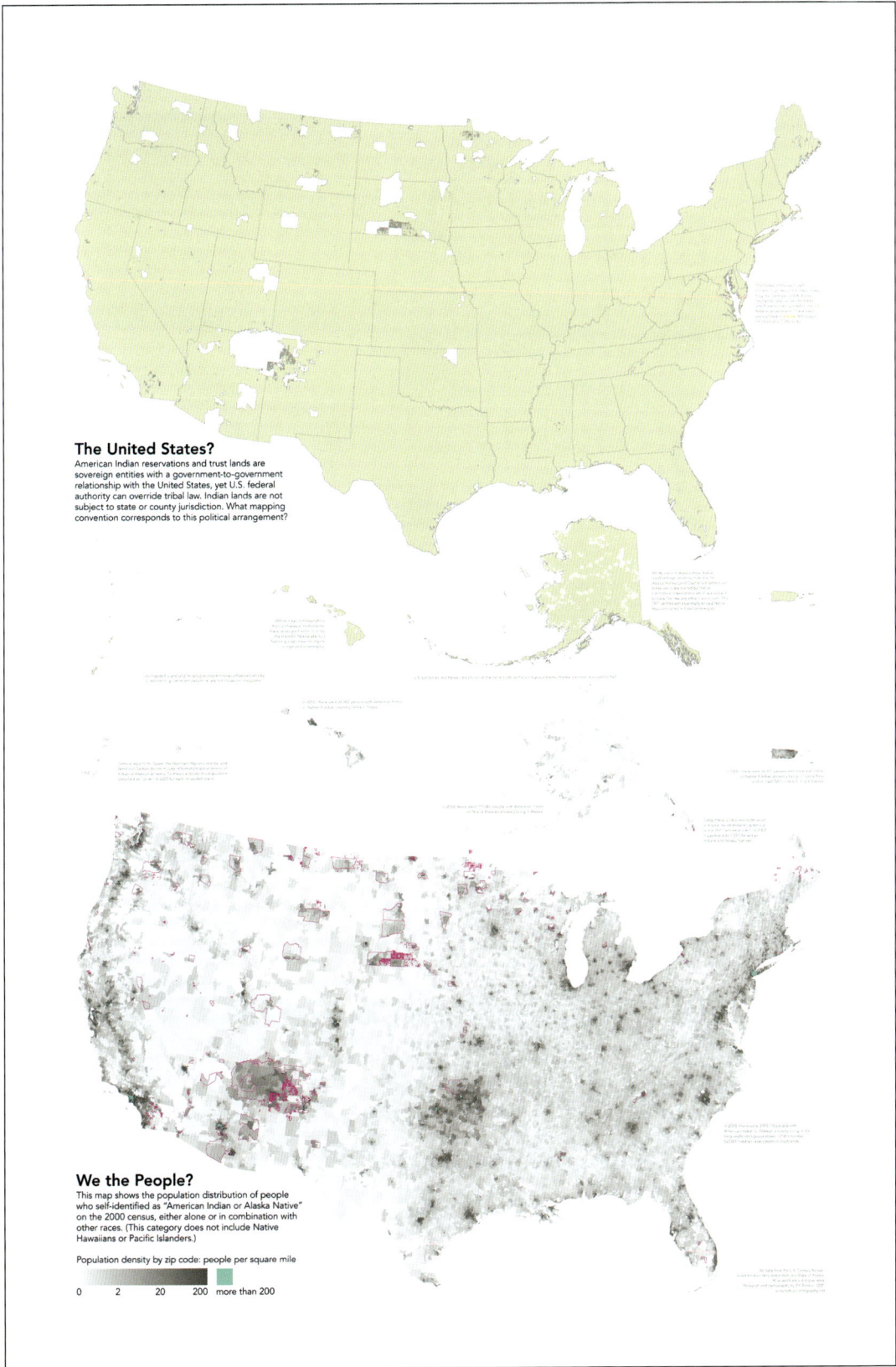

## The United States?

American Indian reservations and trust lands are sovereign entities with a government-to-government relationship with the United States, yet U.S. federal authority can override tribal law. Indian lands are not subject to state or county jurisdiction. What mapping convention corresponds to this political arrangement?

## We the People?

This map shows the population distribution of people who self-identified as "American Indian or Alaska Native" on the 2000 census, either alone or in combination with other races. (This category does not include Native Hawaiians or Pacific Islanders.)

Population density by zip code: people per square mile

| 0 | 2 | 20 | 200 | more than 200 |

Left: Bill Rankin, *My Cities*, 1978-2004. A map documenting the artist's routines and habits in various cities.

This page: Bill Rankin, *The United States?* 2003–07. Above: a map documenting the locations of U.S. Indian reservations. Below: a map of self-identified Indians overlaid with the locations of U.S. Indian reservations.

# THE CARGO CHAIN

How does this dizzying array of commodities get from the factory to the shopping mall? Let's take the example of the iPod, the music player that 35 million Americans have snatched off the shelves over the past six years.

## THE CORPORATIONS

Who sits atop this new web of worldwide production, shipping, and distribution? Some companies are household names; others are anonymous giants of today's global economy.

## THE WORKERS

Each link in the chain depends on its own workforce, but the system of global cargo transportation requires coordination between every group of workers. A problem at any link in the chain can cause the entire system to back up.

**SOLIDARITY VER**
FIGHTING FOR GOOD

This pamphlet shows the t use to move goods into the stretches through Canada national boundaries, indust

Workers in this system can and secure good jobs for th find a way to act together. also use their position in th retail workers in the US an

Corporations see the transp and it is important for work network reveal where work highways, and rail lines that and to the rest of the worlc can short-circuit that powe system against one anothe

In this context, workers mu organizing and solidarity—t and building ties between w

Longshore workers must fo as well as with port trucker warehouse workers. The sa system. The old saying is a an injury to all."

---

### 1. THE FACTORY & LOADING DOCK

Odds are that an iPod bought today was probably made in Longhua, China, in a factory complex nicknamed iPod City. More than 200,000 work in iPod city. Apple's subcontractor, FoxConn, produces 116,000 music players every day. They are individually packaged, put into larger cartons, and eventually loaded into a shipping container.

### 2. EXPORT TRUCK, RAIL & PORT

That 40-foot-long container is driven 10 miles to the port of Shenzhen, where a 150-foot crane loads it onto a container ship, and it joins 3,000 other containers for the 15-day journey across the Pacific Ocean.

### 3. THE SHIP & OCEAN VOYAGE

A crew of 30 guides this ship across the Pacific, most likely to the port of Los Angeles/Long Beach, the largest container hub in the US. Although the ship may start its journey in China, there is a good chance it is owned by a Danish company and registered in Panama or Monrovia in order to avoid the labor and environmental regulations of Europe and the US.

### 4. THE HARBOR

A harbor pilot boards the ship and guides it into the port. Tugboat operators help the ship dock.

### 5. IMPORT TERMINAL

Once secure, longshore workers unload the ship's 3,000 containers. With each crane able to move one container every two to three minutes, the crane operators and container equipment drivers will have the ship unloaded in less than a day. Chances are good these workers will place the container onto a double stack rail car or truck chassis.

### 6. TRUCK & RAIL

If our container ends up on a double stack rail car, it heads to Salt Lake City before being transferred to points further east. If it ends up on a truck chassis, it is likely picked up by an independent port trucker bound for an intermodal station in Ontario, California, where it is transferred to a long-haul trucker or put on a railroad car headed for its next destination.

### 7. DISTRIBUTION CENTERS, WAREHOUSES & CROSS DOCKING

Once our container arrives at the distribution center, workers unload it and temporarily store it until the next leg of the journey. In some cases, the box may never see a warehouse shelf, as it is "cross docked" from the container into another truck bound for a store.

### 8. THE STORE

Workers unload the truck and stock the shelves. Now you can buy the iPod you've always wanted.

### PLANNING, INFORMATION & CLERICAL SERVICES (AKA LOGISTICS)

Coordinating all this movement behind the scenes are workers in a new field known as logistics. These workers handle the paperwork, transportation, and planning involved in moving products from the factory to the shopping mall. They deal with customs, insurance, and cargo receipts known as "bills of lading." They also help track the cargo and inventory.

---

## CARRIERS OR SHIP OWNERS

- These companies own or lease large container ships.
- They hire long-term container ship crews, and contract with importers and exporters who shepherd cargo in and out of the country.
- Ocean shipping is by far the most common and cost-effective method for moving freight. According to the *Financial Times*, "it often now costs more to ship a container by road 100km from a port to its final destination than it does to move a container by sea from China to Europe."
- The world's top three shippers bring over a quarter of the total goods into the US. The largest shipper is AP Moller-Maersk, headquartered in Copenhagen, Denmark. Maersk has twice the shipping capacity of its nearest rival. Last year, Maersk ships brought in 14 percent of all goods entering the US.

## TERMINAL OPERATORS OR STEVEDORES

- These companies operate the terminals at the ports where ships are loaded and unloaded.
- The companies lease waterfront land, and own or lease the gantry cranes, docks, and warehouses needed to move goods through the port.
- A small number of international companies dominate the market. The world's largest port operator is Hong Kong's Hutchison Whampoa, followed by Singapore's state-owned PSA, and then Dubai Ports World.
- SSA Marine is the largest US-owned container terminal operator, moving more than 4 million TEUs in 2005.
- Investment and holding companies, such as Deutsche Bank, Ontario Teachers Pension Plan, and AIG, have purchased large terminal operations in the US and abroad.
- The world's largest carrier, AP Moller-Maersk, also operates terminals in 13 US ports under the name APM Terminals, including a new facility in Hampton Road, Virginia that opened in 2007.

## FREIGHT SHIPPING

- These companies transport goods by truck inside the US.
- Schneider National is the largest truckload carrier in North America. Privately held, with estimated revenue of $3.5 billion in 2006, Schneider operates over 14,000 trucks nationally.
- Yellow Roadway Corporation is the largest less-than-truckload (LTL) carrier in North America. LTLs collect cargo from different shippers and use a network of truck terminals and hubs to consolidate freight. Yellow Roadway's revenues were close to $10 billion in 2006. It operates over 17,000 trucks nationwide.

## RAILROAD TRANSPORT

- These companies transport goods through the US, Canada, and Mexico.
- They own the track and employ dispatchers, engineers, conductors, signal men, and yardmasters to transport cargo throughout their private rail systems.
- Union Pacific, the largest rail company in North America, operates over 32,000 miles of track inside the US, with the BNSF (Burlington Northern Santa Fe Corporation) coming in a close second.

## EXPRESS DELIVERY

- These companies use a network of air and ground hubs tied together by a fleet of package cars, tractor trailers, and cargo planes.
- UPS, FedEx, and DHL dominate the market, together delivering over six billion letters and packages in 2006. UPS is the world's largest package delivery company.

## RETAILERS

- These companies are the household names that sell us products manufactured around the world.
- The top three retail importers include: Wal-Mart with 695,000 TEUs in 2005, Target with 371,000, and Home Depot with 335,000.
- Other large retail importers include Sears, Dole, Chiquita, Red Bull, Heineken, LG, and Ikea.

## LOGISTICS PLANNING COMPANIES

- Many carriers and retailers have created their own logistics divisions; other companies subcontract to third party logistics planners. These companies hire the office workers who do the work.

---

## CONTAINER SHIP CREWS

- 100,000 men and women worldwide work on container ships.
- They do everything from cooking meals to operating deck equipment like anchors and lines.
- The largest segment of the workforce is from the Philippines (close to one quarter of the seafaring population).

## HARBOR PILOTS & TUGBOAT OPERATORS

- 28,000 people work on tugboats or as harbor pilots in the US.
- Harbor pilots board large ships once they reach port, steering them in and out of their berths.
- Tugboat operators guide large ships in and out of port.
- Many of these workers are members of either the West Coast International Longshore and Warehouse Union (ILWU) or the East Coast International Longshoremen's Association (ILA).

## LONGSHORE WORKERS

- 60,000 US workers move cargo across the nation's docks.
- Longshore workers handle containers, cars, tankers, and bulk cargo like grains, coal, and other raw materials. They operate cranes and forklifts, lash cargo, and tend to mooring lines.
- Most longshore workers are union members, represented on the West Coast by the ILWU and on the East Coast by the ILA.

## PORT TRUCKERS

- 60,000 drivers carry containers out of the nation's ports to nearby rail transfer stations or warehouses.
- Because they are hired as independent contractors instead of employees, this largely immigrant workforce has often been denied the right to unionize. The International Brotherhood of Teamsters is currently waging a campaign to organize port truckers on both coasts.

## FREIGHT DRIVERS

- 850,000 freight truckers crisscross the nation's highways every year.
- They move close to 65 percent of the nation's commerce by volume and roughly 75 percent by value.
- Prior to the deregulation of the trucking industry in 1980, about 60 percent of the industry was unionized, primarily with the Teamsters. Today less than 13 percent of the trucking industry is unionized.

## RAILROAD WORKERS

- 165,000 people work in the railroad industry in the US.
- They move close to 14 percent of the nation's freight by volume and four percent by value.
- More than 70 percent of the nation's railroad workers are unionized, with the vast majority belonging to three unions, the Brotherhood of Maintenance and Way Employees and the Brotherhood of Locomotive Engineers and Trainmen—both of which are now part of the Teamsters union—and the United Transportation Union.

## WAREHOUSE WORKERS

- More than 2 million people work in the nation's network of warehouses and distribution centers.
- These workers unload and store the goods that move around the US every year.
- Less than 20 percent of the nation's warehouse workers are unionized, but those that are typically belong to one of four unions—the ILA, the ILWU, the Teamsters, or the United Food and Commercial Workers.

## EXPRESS PACKAGE DELIVERY

- 370,000 workers move packages for UPS, FedEx, and DHL nationwide.
- Approximately 30 percent of the industry's workforce is unionized, primarily affiliated with the Teamsters.

## LOGISTICS PLANNERS

- 160,000 people work in the logistics industry.
- They coordinate the movement of goods from factory to consumer, navigate the different modes of transport, and arrange the customs and insurance systems in different countries.
- These workers are a mix of professional and clerical workers, mostly non-union.

# THE CARGO CHAIN

### WORKERS WHO MAKE OUR ECONOMY MOVE

**CREDITS**

This project is part of Making Policy Public, a series of collaborations between researchers, activists, and designers sponsored by the Center for Urban Pedagogy (CUP).

**THE CENTER FOR URBAN PEDAGOGY (CUP)**
CUP produces creative education about places and how they change.
www.anothercupdevelopment.org

**LABOR NOTES**
Labor Notes is a non-profit organization that has been the voice of union activists who want to "put the movement back in the labor movement" since 1979. Through our monthly magazine, books, and conferences we connect workers across the country and around the world who want to fight back and win at work.
www.labornotes.org

**THE LONGSHORE WORKERS' COALITION (LWC)**
The LWC is a movement of ILA members and retirees organizing to build a stronger and more democratic longshore union. We are crane operators and car drivers, checkers and baggage handlers, lashers, mechanics, hustler drivers, break bulk handlers, tugboat operators and warehouse workers. We are black and white workers, women and men, immigrants and native born. We have members in ports up and down the East and Gulf Coasts.

Contact the LWC:
www.lwcjustice.com
Longshore Workers' Coalition (LWC)
PO Box 21230
Charleston, SC 29413

**THUMB**
Thumb is a graphic design office that works on both commissioned and speculative projects, usually in the areas of architecture and urbanism.
www.thumbprojects.com

**BILL RANKIN**
Bill Rankin is a historian and cartographer currently finishing a PhD at Harvard University and making sporadic updates to his website.
www.radicalcartography.net

Additional illustrations by William Hood

State of the Arts

NYSCA

NYCulture

Support for this project was provided by the Diane Middleton Foundation, the New York State Council on the Arts (NYSCA), and the New York City Department of Cultural Affairs.

Over the last 35 years, changes in the global economy have undermined bargaining power for many US workers. Corporations have pitted US workers against workers in other countries to drive down wages, erode health and safety standards, and avoid regulation. But changes in the ways that goods are made and moved have also created enormous leverage for workers in the transportation chain, giving them the potential to reverse the global race to the bottom. With organization and solidarity, these workers are in a better position than most to reclaim good jobs for themselves and for millions of other workers across the country and around the world.

This pamphlet looks at the network of ship hands, longshoremen, truck drivers, railroad operators, and warehouse workers that make the global marketplace possible. To the average consumer these workers are almost invisible, but they stand at the center of today's economy, moving billions of dollars of goods daily. If globalization has allowed modern corporations to use the world as their workshop, it's only possible because of the increasingly integrated network of people and machines that move things from one place to another.

## A REVOLUTION IN GLOBAL SHIPPING

Today the global economy depends on goods flowing seamlessly over oceans and across borders. Retailers rely less on inventory stored in big warehouses. Now they deliver goods "just-in-time" to the customer, using ships, terminal yards, and trucks as their mobile warehouses. This global transportation network has become the circulatory system of the international economy.

Prior to the invention of the shipping container, transporting goods across the ocean was slow, costly, and labor intensive. A small army of longshoremen handled the crates, barrels, and cartons that mingled with fresh fruit, steel coils, and sacks of coffee in a ship's hold. Muscle, not machinery, was the most common solution to moving goods in or out of port.

The container, a dull, 40-foot steel box, changed all that. Now the cargo riding inside a ship could be quickly unloaded by crane onto a rail car or the back of a truck. After containerization, a job that previously took 125 dockworkers 10 days could now be done by 40 dockworkers in 12 hours. By transforming the ways that things are moved, the container made it possible for manufacturers to put their factories nearly anywhere. Corporations jumped at the chance to boost profits, scouring the globe in search of low wages and lax labor and environmental standards.

### TEUS (TWENTY-FOOT EQUIVALENT UNITS) ENTERING OR EXITING THE US, CANADA, OR MEXICO

| | 1980 | 1990 | 2000 | 2006 |
|---|---|---|---|---|
| | | | | |

10 million TEUs
20 million TEUs
30 million TEUs
40 million TEUs
50 million TEUs

United States
Mexico
Canada

A Twenty-Foot Equivalent Unit, or TEU, is a volume measurement equal to the dimensions of a 20-foot shipping container. In 2006, over 44 million TEUs moved in and out of the US—almost double the volume of 1997 and more than four times as much as in 1980.

### GLOBAL CONTAIN...
Measured in Twenty-Foot Equ...
container box with dimensions...

TEUs handled in 2004 (top 50...

### US INTERNATIONAL TRADE
Total value of all goods traded with the US (imports plus exports) in 2006, measured in US dollars.

China includes Hong Kong and Macau, but not Taiwan.

550 billion · 300 · 100 · 50 · 0

Canada · China · Mexico · Japan · Germany · South Korea · United Kingdom · Taiwan · France · Italy

New York · Minneapolis

10 · 5 · 2

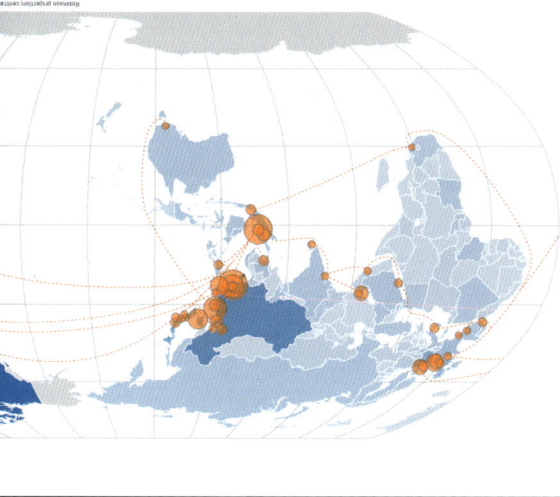

Robinson projection, centred...

Above: The Center for Urban Pedagogy (CUP) (with Rosten Woo, Longshore Workers Coalition, Labor Notes, Bill Rankin, thumb projects, Stephanie Whitehouse, and William Hood), *The Cargo Chain* (from the Making Policy Public Series), 2008 (front)

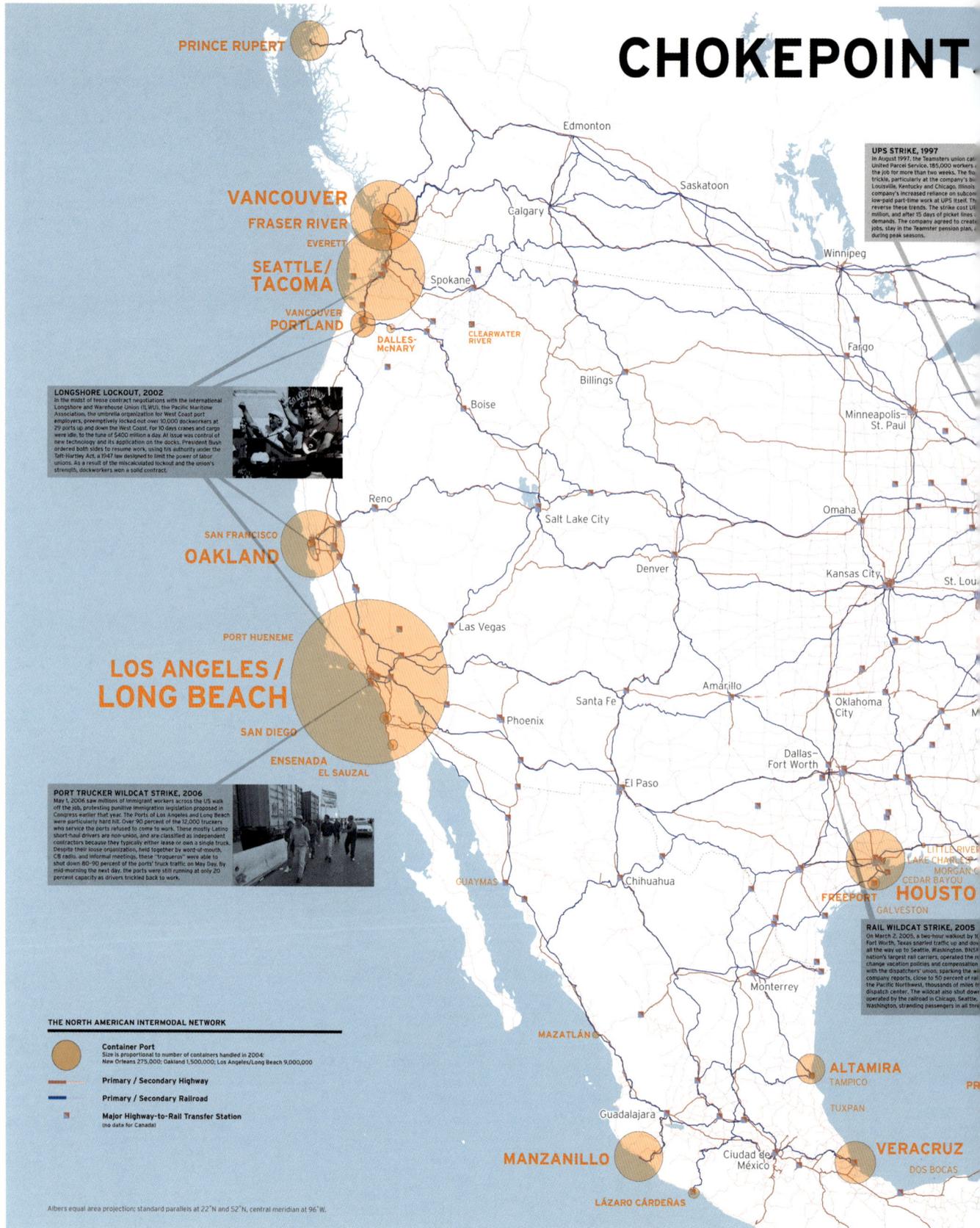

PRINCE RUPERT

Edmonton

Saskatoon

Calgary

VANCOUVER

FRASER RIVER

EVERETT

SEATTLE/
TACOMA

Spokane

Winnipeg

VANCOUVER
PORTLAND

DALLES-
McNARY

CLEARWATER
RIVER

**UPS STRIKE, 1997**
In August 1997, the Teamsters union ca...
United Parcel Service, 185,000 workers ...
the job for more than two weeks. The flo...
trickle, particularly at the company's bi...
Louisville, Kentucky and Chicago, Illinois
company's increased reliance on subcon...
low-paid part-time work at UPS itself. Th...
reverse these trends. The strike cost UP...
million, and after 15 days of picket lines ...
demands. The company agreed to create...
jobs, stay in the Teamster pension plan, ...
during peak seasons.

Fargo

Billings

Boise

Minneapolis–
St. Paul

**LONGSHORE LOCKOUT, 2002**
In the midst of tense contract negotiations with the international
Longshore and Warehouse Union (ILWU), the Pacific Maritime
Association, the umbrella organization for West Coast port
employers, preemptively locked out over 10,000 dockworkers at
29 ports up and down the West Coast. For 10 days cranes and cargo
were idle, to the tune of $400 million a day. At issue was control of
new technology and its application on the docks. President Bush
ordered both sides to resume work, using his authority under the
Taft-Hartley Act, a 1947 law designed to limit the power of labor
unions. As a result of the miscalculated lockout and the union's
strength, dockworkers won a solid contract.

Reno

Salt Lake City

Omaha

Denver

Kansas City

St. Lou

SAN FRANCISCO

OAKLAND

Las Vegas

PORT HUENEME

Santa Fe

Amarillo

Oklahoma
City

M

LOS ANGELES /
LONG BEACH

Phoenix

SAN DIEGO

Dallas–
Fort Worth

ENSENADA
EL SAUZAL

El Paso

**PORT TRUCKER WILDCAT STRIKE, 2006**
May 1, 2006 saw millions of immigrant workers across the US walk
off the job, protesting punitive immigration legislation proposed in
Congress earlier that year. The Ports of Los Angeles and Long Beach
were particularly hard hit. Over 90 percent of the 12,000 truckers
who service the ports refused to come to work. These mostly Latino
short-haul drivers are non-union, and are classified as independent
contractors because they typically either lease or own a single truck.
Despite their loose organization, held together by word-of-mouth,
CB radio, and informal meetings, these "troqueros" were able to
shut down 80-90 percent of the ports' truck traffic on May Day. By
mid-morning the next day, the ports were still running at only 20
percent capacity as drivers trickled back to work.

LITTLE RIVER
LAKE CHARLES
MORGAN C
CEDAR BAYOU

FREEPORT    HOUSTO

GALVESTON

GUAYMAS

Chihuahua

**RAIL WILDCAT STRIKE, 2005**
On March 2, 2005, a two-hour walkout by N...
Fort Worth, Texas snarled traffic up and dow...
all the way to Seattle, Washington. BNSF ...
nation's largest rail carriers, operated the r...
change vacation policies and compensation ...
with the dispatchers' union, sparking the wi...
company reports, close to 50 percent of rai...
the Pacific Northwest, thousands of miles fr...
dispatch center. The wildcat also shut dow...
operated by the railroad in Chicago, Seattle, ...
Washington, stranding passengers in all thre...

Monterrey

**THE NORTH AMERICAN INTERMODAL NETWORK**

**Container Port**
Size is proportional to number of containers handled in 2004:
New Orleans 275,000; Oakland 1,500,000; Los Angeles/Long Beach 9,000,000

**Primary / Secondary Highway**

**Primary / Secondary Railroad**

**Major Highway-to-Rail Transfer Station**
(no data for Canada)

MAZATLÁN

ALTAMIRA
TAMPICO

TUXPAN

Guadalajara

PR

Ciudad de
México

VERACRUZ
DOS BOCAS

MANZANILLO

LÁZARO CÁRDENAS

Albers equal area projection; standard parallels at 22°N and 52°N, central meridian at 96°W.

# A FRAGILE NETWORK

Big corporations rely on an integrated network of docks, railways, trucking barns, transfer yards, warehouses, distribution centers, and dispatch offices to keep goods flowing across the US, Mexico, and Canada. But the network has become overstressed and fragile, placing more power in the hands of workers at different links in the chain. If workers build strong connections across different industries and unions, they can magnify this power and use their collective leverage to create good jobs, with wages and benefits that can support families and communities.

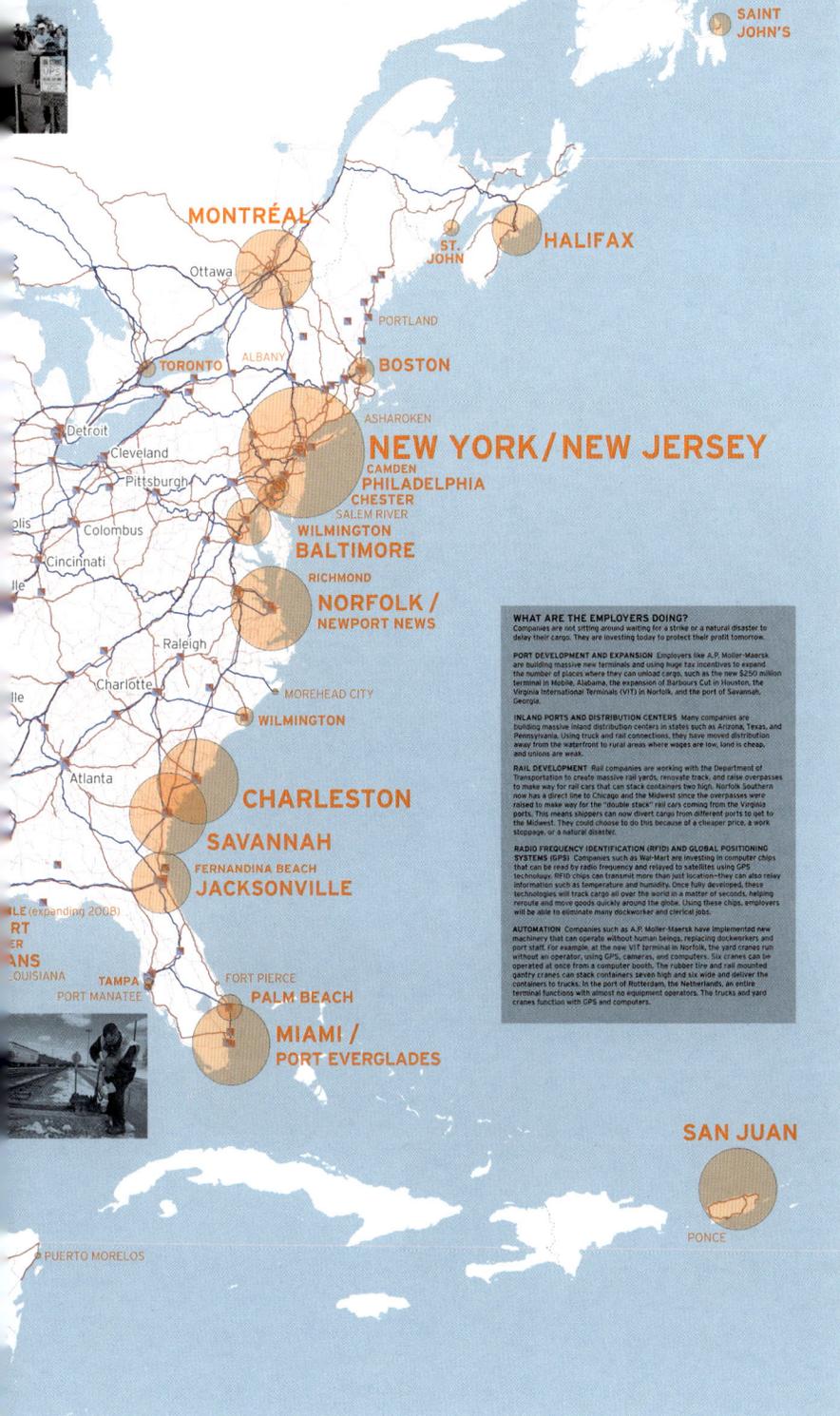

SAINT JOHN'S

MONTRÉAL
Ottawa
ST. JOHN
HALIFAX
PORTLAND
TORONTO
ALBANY
BOSTON
Detroit
Cleveland
ASHAROKEN
Pittsburgh
NEW YORK/NEW JERSEY
CAMDEN
PHILADELPHIA
CHESTER
Colombus
SALEM RIVER
WILMINGTON
Cincinnati
BALTIMORE
RICHMOND
NORFOLK /
NEWPORT NEWS
Raleigh
Charlotte
MOREHEAD CITY
WILMINGTON
Atlanta
CHARLESTON
SAVANNAH
FERNANDINA BEACH
JACKSONVILLE
LE (expanding 2008)
RT
ER
ANS
LOUISIANA
TAMPA
PORT MANATEE
FORT PIERCE
PALM BEACH
MIAMI /
PORT EVERGLADES
SAN JUAN
PONCE
PUERTO MORELOS

**WHAT ARE THE EMPLOYERS DOING?**
Companies are not sitting around waiting for a strike or a natural disaster to delay their cargo. They are investing today to protect their profit tomorrow.

**PORT DEVELOPMENT AND EXPANSION** Employers like A.P. Moller-Maersk are building massive new terminals and using huge tax incentives to expand the number of places where they can unload cargo, such as The new $250 million terminal in Mobile, Alabama, the expansion of Barbours Cut in Houston, the Virginia International Terminals (VIT) in Norfolk, and the port of Savannah, Georgia.

**INLAND PORTS AND DISTRIBUTION CENTERS** Many companies are building massive inland distribution centers in states such as Arizona, Texas, and Pennsylvania. Using truck and rail connections, they have moved distribution away from the waterfront to rural areas where wages are low, land is cheap, and unions are weak.

**RAIL DEVELOPMENT** Rail companies are working with the Department of Transportation to create massive rail yards, renovate track, and raise overpasses to make way for rail cars that can stack containers two high. Norfolk Southern now has a direct line to Chicago and the Midwest since the overpasses were raised to make way for the "double stack" rail cars coming from the Virginia ports. This means shippers can now divert cargo from different ports to get to the Midwest. They could choose to do this because of a cheaper price, a work stoppage, or a natural disaster.

**RADIO FREQUENCY IDENTIFICATION (RFID) AND GLOBAL POSITIONING SYSTEMS (GPS)** Companies such as Wal-Mart are investing in computer chips that can be read by radio frequency and relayed to satellites using GPS technology. RFID chips can transmit more than just location—they can also relay information such as temperature and humidity. Once fully developed, these technologies will track cargo all over the world in a matter of seconds, helping reroute and move goods quickly around the globe. Using these chips, employers will be able to eliminate many dockworker and clerical jobs.

**AUTOMATION** Companies such as A.P. Moller-Maersk have implemented new machinery that can operate without human beings, replacing dockworkers and port staff. For example, at the new VIT terminal in Norfolk, the yard cranes run without an operator, using GPS, cameras, and computers. Six cranes can be operated at once from a computer booth. The rubber tire and rail mounted gantry cranes can stack containers seven high and six wide and deliver the containers to trucks. In the port of Rotterdam, the Netherlands, an entire terminal functions with almost no equipment operators. The trucks and yard cranes function with GPS and computers.

Above: The Center for Urban Pedagogy (CUP) (with Rosten Woo, Longshore Workers Coalition, Labor Notes, Bill Rankin, thumb projects, Stephanie Whitehouse, and William Hood), *The Cargo Chain* (from the Making Policy Public Series), 2008. (back) This map highlights points in the North American transportation system that are vulnerable to activism by organized labor.

# BGSU

## Big Technology Connections

Day Care Center

Life Sciences Building

Physical Sciences Building

Student Union

Family & Consumer Sciences Building

Education Building

Campus Commons

Business Administration Building

ROTC

THURSTIN
N COLLEGE
PARK
FRAZEE
LEROY
MERRY
OAK GROVE CEMETERY
MERRY
MERCER
TENNIS
RIDGE
ALUMNI
WOOSTER
COURT
THURSTIN
MERCER
ALUMNI
WOOSTER
WOOSTER
CLOUGH
CLOUGH
N. MAIN ST.
MANVILLE
S. MAIN ST.

Wh
knowledg
migra

This map tra
technology
Biopower is a
and reproduc
map an
www.

The *Cultures of Tec*
project. For more info

Presented at Bowli
& *Art Festival 23*, Oct
First Year Program, S
BGSU Technology Fa
Departments of Polit
Communication Stu
Foundation (NY), Pen
Carnegie Mellon. Than

105

School of Art &
Communications

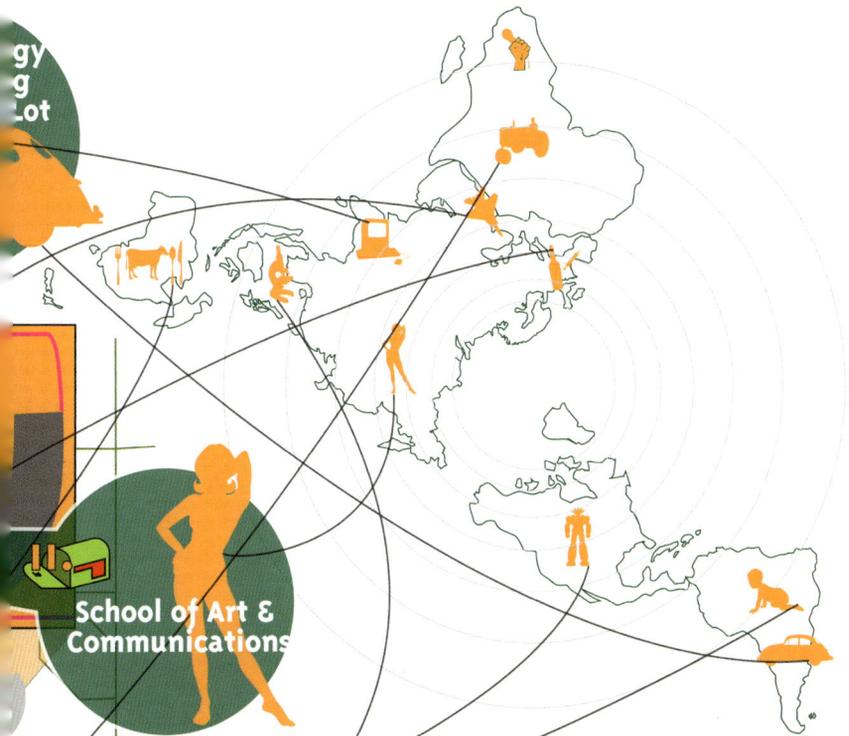

ersity students,
factory farmers and
have in common?

university
tory farm?

Biopower?

ould you
about poo?

s between different cultures of
the apparatus of Biopower.

that regulates "the production
.." Learn all about it from this
VER UNLIMITED web site!

nism.net/biopower

*Biopower Unlimited!* a subRosa tactical media
eminism.net

sity as part of *Ghosts in the Wiring, New Music*
s subRosa project is supported by the BGSU
rts Center Galleries; Computer Art Division;
er; Partnerships for Community Action; the
Women's Studies, American Culture Studies,
mposition/Theory; the Creative Capital
he Arts, and the STUDIO for Creative Inquiry,
dia.

# CULTURES OF TECHNOLOGY

## at Bowling Green State University, Ohio

Above: subRosa, *Cultures of Technology at Bowling Green State University, Ohio*, 2002. A map that links the Bowling Green State University's campus to forces of "biopower"—structures and communities that contribute to "the production of life."

# UNC is...

This *Dis-Orientation Guide* is the product of a Counter Cartographies Collective (3Cs) initiative that uses mapping to produce new ways of thinking about the university.

3Cs is a working group of the Cultures of Economies Project supported by the University Program of Cultural Studies.

3Cs formed in the spring of 2005 as a way to explore the uses of cartography and map-making to critically understand and intervene in the world we live in, especially the communities, ecologies and economies of our university.

3Cs is a network of people contributing their skills and knowledge to build a common project for a different/better University. As an open collective, 3Cs attempts to engage in non-hierarchical forms of decision-making, as well as participatory and action-oriented projects.

Terms like globalization, global networks, cyber infrastructures, mass immigration, global free trade policies leave us questioning how these issues pertain to us. Is it just something that happens "out there"? Mapping provides a way to make the connections between UNC and the "real world" visible.

Maps are more and more common in daily life. Through popular programs such as Google Maps and Pentagon mainframe cartographic systems, mapping is an increasingly important way for individuals and institutions to frame their roles and activities in the world. Mapping the university challenges existing notions of higher education institutions and our roles in them.

For more information, email countercartographies@unc.edu
or visit us on the web at http://www.countercartographies.org

## Pedestrian Space in Chapel Hill

**Why are so many maps organized by roads?**
These views map space differently by assuming the perspective of a pedestrian.

### The Most Dangerous Intersection in North Carolina for Pedestrians

14 of the 26 accidents at this intersection in recent years involved pedestrians, more than any other intersection in the state.

### Dangerous Places for Pedestrians

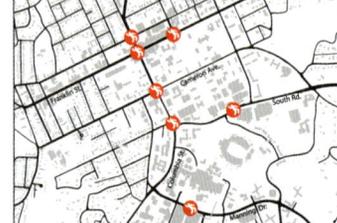

### Automotive Spaces in Downtown Chapel Hill

Roads and Parking Lots
Crosswalks

### Pedestrian Spaces in Downtown Chapel Hill

Sidewalks
Crosswalks

## Research Triangle Park

UNC is part of a local network of organizations which make money through doing research (some by taking in grants from government agencies and other corporations, some as R&D branches of larger companies). Each circle on the map at right is centered on the location of an organization in the local research industry; companies with circles which are larger and darker purple have more researchers. You'll find concentric circles on the map where a number of different companies share office space in the same building, often the largest organization is an incubator providing lab space for other smaller organizations. The 8 largest organizations are labeled on the map and described above.

## Triangle Research Corporations

1. **GlaxoSmithKline PLC**
   Center of pharmaceutical research for GSK, whose major products include Advair (asthma medication), Valtrex (herpes), Paxil and Wellbutrin. GSK is headquartered in London, and had a $30.6 billion profit in 2005.

2. **University of North Carolina**
   Research includes neurosciences, genomic and genetic science, disease prevention, public health, education. UNC took in $579 million in research funding in 2005, around 2/3 of which went to medical-related research (mostly NIH grants).

3. **Laboratory Corporation of America**
   One of the world's top providers of clinical laboratory services. Headquartered in Burlington, NC. $1.4 billion profit in 2005.

4. **RTI International**
   Created in 1959 by the Research Triangle, governed jointly by... conducts contract research areas ranging from p... weapons systems to... contract with the U.S... governance in Iraq).

5. **US Environmental Prot...**

6. **North Carolina State U...**
   Strong especially in t... nanotechnology. Rec... funding for research...

7. **Duke University**
   Clinical research, ge... medical science, pl...

8. **National Institute of E...**
   Government agency... in RTP. Does researc... dysfunction from are...

## ...a functioning body

The processes of creating knowledge at UNC all occur in a particular set of material and social circumstances. The experience of UNC is more than a B.A. or even a Ph.D. UNC happens somewhere, and it requires bodies, commutes, housing, businesses, roads, rivers, and land.

UNC has bodily functions: sleeping, walking, driving, and consuming. We rarely associate these material activities with a university. However, the university is all these things. We create this university everyday with our actions, consciously or unconsciously, and those decisions make us responsible to a variety of communities beyond the classroom.

How does Franklin Street appear differently to a pedestrian and a motorist? Where does your water go? What responsibility do you have to your river system? Who makes up Chapel Hill, only those who reside there? What economic exchanges, mainstream and alternative, take place in and around Chapel Hill?

Looking at UNC as a series of social and material networks brings into question the idea of a universal "college education" in a "college town." UNC-Chapel Hill stretches beyond the confines of its campus and generic categories. We can see the University as a place made up of connections and relations among diverse groups, inhabiting particular territories including streets and watersheds, business districts and geologic strata.

## Geology of "The Hill"

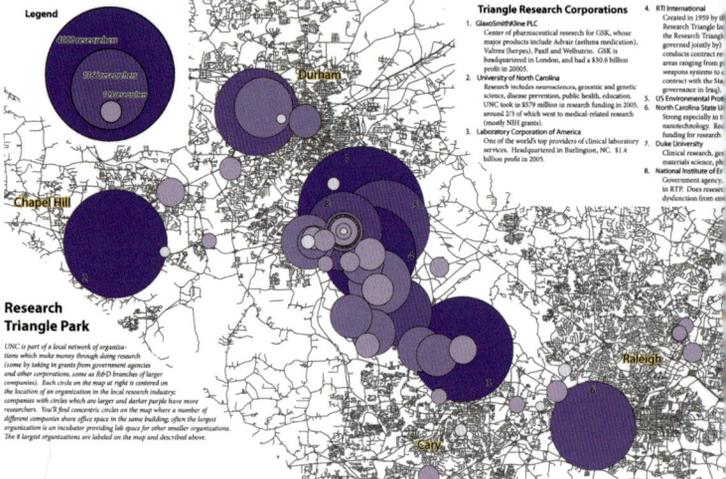

Dikes
Faults
Triassic Basin
Granite intrusions

## Where UNC Sleeps

Number of faculty
Number of staff
1 - 9
10 - 99
100 - 499
500 - 999
1000 - 3000

The place-names on this... come from course listin... 2005 Undergraduate B... Most of them are regul... and all have been revie... approved by the Colleg... Sciences. To make the... place names in order f... ied list of courses in th... ate Bulletin (e.g. we us... Japan" to label Japan b... randomized list is mear... about Japan).

Some regions have man... taught about them at U... listed on this map: Wes... (especially Germany),... United States. But in g... are few or no courses a... the map, there are few... at UNC.

## ...a factory

Universities, especially research universities such as UNC, form vital nodes of the knowledge economy.

In the current economy, knowledge produces economic value (e.g. ideas, inventions, know-how, information, research). In fact, products of knowledge industries may be even more important, in terms of profit and investment, to today's economy than industries that produce stuff (cars, refrigerators, clothes).

Knowledge cannot be quantified or traded - it never runs out, cannot be held in place, and continuously refines itself. Knowledge economies produce specialized workers (researchers, programmers, and inventors) and research findings to be sold for high profits. They also create a new set of working and living conditions for employees (see *Precarity*, on reverse).

UNC, a leading US research University, is part of a dense network of higher education institutions in the area, and it is closely connected to one of the most-referenced research and development parks in the world: the Research Triangle Park (see *RTP*, on reverse).

UNC is a machine of knowledge production and workforce training:
• The university's graduates are cherished raw material for the Knowledge Economy. Graduates and professors find contracts at corporate laboratories and research industries in RTP, of which UNC is a founding member. In fact, this area has one of the highest concentrations of PhDs in the country.
• Spin-off companies start as university initiatives to funnel research findings into lucrative deals for companies investing in the area. Patents for new discoveries generate economic gain but limit access to the knowledge to a few researchers.
• The types of research in which corporations and the government choose to invest affect the direction of UNC in its role as a factory of the Knowledge Economy.

Whereas we once thought that coming to a university meant "leaving the real world," if we take another look, it seems that the real world may be "going back to school".

### International students enrolled at UNC-CH in 2005

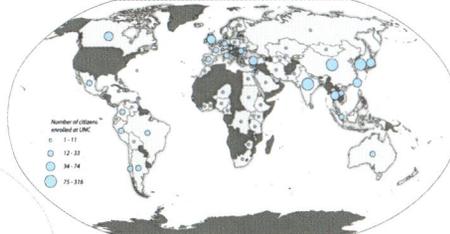

Number of citizens enrolled at UNC
○ 1 - 11
○ 12 - 33
○ 34 - 74
○ 75 - 516

### UNC-CH Students studying abroad in 2005

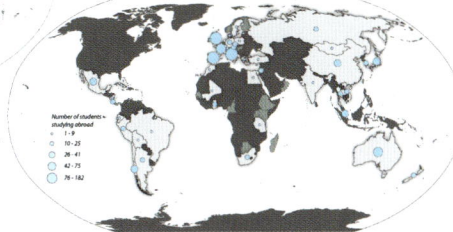

Number of students studying abroad
○ 1 - 9
○ 10 - 25
○ 26 - 41
○ 42 - 75
○ 76 - 182

Country where UNC students studied abroad in 2005-2006 | Country where no study abroad programs are endorsed by UNC | Country where UNC-endorsed programs are offered, but no students studied in 2005-2006.

Source: Fall 2005 Passport and Study Abroad Office

### Graduate Research at UNC-CH, 1996-2005

Each dot represents a specific place mentioned in the title of a dissertation written by a UNC graduate student.
Source: ProQuest CurrentResearch@UNC database, and Metacarta Labs

### A note on projections...

We used a Mercator projection for *The World Through Course Titles* (below) because it has historically been used for navigational maps, which we wanted to evoke. As a rectangular, navigational map, it grossly distorts the size of landmasses (despite its appearance below, Greenland is, in fact, only about the size of Mexico). We used a round Mollweide projection for the graduate research map (above) because it preserves areas, making the relative areas of each country equal to all others and thereby allowing direct comparisons of dot density. The study abroad and international enrollment maps to the right both use the Robinson projection. It spreads the globe in a way that makes individual countries and symbols easier to distinguish, but distorts areas near the poles. The map on the front cover uses our own antipodal projection, where the center of the map is the point opposite Chapel Hill on the globe, and the outer ring of the map is North Carolina (and Chapel Hill).

THE WORLD
THROUGH COURSE TITLES

The Viking Age

RUSSIAN FAIRY TALES

DANDIES AND DEAD SOULS: RUSSIAN LITERATURE AND CULTURE, 1800-1850

REVOLUTION IN RUSSIA, 1900-1930

EASTERN EUROPE SINCE WWII

GOVERNMENT AND POLITICS OF EAST ASIA

EUROPEAN UNION

LITERATURE OF RUSSIAN TERRORISM

MODERN MUSLIM WORLD

ASIA AND WORLD AFFAIRS

Trans-Atlantic Slave Trade

WEST AFRICA

NORTH-EAST AFRICA

CONTEMPORARY AFRICA

INTRODUCTION TO ARAB CULTURE

MUGHAL ART

CHINESE WORLD VIEWS

History of Sea Power

EAST AFRICAN SOCIETY

AFRICAN RELIEF SYSTEMS, PHILOSOPHY AND RELIGION IN SUB-SAHARAN AFRICA

POP CULTURE OF MODERN SOUTHEAST ASIA

INTRO TO LATIN AMERICAN STUDIES

HISTORY OF BRAZIL

SOUTHERN AFRICA IN CONFLICT

Biological Oceanography

AUSTRALIA / US COMPARATIVE HISTORY

Seminar:
...d all
.a Go?

CONTEMPORARY LATIN AMERICAN POLITICS

Above: Counter-Cartographies Collective, *Disorientation Guide,* 2006. Produced by students, this map was distributed on the UNC-Chapel Hill campus during campus orientation. The map proposes links between UNC-Chapel Hill and a variety of structures in the world economy.

# STATEMENT OF INTENT BOUNDARIES
## BRITISH COLUMBIA'S COASTAL FIRST NATIONS

**Legend**

- Reserves (populated & unpopulated)
- Parks & Protected Areas (2007)

**Non-SOI Territory Extents**

- Nisga'a
- Lil'wat (Mt. Currie)
- Hesquiaht
- Tahltan

**Statement of Intent Areas (alphabetical)**

- Acho Dene Koe First Nation (45) - F1
- Allied Tribes of Lax Kw'alaams (57) - C3
- Carcross/Tagish First Nation (37) - B1
- Cariboo Tribal Council (5) - F4
- Carrier Sekani Tribal Council (36) - E3
- Champagne and Aishihik First Nations (35) - A1
- Cheslatta Carrier Nation (25) - E4
- Council of the Haida Nation (40) - B4
- Da'naxda'xw Awaetlatla Nation (28) - E5
- Ditidaht First Nation (24) - G9
- Esketemc First Nation (15) - F5
- Gitanyow Hereditary Chiefs (34) - D3
- Gitxsan Hereditary Chiefs (33) - D3
- Gwa'Sala-'Nakwaxda'xw Nation (27) - D5
- Haisla Nation (42) - D4
- Hamatla Treaty Society (44) - E5 & G7
- Heiltsuk Nation (41) - D5
- Homalco Indian Band (23) - G7 & E5
- Hul'qumi'num Treaty Group (Core) (52) - H8
- Hul'qumi'num Treaty Group (Marine) (53) - H9 & H8
- Hupacasath First Nation (1) - G8
- In-SHUCK-ch Nation (48) - I1
- Kaska Dena; Liard FN; Ross River Dena (32) - D1
- Katzie Indian Band (14) - I8
- Klahoose Indian Band (22) - G7 & E5
- Kwakiutl Nation (21) - D5
- Lake Babine Nation (38) - E3
- Lheidli T'enneh Band (7) - F4
- Maa-nulth First Nations (56) - D6 & G8
- McLeod Lake Indian Band (49) - F3
- Musqueam Nation (13) - H8
- 'Namgis Nation (20) - D6
- Nazko Indian Band (6) - F4
- Nuu-chah-nulth Tribal Council (50) - G8 & E6
- Pacheedaht Band (19) - G9
- Quatsino First Nation (16) - D5
- Sechelt Indian Band (12) - H7
- Sliammon Indian Band (18) - G7
- Snuneymuxw First Nation (43) - H8
- Squamish Nation (11) - H7
- Sto:lo Nation (10) - I8
- Taku River Tlingit First Nation (31) - B1
- Te'mexw Treaty Association (54) - H8 & H9
- Teslin Tlingit Council (30) - C1
- Tlatlasikwala Nation (17) - D5
- Tlowitsis First Nation (58) - E5
- Tsawwassen First Nation (9) - H8
- Tsay Keh Dene Band (29) - E2
- Tsimshian First Nations (55) - C4
- Tsleil-Waututh Nation (Burrard Band) (8) - I7
- Wet'suwet'en Nation (2) - D4
- Wuikinuxv Nation (Oweekeno) (26) - E5
- Yale First Nation (51) - F6
- Yekooche Nation (39) - E3

First Nations are the indigenous peoples of what is now known as Canada.

NOT ALL FIRST NATION TERRITORIES ARE REPRESENTED ON THIS MAP.

The data used to produce this map has been collected and presented without prejudice. This map is an interpretation of Statement of Intent boudaries, submitted by First Nations to the BC Treaty Commission as required in Stage 1 of the Six-Stage Treaty Process. Statement of Intent boundaries only include Nations that intend to negotiate treaties.

0 50 100 200
Kilometers
1:1,700,000

**ecotrust**
c a n a d a

Map produced by Ecotrust Canada
Copyright © 2008
www.ecotrustcan.org
www.nativemaps.org

0 12.5 25 50
Kilometers

Inset Map

See Inset Map

Left: Ecotrust Canada, *Statement of Intent Boundaries,*
2008

Above: Beehive Design Collective, *FTAA*, 2003. An
interpretation of the FTAA, this map was distributed at
an FTAA protest in Miami in 2003.

## >> militarización

> SIVE [Servicio Integrado de Vigilancia Exterior]
> Fronteras militarizadas, aduanas, puestos fronterizos

> Instalaciones militares: Rota, San Fernando, Barbate, Morón, Gibraltar, Ceuta, Melilla, Vélez, Alhucemas, Chafarinas... Submarinos nucleares
> Radares, satélites militares
> Centros de vigilancia SIGINT / UKUSA

> Centros de internamiento de inmigrantes
> Centros de internamiento de jóvenes inmigrantes
> Delegaciones provinciales de la policía marroquí para la lucha contra la inmigración ilegal
> Redadas contra inmigrantes, deportaciones
> Incidentes racistas contra inmigrantes

**Otros centros de internamiento de extranjeros en el Estado Español** [2003 / existentes y en proyecto]:
> Madrid Moratalaz / Madrid Carabanchel / Barcelona Zona Franca / Barcelona la Verneda / Valencia / Murcia...

**Cárceles y presos en el Estado Español** [2004]
> 58.378 presos / 77 prisiones / 150% ocupación [El País]
> España es el segundo país europeo en número de reclusos
> En el 2003 se comienzan a promover 4 nuevas cárceles [2 en Sevilla y Cádiz]

**Desplazamiento / extensión de la frontera** [ver análisis en indymedia]
Durante 2004 se ha intensificado la política de desplazamiento a Marruecos de los controles sobre la movilidad, entre cuyas medidas pueden incluirse:
> Redadas y deportaciones en campamentos de refugiados en Marruecos
> Reforzamiento de los pasos fronterizos de Ceuta y Melilla [inversión de 1.750 millones de euros en subir la valla de 3 a 6m de altura y dotación de nuevos equipos de audio/video vigilancia y procesamiento de datos / 08.04 / Presupuesto para Ceuta]
> Detención de 56.000 migrantes ene 2003 - ago 2004 en Marruecos [Fuente EP]
> La UE ha aprobado la financiación de campos de detención de migrantes en Marruecos, Mauritania, Libia, Túnez y Argelia (10.04)...

Frontera en Melilla 2003.
Fuente: El País

**Flujos capital: tráficos diversos, paraísos fiscales, especulación inmobiliaria /**
Marruecos, que genera e ingresa tanto del "tráfico" de migrantes como de drogas, Gibraltar como paraíso fiscal para el blanqueo inicial de capitales y la Costa del Sol como destino final y receptor del blanqueo de capitales y financiador en parte del "tráfico" que se genera en el Estrecho. [Contribución en indymedia]

## >> migraciones

> Rutas pateras / Estrecho de Gibraltar - Canarias
> Áreas de procedencia de l*s migrantes que cruzan el Estrecho
> Campamentos de refugiados económicos en Marruecos y el estado español
> Zonas de destino: El Ejido, Fresa Huelva, capitales, otros...
> Mafias, conexiones con tramas financieras fraudulentas

> Procesos de autoorganización social y de la [in]migración

**Datos Inmigración Estado Español [Ministerio del Interior / 2003]**
> Número total inmigrantes "con papeles":1.647.000
> Porcentaje sobre el total de la población: 3.8%
> Número de inmigrantes africanos "con papeles": 432.600
> Número de inmigrantes marroquíes "con papeles": 333.700
> Número de inmigrantes "con papeles" en Andalucía: 208.523
> Número de inmigrantes africanos "con papeles" en Andalucía: 62.864
> Destinos principales de los inmigrantes en el Estado Español: Madrid [20%], Barcelona [16%], Levante, Andalucía, Canarias y Baleares
> Número de inmigrantes empadronados: 2.500.000 [852.000 más que los "regularizados" / Fuente: El País]
> Estimación de la población inmigrante en el Estado Español para el 2015: 11.777.000 / 27% [Fuente: Papeles de Economía Española]

> El **proceso de regularización de inmigrantes** del gobierno del estado español, que se iniciará a principios de 2005, supone la regularización potencial de 800 mil a 1 millón de inmigrantes. Debe ser valorado como una conquista de las luchas sociales de los últimos años y, en particular, de la migración como movimiento social.

Inicio del muro occidental

Frontera saharaui-marroquí

Cientos de kilómetros de muros militares marroquíes segregan y controlan a la población autóctona del Sahara Occidental que en gran número vive en campamentos de refugiados del Frente Polisario en la zona de Tinduf [Argelia]

>>conflicto por la autodeterminaci... pueblo saharaui

Ifni

Agadir

Ouarzazate

Er-Rachidia

MARRAKECH

Essaouira

Beni-Mellal    Fkih Ben Salah

Safi

**MAGREB**

Khouriga

Settat

**MARRUECOS**
Población: 30.988 mill.hab [2002]
Sup: 446.550 km2
PIB/hab: 3.600 U$/hab [2004]
Índice Desarrollo Hum.: núm. 126

Atentado extremista islámico 2003

CASABLANCA

Astras serie emitiendo so... y Canarias, Al-Jazeera. Otros cons... recibe en el Hotbird de E... & 1B, Intelsa...

Según esp... utiliza... militares dur... Las tareas d... disp... reconocimi... de comuni... tierra, t... misiles y "s... inmediata... 24 sat... conform... System tamb...

Se estim... satélites de c...

**ARGELIA**

Oujda

Guercif

Taza

FEZ

MEKNÉS    Temara / DST

RABAT
Salé

Kenitra

http://liftoff.msfc.nasa... tml & Michael...

Ketama

Ouazzane

Operación Paso del Estrecho [anual para el verano]:
1.000.000 pasajes
250.000 vehículos
2.000 rotaciones Algeciras-

SIVE

Nador

Islas Chafarinas

Melilla

Alcázar-Kebir
Chauen

Larache

RIF

170 Km

Al-Hoceima

Peñón de Alhucemas

Peñón de Vélez de la Gomera

Frontera militarizada
>ver detalle

Tetuan

Asillah

Martil
Mdiq
Smir

Frontera militarizada

Zona militarizada por el S.I.V.E. [2001-2004]

Ksar
Segu...

Sebta

Tanger

56.679 barcos anuales cruzan El Estrecho. Aprox. 5.000 petroleras [Greenpeace / 2001]

Gibraltar
YES
La Bolonia
Zahara

Tarifa

Caños Vejer
Barbate
Conil

YES

Algeciras

EVA 11
Puerto Real
San Fernando

Cádiz

Sigint UKUSA

Rota

Almería

El Ejido

Invernaderos y cultivos intensivos

Motril    Almuñécar

YES

MÁLAGA

Marbella

YES

Jerez

Puerto de Sta. María

GRANADA

Morón

SEVILLA

Faro

Almonte    Palos
Moguer    Lepe

Huelva

Comarca de la Fresa de Huelva

Córdoba

Constantina
EVA-3

**ESPAÑA**
Población: 42.717 mill. hab [2002]
Sup: 505.990 km2
PIB/hab: 19.472 U$/hab [2000]
PIB/hab: 95% UE-25 [2004]
Índice Desarrollo Hum.: núm. 21

**UNIÓN EUROPEA**

**PORTUGAL**

Tran...

Una cart...

La multit...

Libertad...

>> flu...

SIVE:
Inversión 2002-2004: 103 millones de eu...
Inversión 2004-2008: 130 millones de eu...
Ampliación Granada, Málaga, Almería, Huelva, Ceuta, Gran Canaria...
61 patrulleras...
2 aviones...
tecnología varia...

ISLAS CANARIAS

El-Aaiun
Tarfaya
Cabo Juby
GRAN CANARIA
Las Palmas de Gran Canaria
Fuerteventura
Santa Cruz
TENERIFE
La Gomera
El Hierro
Malpaso proyecto
La Palma
Arrecife
Lanzarote
EVA-22
EVA-21
Taborno proyecto
Santuario de zifios afectados por maniobras militares
Deportaciones Península
Faro de la Entallada
Aeropuerto El Matorral [2003]

Rutas de las pateras entre el Sahara y Canarias
Rutas de "barcos negreros" desde Mali y Senegal

ainas antipersona

deslocalización de la producción

l estado español operaban Marruecos en el año 2003 [Datos mía], desarrollando actividades en los sectores de banca, ones, sanitarios, metalurgia, suministro de agua, productos de n, petróleo y gas, promoción inmobiliaria y construcción.

s en los que se está produciendo el proceso global de roducción son los de telecomunicaciones [teleoperador*s: xtil [Zara, Cortefiel, Corte Inglés...], producción de frutas y

ntre los dos estados es favorable en un 122% para España, acar que la mayor parte de los intercambios entre los dos l comercio entre las propias empresas españolas a uno y otro

millones de turistas [2002] or los migrantes suponen la primera fuente de divisas del país

cción, Tánger Med SA, de financiación marroquí e erá un macropuerto en Alcazar S... y una zona económica de entre Ceuta a Tánger para el establecimiento de scala (http://www.tmsa.ma)

Footprint de la serie Hotbird de Eutelsat / GEO: 13° E, por los que se emiten 700 canales fadaiat de TV en más de 30 lenguas diferentes, entre otros: Al Jazeera Sat Channel, Al Hayat, Al Arabiya...

Internet y la telefonía móvil han supuesto una radical transformación social del territorio madiaq: tripulantes de pateras en comunicación con tierra, campamentos de refugiados con equipos autónomos para recarga de móviles, ubicuos cibercafés, redes sociales y productivas que sobrevuelan El Estrecho...

HOT BIRD 2, 3, 4 AND 5 WIDEBEAM

50 dBW 60cm
49 dBW 70cm
48 dBW 75cm
47 dBW 80cm
46 dBW 90cm
44 dBW 1.20m
42 dBW 1.50m
40 dBW 1.80m

70 cm

Pateras interceptadas por la Guardia Civil [2002-2003]

Totales
848
775

Se estima que entre 1997 y 2001 han muerto 3286 personas intentando cruzar El Estrecho [AFVIC]. Para el periodo de estudio estimaciones razonadas cifran las detenciones en un 20-30% del total de migrantes que usan este medio para cruzar El Estrecho.

Canarias
344
450

Península
504
325

Migrantes interceptados por la Guardia Civil [2002-2003]

Totales
15.985
13.500
+18.4%

En septiembre de 2004 las detenciones por el SIVE se habían reducido en un 17% respecto del año anterior

Canarias
7.657
6.875

Península
5.843
9.110

nes/fadaiat

territorio geopolítico del Estrecho de Gibraltar / 11.2004
el Imperio
miento | Libertad de movimiento
>>militarización
>>migraciones
tal / deslocalizaciones
>>comunicación
> flujos de la multitud

version 1.0

Licencia de distribución: creative commons :: attribution / non-commercial / share alike
ver: http://creativecommons.org/licenses/by-nc-sa/2.0/

Producción: indymedia estrecho, hackitectura.net, casa de iniciativas 1.5, indymedia canarias

Colaboradores investigación:
fmm cabeza de vaca, jv araújo (tarifa)
colectivo aljaima (tánger)

UNIA arteypensamiento

Above: Hackitectura and collaborators, *Tactical Cartography of the Straits,* 2004 (front). Hackitectura, a Spanish collective, maps Spain, Portugal, and Morocco and attempts to illustrate the geography of "Empire" and "the Multitude."

# The World Government

intelligence complex

state-controled complex

French strategic area

Bureau d'études, 2005

Above: Bureau d'études, *The World Government*, 2005.
The French collective Bureau d'études' interpretation
of "world government," a structure that they outline
as including a colossal range of state and non-state
actors. The map is organized along four axes: a
"financial heart"; a "psychological complex (medias)";
a "state-controlled complex"; and an "intelligence
complex."

# Malibu Public Beaches

## WELCOME TO THE BEACH!

Just a stone's throw from Los Angeles, the world-famous Malibu coastline offers 27 miles of scenic public beaches. Spend a day in the sun on one of the beautiful all-public beaches. Or head for the 20 miles of public beaches that are lined with private property—where you can go beachcombing and wildlife-watching on the state lands below the high tide line and sunbathing and sign-watching on the abundant public easements on the dry sand. Whether you're visiting from far away or from the properties next door, Malibu's public beaches will reward you with abundant opportunities for recreation and discovery.

> "Development shall not interfere with the public's right of access to the sea...including...the use of the dry sand and rocky coastal beaches to the first line of terrestrial vegetation."
>
> — California Coastal Act, Section 30211 (1976)

> "The state of California owns...the lands seaward of what is called the 'mean high tide line'.... Although it is difficult to ascertain the boundary between public and private lands, a general rule to follow is that visitors have the right to walk on the wet beach."
>
> — California Coastal Commission, *CA Coastal Access Guide* (2003)

WHERE IS

to 101
Ventura Fv

to Ventura

to 101
Ventura Fwy

mulholland hwy

Broad Beach Rd

pacific coast highway (PCH)

trancas canyon rd

Heathercliff Rd

kanan dume rd

Latigo Shore Rd

latigo cyn rd

corral cyn rd

malibu cyn rd

Pepperdine University

Leo Carrillo State Beach **R**

Nicolas Canyon County Beach **R**

El Pescador State Beach **R**

La Piedra State Beach **R**

El Matador State Beach **R**

Lechuza Beach

Trancas (Broad) Beach

Westward Bch Rd

Malibu Cove Col Dr

Escond Bch Rd

Latigo Beach

Dan Blocker County (Corral) Beach **R**

Malibu Rd

Malibu Beach

Zuma County Beach **R**

Point Dume State Beach **R**

Westward Beach

Point Dume

Paradise Cove

Little Dume Beach

Big Dume Beach

Escondido Beach

Malibu Road Beaches (Puerco & Amarillo)

Malibu Bluffs St Recreati Area **R**

PACIFIC OCEAN

**1 2 3 4 5 6 7 8 9 10 11 12 13**

## ACCESS TO PUBLIC-PRIVATE BEACHES

### Lechuza Beach
**1** Broad Beach Rd at West Sea Level Dr
**2** Broad Beach Rd at Bunnie Ln
**3** Broad Beach Rd at East Sea Level Dr
*All-public beach between West Sea Level Dr and 1 house west of Bunnie Ln*

### Broad Beach
**4** Between 31346-31340 Broad Beach Rd
**5** Between 31138-31202 Broad Beach Rd

### Escondido Beach
**6** Between 27420-27400 PCH
*Just West of Geoffrey's restaurant*
**7** Between Malibu Cove Colony Dr and Escondido Beach Rd
*Just East of Geoffrey's restaurant*

### Latigo Beach
**8** Latigo Beach
Latigo Shore Rd
*Park on PCH*

### Malibu Road Beaches (Puerco & Amarillo)
*Turn on Webb Way from PCH*
**9** Between 25120-25116 Malibu Rd
**10** Between 24742-24712 Malibu Rd
**11** Between 24604-24572 Malibu Rd
**12** Between 24436-24434 Malibu Rd
**13** Between 24320-24314 Malibu Rd

**14 Malibu Beach**
Take the path wes
parking lot.

### Carbon Beach
**15** "Zonker Harris Acc
East edge of 227
**16** West edge of 2212

### Big Rock Beac
**17** Between Moonsha
*Closed due to stor*
**18** Between 20000-19

## C BEACH?

Private property

Photo-maps like the one below are a handy tool for locating dry-sand easements, and are available on the Coastal Commission website for Broad and Carbon beaches. Less detailed Public Access maps for all of Malibu are also available under the "Malibu LCP" section. See www.coastal.ca.gov/pubs.html.

Public Easement
Many private beach properties have public easements on the dry sand

Mean High Tide Line (MHTL):
18-yr. avg. high tide (unmarked)

Daily High Water Line (DHWL):
Wet/dry boundary (last high tide)

Wet Sand
Public property—You can walk here!

31054
31052

31054    31052

Public Access: extending 25 ft inland from daily high water line (b)

Public Access: extending 25 ft inland from MHTL

las flores cyn rd
big rock rd
topanga cyn rd
sunset blvd

ek Rd

1

16  La Costa Beach    Las Flores Beach    Big Rock Beach    **Las Tunas State Beach**    **Topanga State Beach**    to Santa Monica and 10 Fwy
arbon
each
17    18    R    R

alibu Pier
r

Beach hours vary. 7am-10pm at most all-public beaches. Public-private beaches open 24 hrs; access gates open sunrise-sunset for entry, 24 hours for exit (not locked from beach side).

lony)
u Lagoon

### Legend
North

**1** Access to public-private beaches
**R** Restroom
**M** MTA 534 bus stop, www.metro.net
**S** ParkLink Shuttle Stop, www.parklinkshuttle.com

*Bold indicates all-public beaches.*

*East of Broad Beach, public-private beaches are often not passable at high tide. See other side for "Reading a Tide Chart."*

0340 PCH

Above: Los Angeles Urban Rangers, *Malibu Public Beaches*, 2007

# Los Angeles Urban Rangers

Los Angeles Urban Rangers

*garden LAb experiment*
The Wind Tunnel
Art Center College of Design
950 S. Raymond Avenue
Pasadena, California
September 7 - October 16, 2004

**The Los Angeles Urban Rangers is an interdisciplinary collective of local writers, artists, planners, architects, geographers, scientists, environmental historians, and educators. In conjunction with the *garden LAb experiment*, the Los Angeles Urban Rangers will offer a series of interpretive programs to address notable aspects of urban ecology in Los Angeles. Please join us at Art Center's South campus (a.k.a. the Wind Tunnel), at the Campfire Circle, on Saturdays throughout the exhibit. Sample Campfire programs are described here. Please be sure to check www.gardenlab.org for the most up-to-date schedule of events.**

*Project Organizers:* Emily Scott, Jennifer Price, Sara Daleiden, Therese Kelly

## Thoreau Goes to Los Angeles

How can we write about nature in L.A.? Why have nature writers shunned this megalopolis? Why should L.A. in fact be a mecca for nature writing? Why would an interest in cities save nature writing from being so terribly boring? Ranger Jenny Price explores these questions and more as she surveys a wide range of urban nature stories that this literary genre has entirely ignored. Join her as she describes our connections to nature in L.A. through such topics as mango body whips, murdered chihuahuas, the social geography of L.A.'s air, and the saga of the L.A. River – which is arguably the most important L.A. nature story of all.

## Sustainability vs Sprawl: Revisiting Banham's Four Ecologies

Long maligned as the poster child of smog, sprawl and unsustainable development, Los Angeles has in the past few years surprisingly emerged as a leader in "green" urbanism. The three "greenest" buildings in the U.S. are located in Los Angeles, pioneering efforts in integrated watershed management throughout the L.A. River basin, locally-based efforts to reclaim abandoned industrial lands for parks, gardens and open space, and innovations in transit planning in the L.A. region are just a few of the growing number of important "green" designs, plans and policies shaping the city. Join Ranger Alan Loomis as he explores the beaches, the foothills, the freeways, and the flatlands of Green L.A.

## Industrial Habitat: The Baldwin Hills

Did you know that the only canine that can climb trees lives in the very heart of Los Angeles? Ranger Therese Kelly will share the story of the rare Gray Fox who's crazy feats also include living amongst 400 bobbing oil derricks in a massively degraded habitat. The Baldwin Hills – heavily industrial yet ecologically fragile – is set to become the largest urban park in state history. Rising 500 feet above the L.A. basin, the Baldwin Hills command impressive views to the Santa Monica Bay, the San Gabriel Mountains, the whole of developed Los Angeles, and even Point Dume. Come learn about this fascinating brownfield site in the middle of the city, which supports a rich array of native plants, insects, and animals.

## Hunting and Gathering in the Big City

Often when we think of hunting and gathering, ancient or "traditional" cultures come to mind. In many of America's greatest cities, however, the urban poor still forage for wild and domestic food simply to meet their daily caloric needs. These resources are not just limited to discarded trash, but include wild and feral urban animals such as birds, cats and dogs, fish, and rodents. In cities like Los Angeles, those without daily food security may also be forced to trespass onto private property in order to collect fruits, nuts, and other edible plants. Join Ranger Pete Alagona as he explores L.A.'s networks for finding, collecting, sharing, and preparing these urban foods. How do these foraging activities change traditional notions of human ecology, hunting and gathering, and ecological resources in the urban environment? And what do these practices – and our reactions to them – say about urban America today?

## End Landscaping: Los Angeles Freeway Gardens

Everyday, countless Angelenos whiz along the freeway at many miles per hour without noticing the landscaping at their side. Join Ranger Emily Scott to learn more about who manages these edgy green spaces, which plants cover the more than 8,000 acres of sinewy freeway "gardens" in Los Angeles and Ventura counties, why various flora are chosen for their ornamental value and/or abilities to endure drought, buffer sound, control erosion, resist weeds, and even counterbalance auto emissions. Discover, also, the wonderful world of "transportation art," intended for maximum community pleasure and minimum driver distraction. Finally, consider how and why these areas – first pitched as ideal picnic stops for leisurely Sunday afternoon excursions – are now almost entirely access controlled, or off-limits to embodied exploration and occupation.

## Toxic Tourism in Los Angeles

Ranger Donna Houston explores the toxic history of Los Angeles from the perspective of environmental justice. Participants will learn about the history and politics of environmental justice activism in Los Angeles as well as become acquainted with some important sites of environmental struggle via a virtual toxic tour of the city. Toxic touring is is a way of reclaiming landscapes blighted by industrial pollutants and wastes as places of community and cultural memory. Toxic touring involves developing different strategies for 'walking in the city' in order to recover histories suppressed through the often violent reorderings of L.A.'s urban and industrial landscape.

## Los Angeles and the Nature of Time

How we experience time in Los Angeles is structured by everything from cell-phones, which seek to minimize it, to movies featuring natural disasters in town, which seek to maximize it. Both are examples, however, of living only in the present. Ranger Bill Fox will help us rediscover time across a longer spectrum in Los Angeles – from the La Brea Tar Pits to the Forest Lawn Memorial Parks to the Mt. Wilson Observatory. Along the way we'll detour into the human neurophysiology of time, how to make lava for Hollywood, and why Los Angeles has the largest collection of faux classical Italian sculpture in its gardens.

## Alley CAT

The ranger-led alleyCAT tour will explore several alley sites located between ArtCenter's Wind Tunnel exhibition space and downtown Los Angeles. This is both a driving and walking tour with multiple stops, so be prepared to carpool/caravan and hit the alley trails. We will encounter illegally dumped trash, graffiti and tagging, as well as sublime views and wildlife. Your ranger will lead you on an encounter of these urban landscapes to spark discussion on their current state and provide a forum for participants to share their own reactions and visions. Alley's are a world away right behind our homes, a lesser-explored touch-point between public and private urban space. Please check www.gardenlab.org for sign-up and schedule for this tour.

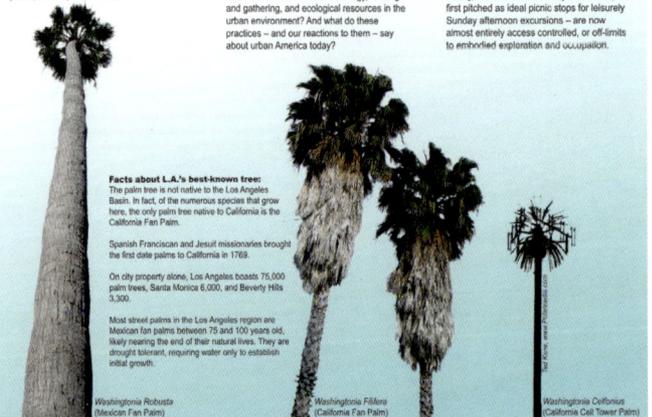

**Facts about L.A.'s best-known tree:**
The palm tree is not native to the Los Angeles Basin. In fact, of the numerous species that grow here, the only palm tree native to California is the California Fan Palm.

Spanish Franciscan and Jesuit missionaries brought the first date palms to California in 1769.

On city property alone, Los Angeles boasts 75,000 palm trees, Santa Monica 6,000, and Beverly Hills 3,300.

Most street palms in the Los Angeles region are Mexican fan palms between 75 and 100 years old, likely nearing the end of their natural lives. They are drought tolerant, requiring water only to establish initial growth.

*Washingtonia Robusta*
(Mexican Fan Palm)

*Washingtonia Filifera*
(California Fan-Palm)

*Washingtonia Cellphonius*
(California Cell Tower Palm)

# Los Angeles Urban Rangers

Los Angeles Urban Rangers

garden LAb experiment
The Wind Tunnel
Art Center College of Design
950 S. Raymond Avenue
Pasadena, California
September 7 - October 16, 2004

**The Los Angeles Basin**
Los Angeles County is an 834-square-mile multiple-use area. Its beaches, mountains, and flatlands offer a great abundance and diversity of opportunities for dwelling, working, foraging, shopping, socializing, mating, and recreation.

**Getting Here/ Getting Around**
The L.A. basin is easily accessible by car and aircraft; bus, train, and boat; motorcycle and scooter; foot, bicycle, and roller and inline skates; internet, phone, and fax; and movies and TV shows in many languages. Travel within the basin can be done also by subway

and light rail in limited areas. The most common method of travel is by car.

**The Landscape**
The L.A. basin is a mosaic of geological zones, as well as ecological zones that include chaparral, coastal scrub, riparian areas, wetlands, oak woodlands, and grasslands. These zones have been overlaid by a territorial grid of city and county jurisdictions, as well as a transportation grid, a land-use grid, and a grid of shifting socioeconomic zones. These systems all interact in complex ways that can be difficult to predict. L.A.'s inhabitants have also translated

these interacting systems into a landscape of identity, with key zones that include the Valley, Pasadena, Long Beach, Downtown and Silver Lake, East L.A., South L.A., and the Westside.

**L.A.'s Famous Climate**
Many people think of Los Angeles as a desert with year-round warmth and little rain. But in fact, L.A. enjoys a semi-arid, Mediterranean climate – a rare climate, enjoyed by just five areas worldwide, with hot, dry summers and mild winters with intermittent rains. A foggy layer of "June Gloom" often visits coastal areas in early summer as the inland region

heats up and draws moisture from the cool sea. From October to February, dry, hot Santa Ana winds may blow in from the desert at gusts of over 100 mph.

**Flora and Fauna**
The distribution of animals and plants in this region is extremely complex, and includes species that are exotic (kudzu, starlings), native (chaparral species, mountain lions), wild domestic (ferrets), domestic gone wild (peacocks), wild domestic gone wild (parrots), cultivated (palms, peaches), and imported by the pound (most species in markets and restaurants). The potential for conflicts is

high, and poses one of the greatest management challenges in the region.

**Our Public Lands:**
**Find and Enjoy them**
We encourage you to enjoy public lands while respecting private property. Finding and using public lands successfully, safely, and legally in the L.A. basin can require careful effort and preparation. Poorer neighborhoods tend to be short on parkland, while gated neighborhoods typically offer no public spaces or roads; rivers and other public spaces can be illegal to enter; residents in some coastal and other areas will protect public lands

as private; and some public spaces intermittently become private for events such as film shoots and valet parking.

**For a Safe Visit**
Proper sun protection such as a hat, sunscreen, and/or sunglasses is encouraged. When traveling, watch for drivers on cell phones. In mountain areas, beware of rattle snakes and mountain lions, and be prepared to evacuate in case of fire or mudslides. On some beaches, be prepared to show adjacent homeowners a copy of the California Coastal Act which describes public boundaries and access.

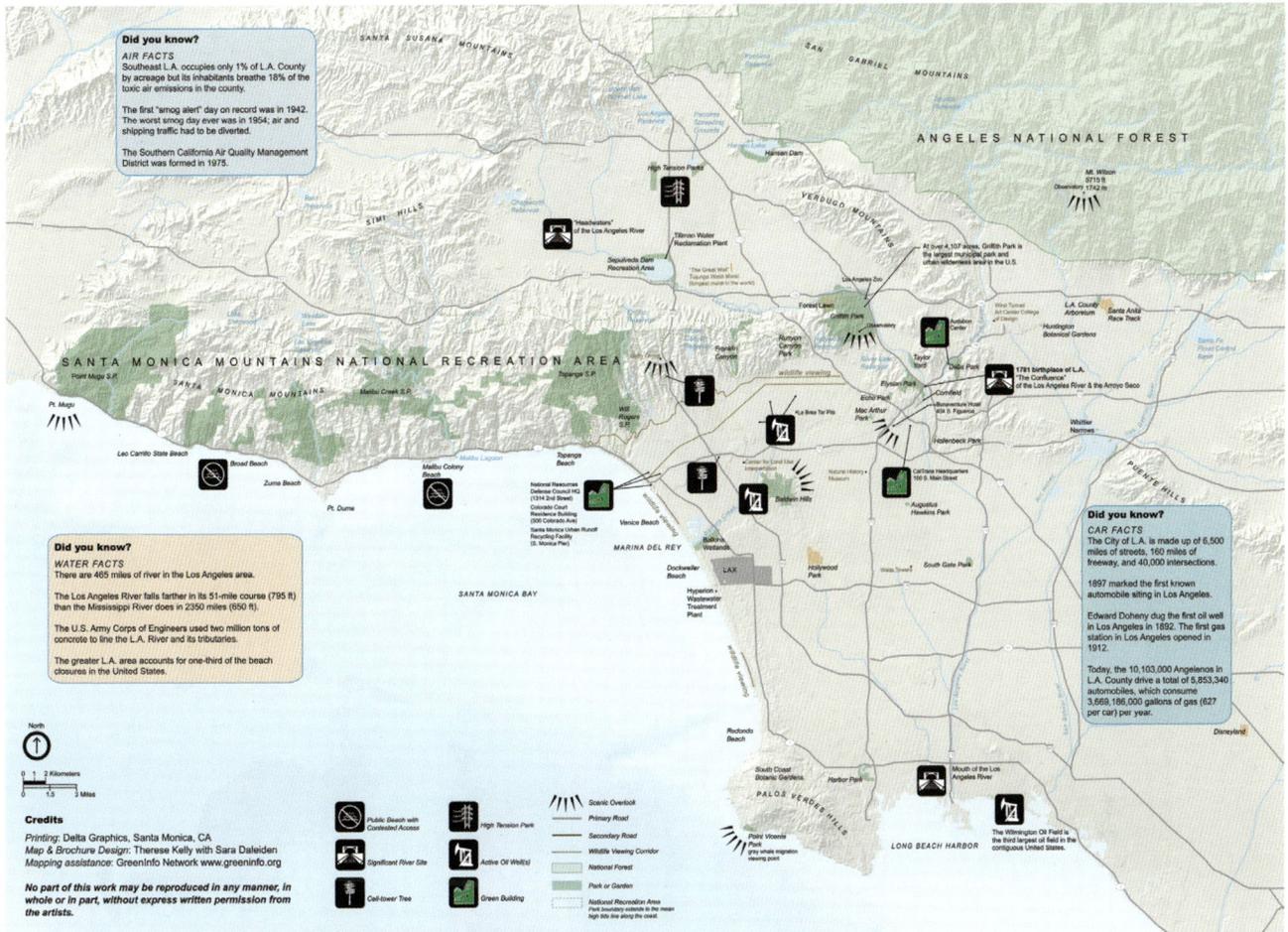

**Did you know?**
*AIR FACTS*
Southeast L.A. occupies only 1% of L.A. County by acreage but its inhabitants breathe 18% of the toxic air emissions in the county.

The first "smog alert" day on record was in 1942. The worst smog day ever was in 1954; air and shipping traffic had to be diverted.

The Southern California Air Quality Management District was formed in 1975.

**Did you know?**
*WATER FACTS*
There are 465 miles of river in the Los Angeles area.

The Los Angeles River falls farther in its 51-mile course (795 ft) than the Mississippi River does in 2350 miles (650 ft).

The U.S. Army Corps of Engineers used two million tons of concrete to line the L.A. River and its tributaries.

The greater L.A. area accounts for one-third of the beach closures in the United States.

**Did you know?**
*CAR FACTS*
The City of L.A. is made up of 6,500 miles of streets, 160 miles of freeway, and 40,000 intersections.

1897 marked the first known automobile siting in Los Angeles.

Edward Doheny dug the first oil well in Los Angeles in 1892. The first gas station in Los Angeles opened in 1912.

Today, the 10,103,000 Angelenos in L.A. County drive a total of 5,853,340 automobiles, which consume 3,669,186,000 gallons of gas (627 per car) per year.

**Credits**
Printing: Delta Graphics, Santa Monica, CA
Map & Brochure Design: Therese Kelly with Sara Daleiden
Mapping assistance: GreenInfo Network www.greeninfo.org

No part of this work may be reproduced in any manner, in whole or in part, without express written permission from the artists.

**Legend**
- Public Beach with Contested Access
- Significant River Site
- Cell-tower Tree
- High Tension Park
- Active Oil Well(s)
- Green Building
- Scenic Overlook
- Primary Road
- Secondary Road
- Wildlife Viewing Corridor
- National Forest
- Park or Garden
- National Recreation Area — Park boundary extends to the mean high tide line along the coast

North

0  1  2 Kilometers
0  1.5  3 Miles

Left and Above: Los Angeles Urban Rangers, *Los Angeles Urban Rangers Official Map and Guide,* 2004. A critical guide to L.A. County, which highlights sensitive environmental sites and public beaches.

# L.A. County Fair

Los Angeles Urban Rangers

*Fair Exchange*
Millard Sheets Gallery
Pomona, California
September 8 - October 1, 2006

## FAIR-GROUNDING: A SELF-GUIDED TOUR OF THE L.A. COUNTY FAIR

Welcome to the L.A. County Fair, a haven of lively farm animals, deep-fried delicacies, carnival rides, and hard-earned blue ribbons! This map and guide, produced by the Los Angeles Urban Rangers for the exhibition *Fair Exchange*, investigates the Fair as a found ecology, urban microcosm, and regional representation.

We encourage you to become an active Fair explorer – to closely observe the stories the L.A. County Fair constructs about regional culture and nature; to create your own thematic tours (e.g. geography of waste, corporate sponsorship, or bugs at the Fair); and to collect field samples that function as one-of-a-kind (anti-) souvenirs.

Also, please join the Los Angeles Urban Rangers for weekly ranger-led hikes, departing from the Millard Sheets Gallery each Sunday at noon (September 17, 24, and October 1).

*Recommended tools for your Fair expedition include a map, binoculars, camera, field notebook, magnifying glass, and specimen containers.*

## 1. PARKING LOT

Did you arrive by car today? Paved parking lots, a familiar fixture of L.A.'s topography, cover 238 of the Fair's 543 acres, and accommodate more than 30,000 cars. That's more cars than all the cows, pigs, sheep, chickens, horses and ponies combined in L.A. County! Here, one transitions from an automotive to pedestrian mode, encountering the dense crowds that characterize much of the Fair experience. Notice your sense of scale, speed, and ambient temperature as you exit the car, as well as how the parking lot is coded for navigation and social interaction. (Note: In the off-season, the L.A. County sheriff's department uses the main parking lot to practice high-speed driving.)

## 2. FAIRVIEW FARMS

The arguable epicenter of any county fair, the farm animal display offers a feast for the senses: Bask in the pungent aromas of fresh-tilled earth and beastly sweat, test your hand at the udder, indulge in freshly produced cow-to-cone ice cream, witness a live birth or mammalian oddities including exotic zebra hybrids and a 36" tall miniature Mediterranean donkey dwarfed by its 900-pound cousin. Cheer on your favorite sheep, chicken, or other Kountry Kritter in one of the regularly scheduled animal skillathons. What connections can be drawn between the farm animals here and other parts of the Fair (e.g. wool for knitting, eggs for baking, manure as fertilizer)? How do we view, smell, and touch these creatures differently from other "wildlife" in Los Angeles? To learn more about agriculture in L.A. County, see reverse side.

## 3. CALIFORNIA HERITAGE

Reminiscent of Disneyland or Universal Studios, California "heritage" here takes the form of a set. Costumed characters re-enact historical events while fair-goers have the chance to pan for gold, build adobe bricks, visit a Western trading post, and witness traditional blacksmithing. What stories about California are cast here? If you were to design a square dedicated to L.A. County culture, what would you include? (Note: Movies filmed at the fairgrounds include *The Grifters, Seabiscuit*, and *Pee Wee's Big Adventure*.)

## 4. FAIRPLEX 4

This vast and spare-looking hall hosts the Stars of the Peking Acrobats during the Fair and naturalization ceremonies for new U.S. citizens the rest of the year. For more on the glitzy "Palace of Agriculture" that formerly occupied this site, see timeline on reverse.

## 5. GRANDSTAND

The vista from atop the Grandstand locates the fairgrounds at the heart of a geologic, transportation, and cultural crossroads. Looking northeast at both the San Gabriel and San Bernardino mountain ranges, you can make out the Cajon Pass that runs between them. This pass is also the path of the San Andreas Fault, the route that Mormon settlers followed on their way to founding the town of San Bernardino, and the modern-day rail and shipping trail from L.A. to points north and east. Can you see any mountains from your home in L.A. County? To what extent do topographic features help you to orient yourself in the city? See L.A. County map on reverse.

## 6. MILLARD SHEETS GALLERY

Since the Fair's inception in 1922, the "fine arts" have been a celebrated attraction. In 1937, the Works Progress Administration built this gallery. Controversies raged in the middle 20th century over whether modern abstract art should be displayed here, as critics questioned its skill and taste. While in the past, juried competitions determined which artworks graced the gallery's walls, this year curator Irene Tsatsos has invited contemporary L.A. artists to take on the subject of the Fair itself. As you move through the exhibit, consider if and how you view art differently than other attractions at the Fair.

## Geography of a Corn Dog

**Pork or beef:** 550 pigs and 5,063 cows live in L.A. County (live specimens on view at Fairview Farms).

**Stick:** To learn more about trees like the one your stick came from, visit Camp Smokey in California's Heritage Square.

**Corn batter:** Made with corn trucked in from Iowa. Most of the small acreage of corn crops grown in California goes to feeding dairy cows, not people.

L.A. is America's #2 hot dog consuming city, second to New York. (National Hot Dog & Sausage Council)

## 7. FAIR NATURES

A myriad of landscapes abound at the L.A. County Fair. Discover expansive deserts at the Moroccan-themed Flower and Garden Pavilion, bonsai topiary at the historic Fairplex Garden Railroad, a mini-wilderness at Camp Smokey, a court of redwoods behind the Millard Sheets Gallery, and scaped table settings at the Village on Broadway. How do these designed natures, both "wild" and ornamental, offer insights into the natural world? Which trees, birds, and bugs can you identify at the Fair?

*The amateur work has finally been separated from the professional and given exhibition quarters under the grandstand. [...] Many of the exhibits are by women's club groups and the high quality of work is a fine indication of their intelligent interest in the crafts.* – L.A. Times (1933)

## 8. VILLAGE on BROADWAY

The domestic habitat humans occupy, design, and perfect is on display in this feminized home-arts space. Eating surfaces become tablescapes, baked goods fermented ecologies, Christmas trees bejeweled. This year, *Fair Exchange* artworks are thrown into the mix (e.g. the Institute for Figuring's crochet models of hyberbolic space, Daniel Marlos's What's that Bug? quilt, Lisa Anne Auerbach's radical sweaters). Meanwhile, amateur contestants battle fiercely in such events as the Mother/Daughter Look-Alike Contest and Great American SPAM Competition. To learn about this building's military past, see timeline on reverse.

## 9. EDIBLE FARE

Prize-winning eggplants, cabbages, and other homegrown fruits and vegetables are not the only food at the Fair. Australian battered crocodile potatoes, ice-cold beer, Pink's chilidogs, and deep-fried Twinkies are among the Fair's 3,000 culinary delights. Many come on a stick and are ready for the trail (e.g. pork chop on a stick, cream puff on a stick, egg roll on a stick). Before sinking in your teeth, ask of your edible: from what part of the world does its recipe originate? How many ingredients are locally produced and/or can be found on site? Keep your eyes open for artist Fritz Haeg's *Edible Estates* kiosks throughout the Fair, which provide information on how to grow your own edible garden in Southern California.

# CONTAMINATING THE PRESERVE

## Timucuan Ecological and Historic Preserve

Florida

Founded in 1988, the Timucuan Ecological and Historic Preserve was signed into law by President Ronald Reagan, following more than 60 years of effort by people wishing to celebrate the European discovery of La Florida. The preserve's original boundaries enclose 47,000 acres, a vast tract of ecosystems managed by federal, state, city and private landholders. Some of the key sites included within the preserve include: a slightly scaled down model exhibit of the French Fort

Caroline, a reproduction of a monument to French entrepreneur and colonist Jean Ribault, Kingsley Plantation - one of the most intact examples of the slave plantation system from the 18th-19th centuries, and vast tracts of Florida wetlands and forests with hiking trails. The Preserve is named for the cultures that inhabited the area at the time of French and Spanish arrival, the Timucua.

The Temporary Travel Office has been investigating the potential to develop alternative forms of tourism within the Preserve. There are many stories surrounding the Preserve that are not currently part of the experience offered to its visitors. To these ends, the Travel Office has come up with a multi-part proposal for expanding the Preserve's spatial and narrative boundaries.

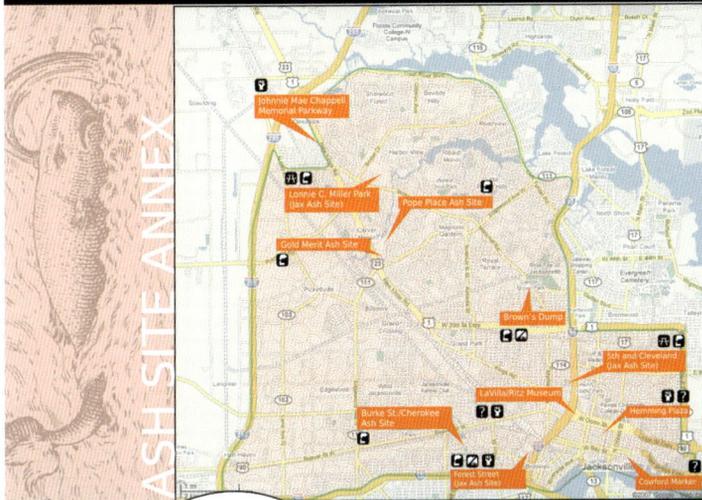

ASH SITE ANNEX

The Ash Site Annex would add approximately 40 square miles to the almost 72 square miles that currently make up the Timucuan Preserve.

The proposed Annex would expand the historical and ecological purview of the Preserve, as well as enlarge its physical area with the addition of more than 261 acres of ash contaminated land.

Proposed Ash Site Annex

Civil Rights/ Black Freedom

Contamination

Park

Closed School

Historical Information

GUANABACOA TRAIL

ATLANTIC OCEAN

The last known Timucuan, Juan Alonso Cavale, was born in 1709 at Mission Nuestra Señora de la Lecha in what would become the State of Florida. After devastating attacks by British supported Yamasee Indians on the Spanish supply route known as the Camino Real, the Spanish eventually ceded Florida to the British, evacuating their St. Augustine stronghold. They took the estimated 89 surviving missionized Indians with them to Guanabacoa, Cuba where Juan Alonso Cavale would die in 1767.

Guanabacoa, now a suburb of Havana, Cuba played an important role in the historical narrative of slavery in the "New World." Once the site of forced reservation camps for indigenous peoples, Guanabacoa would become a haven for escaped slaves from the United States. Here, a small stretch of New Kings Road running through Jacksonville, Florida is reconstructed on the site of a former reservation. The actual stretch of road is now named for Johnnie Mae Chappell, an African-American woman who was gunned down as she walked along the road on March 23, 1964. Several miles away in downtown Jacksonville, protests against the inequities of racial segregation turned violent as whites fought the advances of civil rights.

temporary travel office
www.temporarytraveloffice.net

Left: Los Angeles Urban Rangers, *L.A. County Fair*, 2006

Above: Temporary Travel Office, *Contaminating the Preserve*, 2008. A map of the Timucuan Ecological and Historical Preserve that advertises the preserve as a tourist destination.

The PRISON INDUSTRIAL COMPLEX (the PIC) is the interaction of all the interests who help expand the prison system, some *intentionally*, some *coincidentally*, but all for reasons *other than our safety and justice*. Most of them influence prison growth for reasons of their own *profit*: some profit in terms of cash–$$, others in terms of political pow TV ratings. Some profit from the business out of their way, "criminalized" and loc

## INFLUENCES ON PRISON GROWTH
(Key to chart)

**PRIMARY INFLUENCES:** The police & prison system itself; those who profit directly from locking up more people, building new prisons & getting new jobs.

**SECONDARY INFLUENCES:** One step removed from prisons, supplying them with prisoners, services & goods. They profit indirectly by locking up more people.

**IDEOLOGICAL INFLUENCES:** Influence how we think about different groups of people, crime, poverty & prisons; they use "crime" as a tool to divide, to blame, & to justify inequalities.

**ENVIRONMENTAL INFLUENCES:** Create the environment of inequality & violence that push people toward prison; they exploit, destroy and rob communities of progress and development.

**PROBLEMS CAUSED BY INEQUALITY:** the results of powerlessness, social control and the ENVIRONMENTAL INFLUENCES on communities; 'prisons on the outside', problems that go untreated or get criminalized & fed into prisons.

### EXCLUSION FROM POLITICS, DISENFRANCHISEMENT

### LIMITED ACCESS TO RESOURCES

### POLLUTION & ENVIRONMENTAL HAZARDS

### MALNUTRITION

### POLITICAL ACTION COMMITTEES

...(PACs) are for political lobbying by 'special interest groups.' While there are limits to how much money a group can contribute to a politician *directly*, they can contribute more $$ *indirectly* through a PAC. PACs usually represent a particular issue, industry or interest: **prison guards** and **law enforcement** both have their own PACs; **private prison corporations**, **prison builders** & the **industry** also give big $$ through PACs to influence politicians and push new "tough" laws, to build new prisons and end parole, education & rehab programs. PACs are another way the **PIC** monopolizes our political system & profits off of crime.

### COURTS

...are extremely overcrowded. Judges rarely face the realities that they 'judge' each day, nor do they know the realities of the prisons they send people to. People without resources spend *months & years* just waiting for trial, and most never get any real defense. In order to speed through cases, the courts push defendants to "plea–bargain," where, if they waive their *right to trial* they'll get a *shorter sentence*. This manipulation floods prisons with people who lack resources & don't know their rights; People of Color are 3 times as likely to get harsher sentences than Whites for the same crime

### POLITICIANS (tough on crime!)

...play a large part in expanding the prison system, using the "fear of crime" to win votes. But the "fear of crime" is shorthand for racism: *the fear of Black & Brown people & poor people having power;* a "fear" that became a political tool during the Civil Rights era. Today, being "tough on crime" helps maintain those same structures of segregation and inequality, helping to fulfill the agendas of big business, real estate developers, police & prison guards. While politicians get big $$ to flex their muscles & invent new ways to lock more people up, we are left out of the political process, scared of our neighbors & afraid for our jobs.

### PRISON GUARD UNIONS

...depend on the number of members in their unions: *more members = more power.* They push for harsher laws because that means more prisoners; *more prisoners* mean more prisons, more jobs, and their unions GROW. Guards are politically powerful & push for laws that make new things 'criminal,' that will keep more people locked up for longer & make life harder on prisoners. They push laws that make themselves less accountable for brutalizing prisoners, ones that attack prisoners' rights and access to their families, libraries & rehab programs, hoping to keep prisoners locked up longer, & coming back sooner. They support **victims' rights groups** and use them as a front to get public sympathy & consent.

### PRI
...work li by corpor

## PRISON & JAIL

...profit from warehousing pe warehouse the people society has discriminates against, while disappearing abuses they suffer. Prisons are wareh *sexism, homophobia, poverty, unemp addiction, homelessness, public & m environmental destruction, government & co other things that make people powerless.* based on the number of prisoners it holds & provides, so "profit" comes by getting mo *more cells & units*, and re-classifying *dangerous.*" Instead of eliminating injustic *room for injustice to be waged on the o violence & confront problems with viol us that violence is how we solve send violence back into our con cripple our families and dra political power...

### BIG INDUSTRY & CORPORATIONS

...want more control over resources & political power, and with $$ (lobbying & pay-offs) they influence government policy to get it. They compete by *paying less* for workers, and use unemployment & insecurity to bring down our wages. They refuse to give taxes for *social welfare*, but demand *our tax–$$* for *corporate welfare*, investing instead in building new prisons. Prisons make the problems they cause "disappear" by *blaming & criminalizing the poor* instead of blaming *the policies that make them poor.*

### PROSECUTING ATTORNEYS, DAs

...are all elected, based on how many "convictions" they get (putting people in prison or giving the death penalty, etc.). So they often exploit the tragedies of crime–victims to advance their records, while driving the public's fear of crime through the media. They get extra convictions by pushing naive, 'small time' defendants into plea–bargains, and through the District Attorneys' Association, constantly push for more power & new ways to convict people: harsher, 'big headline' sentences, 'mandatory minimum' laws like '3 Strikes', or new crimes to give the death penalty to. They push for longer prison time & discourage effective alternatives to advance their own careers.

### LAW ENFORCEMENT

...profit from growing, and in order to grow, they need us to think that they (and only they) can guarantee our "safety." In the face of inequality & poverty, their role is to maintain *social control and the appearance of "order,"* often at the cost of the public's real safety. They hold great influence over politicians, and have big public relations departments to gain influence over us. They create propaganda like the TV show 'COPS' & release their own news stories to t media, sensationalizing crime & justifying their desire for more power, bigger budgets & technolog

### POOR EDUCATION, DROP OUTS

### UNEMPLOYMENT, EXPLOITATION & OVER-WORK

### DEBT, DEBT & MORE DEBT

### DAY TO DAY INSECURITY

### VIOLENCE

### VICTIMS' RIGHTS GROUPS

...came out in the last 15 years. They say, *"why do 'criminals' have all the rights? What about the rights of victims?"* They often include people who've suffered tragedy, lost loved ones & property, and are frustrated by the unaccountability of the justice system. But they are usually organized & paid for by law enforcement groups & 'tough-on-crime' pushers, who organize their pain into a voice for vengeance & political gain. Both prison guards & police exploit their tragedies to extend their influence over politicians, pushing harsher sentences, dehumanization, & distraction from the true problems on the outside—the injustices of the larger system.

### THE WAR ON DRUGS

...offers big $$ and resources to law enforcement if they police & imprison *for drugs*. Similar to new laws that encourage police to target immigrants & youth, the War on Drugs offers *federal grant $$* and allows police to *sell property* they seize during drug busts, which become resources, incentives & excuses to profile, harass, brutalize & imprison. Largely designed by **Think Tanks**, it has enabled unprecedented control over poor communities & communities of color through a constant police presence, surveillance & violence against countless youth, homeless, jobless, and mothers who've been pushed off of Welfare.

### CORPORATE WELFARE

...is money given to big corporations, as *tax breaks, subsidies* or *"hand-outs."* Corporations are the biggest recipient of "government hand-outs," and each dollar they get is a dollar that won't get spent on *youth*, on the *elderly*, on *housing, job training, health care, medicine, poverty & homeless prevention, nutrition or drug treatment, environmental protection* and all the things that keep people truly *safe, healthy* and *out of prison.* What used to be invested in communities is now invested in police & prisons. *Corporate* welfare instead of *social* welfare de-stabilizes communities & pushes people *toward* prison.

### SEGREGATION, EXCLUSION FROM POU
### DAILY VIOLENCE AGAINST PEOPLE
### COMMUNITIES, IMMIGRANT & QUEER COMMI

This poster is a part of the
## CORRECTIONS DOCUMENTARY PROJECT

AL COMPLEX important than *people;* where people are
*split* along the lines of *race, gender &*
*culture* so that their labor, resources & power can be exploited & monopolized, and
prisons make invisible the damage done along the way. Is it a conspiracy? It doesn't
have to be—as this chart shows, each group's own interests are set up to GROW...

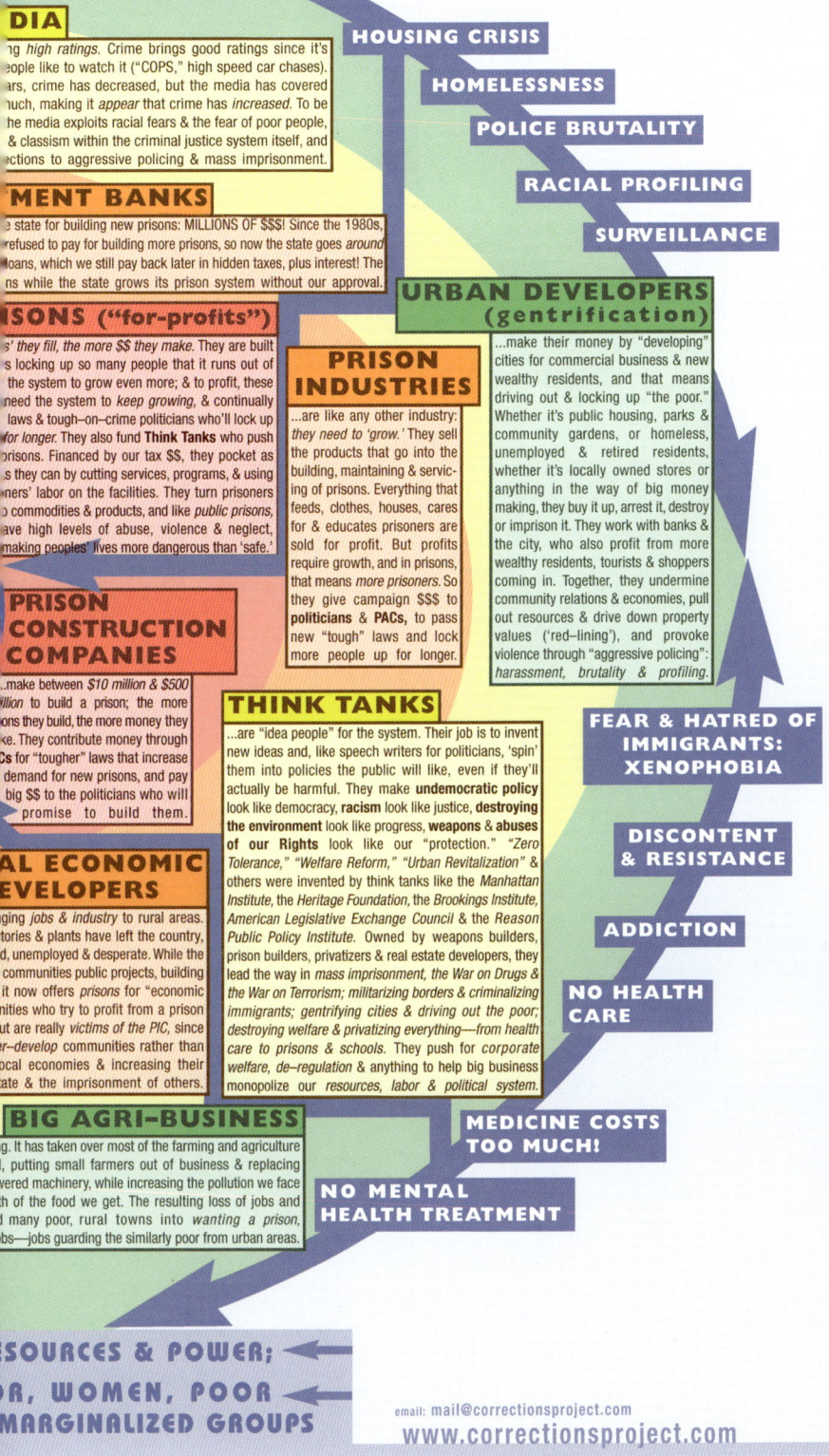

ources & property, or good
others from having people
em where *profit* is more

**DIA**

ng *high ratings.* Crime brings good ratings since it's
eople like to watch it ("COPS," high speed car chases).
ars, crime has decreased, but the media has covered
much, making it *appear* that crime has *increased.* To be
he media exploits racial fears & the fear of poor people,
& classism within the criminal justice system itself, and
ections to aggressive policing & mass imprisonment.

**MENT BANKS**

e state for building new prisons: MILLIONS OF $$$! Since the 1980s,
refused to pay for building more prisons, so now the state goes *around*
loans, which we still pay back later in hidden taxes, plus interest! The
ns while the state grows its prison system without our approval.

**SONS ("for-profits")**

s' they fill, the more $$ they make. They are built
s locking up so many people that it runs out of
the system to grow even more; & to profit, these
need the system to *keep growing,* & continually
laws & tough-on-crime politicians who'll lock up
*for longer.* They also fund **Think Tanks** who push
prisons. Financed by our tax $$, they pocket as
s they can by cutting services, programs, & using
ners' labor on the facilities. They turn prisoners
commodities & products, and like *public prisons,*
ave high levels of abuse, violence & neglect,
making peoples' lives more dangerous than 'safe.'

**PRISON
CONSTRUCTION
COMPANIES**

..make between *$10 million & $500*
illion to build a prison; the more
ons they build, the more money they
ke. They contribute money through
Cs for "tougher" laws that increase
demand for new prisons, and pay
big $$ to the politicians who will
promise to build them.

**AL ECONOMIC
EVELOPERS**

ging *jobs & industry* to rural areas.
tories & plants have left the country,
d, unemployed & desperate. While the
communities public projects, building
it now offers *prisons* for "economic
nities who try to profit from a prison
ut are really *victims of the PIC,* since
r-develop communities rather than
ocal economies & increasing their
tate & the imprisonment of others.

**BIG AGRI-BUSINESS**

ng. It has taken over most of the farming and agriculture
d, putting small farmers out of business & replacing
wered machinery, while increasing the pollution we face
th of the food we get. The resulting loss of jobs and
d many poor, rural towns into *wanting a prison,*
obs—jobs guarding the similarly poor from urban areas.

**HOUSING CRISIS**

**HOMELESSNESS**

**POLICE BRUTALITY**

**RACIAL PROFILING**

**SURVEILLANCE**

**URBAN DEVELOPERS
(gentrification)**

..make their money by "developing"
cities for commercial business & new
wealthy residents, and that means
driving out & locking up "the poor."
Whether it's public housing, parks &
community gardens, or homeless,
unemployed & retired residents,
whether it's locally owned stores or
anything in the way of big money
making, they buy it up, arrest it, destroy
or imprison it. They work with banks &
the city, who also profit from more
wealthy residents, tourists & shoppers
coming in. Together, they undermine
community relations & economies, pull
out resources & drive down property
values ('red-lining'), and provoke
violence through "aggressive policing":
*harassment, brutality & profiling.*

**PRISON
INDUSTRIES**

...are like any other industry:
*they need to 'grow.'* They sell
the products that go into the
building, maintaining & servic-
ing of prisons. Everything that
feeds, clothes, houses, cares
for & educates prisoners are
sold for profit. But profits
require growth, and in prisons,
that means *more prisoners.* So
they give campaign $$$ to
**politicians** & **PACs,** to pass
new "tough" laws and lock
more people up for longer.

**THINK TANKS**

...are "idea people" for the system. Their job is to invent
new ideas and, like speech writers for politicians, 'spin'
them into policies the public will like, even if they'll
actually be harmful. They make **undemocratic policy**
look like democracy, **racism** look like justice, **destroying
the environment** look like progress, **weapons** & **abuses
of our Rights** look like our "protection." *"Zero
Tolerance," "Welfare Reform," "Urban Revitalization"* &
others were invented by think tanks like the *Manhattan
Institute,* the *Heritage Foundation,* the *Brookings Institute,*
*American Legislative Exchange Council* & the *Reason
Public Policy Institute.* Owned by weapons builders,
prison builders, privatizers & real estate developers, they
lead the way in *mass imprisonment, the War on Drugs &
the War on Terrorism;* militarizing borders & criminalizing
*immigrants; gentrifying cities & driving out the poor;*
destroying welfare & privatizing everything—from health
care to prisons & schools. They push for *corporate
welfare, de-regulation* & anything to help big business
monopolize our *resources, labor & political system.*

**FEAR & HATRED OF
IMMIGRANTS:
XENOPHOBIA**

**DISCONTENT
& RESISTANCE**

**ADDICTION**

**NO HEALTH
CARE**

**MEDICINE COSTS
TOO MUCH!**

**NO MENTAL
HEALTH TREATMENT**

**ESOURCES & POWER;**

**R, WOMEN, POOR**

**MARGINALIZED GROUPS**

email: mail@correctionsproject.com
www.correctionsproject.com

Above: Ashley Hunt, *What Is the Prison Industrial
Complex?* 2003

# $200,000,000,000

spent by world governments for Private Military Contractors (PMCs) each year

USA

Hundreds of PMCs exist internationally, founded mainly by former military officers—and are active in conflicts worldwide. Hiring PMCs has various advantages for a government—as private corporations they are less accountable to the public. Also, PMC casualties are less of a public relations problem. In Iraq, as many as 30,000 PMC employees are "on duty," and up to 2000 have been killed to date.

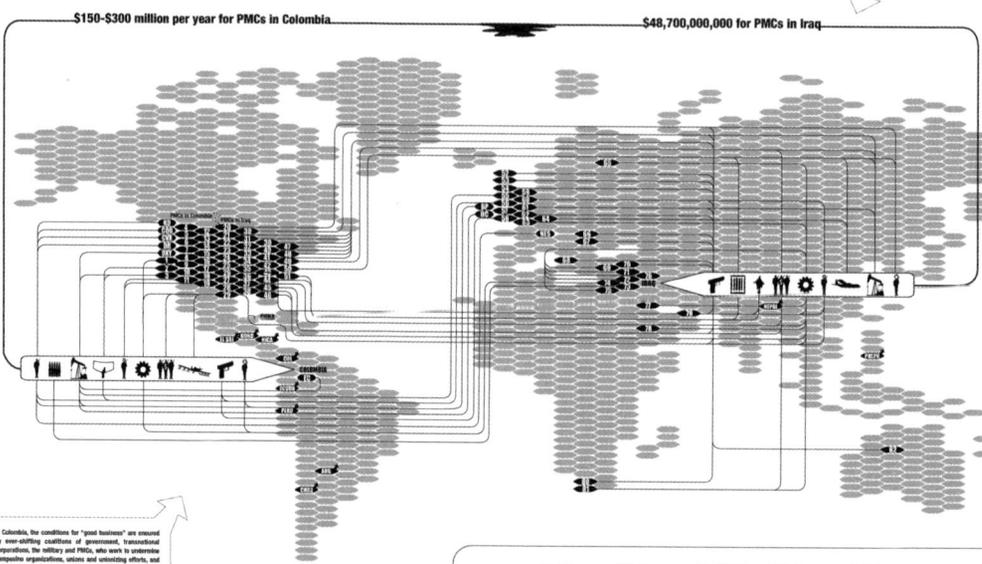

$150-$300 million per year for PMCs in Colombia

$48,700,000,000 for PMCs in Iraq

In Colombia, the conditions for "good business" are ensured by ever-shifting coalitions of government, transnational corporations, the military and PMCs, who work to undermine campesino organizations, unions and unionizing efforts, and social movements, as well as the armed insurgency. The collective work of the PMCs, paramilitaries, and the Colombian army has displaced more than 2.5 million people.

### Legend (left column icons)
- private military contractor (pmc)
- trans-national corporations
- country where pmcs recruit for Iraq
- government
- armed forces/ mercenaries
- paramilitaries
- military consulting
- training
- technical/mechanical support
- visual surveillance
- ammunitions/arms
- security
- mine eradication/ herbicides
- cargo transport
- interrogation
- prisons
- petroleum management

**The Privatization of War:** Colombia as Laboratory and Iraq as Large-Scale Application

### USA
1. Northrup Grumman
2. California Microwave
3. Air Scan
4. DIG
5. Imagery Analysis
6. VES
7. Alion
8. Lockheed Martin
9. Vinnell
10. TRW
11. Bell/Textron
12. ACG Defense
13. ManTech
14. Rendon Group
15. NAVCOM
16. Integrated Aerosystems
17. Cambridge Comm.
18. APSG
19. Sikorsky
20. Diligence LLC
21. Bearing Point
22. McNeil Technologies
23. Environmental Chemical
24. Int'l American Products
25. Wornic
26. DSD Technology
27. SAS International
28. CSC
29. Dyncorp
30. Cochloa Consultancy
31. Triple Canopy
32. AAINC
33. DTS Security
34. Bechtel
35. Athena Innovative Sol.
36. MPRI
37. Blackwater USA
38. General Dynamics
39. 3D Global Solutions
40. Kroll
41. Custer Battles
42. CBS
43. L3
44. CACI
45. Control Risks Group
46. American Services Ctr.
47. The Hart Group
48. Olive Group
49. Halliburton
50. Kellogg, Brown, & Root
51. Titan
ND Coca-Cola Company
COB Chiquita Brands
CVX Chevron/Texaco
DR Drummond Coal
OXY Occidental Petroleum

### COLOMBIA
EC Ecopetrol

### GREAT BRITAIN
52. Genric UK Ltd.
53. Armor Group
54. Global Strategies Group
55. Control Risk
56. Global Risk
57. Defense System Ltd.
58. DSC
59. Risk Advisory Group
60. Janssian
61. Rubicon Ltd.
62. Aegis Defense Services
63. IPBD Ltd.
BP British Petroleum
GE Ocanea

### GERMANY
64. DHL

### SWITZERLAND

65. Air-la

### ROMANIA
66. Danubia Global Inc.

### ITALY
68. PIC

### TURKEY
69. Kaleb Construction
70. Irex Corporation
71. Serka Group

### ISRAEL
72. Israeli Military Ind.
73. GIR S.A. (Guatemala)
74. Silver Shadow

### JORDAN
75. Daoud & Partners Co.

### IRAN
76. 77 Construction

### KUWAIT
77. First Kuwaiti General Trading and Contracting

### SAUDI ARABIA
78. Gulf Catering Company

### DUBAI
79. Prime Projects International

### SOUTH AFRICA
80. Meteoric Tactical Solutions
81. Erinys International

### AUSTRALIA
82. DAM

Lisa Mogel / Dario Azzellini 2007

Left: Lize Mogel and Dario Azzellini, *The Privatization of War: Colombia as Laboratory and Iraq as Large-Scale Application*, 2007/08

Above: Nikolas R. Schiller, *Pentagon Quilt #3*, 2007. An aerial photo of the Pentagon that was digitally manipulated to appear as a quilt.



"Blood For Rent" is about experiences of professional human pharmaceutical research subjects. Magnetic panels placed near 5 research facilities contain excerpts from the on-line comic narrative. —ARTIST, KEVIN PYLE

1

If we fail to establish guidelines for genetic research, will we be dangerously undermining the time-honored medical imperative to "do no harm"? —ARTIST, JAYNE PAGNUCCO

2

Here I have identified this artist only by his blood. Today this valuable gift of life can be given freely. Give Blood. Save lives. —ARTIST, TOM KLEM

3

In 1998, NYC Police Commissioner Howard Safir announces plans to collect DNA samples from blood or saliva of arrested suspects. He says, "The innocent have nothing to fear." —ARTIST, GREG SHOLETTE

4

Nation's first AIDS discrimination lawsuit: People v. 49 West 12th St.
REPOhistory's CIVIL DISTUR-BANCES sign project, 1998-9 —artist NEILL BOGAN & IRENE LEDWITH

5

In 1969, Guerrilla Art Action Group (GAAG) stage the guerrilla performance, "Blood Bath," in MoMA lobby to protest Vietnam War.

6

I.C.E. students, grades 6-12, and teachers Meryl Meisler (Digital Art), Francine LaPorte (French) & Niesha White (Spanish) produce The Bleeding Edge, a multi-lingual, on-line zine that explores blood as a metaphor. —ARTIST, MERYL MEISLER

7

New York Blood Center provides almost 10% of nation's blood and blood products serving more than 200 hospitals and 20 million people in NY, NJ, and Conn.

Visual Aids holds artwork of 100s of artists who died of AIDS including REPOhistorian, Ed Eisenberg.

8

City As School students, grades 9-12, and teachers OSCAR TUAZON & ANDRE KNIGHT produce "BLOOD WORK," a 20 min. video interviews with NY Blood Center, Fire Dept. 9, Nat'l Hemophilia Found., Bronx-Harlem Needle Exchange, and more.

9

The first prison for most NYC immigrants facing deportation is INS's "Service Processing Center" at 201 Varick St. For streamlined removal, the INS has plans to distribute these immigrants to prisons across the US sorted by nationality. —ARTIST, JENNY POLAK

10

Rod Sorge (1968-1999) cofounded the first ACT UP needle exchange (corner of Delancey and Ave. A) in NY, and later headed the first state authorized needle exchange program.

11

1987: First ACT UP demonstration protesting drug company profiting off AIDS epidemic.
REPOhistory's QUEER SPACES sign project, 1994.

12

## KEY

- Approximate routes between New York Blood Center and Manhattan hospitals
- Waste blood transported to depots in Bronx, then to disposal sites north
- Artworks linked to specific sites
- Distribution sites for CIRCULATION artworks and maps
- Needle exchange sites
- Blood Donation Centers of New York Blood Center
- Blood testing clinic sites
- HIV The 4 free HIV testing clinics of NY Dept. of Health

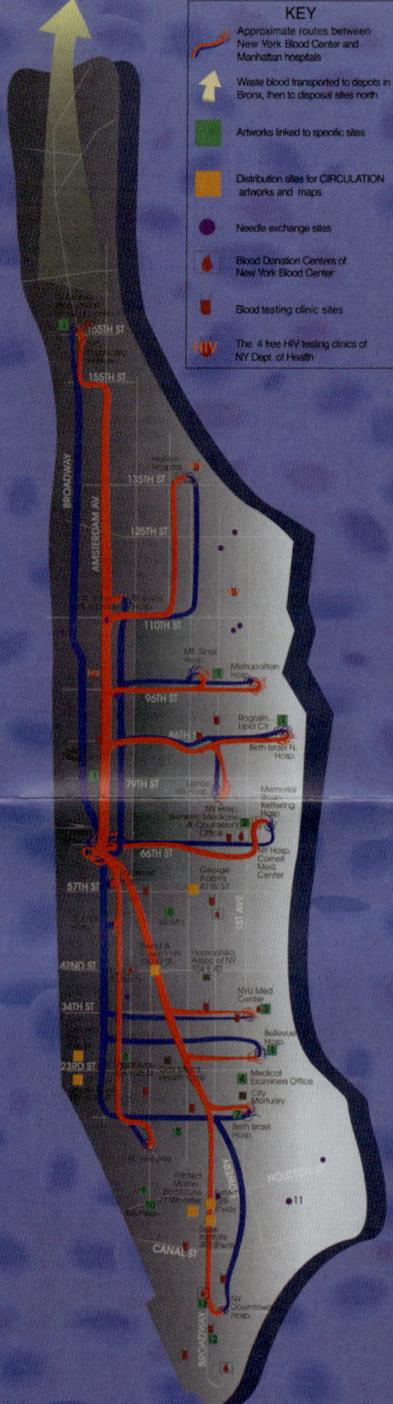

CIRCULATION
www.repohistory.org

## A BRIEF AND SELECTIVE HISTORY OF BLOOD

**1410 BC** "For it is the life of all flesh; the blood of it is for the life thereof; therefore I said unto the children of Israel, Ye shall eat the blood of no manner of flesh; for the life of all flesh is the blood thereof; whosoever eateth it shall be cut off." —Leviticus 17.14 (Holy Bible, King James version)

**200 BC** Nei Jing or Chinese Book of Medicine first describes blood circulation.

**AD 1** Blood of slain gladiators is popular drink of Roman warriors.

**AD 130-200** Galen of Pergamum, Greek physician, originates belief held in Europe until 1200s that blood passes through tiny pores from heart's right to left ventricle.

**AD 400** Anglo-Saxons and Druids use leeches for bloodletting.

**1210-1280** Ibn Al-Nafis, Islamic physician, possibly discovers circulation long before Harvey.

**1492** The dying Pope Innocent VIII has blood of 3 young boys fed to him—all 4 die; Leonardo Da Vinci makes exquisite drawings of heart.

**1628** William Harvey, England, discovers blood circulation disproving Galen's theory; proves that "pumplike" heart pushes blood mechanically, and that heart is at center of circulatory system.

**1665** Dr Richard Lower performs first reported successful blood transfusion from animal to animal.

**1667** Dr. Jean-Baptiste Denis performs first animal to human transfusion.

**1815** Thomas Jefferson, develops complex mathematical equations to determine racial purity.

**1818** British obstetrician, James Blundell, performs first successful transfusion of human blood.

1820s: Abolitionist Frances Wright speaks at Park Theater advocating miscegenation as a means to eliminate racism.
REPOhistory's "Lower Manhattan Sign Project"—artists, JOSELY CARVALHO & DEBORAH MESA-PELLY

13

**1832** French doctors import 41.5 million leeches; bloodletting ends in 1920s

**1850-1900** Hundreds of transfusions are performed in Europe; more than half are fatal.

**1900** Dr Karl Landsteiner discovers A, B, O blood groups necessary for successful transfusions

**1915** Discovery of anticoagulant sodium citrate and refrigeration makes storage of blood possible.

**1916** British under Oswald Robertson establish first blood depot during World War I

**1921** First blood donor pool of tested volunteers organized by British Red Cross.

**1932** The first blood bank is established in a Leningrad, USSR hospital.

**1932** Public Health Service (later named Centers for Disease Control) carries out Tuskegee study of 400 African-American men with syphilis, informs men they had "bad blood" rather than syphilis and withholds medical treatment until 1972 when story becomes public.

**1935** Nazi law is passed to "protect" German blood and German honor.

**1937** Dr. Bernard Fantus of Cook County Hospital, Chicago, establishes the first hospital blood bank and coins the term "blood bank."

**1939** Wartime blood banking is first effectively practiced by anti-Franco forces in Spanish Civil War.

**1939** Drs. Phillip Levine and Alexander Wiener discover Rh blood group.

**1939** Dr. John Elliot discovers the importance of plasma (the liquid medium of blood) and urges it be sent to warfront.

**1940** Dr. Charles Drew heads Blood for Britain campaign in World War II to become first to develop antiseptic, industrial processing of plasma; helps coordinate blood banking program run by American Red Cross but cannot gain membership in American Medical Association because he is African-American.

**1940** Dr. Edwin Cohn develops fractionation, the process of breaking down plasma into components and products.

**1941** US War Department calls for segregation of "black" and "white" blood.

**1945** The infamous plutonium injection experiments begin; physicians working with the Manhattan Project and the Department of Energy conduct secret experiments in which 18 unknowing patients are injected with plutonium and their blood regularly tested for signs of its effects; the experiments remain secret until 1993. (Welsome)

**1947** AABB (American Association of Blood Banks) opens in competition with American Red Cross.

**1947** American Red Cross extends blood banking to civilian population.

**1950** The AABB Clearinghouse (now the National Blood Exchange) is established to provide a centralized system for exchanging blood among blood banks.

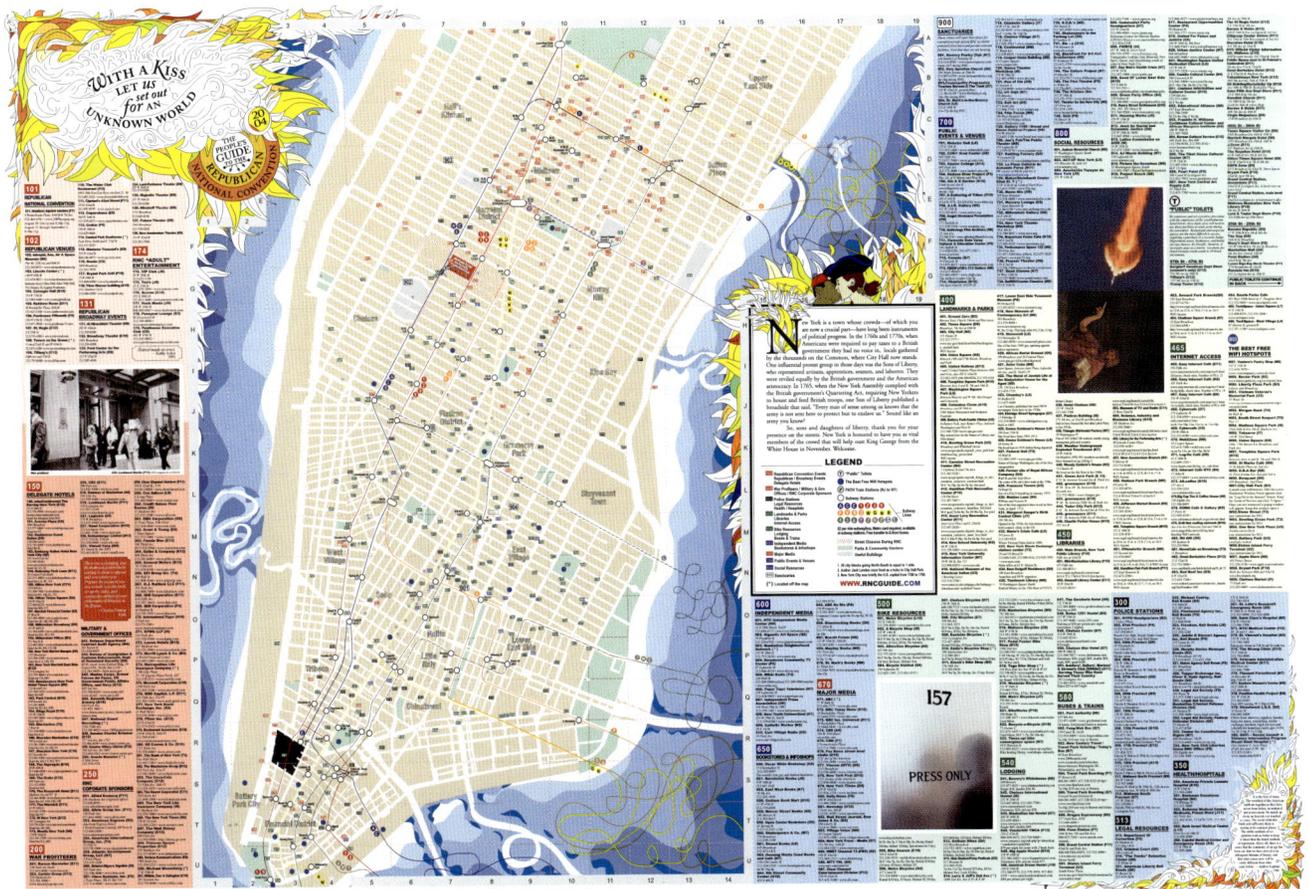

Left: Repohistory, *Circulation*, 2000. This map was
made to accompany a Manhattan-wide signage project,
one that attempted to document the "collecting,
processing, and distribution of hundreds of pints of
human blood."

Above: Friends of William Blake, *The People's Guide
to the RNC*, 2004 (detail). 7,500 copies of this
map—designed to help protestors navigate New York
City—were distributed during the 2004 Republication
National Convention.

**A** 1 2 3 4 5 6

**Sam Azzam Plywood Palace**
Formerly Long's Funeral Home

"Long's was an attractive low rise Victorian-era structure. Azzam replaced it with a large, unattractive literally-built, modern, multi-unit building completely inappropriate for the setting. The neighbors hate it." - R.K.

**That Place Where Freaks Gather to Hula Hoop + Do Other Circus Tricks**
Formerly Cambridge Common

"Because it's what it is. Especially on Wednesday nights." - L.A.

**Riverfest Renaming Event**

In 2006 & 2007, the Institute for Infinitely Small Things set up a renaming tent at the annual Cambridge River Festival where over 300 people submitted new names for public spaces in Cambridge.

**Farming Cows School**
Formerly King/Amigos School

"Because I think it would be fun to have cows at school." - J.S.

**Kontos Korner**
Formerly Gordon Place

"My in-laws moved their family from Greece to Cambridge and settled at 171 Magazine St-one house from the corner of Gordon place. My husband is first-generation Cambridge-American living in the same house he grew up in and bringing up his children and possible grandchildren in the same house he grew up in." - A.K.

**The City Formerly Known as Cambridge**

### Legend

| | |
|---|---|
| STREET | STREET |
| PARK | PARK |
| CEMETERY | CEMETERY |
| COLLEGE | COLLEGE CAMPUS |
| Point | POINT OF INTEREST |
| SCHOOL | SCHOOL |
| SQUARE | SQUARE/NEIGHBORHOOD |
| | MBTA LINE |
| | RENAMING EVENT |

Copyright ©2008 by Institute for Infinitely Small Things
Map base and cartography copyright © 2008 by Hedberg Maps, Inc.
Design by Studio Jallyn, Mya, The Art Institute of Boston

## A hypothetical *(but entirely possible!)* map of Cam

### About this map

The City Formerly Known as Cambridge is a hypothetical (but entirely possible!) map of Cambridge, Massachusetts. During 2006–7, the Institute for Infinitely Small Things invited residents and visitors to the city (you) to rename any public place in Cambridge. This was a big experiment to see what the city would look like if the people that live and work here renamed it, right now. We collected over 330 new names along with reasons that ranged from vanity to politics to silliness to forgotten histories to the contested present. This map is a collection of your names and stories about Cambridge, its diverse inhabitants and visitors, its traditions and ever-changing attitudes.

This map also makes the case that names matter. Who gets to name things? Whose stories get remembered? Whose history is consecrated and whose is forgotten? Most Cambridge history books, for example, begin in 1636 with the founding of Newtowne, though there were Native Americans living here long before that time with their own names for its geography. On this map, we have mixed in some real renamed places from the city's history to recall those geographic places that have been contested, disputed, and transformed over time. A city's names, like its communities, are a living, breathing organism.

## We collected
### over 330 new names.

## Whose history
### *is consecrated*
and whose is **forgotten?**

ople's Republic
of
ambridge

**Queen Kay of Miaocoookuri St**

Formerly Walker St

"We named it for Kay Gerould, Queen of Walker Street, archetypal Cambridge Lady, and our landlady. She lived there (with her parents at first) from the 1930s 'til her death in 2001. Miaocoookuri is a combination of nicknames for the last 3 of her 50 or 60 years of tenants and her loyal subjects." –K&M

A

B

**Harvard Square Renaming Event**

The Institute for Infinitely Small Things set up our renaming booth on the corner of Brattle Street on Sunday, June 4th 2006, and collected over 30 new names.

C

**Da Liberiana**

Formerly Charles St

"I chose this name because Liberia is where my ancestors came from. I want this for my own street because that is the nickname my friends gave me." –M.N.

D

**Candyland**

Formerly Neighborhood 4

"Former home of Necco and Squirrel Brand candy companies." –M.M.

E

**Prince Hall Blvd**

Formerly Massachusetts Ave

"Prince Hall is a famous African American who conferred with George Washington on the Cambridge Common" –L.C.

, Massachusetts.

F

**worked**

ese names were collected through face-to-face conversations with Cambridge. The Institute for Infinitely Small Things set up its g Booth in commercial centers, at farmers markets, at community and even at a four-square tournament to collect names. Renaming n to everyone and the Institute did not play any editorial role other recting spelling mistakes. Everyone who contributed a new name to received a free copy mailed to them.

**about the $$?**

notice the dollar amounts ($) attached to names on the map. In he most popular parts of Cambridge were auctioned off for small of money. This was designed both to make a political point and to problem: what should happen when 2 people or more wished to the same place (say, Harvard Square)? Instead of making a al decision, we decided to mirror real life, which is to say: the person s the most money wins. The first time a place was renamed it was ch time it was subsequently renamed by a different person, the price by $0.25. The money earned from auctioning off names (in total 0) went towards the production of this map and represents about % of the cost of producing the map.

About the Institute for Infinitely Small Things

The Institute for Infinitely Small Things conducts creative, participatory research that aims to temporarily transform public spaces dominated by corporate and political agendas. Using performance and conversation, we investigate social and political "tiny things". These have included corporate ads, street names, and post-9/11 security terminology. The Institute advocates for public engagement through its research reports in the form of maps, books and videos. This interdisciplinary group has a varied and open membership which includes artists, filmmakers, computer programmers, historians and hula hoopers. For this project, the Institute was Shannon Coyle, Catherine D'Ignazio, Heloisa Escudero, Toby Kim Lee, James Mayhew, James Manning, Dave Raymond, Heather Ring, Katharine Urbati, Matilda Sabal, Max Sabal, Rob Sabal, Nicole Siggins, and Savic Rasovic.

The Institute for Infinitely Small Things

www.infinitelysmallthings.net
info@infinitelysmallthings.net

This project was made possible with the support of the Cambridge Arts Council, the LEF Foundation and iKatun.

Map design by:
Maegan Reusa, Ryan Torres and Tarek Awad

Special thanks to:
Alica Shapiro & Fabris Lazardou Hatzigoga (modular table design), James Manning (construction & documentation), Jane Beal & Elizabeth White at the Cambridge Arts Council, Nat Case & Hedberg Maps (cartography), the Cambridge Historical Commission, Rob Coslow (Map photography), Universal Millennium (printing) and Rick Rawlins and the Senior Design Studio (Unit Flux) at the Art Institute of Boston

G

H

Above: The Institute for Infinitely Small Things, *The City Formerly Known As Cambridge*, 2008. A re-imagining of Cambridge, Massachusetts, the result of a survey of local residents.

# AQUI VIVEN

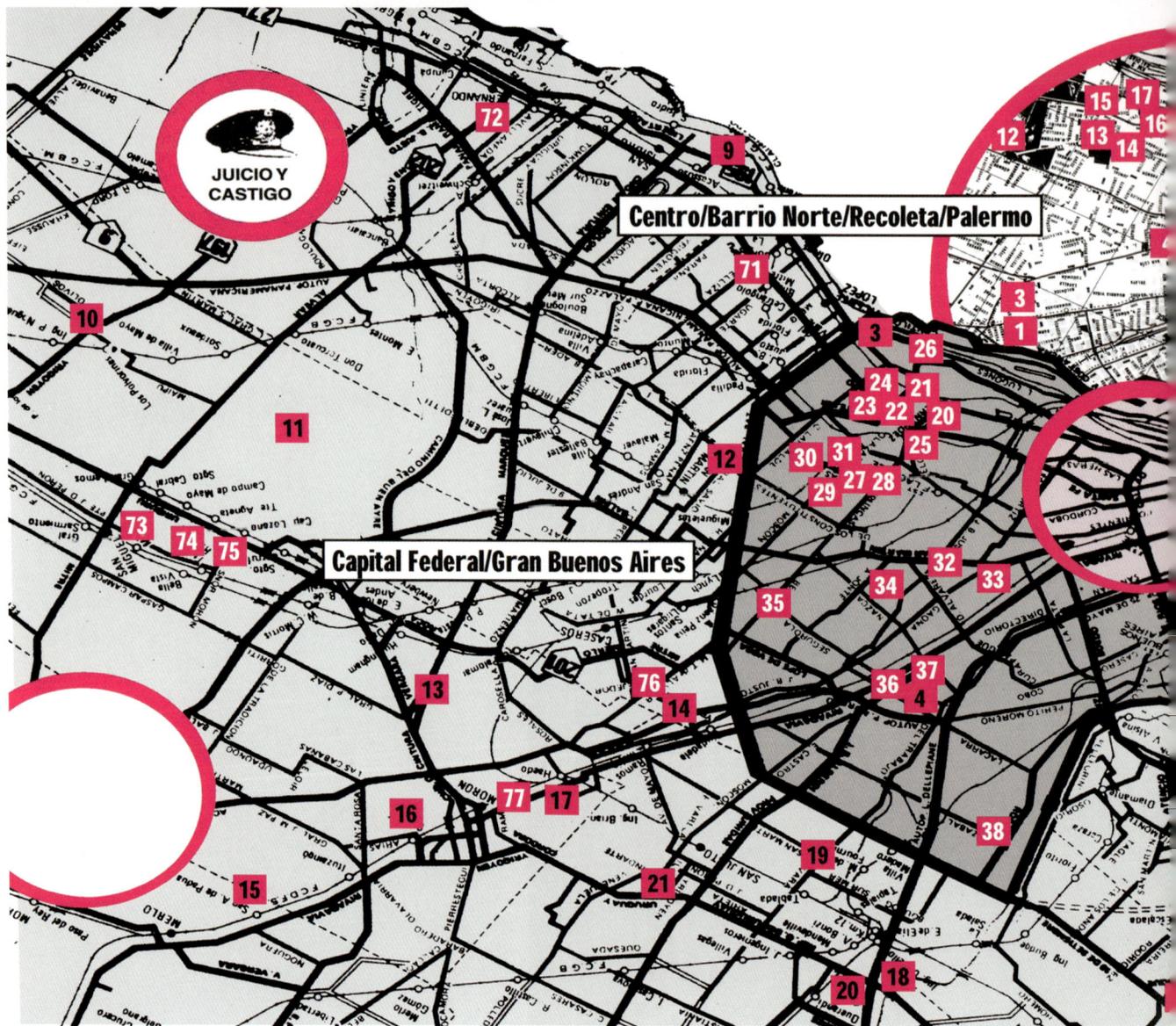

JUICIO Y CASTIGO

Centro/Barrio Norte/Recoleta/Palermo

Capital Federal/Gran Buenos Aires

# GENOCIDAS

**11** **GENOCIDAS**

*CAPITAL FEDERAL.* ALMAGRO/PALERMO/BARRIO NORTE/RECOLETA: 1**MARENZI**, Remo/*Yatay 395 1D.* 2**HARGUINDEGUY**, Albano-/*Santa Fe 2385 6ºC.* 3**YEDRO**, Martín/*Palestina 698 6º"B".* 4**ETCHECOLATZ**, Miguel Osvaldo/*Pueyrredón 1035 9ºA.* 5**MARTINEZ DE HOZ**, José A./*Florida 1065.* 6**SUAREZ MASON**, Guillermo/*Libertad 982 Piso10.* 7**ARRIETA DE BLAQUIER**, Nelly/*Arenales 735.* 8**SANCHEZ RUIZ**, Raúl/*Peña 2065* 9**DURAN SAENZ**, Pedro/*Av. Callao 1307 1.* 10**MAGNACCO**, Jorge Luis/*M. T. de Alvear 1665.* 11**WARCKMEISTER**, Luis/*Rodríguez Peña 1416.* 12**CORACH**, Carlos V/*Sinclair 3276.* 13**GRONDONA**, Mariano/*S. L. Ruggieri 2930.* 14**NEUSTADT**, Bernardo/*S. L. Ruggieri 2930.* 15**MASSERA**, Emilio Eduardo/*Av. del Libertador 2423.* 16**PERTINE**, Basilio B./*Coronel Díaz 2665.* 17**RADICE** Jorge C./*Billinghurst 2533 "1".* CONSTITUCION/CENTRO: 18**SIMON**, Julio (alias Turco Julián)/*San Juan 1171.* SAN CRISTÓBAL: 19**ROVIRA** Miguel A. BELGRANO: 20**ACOSTA**, Jorge E./*Amenábar 2264 6ºA.* 21**RIVEROS**, Santiago Omar/*3 de Febrero 1950 4º.* 22**VIDELA**, Jorge Rafael/*Av. Cabildo 639.* 23**SAINT JEAN**, Ibérico/*Av. Cabildo 639* 24**OJEDA**, René/*Av. Cabildo 639.* 25**BRINZONI**, Ricardo G./*Maure 2124.* 26**WHAMOND**, James M. D./*Av. Libertador 5312.* 27**CARDENAL ARAMBURU**, Juan C./*La Pampa 4022.* 28**ALEMAN**, Roberto/*Melian 1831.* VILLA URQUIZA: 29**DI BENEDETTO**, Agatino F./*Av. Triunvirato 5177.* 30**PEYON**, Fernando Enrique/*Capdevila 2852 13B.* 31**ROLON**, Juan Carlos/*Capdevila 2852 8 B./ Pasco 1032.* PATERNAL: 32**DEL CERRO**, Juan Antonio (alias Colores)/*Baigorria 2397* 33**DONOCIK**, Luis J./*Honorio Pueyrredón 1047.* 34 **SCIPO MÓDICA**, Ricardo "Alacrán-"/*Condarco 1955.* VILLA DEVOTO: 35**GALTIERI**, Leopoldo Fortunato/*Chivilcoy 3102 1º.* VILLA LURO/FLORESTA: 36**WEBER**, Ernesto Frimon/*Virgilio 1245 PB 3.* 37**DINAMARCA**, Víctor Hugo/*Benedetti 66 1A.* VILLA LUGANO: 38**BUFANO**, Rubén Osvaldo/*Madariaga 6236 PB 2.*

*ZONA SUR.* AVELLANEDA/WILDE: 39**CARNOT**, Roberto R./*Av. B Mitre 5865 13 A.* QUILMES: 40**BERGES**, Jorge A./*Magallanes 1441.*

*LA PLATA:* 41**ZAMORA**, Rubén Héctor/*122 nº 553.* 42**NILSSON**, Enrique Aníbal/*514 e/ 8 y 9.* 43**PIAZZA**, Jorge Luis/*119 nº 141.* 44**GONZALEZ CONTI**, Rodolfo/*43 nº 623.* 45**MADRID**, José Félix/*40 nº 673.* 46**DOMATO**, José Antonio/ 44 nº 1044. 47**TREDICCE**, Vicente Oscar/*38 nº 1010.* 48**GIL**, Enrrique Alberto/*42 nº 1328.* 49**FAVOLE**, Luis D./*48 nº 951.* 50**DAMARIO**, Hugo "Jirafa"/*10 nº825 1/2 e/ 48 y 49.* 51**MACELLARI**, Oscar Carlos/*378.* 52**BARROSO**, Julio/*5 nº1682 e/66 y 67.* 53**VITON**, Gustavo/*60 nº1410.* 54**RODRIGUEZ**, Jorge Omar/*25 nº1785.* 55**ROTELA**, Tomás/*57 nº2678.* 56**GRILLO**, Roberto

Omar/*81 nº1440.* 57**LANGONI**, Vicente C./ 98 esq. 8. LOS HORNOS: 58**OJEDA**, Juan Domingo/*86 nº146.* 59**GAUNA**, Ceferino/*132 esq. 82 y 83.* 60**CERECETO**, Ramón/*136 e/ 75 y 76.* 61**ABRIGO**, Walter/*62 e/ 148 y 149.* 62**LOPEZ**, Justo José/*156 y 59.* ARANA: 63**PATRAULT**, Luis Vicente/*132 y 642.* OLMOS: 64**JAIME**, Mario/*197 e/ 39 y 40.* MELCHOR ROMERO: 65**TOCHO**, Mario Oscar/*171 nº955.* CITY BELL: 66**BEROCH**, Néstor/*474 nº2875.* RINGUELET: 67**OJEDA**, Lino/9 nº2214 e/ 509 y 510. 68**ANTONINI**, Santiago/*4 bis e/ 518 y 518 bis.* ENSENADA: 69**LACAY**, Daniel Omar/ Além y México.70**PACHECO**, Mario/*La Merced, 25 nº666.*

*ZONA NORTE.* VICENTE LOPEZ/OLIVOS: 71**OLIVERA**, Jorge/*Quintana 2215.* SAN ISIDRO/BECCAR: 72**PERREN**, Jorge E./*Marconi 3495.*

*ZONA NOROESTE.* GRAL SARMIENTO/SAN MIGUEL: 73**RICO**, Aldo-/*Municipalidad de San Miguel.* BELLA VISTA: 74**ZIMMERMANN**, Mario Albino/*Av. Ricchieri 425.* 75**BIANCO**, Norberto Atilio/*Clínica del Buen Ayre, Av. Richieri y Paraná.* 3 DE FEBRERO/CIUDADELA: 76**MIARA**, Samuel/*Chubut 4437.*

*ZONA OESTE.* MORON/HAEDO: 77**SANCHEZ TORANZO**, Carlos O./*2da Rivadavia 15.551.*

**1** **CENTROS CLANDESTINOS DE DETENCIÓN**

*CAPITAL FEDERAL:* 1**SUPERINTENDENCIA DE SEGURIDAD FEDERAL**/*Moreno 1417.* 2**GALERIAS PACIFICO**/*Córdoba y Florida.* 3**ESMA**/*Libertador entre Cdro. Rivadavia y Leopoldo Lugones.* 4**OLIMPO**/*Ramón Falcón y Olivera.*

*ZONA SUR:* 5**BRIGADA N. 2 DE INVESTIGACIONES DE LANUS**/*12 de Octubre 234.* 6**PUESTO VASCO**/*Pilcomayo 59 (prox. Estac. Don Bosco, FCG Roca).* 7**POZO DE QUILMES**/*Allison Bell y Garibaldi.* 8**POZO DEBANFIELD**/*Siciliano y Vernet*

*ZONA NORTE/NOROESTE:* 9**C.O.T I MARTINEZ**/*Libertador 14.237.* 10**CASA DEL CILINDRO**/*Predio de la Cía. de Comunicaciones 601, entre la ruta 197, Ing. Huergo y vías del FCGMB.* 11**CAMPO DE MAYO.** 12**LOGISTICO 10**/*Predio entre Av. Gral. Paz y Constituyentes, Zufriategui y Brasil.*

*ZONA OESTE:* 13**LA CASONA**/*Interior de la Brigada Aérea de Palomar.* 14**GADA E 101**/*Predio del Ejército: entre Carlos Pellegrini, Irigoyen, Comesaña y Reconquista.* 15**VII BRIGADA AEREA DE MORON**/*Av. Pierrestegui entre A. Paché y Coronel Arena.* 16**COMISARIA N. 3 DE MORON**/*Libertador Gral. San Martín 654.* 17**HOSPITAL POSADAS**/*Av. Martínez de Hoz entre Marconi y Perdriel.* 18**EL BANCO**/*Autopista Ricchieri y Camino de CIntura (Ruta Nac. Nº4) (Puente 12).* 19**SHERATON**/*Tapalqué y Quintana.* 20**EL VESUBIO**/*Cerca del Camino de Cintura con Av. Ricchieri.* 21**BRIGADA DE INVESTIGACIONES DE SAN JUSTO**/*Calle Salta, contigua a la Comisaría N. 1.*

Above: Grupo de Arte Callejero, *Aqui Viven Genocidas*, 2001. Made in collaboration with "HIJOS"—the children of the disappeared—this map shows the residences of former employees of the Argentine military dictatorship. The title *Aqui Viven Genocidas* translates as "assassins live here." The map also displays the sites of past protest at the residences, interventions known as *escrache*.

VANCOUVER — Jayce Salloum

Mexico begins here

OLYMPIC · CSC, INC. ESMORE COLVILLE
SEATTLE · SEA-TAC · James Yee · GLACIER · BLACKFEET · FORT BELKNAP
TAKOMA · CAMP LEWIS
YAKIMA FIRING CENTER · YAKAMA · NEZ PERCE · FLATHEAD · FORT BERTHOLD · RED EARTH
POWELL BOOKS · WARM SPRINGS · MISSOULA · Montana · North Dakota · WHITE EARTH · LEECH L.
PORTLAND · BUTTE · BISMARCK · FARGO
Washington · Oregon · BILLINGS · CROW · OUT · STANDING ROCK · Minnesota
Idaho · YELLOWSTONE · Pierre Clastres · NORTHERN CHEYENNE · CHEYENNE RIVER · MINNEAPOLIS
GRAND TETON · HEART MOUNTAIN · Wyoming · South Dakota
MINIDOKA · FORT HALL · PINE RIDGE · ROSEBUD · Iowa
LAND OF NATIONS (Sub-titles And Ask Asa) · CASPER · YANKTON · SANTEE
TULE LAKE · Carl Schmitt · WIND RIVER Shoshone National Forest
PYRAMID LAKE · DUCK VALLEY · SALT LAKE CITY · CHEYENNE · Nebraska · OMAHA · DE
Pacific · Nevada · WALKER RIVER · DUGWAY PROVING GROUND · Utah · ROCKY MOUNTAIN · Ward Churchill
SAN FRANCISCO · OAKLAND · Temescal Amity Works · FALLON NAVAL AIR STATION · BASE CAMP · DENVER · Museum of Contemporary Art
Gertrude Stein · Judith Butler · Trevor Paglen · Retort · TOPAZ · Mark M · AURORA · WACKENHUT CORRECTIONS CORP.
NELLIS AFB · UNITAH AND OURAY · BRYCE CANYON · MOAB · Colorado · CAMP FUNSTON · KANSAS CITY · Miss
CAMP ROBERTS · DEATH VALLEY · INDIAN SPRINGS AFS · ZION · CANYONLANDS · UTE MOUNTAIN · FORT CARSON · Kansas
FORT HUNTER LIGGETT · California · CHINA LAKE NAVAL WEAPONS CENTER · LAS VEGAS · GRAND CANYON · NAVAJO · SOUTHERN UTE · GRANADA (Amache) · WICHITA
Ashley Hunt · Wendy Cheng · MANZANAR · FORT IRWIN · HOPI · OUT · SANTA FE · Alden Naranjo · Archie Hoffman · OSAGE
EDWARDS AFB · PALMS AIR GROUND COMBAT CENTER · LEUPP · Native American Church Meeting · ALBUQUERQUE · OKLAHOMA CITY
LOS ANGELES · Sandpaper Books · CAMP KEARNY · JOSHUA TREE · POSTEN · Arizona · FORT APACHE · New Mexico · PALO DURO CANYON · Oklahoma
SAN PEDRO SPC. · CAMP PENDLETON · PHOENIX · FORT SILL
SAN DIEGO · EL CENTRO NAVAL AIR FACILITY · YUMA PROVING GROUND · GILA RIVER · SAN CARLOS · MESCALERO · Constance Simons · WHITE SANDS MISSILE RANGE · WHITE SANDS · Franz Kafka
How to give soldiers fresh water · TUCSON · TOHONO O'ODHAM · CAMP CODY FORT BLISS · FORT WORTH · DALLAS
USA · Mexico · CAMP ARTHUR J. JONES · EL PASO · GUADALUPE MOUNTAINS · Texas · CAMP MacARTHUR
CIUDAD JUAREZ · ELPASO SCP. · FORT DAVIS · CAMP CASEY · FORT HOOD
MARFA 16.1 Chinati Foundation 16.2 Marfa Public Radio · SHEFFIELD · CAMP TRAVIS · CAMP LOGAN · ASTRODOME
BIG BEND NATIONAL PARK · Camping – Amistad Res. – Ciudad Acuña & Del Rio · HOUSTON · FDC HOUSTON
Richard G. Santos · CRYSTAL CITY 14.1 Internment Camp 14.2 Youth Boot Camp · SAN ANTONIO
LAREDO CORRECTIONS CORP OF AMERICA · PORT ISABEL SPC · LOS FRESNOS

### Left margin notes

What did he say? I was disagreeing with him. He said he didn't have it by his side

Wait a minute. When will you remember about me. Tomorrow. Yes. Tomorrow. Yes. Yes

I am angry. Have you been. I am angry with n am. I am angry so you see. Egypt and for Syrie

I am not going to talk about it. I am not going to talk about it

Mexico border. I love the letters n and a

A legal pencil a really legal pencil is incredible. it fastens the whole strong iron wire calendar

Example.
Put something down
Put something down some day
Put something down some day in
Put something down some day in my
In my hand
In my hand right
In my hand writing
Put something down some day in my hand writing

Do I begin this
Yes you begin this
Of course we did
Yes indeed we did

Counting tomorrow can we count a month before they leave the country. It is a disappointment to me that we have not been able to be rid of that which is bothering us as it is a great disappointment to me. Two count. we count two. The one camp first.

I like to ask you questions

Why is there a difference between South America and North America

### ㉛
Our last trip is through downtown Los Angeles at night. A tent city, hundreds of tents strewn along the sidewalks just south of the large banks and office towers. Here is an improvised camp comprised of the city's outcasts, derelicts, mentally ill, drug addicts, poor, homeless, abandoned, or exiles. Here camp is a signifier for where one's self resides. Here camp is a testimony for the failures, the cracks and gaps of economic and social policies, here camp is the last stop, the final frontier in the continual reinscription and rearticulation of the assumed border which separates man from animal. Here camp presages an abandonment that awaits anyone who is too weak, unable, or unwilling to play.

### Note
The existence of the internment camps in Guantanamo Bay, Cuba is further evidence of a fundamental question we must confront with the law.

What is the relation between the law that is written and the force or violence that underlies it?

We want to contribute to a movement that would question the existence of these camps, but we know that the struggle is far greater. As we are ready to embark on this journey, we have within our own work found evidence of the legal framework of the camp – namely, a law which applies by disapplying itself or a law which includes what is outside the law in the form of an exception in the guise of an emergency – in the middle east of Baltimore, in Lod, Ramleh, and Al-Naqsb within Israel, as well as the Occupied Territories of the Palestinian people. Thus, we do not want to make Guantanamo Bay a pure object of our work.

Here we set deliberately set out in the opposite direction. Rather than deducing the definition of camp from the practices which take place there, we will ask instead What is a camp? What is its political-juridical structure? How can such events have taken place there?

We need to explore these issues through the concrete and material history of this country and we also need to be present to the manifestations of this camp within less apparent circumstances.

The tradition of the oppressed teaches us that the 'state of exception' in which we live is the rule. We must arrive at a concept of history that corresponds to this fact. Then we will have the production of a real state of exception before us as a task.

Giorgio Agamben

### ㉑
Here we inquire about the notion of a Form-of-life, a way of life of the Native Americans who occupied this land before they were forcibly removed, transferred, or killed. Here we learn of a history of camp that goes much further back. Here learn that bare life and political life, cultural life, spiritual life, the life around us are intrinsically inter-connected and it is the modern nation-state, which has acted as a rupture between them.

### ㉕
It is said that the history of people who have a history is a history of class struggle. It might be said with at least as much truthfulness, that the history of peoples without history is the history of their struggle against history.

### ㉖
Deeply lost in the night. Just as one sometimes lowers one's head to reflect, thus to be utterly lost in the night. All around people are asleep. It's just play acting, an innocent self-deception, that they sleep in houses, in safe beds, under a safe roof, stretched out or curled up in mattresses, in sheets, under blankets, in reality they have flocked together as they had once upon a time and again later in a deserted region, a camp in the open, a countless number of men, an army, a people, under a cold sky on cold earth, collapsed where once they had stood. Forehead pressed on the arm, face to the ground, breathing quietly. And you are watching, are one of the watchmen, you find the next one by brandishing a burning stick from the bushwood pile beside you. Why are you watching? Someone must watch, it is said. Someone must be there

### ㉗
I am outraged, we should all be outraged

### ㉙
Arriving near the former site of the internment camp in the late afternoon, we find a fenced area with barracks not unlike those which may have similarly housed the transferred internees. The current residents appear to be migrant or undocumented workers, occupying the intersection between the logic of the camp and the logic of neoliberalism.

The exception most clearly reveals the essence of the state's authority. The decision parts here from the legal norm and (to formulate it paradoxically) authority proves that to produce law it need not be based on law. The exception is more interesting than the normal case. The normal proves nothing, the exception proves everything. The exception does not only confirm the rule, the rule as such lives off the exception alone.

### ㉙
Fear has a history here.

Because it was working so silently the machine simply escaped one's attention

We are in a diner, in the middle of the west, like the Film, open land, open sky, all sky, all caught in a rhapsody, a criminal act, so to speak. We note a man wearing a bandanna with the Famous American POV insignia and we have a wish to speak to him. Out back, as we are leaving, he is preparing to ride away in his motorcycle, a Harley, no doubt, leather jacket, he is beaten and resilient. We ask, Guantanamo Bay. He is angry. No connection, that's different son. You ever been to Iraq, fought in Vietnam? Then you don't know nothing. But you were held in Vietnam, so wouldn't you of all people, understand a prisoner of war? No, the ones they got in Gtmo are not like our boys. I'd say they're been treated too well. If it was up to me, I'd kill em all. and let God decide when all is said and done. For the next 60 minutes of driving it is unclear whether he is following us, or we are following him, into an uncertain horizon, clouds gathering, wipers no longer working.

### ⑳
Father was sent to Fort Sill — Grandmother was shipped by train to Florida to learn — to learn what!

I saw a photo of my father years ago wearing women's clothes. They also cut his hair. Since ideas about manhood

What is a reservation?

What is the relation between a reservation and a camp?


We started across the ...
Initially no ca...
camp for Japanese...
here during WWII. Suddenly ...
a child then, she knows exact...
into a primary school. For some wa...
minutes later, the director arrang...
Santos, local historian and organiz...
with families and individuals who we...
camp. He tells about its history, ...
site ending up near the remnants o...

Santos insisted on remembering t...
families were also interned ...

Is there a way to view our curren...
war, loss of civil liberties, the ren...
camps and secret prisons, ... withou...
repetitions of a previous history?...
here! What is new or different in t...
iteration of the camp? Can we imagin...
these forces that does not rely o...

What is the function of this borde...
What is the relation of a gated co...
and a camp?

We cross into Juarez and we speak...
undocumented worker, living in Chica...
father of two, his partner a US c...
crime he did not commit, wrong plac...
recently deported, now it's just sa...
calls, letters, hoping to see his k...
life on the other side, selling drin...
street stand, near a park, about ...

Is it here that we might begin to d...
discursive, legal and spatial practi...
the camp intersect with the econom...
neoliberalism?

Is this where we might find the clu...
of a new form of (liberal) fascism?

Claire Parnet & Gilles Deleuze

The other way of beginning again, on the other hand, is to take up the interrupted line, to join a segment to the broken line, to make it pass between two rocks in a narrow gorge, or over the top of the void, where it had stopped. It is never the beginning or the end which are interesting, the beginning

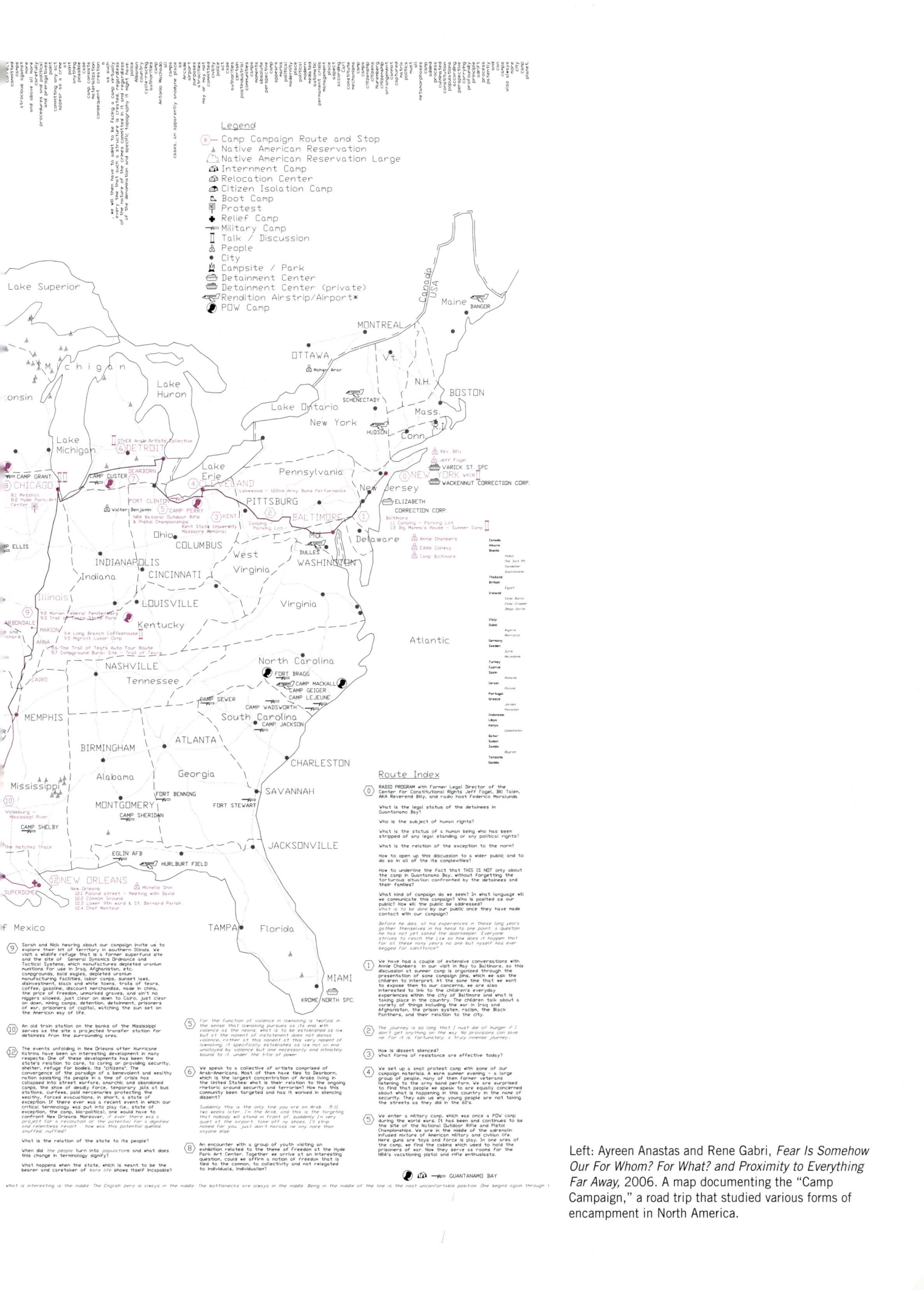

## Legend

- Camp Campaign Route and Stop
- Native American Reservation
- Native American Reservation Large
- Internment Camp
- Relocation Center
- Citizen Isolation Camp
- Boot Camp
- Protest
- Relief Camp
- Military Camp
- Talk / Discussion
- People
- City
- Campsite / Park
- Detention Center
- Detention Center (private)
- Rendition Airstrip/Airport*
- POW Camp

## Route Index

(0) RADIO PROGRAM with Former Legal Director of the Center for Constitutional Rights Jeff Fogel, Bill Talen, AKA Reverend Billy, and radio host Federico Maralunda.

What is the legal status of the detainees in Guantanamo Bay?

Who is the subject of human rights?

What is the status of a human being who has been stripped of any legal standing or any political rights?

What is the relation of the exception to the norm?

How to open up this discussion to a wider public and to do so in all of the its complexities?

How to underline the fact that THIS IS NOT only about the camp in Guantanamo Bay, without forgetting the tortuous situation confronted by the detainees and their families?

What kind of language do we seek? In what language will we communicate this campaign? Who is posited as our public? How will the public be addressed?
What is to be done by our public once they have made contact with our campaign?

Before he dies, all his experiences in these long years gather themselves in his head to one point, a question he has not yet asked the doorkeeper. Everyone strives to reach the Law so how does it happen that for all these many years no one but myself has ever begged for admittance?

(1) We have had a couple of extensive conversations with Annie Chambers. In our visit in May to Baltimore, as this discussion at summer camp is organized through the presentation of some campaign pins, which we ask the children to interpret. At the same time that we want to expose them to our concerns, we are also interested to link to the children's everyday experiences within the city of Baltimore and what is taking place in the country. The children talk about a variety of things including the war in Iraq and Afghanistan, the prison system, racism, the Black Panthers, and their relation to the city.

(2) The journey is so long that I must die of hunger if I don't get anything on the way. No provisions can save me for it is fortunately, a truly immense journey.

(3) How is dissent silenced?
What forms of resistance are effective today?

(4) We set up a small protest camp with some of our campaign materials. A warm summer evening – a large group of people, many of them former veterans listening to the army band perform. We are surprised to find that people we speak to are equally concerned about what is happening in this country in the name of security. They ask us why young people are not taking the streets as they did in the 60's.

(5) We enter a military camp, which was once a POW camp during the world wars. It has been and continues to be the site of the National Outdoor Rifle and Pistol Championships. We are in the middle of American infused mixture of American military and civilian life. Here guns are toys and force is play. In one area of the camp, we find the cabins which used to hold the prisoners of war. Now they serve as rooms for the NRA's vacationing pistol and rifle enthusiasts.

For the function of violence in lawmaking is twofold in the sense that lawmaking pursues as its end with violence as the means what is to be established as law but at the moment of instatement does not dismiss violence, rather at this moment at this very moment of lawmaking it specifically establishes as law not an end unalloyed by violence but one necessarily and intimately bound to it, under the title of power.

(6) We speak to a collective of artists comprised of Arab-Americans. Most of them have ties to Dearborn, which is the largest concentration of Arabs living in the United States; what is their relation to the ongoing rhetoric around security and terrorism? How has this community been targeted and has it worked in silencing dissent?

Suddenly this is the only time you are an Arab. 9/11 two weeks later. I'm the Arab, and this is the targeting that nobody will stand in front of, suddenly I'm very quiet at the airport, take off my shoes, I'll strip naked for you, just don't harass me any more than anyone else.

(7)

(8) An encounter with a group of youth visiting an exhibition related to the theme of Freedom at the Hyde Park Art Center. Together we arrive at an interesting question, could we affirm a notion of freedom that is tied to the common, to collectivity and not relegated to individuals, individualism?

(9) Sarah and Nick hearing about our campaign invite us to explore their bit of territory in southern Illinois. We visit a wildlife refuge that is a former superfund site and the site of General Dynamics Ordnance and Tactical Systems, which manufactures depleted uranium munitions for use in Iraq, Afghanistan, etc. campgrounds, bald eagles, depleted uranium manufacturing facilities, labor camps, sunset laws, disinvestment, black and white towns, trails of tears, coffee, gasoline, discount merchandise, made in china, the price of freedom, unmarked graves, and ain't no niggers allowed, just clear on down to Cairo, just clear on down, mining camps, detention, detainment, prisoners of war, prisoners of capital, watching the sun set on the American way of life.

(10) An old train station on the banks of the Mississippi serves as the site a projected transfer station for detainees from the surrounding area.

(12) The events unfolding in New Orleans after Hurricane Katrina have been an interesting development in many respects. One of these developments has been the state's relation to care, to caring or providing security, shelter, refuge for bodies, its "citizens." The convergence of the paradigm of a benevolent and wealthy nation assisting its people in a time of crisis has collapsed into street warfare, anarchic and abandoned camps, the show of deadly force, temporary jails at bus stations, curfews, paid mercenaries protecting the wealthy, forced evacuations, in short, a state of exception. If there ever was a recent event in which our critical terminology was put into play (i.e., state of exception, the camp, bio-politics), one would have to confront New Orleans. Moreover, if ever there was a project for a revolution or the potential for a dignified and relentless revolt how was this potential quelled, snuffed, nuffled?

What is the relation of the state to its people?

When did the people turn into populations and what does this change in terminology signify?

What happens when the state, which is meant to be the bearer and caretaker of bare life shows itself incapable?

What is interesting is the middle. The English zero is always in the middle. The bottlenecks are always in the middle. Being in the middle of the line is the most uncomfortable position. One begins again through t

Left: Ayreen Anastas and Rene Gabri, *Fear Is Somehow Our For Whom? For What? and Proximity to Everything Far Away,* 2006. A map documenting the "Camp Campaign," a road trip that studied various forms of encampment in North America.

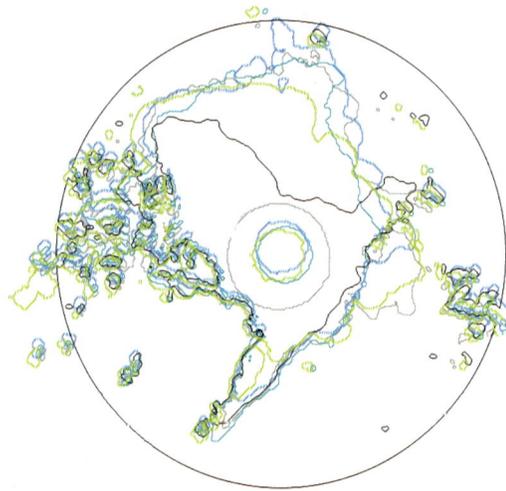

Left and Above: Adriane Colburn, *Whose On Top (race to the pole, part two)*, 2008. Maps documenting Antarctica's melting ice caps.

# BIBLIOGRAPHY
## COMPILED BY SARAH THOMAS

Agnew, J. and Duncan, J., eds. *The Power of Place: Bringing Together the Geographical and Sociological Imaginations.* Boston: Routledge, 1989.

Agnew, John, David N. Livingstone and Alisdair Rogers, eds. *Human Geography: An Essential Anthology.* Oxford: Blackwell Publishers, 1996.

Aldiss, Brian. *Earthworks.* New York: Doubleday and Co., 1996.

Alÿs, Francis, and Cuauhtémoc Medina. *When Faith Moves Mountains.* Madrid: Turner, 2005.

Armetta, Amoreen. "Performing Landscapes: Traveling to Greenland with Ilana Halperin." *Art on Paper*, vol. 11, no. 3 (January–February 2007), pp. 35–36.

Bachelard, Gaston. *The Poetics of Space.* Trans. Maria Jolas. Boston: Beacon Press, 1969.

Baker, Elizabeth. "Artworks on the Land." *Art in America*, vol. 64 (January–February 1976), pp. 92–96.

Beardsley, John. *Earthworks and Beyond: Contemporary Art in the Landscape.* New York: Abbeville Press Publishers, 1998.

—. *Probing the Earth: Contemporary Land Projects*, Exh. cat. Washington, D.C.: Smithsonian Institution Press, 1997.

Benjamin, Walter, and Rolf Tiedemann. *The Arcades Project.* Cambridge, Mass: Belknap Press, 1999.

—. *Illuminations.* New York: Harcourt, Brace & World, 1968.

Benko, Georges and Ulf Stromayer, eds. *Space and Social Theory: Interpreting Modernity and Postmodernity.* Oxford: Blackwell Publishers, 1997.

Boettger, Suzaan. *Earthworks: Art and the Landscape of the Sixties.* Berkeley: University of California Press, 2002.

Bourdon, David. *Designing the Earth: the Human Impulse to Shape Nature.* New York: Harry N. Abrams, 1995.

Callicot, J. Baird. *In Defense of the Land Ethic: Essays in Environmental Philosophy.* Albany: State University of New York Press, 1989.

Carter, Erica, James Donald, and Judith Squire, eds. *Space and Place: Theories of Identity and Location.* London: Lawrence & Wishart, 1993.

Certeau, Michel de. *The Certeau Reader.* Ed. Graham Ward. Oxford: Blackwell Publishers, 2000.

Coolidge, Matthew and Sarah Simmons, eds. *Overlook: Exploring the Internal Fringes of America with the Center for Land Use Interpretation.* New York: Metropolis Books, 2006.

Davis, Mike. *City of Quartz: Excavating the Future in Los Angeles.* Los Angeles: Vintage Books, 1992.

Deutsche, Rosalyn. *Evictions: Art and Spatial Politics.* Cambridge, Mass.: MIT Press, 1998.

Godlewska, Anne and Neil Smith. *Geography and Empire.* Oxford: Blackwell Publishers, 1994.

Graziani, Ronald Sisto. *Robert Smithson and the American Landscape.* Cambridge, U.K.: Cambridge University Press, 2004.

Gregory, Derek and Allan Pred, eds. *Violent Geographies.* New York: Routledge, 2006.

Hartshorne, Richard. *The Nature of Geography: A Critical Survey of Current Thought in the Light of the Past.* Lancaster: The Association, 1939.

Harvey, David. *Explanation in Geography.* London: Edward Arnold, 1969.

—. *Justice, Nature, and the Geography of Difference.* Oxford: Blackwell Publishers, 1996.

—. *Spaces of Capital: Towards a Critical Geography.* Edinburgh: Edinburgh University Press, 2001.

—. *Spaces of Hope.* Berkeley: University of California Press, 2000.

Herman, Daniel. "Lords of Muddled Earth." *Artforum International*, vol. 42, no. 5 (January 2004), pp. 49–50.

Hobbs, Robert, ed. "Earthworks: Past and Present." *Art Journal*, vol. 42 (Fall 1982), pp. 191–233.

Hooson, David, ed. *Geography and National Identity.* Oxford: Blackwell Publishers, 1994.

Howett, Catherine. "New Directions in Environmental Art." *Landscape Architecture*, vol. 67 (January 1977), pp. 38–46.

Kastner, Jeffrey and Brian Wallis, eds. *Land and Environmental Art.* London: Phaidon, 1998.

Kastner, Jeffrey. "True Beauty." *Artforum International*, vol. 43, no. 10 (Summer 2005), pp. 286–287.

Kepes, Gyorgy, ed. *Arts of the Environment.* New York: George Braziller, 1965.

Knabb, Ken, ed. *Situationist International Anthology.* Berkeley: Bureau of Public Secrets, 1981.

Lefebvre, Henri. *Critique of Everyday Life: Foundations for a Sociology of the Everyday.* Trans. John Moore. vol. 2. London: Verso, 2002.

—. *The Production of Space.* Trans. Donald Nicholson-Smith. Oxford: Blackwell Publishers, 1991.

Lambert, Jean Clarence. *Cobra*. New York: Abbeville Press, 1984.

Lipke, William C. and Willoughby Sharp. *Earth Art*. Exh. cat. Ithaca: Andrew Dickson White Museum, Cornell University, 1970.

Lippard, Lucy. *The Lure of the Local: Senses of Place in a Multicentered Society*. New York: The New Press, 1997.

Morris, Robert. *Earthworks: Land Reclamation as Sculpture*. Exh. cat. Seattle: Seattle Art Museum, 1979.

Paglen, Trevor. *I Could Tell You but Then You Would Have to Be Destroyed by Me: Emblems from the Pentagon's Black World*. New York: Melville House, 2008.

—. *Torture Taxi: On the Trail of the CIA's Rendition Flights*. New York: Melville House, 2006.

Rancière, Jacques. *The Politics of Aesthetics: The Distribution of the Sensible*. Trans. Gabriel Rockhill. New York: Continuum, 2004.

Roberts, Jennifer L. "Landscapes of Indifference: Robert Smithson and John Lloyd Stephens in Yucatan." *Art Bulletin*, vol. 82, no. 3 (September 2000), pp. 544–567.

Sanford, Melissa. "The Salt of the Earth Sculpture: Debating Intervention as Nature does it work." *The New York Times* (January 13, 2004), p. E1.

Shield, Peter, and Graham Birtwistle. *Cobra: Copenhagen, Brussels, Amsterdam*. London: Hayward Gallery, 2003.

Smith, Neil. *The New Urban Frontier: Gentrification and the Revanchist City*. New York: Routledge, 1996.

Smithson, Robert. *Robert Smithson, The Collected Writings*. Ed. Jack Flam. Berkeley: University of California Press, 1996.

—. *The Writings of Robert Smithson: Essays and Illustrations*. Ed. Nancy Holt. New York: New York University Press, 1979.

Soja, Edward W. *Postmodern Geographies: The Reassertion of Space in Critical Social Theory*. London: Verso, 1989.

—. *Thirdspace: Journeys to Los Angeles and other Real-and-Imagined Places*. Oxford: Blackwell Publishing, 1996.

Strausbaugh, John. "Take Nature, Add Humans, Observe Results." *The New York Times* (September 24, 2006), Section 2.

Sussman, Elizabeth, ed. *On the Passage of a Few People Through a Rather Brief Moment in Time: The Situationist International, 1957–1972*. Exh. cat. Cambridge, Mass.: MIT Press, 1989.

Tiberghien, Giles A. *Land Art*. New York: Princeton Architectural Press, 1995.

Tilman, Sidney. "Earthworks and the New Picturesque." *Artforum*, vol. 7 (December 1968), pp. 42–45.

Tsai, Eugenie, and Cornelia Butler. *Robert Smithson*. Exh. cat. Berkeley: University of California Press, 2004.

Tuan, Yi-Fu. "Realism and Fantasy in Art, History, and Geography." *Annals of the Association of American Geographers*, vol. 80 (1990), pp. 435–46.

Whitehand, J.W.R. *The Making of the Urban Landscape*. Oxford: Blackwell Publishing, 1991.

# EXHIBITION CHECKLIST

*Note: height precedes width precedes depth; all dimensions provided are for unframed work unless otherwise specified.*

**Francis Alÿs (in collaboration with Cuauhtémoc Medina and Rafael Ortega)**
Born 1959 in Antwerp, Belgium. Lives in Mexico City.

*The Making of Lima*, 2002
Single-channel video projection with color and sound
15 min., 37 sec.
Courtesy the artist and David Zwirner Gallery, New York

**AREA Chicago**
Founded in 2006. Based in Chicago.

*Notes for a People's Atlas*, 2006–ongoing
Interactive distribution network comprised of local maps
Individual works 11 x 17 in. (27.94 x 43.18 cm.), number of works variable
Courtesy the artists

**The Center for Land Use Interpretation**
Founded in 1994. Based in Los Angeles.

*Untitled (image and text panels depicting the programs and projects of CLUI)*, 2007
Twelve inkjet prints
16 x 24 in. (40.64 x 60.96 cm.) each
Courtesy the artists

**The Center for Urban Pedagogy (CUP)**
Founded in 1997. Based in New York.

*Garbage Education Display System (Garbage City & Landfill vs. Incinerator)*, 2002–08
Two vinyl banners, metal structure
Approximately 84 x 120 x 60 in. (213.4 x 304.8 x 152.4 cm.)
Courtesy the artists

CUP Participants:
Andrea Meller, Damon Rich, Rosten Woo (project leaders)
Jason Anderson, Zoë Coombes, Geneva Eddy, Justyna Judycka, André Knights, Leo Paulino, Danny Poutchkov, Brandon Rivera, Francisco Rodriguez, Elizabeth Sanchez, Lemar White

**e-Xplo**
Founded 1998. Based in Berlin and New York.
*Untitled—Collection of Five Independent Audio Works*, 2008
Sound work comprised of five audio recordings
Approximately 48 min. each
Courtesy the artists

e-Xplo Members:
Rene Gabri, Heimo Lattner, and Erin McGonigle

**Ilana Halperin**
Born 1973 in New York. Lives in Glasgow, Scotland.

*Boiling Milk (Solfataras)*, 2000
Chromogenic print
19 5/8 x 30 in. (49.8 x 76.2 cm.)
Courtesy the artist and doggerfisher, Edinburgh

*Iceberg City (from the project Towards Heilprin Land)*, 2007
Etching on handmade Fabriano paper
18 x 23 in. (45.72 x 58.42 cm.)
Courtesy the artist and doggerfisher, Edinburgh

*Near ITTOQQORTOORMIIT (from the project Towards Heilprin Land)*, 2007
Etching on handmade Fabriano paper
18 x 23 in. (45.72 x 58.42 cm.)
Courtesy the artist and doggerfisher, Edinburgh

*The Hanging Glacier (from the project Towards Heilprin Land)*, 2007
Etching on handmade Fabriano paper
18 x 23 in. (45.72 x 58.42 cm.)
Courtesy the artist and doggerfisher, Edinburgh

*Towards Heilprin Land*, 2007
Wooden bookshelf with complimentary booklets, bound in cardstock
Bookshelf: 9 1/8 x 26 3/8 x 6 5/8 in. (23.18 x 66.99 x 16.83 cm.)
Booklets: 8 1/2 x 5 1/2 in. (21.59 x 13.97 cm.)
Courtesy the artist and doggerfisher, Edinburgh

**kanarinka (Catherine D'Ignazio)**
Born 1975 in Chapel Hill, North Carolina. Works in Boston.

*It Takes 154,000 Breaths to Evacuate Boston*, 2007
Twenty-six glass jars with speakers, cd players, and painted wood table
50 x 72 x 16 in. overall (127 x 182.88 x 40.64 cm.)
Courtesy the artist

**Julia Meltzer and David Thorne**
Born 1968 in Hollywood, California; 1960, Boston, Massachusetts. Live in Los Angeles.

*take into the air my quiet breath*, 2007
Single-channel video with color and sound, looped
17 min.
Courtesy the artists

**Lize Mogel**
Born 1972 in New York. Lives in New York.

*Mappa Mundi*, 2008
Digital print
52 x 48 in. (132.1 x 121.9 cm.)
Courtesy the artist

**Multiplicity**
Founded in 1995. Transnational.

*The Road Map*, 2003
Installation of two-channel video projection and four-channel
video on monitors with color and sound
Two projections: 28 min. 14 sec. and 28 min. 48 sec., each looped; Four monitors: two at two min. each, each looped; two with still images
Courtesy the artists

Multiplicity Members:
Stefano Boeri, Maddalena Bregani, Maki Gherzi, Matteo Ghidoni, Sandi Hilal, Anniina Koivu, Alessandro Petti, Salvatore Porcaro, Francesca Recchia, Eduardo Staszowsky.

**Trevor Paglen**
Born 1974 in Washington, D.C. Lives in Berkeley, California.

*The Salt Pit (Shomali Plains northeast of Kabul, Afghanistan)*, 2006
Chromogenic print
24 x 36 in. (60.96 x 91.44 cm.)
Courtesy the artist and Bellwether, New York

*Black Site (Kabul, Afghanistan)*, 2006
Chromogenic print
24 x 34 in. (60.96 x 86.36 cm.)
Courtesy the artist and Bellwether, New York

*"James Thomas Harbison" (CIA Officer Wanted in Connection with the Abduction of Abu Omar from Milan, Italy)*, 2007
Silkscreen on canvas
60 x 50 in. (152.4 x 127 cm.)
Courtesy the artist and Bellwether, New York

**Raqs Media Collective**
Founded in 1991 in New Delhi. Based in New Delhi.

*Erosion by Whispers*, 2007
Wood, chromogenic prints, chicken-wire, and fluorescent lights
26 1/8 x 30 1/8 x 3 7/8 in. each (66.5 x 76.5 x 10 cm.); 26 1/8 x 66 1/4 x 3 7/8 in. overall (66.36 x 168.7 x 9.84 cm.)
Courtesy the artists and Bose Pacia Gallery, New York

Raqs Media Collective Members:
Jeebesh Bagchi, Monica Narula, Shuddhabrata Sengupta

**Ellen Rothenberg**
Born 1945 in Buffalo, NY. Lives in Chicago.

*De-Stabilized Geography: Map 3*, 2007–08
Camouflage fabric, metal and plastic map tacks, metal and plastic map flags, zip ties, wire
Approximately 120 x 336 in. (304.8 x 853.4 cm.)
Courtesy the artist

**Spurse (with involvement from Chris Archer, Cole Caswell, and Jeffrey Jenkins)**
Founded in 1994. Transnational.

*Micromobilia: Machines for the Intensive Research of Interior Bio-Geographies*, 2005–08
Three units, each with plywood shelving and interior foam packing, five modular chairs, two digital microscopes, refrigerator, DVD player, research book selection, one DVD video, diagrams, laboratory clothing, office supplies, Petri dishes, cotton swabs, sampling and testing implements, glass and plastic jars, nine chalk boards with fixed diagrams
27 x 22 x 72 in. (68.6 x 55.9 x 182.9 cm.) each, overall dimensions variable
Courtesy the artists

**Deborah Stratman**
Born 1967 in Washington D.C. Lives in Chicago.

*Park*, 2000
Eight chromogenic prints, eight Polaroid prints, and parking booth with steel, wood, Plexiglas, and hardware
Chromogenic prints: 16 x 16 in. (40.64 x 40.64 cm.) each
Polaroid prints: 3 1/2 x 4 1/4 in. (8.89 x 10.79 cm.) each
Booth: 96 x 31 x 36 in. (243.84 x 78.74 x 91.44 cm.)
Courtesy the artist; partially supported by a grant from the Illinois Arts Council.

**Daniel Tucker (project organizer)**
Born 1983 in Louisville, Kentucky. Lives in Chicago.

*The We Are Here Map Archive*, 1997–07
Twenty-seven maps in a freestanding poster display
Map dimensions varied
30 x 40 x 8 1/2 in. overall (76.2 x 101.6 x 21.59 cm.)
Courtesy the artist

Contributors:
Ayreen Anastas and Rene Gabri, Beehive Design Collective, Bureau d'études, The Center for Urban Pedagogy (with Rosten Woo, Longshore Workers Coalition, Labor Notes, Bill Rankin, thumb projects, Stephanie Whitehouse, and William Hood), Adriane Colburn, Counter-Cartographies Collective, Ecotrust Canada, Amy Franceschini, Friends of William Blake, Hackitectura and collaborators, Grupo de Arte Callejero, Ashley Hunt, Indymedia Estrecho and collaborators, The Institute for Infinitely Small Things, Los Angeles Urban Rangers, Lize Mogel and Dario Azzellini, Indypendent, New York City, Bill Rankin, Repohistory, Nikolas R. Schiller, subRosa, Temporary Travel Office, and Jeffrey Warren.

**Alex Villar**
Born 1962 in Vitoria, Brazil. Lives in New York.

*Upward Mobility*, 2002
Single-channel video with color, looped
7 min. 43 sec.
Courtesy the artist

**Yin Xiuzhen**
Born 1963 in Beijing, China. Lives in Beijing.

*Portable Cities: Singapore*, 2003
Audio CD recording and suitcase containing fabric clothing, paper map, magnifying lens, and light
32 1/8 x 59 x 35 1/2 in. (81.6 x 149.86 x 90.17 cm.) open
Courtesy Chambers Fine Arts, New York

# INDEX

# PHOTO CREDITS

All images are courtesy of the artist unless otherwise noted.

**Francis Alÿs (pp. 48, and 50–51)**
Courtesy David Zwirner Gallery, New York

**Ilana Halperin (pp. 34–35, 52, and 54–55)**
Photo: Ruth Clark. Courtesy doggerfisher, Edinburgh

**Trevor Paglen (pp. 26–27, 74, and 76–77)**
Courtesy Bellwether Gallery, New York

**Ellen Rothenberg (pp. 110, and 112–113)**
Photo: Damla Tokcan Faro

**Yin Xiuzhen (p. 102)**
Courtesy Chambers Fine Arts, New York

**Photo of the Bingham Mine (p. 36)**
Courtesy the Center for Land Use Interpretation

**Photo of Holt's *SunTunnels* (p. 38)**
Courtesy the Center for Land Use Interpretation

**Photo of Thiokol Rocket Plant (p. 37)**
Courtesy the Center for Land Use Interpretation

**Photo of Smithson's "Toward the Development of an Air Terminal Site" (p. 36.)**
©Artforum, June 1967

**Photo of Warhol's *Green Car Crash* (p. 14)**
© Christie's Images Limited 2007, © 2008 Andy Warhol Foundation for the Visual Arts/ARS, New York

**Photo of Debord's *The Naked City* (p. 17)**
Courtesy RKD, The Hague

**Photo of Nieuwenhuys' *Yellow Sector* (pp. 12–13 and 17)**
© 2008 Artists Rights Society (ARS), New York, Beeldrecht, Amsterdam

**Photo of Piper's *The Mythic Being* (p. 20)**
Photo: Peter Kennedy
© Adrian Piper Research Archive
Collection Adrian Piper Research Archive